Mutual combinations of the eight trigrams
result in the production of the ten thousand things.

—Shao Yong (1011–1077)
Outer Chapter on Observation of Things

The ten thousand things are produced and reproduced,
so that variation and transformation have no end.

—Zhou Dunyi (1017–1073)
Diagram of the Supreme Ultimate Explained

萬物

雷德康、亮新著

罗传沂

Lothar Ledderose

Ten Thousand Things

Module and Mass Production in Chinese Art

The A. W. Mellon Lectures in the Fine Arts, 1998
The National Gallery of Art, Washington, D.C.
Bollingen Series XXXV:46

Princeton University Press
Princeton, New Jersey

Frontispiece Fu Shen (born 1937), *Wanwu* (*Ten Thousand Things*), March 1997. Calligraphy.

Copyright © 2000 by the Trustees of the National Gallery of Art, Washington, D.C.
Published by Princeton University Press, 41 William Street, Princeton, New Jersey 08540
In the United Kingdom: Princeton University Press, Chichester, West Sussex

This is the forty-sixth volume of the A. W. Mellon Lectures in the Fine Arts, which are delivered annually at the National Gallery of Art, Washington. The volumes of lectures constitute Number XXXV in Bollingen Series, sponsored by the Bollingen Foundation.

Library of Congress Cataloging-in-Publication Data

Ledderose, Lothar.
 Ten thousand things : module and mass production in Chinese art / Lothar
Ledderose.
 p. cm. — (The A.W. Mellon lectures in the fine arts ; 1998) (Bollingen series ; 46)
 Includes bibliographical references and index.
 ISBN 0-691-00669-5 (cloth : alk. paper)
 ISBN 0-691-00957-0 (pbk : alk. paper)
 1. Art, Chinese—Technique. 2. Mass production—China. I. Title. II. Series.
III. Series: Bollingen series ; 46
N7340.L38 2000
709′.51—dc 21 99-34118
 CIP

Composed in Berkeley and Formata by Dix!
Designed and edited by Brian D. Hotchkiss, Vernon Press, Inc.

Printed and bound by CS Graphics, Singapore

10 9 8 7 6 5 4 3 2 1
10 9 8 7 6 5 4 3 2 1 (pbk.)

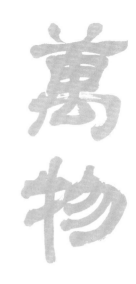

Contents

Acknowledgments *vi*

Introduction *1*

1 The System of Script 9

2 Casting Bronze the Complicated Way 25

3 A Magic Army for the Emperor *51*

4 Factory Art 75

5 Building Blocks, Brackets, and Beams *103*

6 The Word in Print *139*

7 The Bureaucracy of Hell *163*

8 Freedom of the Brush? *187*

Notes *215*

Bibliography *229*

Glossary of Chinese Terms *252*

Index *256*

Picture Sources *264*

Acknowledgments

AS A BOY, I FIRST CAME ACROSS MODULES IN THE GUISE of a jigsaw puzzle. At one particular Christmas I was given a puzzle different from all others I had had so far. A chain of mountain peaks at the left flattened out toward the right into a wide plain dotted with a tower, houses, trees, carriages, and a rider. But the pieces did not have curved edges or interlocking shapes. Rather they were all simple rectangles, tall and thin, arranged in a horizontal sequence. Altogether there were only about a dozen of them. This is easy, I thought, actually, pretty boring.

Only when I took the pieces out of the box and rearranged them on the table did it occur to me that, unlike with other puzzles, there was no fixed position for each piece. The mountains could go into the middle of the landscape or to the right; the tower would as easily fit between the peaks as on the plain, and the rider could be placed heading toward the hills or returning. A coherent panorama invariably emerged.

The trick to completing this puzzle was that, on every single piece, the horizon crossed the left and right edges exactly at midpoint. The pieces could thus be put together in ever new combinations, thousands of them, yet the continuous horizon always guaranteed an intelligible composition.

This jigsaw puzzle had been made in China.

I remembered that puzzle when I studied with Vadime Elisseeff in Paris, in the 1960s. He attempted to isolate and define hundreds of distinct motifs in the endlessly varied decor of ancient Chinese bronzes. His ultimate aim was to devise a computer program that would allow him to arrange all known bronzes in one chronological sequence. We now know that this could not have worked, because the corpus of bronzes is just too complex. Nevertheless, I was fascinated by Elisseeff's premise, which he often repeated—namely that the Chinese create works of art by first defining elements, and then by playing with them.

In the 1970s I joined the research group of Suzuki Kei in Japan to work on their survey of paintings of the ten kings of hell. Minato Nobuyuki, then one of Professor Suzuki's students, analyzed the ways in which the painters of these scrolls assembled their compositions from set parts. In an article on a king of hell painting in Berlin, I suggested that comparable modes of production might be detected in yet other areas of Chinese art.

I first systematically pursued these lines of investigation when, in the Lent Term of 1992, Cambridge University offered me the opportunity to give the Slade Lectures. At that time Jessica Rawson generously helped me sharpen my arguments and to make my English more understandable. When Ernest Gombrich once came to Cambridge, I mentioned to him that I was working on the issue of *Versatzstücke* in Chinese art. Typically, *Versatzstücke* refers to pieces of furniture and other set decor that can be used in a variety of ways and rearranged in many plays to create different stage sets in a theater. Gombrich told me that he knew what I had in mind, but that here existed no precise equivalent for *Versatzstücke* in the English language. Thus, with his blessings, I settled on *module,* a term that is both more understandable and more versatile.

Many institutions and individuals contributed to my further research. Unforgettable is the day when Yuan Zhongyi in Lintong descended with me into the pit of the terra-cotta army. Standing among those soldiers, I finally saw close up the extraordinary variety of faces, gestures, and armor that Chinese artisans had achieved more than two thousand years ago in an ingeniously devised system of modular production.

The Deutsche Forschungsgemeinschaft made possible a sabbatical term that I spent at the Freer and Sackler galleries' marvelous research library in Washington, D.C. The unflagging support of the library staff under Lily Kecskes was invaluable, as were the many conversations with gallery staff members. Jan Stuart read several chapters as I wrote them and offered expert criticism.

A new version of my text was presented in 1998 as the Mellon Lectures at the National Gallery of Art in Washington. Henry Millon, Dean of the Center for Advanced Study in the Visual Arts, and his staff could not have made my stay more enjoyable.

The preparation of the final manuscript would have been impossible without the professional assistance of Patricia Fidler of Princeton University Press, and Brian Hotchkiss and Peter Blaiwas of Vernon Press. Judith Whitbeck graciously agreed to help with the proofreading. At the Institute of Art History of Heidelberg University, Ingeborg Klinger produced excellent photographs and Tsai Suey-ling ably compiled the glossary with the Chinese characters.

Still many other friends and colleagues helped toward completion of the work. To all of them, named and unnamed, I offer ten thousand thanks.

L.L.
Heidelberg, 1999

THROUGHOUT HISTORY THE CHINESE HAVE produced works of art in huge quantities: a tomb of the fifth century B.C. yields bronze artifacts that total ten metric tons in weight; the terra-cotta army in the third-century B.C. necropolis of the First Emperor boasts more than seven thousand soldiers; lacquer dishes manufactured in the first century A.D. have serial numbers ranging in the thousands; a timber pagoda of the eleventh century A.D. is constructed of some thirty thousand separately carved wooden members; and in the seventeenth and eighteenth centuries China exported several hundred million pieces of porcelain to the West.

All this was feasible because the Chinese devised production systems to assemble objects from standardized parts. These parts were prefabricated in great quantity and could be put together quickly in different combinations, creating an extensive variety of units from a limited repertoire of components. These components are called modules in the present book.

Ten Thousand Things investigates module systems in the production of ancient Chinese bronzes, terra-cotta figures, lacquer, porcelain, architecture, printing, and painting. It also explores technical and historical evolution in all these fields as well as the implications of module systems for particular makers and for society at large. Along the way, readers will discover that the West learned about modular production from China, and ultimately the definition of art in China will be addressed.

The following eight chapters present case studies that focus on particular module systems and ask similar sets of questions. The description and analysis of a given system is the main subject of each chapter. The achievement of the module system is then assessed by reconstructing the tasks that the makers were assigned or that they set for themselves. Regardless of the situation, two basic, somewhat contradictory objectives are always evident: they produce objects both in large quantities and of great variety. Taken into consideration are the demands of notorious customers who expected high quality for a low price and thrived on setting difficult deadlines. Module systems were best suited to reach all these conflicting goals.

In roughly chronological sequence, the chapters cover a wide time span. The first case study deals with ritual bronze vessels of antiquity, particularly of the twelfth century B.C. Chapters 6 and 8, respectively, concern an encyclopedia of over one hundred million characters printed with movable type, and a series of bamboo paintings, both dating to the eighteenth century A.D.

To pursue the same issue over a period spanning three millennia, without resorting to the Hegelian concept of China as a country of eternal stasis, begs for explanation. A fundamental justification is to be found in the ubiquity of Chinese script that was in existence from at least the thirteenth century B.C. and is still in use today. Chinese script, which is arguably the most complex system of forms that humans devised in premodern times, is a module system par excellence. Its fifty thousand characters are all composed by choosing and combining a few modules taken from a relatively small repertoire of some two hundred parts.[1]

Script profoundly affected the patterns of thought in China. Almost everyone had at least a rudimentary understanding of the system, as total illiteracy was rare. Most people knew a few characters, if only those used in their own names, or some numbers, and who would not recognize the characters representing happiness (*fu*) and long life (*shou*)? For the educated elite, writing was the core of culture. The decision makers spent the greater part of their formative years learning how to read and write, and then used script every day of their lives. In the course of history, knowledge

of characters became ever more widespread in society. Thus, through their script, the Chinese of all periods were familiar with a pervasive module system. This system is the topic of the first chapter and a paradigm for all later discussions.

All Chinese knew about still other module systems. Probably the most popular one is the binary code expounded in the celebrated opus of divination and wisdom from antiquity, the *Book of Changes* (*Yijing*), which has been called "perhaps the single most important work in China's long intellectual history."[2] It teaches how to build units through combinations of only two elements, a broken line and an unbroken line. There are eight different ways to arrange three lines in one group; those are the eight trigrams. By doubling the strokes into groups of six, the hexagrams, sixty-four different combinations can be formed. Further limitless transformations and changes are said to bring forth the "ten thousand things," the myriad categories of phenomena in the universe.

The binary pattern of thought in the *Book of Changes* has fascinated intellectuals in the West from the time they first encountered it. In the seventeenth century it confirmed the expectation of the mathematician and philosopher Gottfried Wilhelm Leibniz that China would become a major player in a global scientific academy.[3]

Linguists may find modular structures in the Chinese language. There is a repertoire of some 440 syllables, most of which can be pronounced in four different tones. Almost every syllable can assume various meanings. The correct meaning in a particular case derives from its combination with other syllables. Words are formed by combining syllables, not by modifying them.

Many other modular patterns can be identified in the Chinese cultural fabric. To mention but one example, a certain Buddhist rock cave, hollowed out in A.D. 616 not far from Beijing, contains four pillars with a total of 1,056 small Buddha figures carved in relief. Engraved next to each Buddha is his name, consisting of three or four characters. The same characters occur again and again, but through combination over a thousand different names are formed.[4]

Module systems do not occur in China alone; comparable phenomena exist in other cultures. However, the Chinese started working with module systems early in their history and developed them to a remarkably advanced level. They used modules in their language, literature, philosophy, and social organizations, as well as in their arts. Indeed, the devising of module systems seems to conform to a distinctly Chinese pattern of thought.

The Advancement of Modular Systems

Emphasizing the pervasiveness of modular patterns in Chinese history does not mean to deny that there have been developments and changes. Increasing standardization, mechanization, and ever more precise reproduction constitute a unifying trend. A preliminary overview reveals that advances are especially noteworthy during a few crucial periods.

The first such period came after culture in China emerged from its Neolithic beginnings into the light of recorded history. At that point, the thirteenth to twelfth centuries B.C., module systems can be identified in script, bronze casting, and architecture, although none of these systems had yet reached maturity. In script, stroke types were not yet standardized, nor were the shapes of characters, yet more than two thirds of them contain modular parts. Bronze casters deployed a module system to decorate vessels, and a technical modular system to cast them, but they did not yet make use of mechanical duplication. In architecture, a bay and a courtyard system evolved before bracketing came into use.

By the late centuries B.C., bronze casters had begun to reproduce identical parts, and they mass-produced weapons and complicated components for chariots. Makers engraved their names on their products for the sake of quality control. Builders assembled bracket clusters from standardized wooden blocks, and for the first

time, script was reproduced on a flat surface. By the third century B.C., Chinese artisans had become so used to modular production that, with no precedent to which to refer, they could devise a system for a monumental task: the terra-cotta army of the First Emperor. In the same years, this emperor's chancellor designed a standardized, geometrical type of script, in which almost all idiosyncrasies were eliminated.

Another seminal period was the fourth to seventh centuries A.D. Buddhist painters and sculptors produced great quantities of figures and scenes through repetitive use of readily identifiable motifs. Printing with wooden blocks, a technique that allows virtually identical reproductions in limitless numbers, was simultaneously developed. A pervasive module system of timber frame architecture was firmly established. Its crowning achievement was the design of a metropolis laid out on a modular grid, which provided a unified living space for over a million people. Script types were codified and have remained in place for over a millennium and a half. But this was also the time when systematic exploration of the aesthetic dimension of art began. Certain calligraphic pieces were the first objects brought into art collections because of their perceived aesthetic qualities, and a theoretical literature arose that espoused aesthetic values, such as spontaneity and uniqueness, in diametrical opposition to modular production.

During the eleventh to thirteenth centuries, when the compass and gunpowder were invented, block-printing projects of enormous dimensions, such as the Buddhist canon, were realized. Printing with movable type was invented as well. The treatise *Building Standards* (*Yingzao fashi*) of A.D. 1103 prescribed a system for architecture in which all parts were completely and minutely standardized. Ceramic production was organized in large factories. Paintings whose compositions were built from movable parts depict Buddhist hells as bureaucratic agencies.

In the sixteenth and seventeenth centuries, industrial production became common for manufactured goods. In 1577, kilns in the city of Jingdezhen received an imperial order to deliver 174,700 pieces of porcelain. Textile factories and paper mills employed workforces of over a thousand people. An unprecedented upsurge in printing activity made books and illustrations available to a wide range of consumers. The definition of art expanded beyond calligraphy and painting to include manufactured items such as porcelains and lacquer dishes.

This was the very period when contacts between China and the West became direct and frequent, and interaction has not ceased since. During the Middle Ages, techniques of silk manufacture had already been passed from China to Europe, and when Europeans mastered the technique of printing in the fifteenth century, it helped to usher them into the modern age. Yet the great nineteenth-century sinologue Stanislas Julien still found reason to lament that the West did not learn about printing early enough. If there had been timely contacts with China, he says, many of the chef d'oeuvres of Greek and Roman literature, now irrevocably lost, would have been saved.[5]

When communications between East and West intensified, China revealed that it possessed far superior module systems. Europe learned eagerly from China and adopted standardization of production, division of labor, and factory management. By introducing machines, westerners carried mechanization and standardization even further than the Chinese, who continued to rely more on human labor, as they had traditionally done. Consequently, since the eighteenth century, Western production methods have tended to surpass those of China in efficiency.

The story has not yet ended. Perhaps the most pressing problem on the globe now is population growth. In coping with this situation, the capabilities and social virtues that the Chinese have developed over the centuries while working with module systems may, in the future, come into their own yet again: to satisfy the needs of great numbers of people who are accustomed to living in tight social structures and to minimize the use of natural resources by maximizing the input of human intelligence and labor.

Voltaire once remarked that the peoples of the East had formerly been superior, but that the West made up for the lost time to become preeminent on earth.[6] Voltaire wrote more than two centuries ago. Perhaps he was not right. Two centuries from now we will know.

Shaping Society

Modular production shaped the fabric of Chinese society in various ways. If one were to name the single most important factor in China's social history, it would be the country's achievement in supporting great numbers of people since the Neolithic age. And if one were to name the single most important driving force in Chinese social history, it might be the aim to keep these people within one unified political and cultural system. Much was done and much was sacrificed to achieve this goal.

Module systems contributed toward the task. Again, script is the paradigm. Chapter 1 argues that script was the most powerful instrument to foster cultural coherence in China, because it records the meanings of words rather than their ever-changing pronunciation. This required the creation of thousands of distinct characters, which was only possible with a module system.

Preparation of food is another paradigmatic, almost archetypal kind of production. It is the plight of humans that they have to produce food continuously. A society that has to nourish large groups of people is likely to develop elaborate and efficient methods of food production. The Chinese have excelled at this. Although it is not appropriate here to extol Chinese cuisine, there are similarities between preparing meals and making works of art: aesthetic judgment is called for on the part of the producer and taste on the part of the consumer.

Further comparison between the production of food and art was once brought home to me and my students in Jingdezhen. This city in Jiangxi Province, which was one of the greatest industrial centers in the premodern world, now produces more than one million pieces of porcelain per day. One memorable afternoon, we admiringly observed the extraordinary speed and dexterity of the ceramic workers, who kneaded the clay, brought it into cylindrical shape, cut off disks, formed them into cups, embellished them with various colors, fired them, and, after having taken them out of the kiln, added more paint over the glaze. The next morning we had breakfast in a large noodle shop. The cooks skillfully kneaded the dough, which had almost the same consistency as clay, brought it into a cylindrical shape, cut off flat slices, formed them into dumplings, enriched them with various vegetables, cooked them, took them out of the oven, and finally garnished them with a few colorful spices.

Those who frequent Chinese restaurants may have wondered how it is possible to have a menu of over one hundred different dishes, each of which usually arrives within a few minutes after having been ordered. The secret is that many menus are modular. Most dishes are combinations of ready-made parts: pork with mushrooms and bamboo sprouts, pork with mushrooms and soya sprouts, chicken with mushrooms and bamboo sprouts, chicken with mushrooms and soya sprouts, duck with mushrooms and bamboo sprouts, and so forth.

Much of what we call Chinese art today was produced in factories. This is true for artifacts in all the major materials such as bronze, silk, lacquer, ceramic, and wood. Factory production started very early in China. If a factory is defined by its systemic properties, such as organization of the workforce, division of labor, quality control, serial production, and standardization, then it is possible to speak of bronze, silk, and possibly jade factories as early as the Shang period (about 1650–about 1050 B.C.).

These factories already explored methods of mass production. When Henry Ford wrote the article on mass production for the 1947 edition of the *Encyclopaedia Britannica*, he defined it as "the focussing upon a manufacturing project of the principles of power, accuracy, economy, system, continuity, speed, and repetition."[7] Except for

power, which refers to machine power, Ford's principles were probably applied in Shang factories. It might be argued that there was no large consumer market yet, and hence the early factories could not churn out large enough quantities of products to qualify as centers of true mass production. Yet it would be hard to dispute that mass production existed by the sixth or fifth centuries B.C. The most famous example is the foundry at Houma in Shanxi Province. More than thirty thousand ceramic fragments used for casting bronze vessels have been found there, and the casting process entailed mechanical reproduction of parts on a massive scale.

Because production in factories involves large numbers of participants, work tends to be compartmentalized and divided up into ever more separate steps. As a consequence, the performance of each worker becomes more regimented. Control of the workforce, of material resources, and of knowledge is a primary concern. Above the level of workers there has to be a level of managers who devise, organize, and control production. Modular production thus contributes its share toward forging and maintaining structures of an organized society, and it promotes a powerful bureaucracy.

On the consumer side, the availability of many sophisticated luxury goods, such as lacquer- and porcelain ware, pleased great numbers of people, improved the quality of their lives, and contributed to their feeling of privilege. When applied to architecture, the module system allowed timber frame buildings to be erected all over the empire, because they were adaptable to diverse climates and heterogeneous functions. Printing spread information and social values throughout the realm—quickly, cheaply, and in great quantities.

It is another asset of module systems that they allow production of objects in a hierarchy of grades. Individual ritual bronzes or sets of them can be larger or smaller, the differences can be subtle, and the grading fine-tuned. This permits the owners of these objects to define their respective social position and make it known to their peers,

who will recognize the difference between ancestor halls five or seven bays wide and between dinner sets of forty-eight or eighty-four pieces.

Graded products extend the circle of participants in the system. A petty Shang aristocrat owning a few small bronzes could take pride in the fact that his vessels displayed the same kind of decor and were cast in the same technique as the gorgeous bronze sets of the mightiest ruler. A minor Qing-dynasty official serving food to his guests on porcelain plates made in Jingdezhen could relish the thought that the emperor in his palace also used dinner sets from Jingdezhen, even if those differed in decoration and quality. Modular production thus contributes to the fostering of social homogeneity and cultural and political coherence.

The system of grades has advantages for producers, too. It helps them to organize their production process and allows them to attract customers of different economic means. A workshop specializing in paintings of kings of hell that can offer a choice of sets in different sizes and with more (or fewer) figures and motifs will be able to appeal to a wide range of clients.

Yet implementing module systems also required enormous sacrifices. To mention only a few examples, for the sake of political stability the Chinese forfeited the easy way to become literate, the richness of separate national literatures, the metaphysical quality of their hells, some freedom of the painter's brush, and also some aspects of what the West considers human rights. Indeed, module systems are bound to curtail the personal freedom of the makers of objects, and the owners and users. Modular systems engender unbending restraints on society.

The post and beam buildings analyzed in chapter 5 supply a metaphor of a modular society: all blocks and brackets are individually shaped, but the differences between them are small. Each block is made to fit into only one particular position in the building. The joints between the members have to be tight, because the shocks of an earthquake and the gusts of a typhoon must be absorbed and distributed throughout the entire

structure. If one member does not fit perfectly, the adverse effect will multiply. If, however, every part fits well, the precarious construction will enjoy an astonishing resilience. Life is tight in module systems.

The Issue of Creativity

Permeating the concerns of this book is the issue of creativity. One basic definition of humans is that they create objects. They make pots and crossbows, timber pagodas, and mainframe computers. They make objects by certain techniques and give them certain—often very sophisticated—shapes. Manufactured objects can be measured against creations in nature. Nature is prodigious in inventing shapes, in using materials, and in devising systems of forms. Humans are hard-pressed to approach this creativity, let alone to surpass it.

When people develop systems of modular production they adopt principles that nature uses as well in creating objects and shapes: large quantities of units, building units with interchangeable modules, division of labor, a fair degree of standardization, growth through adding new modules, proportional rather than absolute scale, and production by reproduction.[8] The first three of these seven principles are here considered to be fairly self-explanatory and therefore not given further comment, whereas the latter four principles may merit some explanation.

Standardization of units that stops short of perfect duplication is pervasive in modular production: the same decoration on the front and back of a ritual bronze vessel, upon close inspection, is bound to reveal minor discrepancies; eyebrows and beards of the terra-cotta warriors may have the same basic shape because they are formed from molds, but reworking the clay by hand has individualized them all; the prefabricated wooden blocks in the bracketing of a pagoda look totally exchangeable, but exact measuring uncovers differences of a few millimeters between each of them. The following chapters

will take up these phenomena, and analyze how, in specific cases, intentional imperfections are exploited creatively. For now, suffice it to recall that this principle is well known in nature: the ten thousand leaves of a mighty oak all look similar, but exact comparison will reveal that no two of them are completely identical.

Growth in manufactured modular units happens in two ways. For a while, all modules grow proportionally, but at a certain point proportional growth stops and new modules are added instead: the animals in the decorative field of a bronze vessel will be a bit larger on a slightly larger vessel, but not exceptionally large on an exceptionally large vessel; rather, a new decorative zone will have been added. A three-bay hall may be built wider by 10 to 20 percent, but a hall that is wider still will need five bays. Zheng Xie painted clusters of bamboo leaves, say, ten centimeters in diameter in a small album. On a tall hanging scroll the clusters may average twelve or fifteen centimeters, but the painter will need many more of them to fill the composition. This is the principle of a cell growing to a certain size and then splitting into two, or of a tree pushing out a second branch instead of doubling the diameter of the first.

Reckoning with proportional rather than absolute measurements is a principle that has been applied widely and with much sophistication, especially in the field of architecture. As a rule, measurements of brackets and beams are not given in absolute terms, such as inches, but in "sections." The length of one section varies according to the overall size of a building. The chapter on architecture presents evidence that the Chinese explored the principle of relative proportions in their anatomical studies. One particular text divided the total length of the body into seventy-five sections, which were then used to measure body parts. Obviously, the length of the sections varied, depending on the size of the person. The system allowed one to locate exactly the points for acupuncture on the human body, that most familiar and enigmatic creation of nature.

Reproduction is the method by which nature produces organisms. None is created without

precedent. Every unit is firmly anchored in an endless row of prototypes and successors. The Chinese, professing to take nature as their master, were never coy about producing through reproduction. They did not see the contrast between original and reproduction in such categorical terms as did westerners. Such an attitude may be annoying when it comes to cloning software, but it also led to one of the greatest inventions of humankind: the technique of printing. In the Western value system, reproduction in the arts has traditionally had a pejorative connotation. Indicative, and influential in our century, has been the view of Walter Benjamin, who declared that a work of art loses its aura when reproduced by technical means.[9] However, recent research has uncovered that in the arts of the European Middle Ages, for instance, reproduction could indeed be used as a means to define an artistic tradition, and even to reinforce the impact of specific works.[10]

A rich and profuse body of theoretical writings in China deals with the issue of creativity, especially in the visual arts. Invariably, the creativity of humans is described in relation to the creativity of nature, which is upheld as the ultimate model. We are told that a sage of antiquity invented script when gazing at the footprints of birds. Early treatises describe the qualities of calligraphy in terms of nature imagery such as a gentle breeze through a bamboo grove, or a phoenix soaring to the clouds. Praising an artist for his "spontaneity" (*ziran*) and "heavenly naturalness" (*tianran*), or saying that he captured life as nature does, are the highest acclaim a Chinese critic can bestow.

Artists in the Western tradition consider the emulation of nature a primary task, too, but they have been pursuing it on a different course. Beginning with the competition between two Greek painters to determine which of their paintings a viewer would more readily mistake as real, questions of realism, verisimilitude, and mimesis have stimulated and haunted Western artists down to today.[11]

To Chinese artists, mimesis was not of paramount importance. (Only in images of the dead did they strive for verisimilitude.) Rather than making things that *looked* like creations of nature, they tried to create along the *principles* of nature. These principles included prodigious creation of large numbers of organisms. Variations, mutations, changes here and there add up over time, eventually resulting in entirely new shapes.

There seems to be a well-established Western tradition of curiosity, to put the finger on those points where mutations and changes occur. The intention seems to be to learn how to abbreviate the process of creation and to accelerate it. In the arts, this ambition can result in a habitual demand for novelty from every artist and every work. Creativity is narrowed down to innovation. Chinese artists, on the other hand, never lose sight of the fact that producing works in large numbers exemplifies creativity, too. They trust that, as in nature, there always will be some among the ten thousand things from which change springs.

後讀誦修習如是
善利成佛道者不
衆生猶如在此諸
聞無嘗無樂無常
世尊我等今者欲

1 The System of Script

I n the epigrams that together serve as a motto for this book, two eleventh-century Chinese philosophers spell out some of their basic assumptions about the principles of creation: production happens by combining parts (typified by the eight trigrams), and by reproducing, varying, and transforming established categories of units without end. Shao Yong and Zhou Dunyi refer to creations in nature. Yet, and this is my basic thesis, when the Chinese created products in module systems, they did so along the very same principles.[1]

The first module system that I will analyze is the Chinese script. Whereas each system discussed in later chapters—be it bronze casting, post and beam construction, or printing with movable type—has counterparts in other cultures, the Chinese script, with its fifty thousand characters, is all but unique. To have devised a system of forms in which it is possible to produce distinguishable units in a mass of such breathtaking dimensions is the single most distinctive achievement of the Chinese people. This attainment set a standard of quantity and complexity for everything else that was done in China.

In illuminating the principles of construction in the system of forms that is the Chinese script, the second of the two epigrams will serve as a first visual example. Written in Chinese, the quotation comprises ten characters in two lines. Figure 1.2 shows the epigram with the author's name and the title of his text added. To repeat, rendered into English Zhou Dunyi's quotation reads:

> *The ten thousand things are produced and reproduced,*
> *so that variation and transformation have no end.*
> Zhou Dunyi
> Diagram of the Supreme Ultimate Explained

Like all Chinese characters, these seventeen units are built up of single strokes, which are the basic elements. They cannot be further divided. The

Fig. 1.2 Zhou Dunyi epigram (computer print)

萬物生生，

而變化無窮焉。

周敦頤，

太極圖說。

Fig. 1.3 Table of sixty-four stroke types from the calligraphy of Liu Gongquan (778–865)

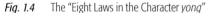

Fig. 1.4 The "Eight Laws in the Character *yong*"

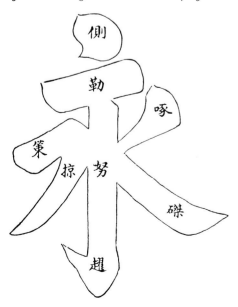

two simplest units in the series are the character "transformation" (*hua*; line 2, third character from the left), and the character "supreme" (*tai*) in the book title (line 4, first character). Each consists of four strokes only. Most complicated is the character signifying "variation" (*bian*; line 2, second character), which has twenty-three strokes.

Between the level of the strokes and the much more complex level of the complete character units is another, intermediate level, which displays moderate complexity. This is the level of building blocks or components, each of which consists of several strokes. In a series of characters such as the seventeen characters in Figure 1.2, these building blocks tend to recur and, in different characters, are used in different combinations.

The component meaning "word" (*yan*), which occupies the center of the upper half of the character "variation" (*bian*), occurs again at the left side of the last character, which means "explain" (*shuo*; line 4, last character). Four horizontal dots are found in the lower part of "without" (*wu*; line 2, character 4), and in the final particle *yan* (line 2, character 6). While this particle is also pronounced and transliterated *yan*, it is not the equivalent of the component that represents word. A part that means "mouth" (*kou*) and looks like a small square occurs in the third line, in *zhou*, *dun*, and *yi* of *Zhou Dunyi*, and in each of the last three characters in line 4, the title—more than once in the penultimate character.

Such components will be called modules. They are interchangeable building blocks that can be put together in varying combinations to make the written characters that have been and still are used today in China.

Thus, the Chinese script is a system of forms built up in a hierarchy of five levels of increasing complexity:

element	a single brushstroke
module	a building block or component
unit	a single character
series	a coherent text
mass	all existing characters

This scheme, in a nutshell, is what this book has to say about modules and mass production.

The following analysis considers the separate levels in the five-tier system of Chinese script, then traces the system's evolution, and finally addresses the question of why the Chinese developed a module system at all for their script.

Brushstrokes

The basic elements, the strokes, are each executed with a single, coherent movement of the writing brush. Its elastic tip consists of a bundle of hairs. Before writing, the tip is dipped in ink. At the beginning of the stroke, it touches the flat writing surface, and as the writer increases pressure, the hairs spread and the stroke becomes wider. The writer only lifts the brush again at the end of the stroke. Thus each stroke has a coherent shape with

clear-cut contours. It is a graphic element that cannot be further divided.

Over the centuries, writers on the theory of Chinese calligraphy have established several sets of stroke types. Some sets are very elaborate, comprising as many as seventy-two different types of strokes. The sixty-four stroke types in the modern list in Figure 1.3 are culled from an inscription by Liu Gongquan (778–865), whose work students of calligraphy often take as standard.[2] Yet many strokes in the list can pass as mere variants. There are, for example, eight different dots in the leftmost column, and eight different horizontal strokes in the third column.

The best known set comprises only eight types of strokes. The character *yong* is said to contain them all: a dot, a horizontal stroke, a vertical stroke, a hooked vertical stroke, and four different diagonal strokes (Fig. 1.4). Doubtless this scheme is somewhat forced: the vertical stroke is counted twice, once with a hook and once without. Additional types of strokes, especially more hooks, can be found in other characters.[3]

The set of eight strokes in the character *yong* enjoyed its popularity nevertheless. Eight is always a welcome number in China, and *yong* has an auspicious meaning: "eternal." Most important, the set of eight strokes has long been connected to the name of Wang Xizhi (303–361), who throughout the ages has been hailed as China's greatest calligrapher. Legend has it that he studied the character *yong* for fifteen years.[4] As it happens, *yong* is also the first character in Wang Xizhi's masterpiece written in A.D. 353, the *Orchid Pavilion Preface* (*Lanting xu*; Fig. 1.5). The *Preface* is the most famous piece of calligraphy in East Asia. Countless generations of calligraphers have studied it and they all had to start with the character *yong*.

It could be demonstrated that every character in the *Orchid Pavilion Preface* and, for that matter, in any other text, is made up of the eight basic strokes and of very few others. Indeed, one can sum up the observations on the stroke types by noting that all Chinese characters make use of only about eight to a dozen basic strokes. The rest are variants.

Fig. 1.5 Wang Xizhi (303–361), *Orchid Pavilion Preface*, A.D. 353. Detail of beginning section of copy called *Number Three of the Eight Pillars* (*Bazhu di san*). Ink on paper, H. ca. 24 cm. Palace Museum, Beijing

Characters

For the following discussion of the other four levels in the system of script, the rubbing of a long inscription cut into stone serves as illustration and reference (Fig. 1.6). It is the beginning of the first chapter of the Buddhist *Lotus Hand Sutra* (*Huashou jing*). The rubbing contains more than twenty-five

世界　世界　世界
世界　世界　世界
世界　世界　世界
世界　世界　世界
世界　世界　世界
世界　世界　世界
世界　世界　世界
世界　世界　世界

hundred characters. The original stone was engraved between A.D. 1055 and 1093 and it is preserved at Yunjusi, the Cloud Dwelling Monastery, near Beijing.[5]

Skipping for a moment the second, module level, and turning directly to the more complex, third level—unit or single character—one point is worth special attention: no two characters show exactly the same shape, not even those that are lexically identical. The reason is simple: the characters were written by hand and not by a machine, and they were also carved into stone by hand.

One particular pair of characters, read *shijie*, is used here to illustrate the point. The two characters mean "world" and they appear frequently in Buddhist scriptures. In the rubbing shown in Figure 1.6, the character pair occurs in more than twenty different places. Twenty-four pairs have been put together in Figure 1.7, all of which resemble one another closely. Upon examination, however, small differences are inevitably discovered in every single case. The right side tip of the horizontal stroke in the upper character *shi* is more pronounced in some characters than in others. The diagonal strokes of the lower character *jie* always begin differently, and when one scans the shapes of the cross form and the four quadrants in the upper, square part of the character, endless small variations are apparent.

To a large extent the scribe makes such variations involuntarily. As soon as he begins to produce them intentionally, he starts a path that will lead him into the realm of art. Whenever he consciously explores the aesthetic dimension of script he turns writing into calligraphy, which will be discussed in chapter 8.

Series and Mass

Focusing on the two uppermost levels, the levels of series and mass, it may be helpful to draw a comparison between the Chinese characters on the rubbing and the leaves of a tree. We are surrounded by the creations of a prodigious nature that are infinite in formal variety and unfathomable in complexity. Everyone shares this experience. The anonymous calligrapher of the sutra text, writing many centuries ago, was familiar with trees similar to the ones that grow today. When juxtaposing tree and rubbing, one can compare leaves and characters. The foliage as well as the written surface is made up of large numbers of many single units. What applies to the characters also applies to the leaves: no two units have a completely identical shape. No leaf is an exact duplicate of another.

Yet beyond the observation that Chinese characters and tree leaves come in large numbers of units, and that those units differ among one another, one can hardly propose further similarities. The dissimilarities, however, are conspicuous. The characters in the sutra form a text in which each unit has its particular place within a definite sequence. If the sequence of the characters were to change, the text would become unintelligible. Leaves within foliage, by contrast, seem to take their positions at random. Botanists

Opposite:
Fig. 1.6 (left) *Lotus Hand Sutra*, A.D. 1055–1093, Yunjusi, Fangshan County. Rubbing of first stone, 152 × 69.5 cm. Private collection

Fig. 1.7 (right) Twenty-four versions of the character pair *shijie* (details of Fig. 1.6)

cannot yet fully explain why a particular leaf grows to a particular shape on a particular twig.

Moreover, in foliage the exact number of units is arbitrary. The tree might yet gain some leaves by growing, or lose some in the wind. But the number of characters in the sutra text is finite. If characters are added or omitted, the educated Buddhist monk will notice. Hence the foliage should be called a mass: it is a coherent entity whose shape and size are not clearly defined, like grains in a heap of sand, or pebbles at the shore. The text with its definite length, by contrast, is a series, rather than a mass, of characters.

Among the two-and-a-half thousand characters engraved on the stone surface, there may be several hundred lexically different characters, all of which are structurally quite distinct. Obviously they differ from one another to a much greater degree than leaves of a tree.

There are seventeen single different characters in the motto discussed at the beginning of this chapter (Fig. 1.2), and several hundred different characters in the rubbing. Schoolchildren learn about 2,000 characters—those used in newspapers. Educated people know 3,000 to 4,000 and scholars up to 10,000 characters.

All these groups of characters are part of a mass: the sum of all lexically distinct characters in Chinese script. As mentioned in the introduction, the largest dictionary, including the most obscure characters and many variants, has almost fifty thousand characters—quite a mass!

The Purpose of Script

With this understanding of the basic level of the single stroke, the level of the character unit, and the uppermost levels of series and mass, we may now ask how these levels were integrated into a system of writing. How was it possible to combine about a dozen different single strokes into fifty thousand different characters? As will be shown, modules offered the best possible solution for the task.

The purpose of script is to record speech by transforming it into a graphic system. Thereby speech becomes recognizable to the eye rather than to the ear, and it gains much more permanence than the spoken word. In all writing systems, two partly conflicting requirements have to be met. To a reasonably complete and precise degree, a script should preserve the information transmitted by speech. Yet a script must not become too unwieldy. The user must be able to learn, read, and write a script fairly easily. The Chinese script certainly meets these requirements. Anybody with a moderate education will read out the sutra text in Figure 1.6 without hesitation—even today. There have even been (and perhaps still are) Buddhists who knew the entire sutra by heart and could write it out when asked to do so.

The Chinese had various theoretical possibilities to devise thousands of characters by combining a few basic strokes. They could have worked out a system according to simple mathematical principles. They might have taken ten basic strokes and formed characters with them. The

first basic stroke could have been a dot, the second a horizontal bar, the third a vertical one, and so forth. Assuming further that each character had four quadrants, corresponding to four digits in a decimal system, the first character could have dots in each quadrant. The second character could have a dot in the first three quadrants but a horizontal stroke in the last quadrant. The third character would have a vertical stroke in the last quadrant, and so on, according to the scheme in Figure 1.8. One could thus design 9,999 different characters.

The telegraph service in China uses such a system, capable of transmitting 9,999 characters, each represented by a four-digit number. An experienced telegraph dispatcher knows them by heart and can swiftly convert the characters into numbers and back again. It is the shortest possible system. There is no redundancy, no repetition of any information. In every unit each bit of information is given only once. If the telegraph dispatcher makes a mistake in one digit, he garbles the entire character.

At the other end of a theoretical spectrum of systems, each of the many thousand characters would be totally unique. Each unit would have a completely individual form, sharing no part with any other unit. To design these would require an extraordinary degree of visual inventiveness, and the characters would have to be very large and unwieldy. Indeed, it is almost inconceivable that such a variety of forms could be achieved at all.

The Chinese found a middle way between the extremes of reduction to the mathematical minimum and boundless individuality. In their characters the average number of strokes is higher than four, and they did not set them into neat quadrants. Rather, they allowed for a great variety in size and relative position of the strokes. The character system has to be more complicated than mathematically necessary, because the human brain does not work like a simpleminded computer. An essential part in all perception processes is the recognition of known elements. (Perception theory teaches us that in identifying shapes, our eyes and brain rely on the repetition of information.) It is easier to remember slightly more complex shapes in which some parts are familiar than shapes in which the repetition is reduced to the minimum. If we miss a bit of the information, recognition of familiar forms allows us to grasp the meaning of the whole unit all the same.

On the other hand, it would be equally impractical and counterproductive if each character were a completely individual creation. Between the extremes of merciless reduction and boundless individuality a solution was developed: the module system.

The modules of the character units are precisely those familiar components that occur again and again and thereby facilitate identification of the characters for the eye and the brain. When learning a new character, one does not have to remember a unique and unfamiliar structure of, say, a dozen strokes, but only the place of perhaps three familiar modules in a specific composition. Similarly, the reader will not look at every single stroke of a character but only at the character components. Eyes and brain thus can identify a character in the split fraction of a second that is available in fast reading.[6]

Fig. 1.8 Imaginary characters composed of four strokes each, arranged in quadrants

In addition to remembering modules as graphic components, the brain can also remember them as semantic units. Almost all modules have a specific meaning, and in most characters the meaning of one module contributes to the meaning of the entire character. This is another layer of repetition that makes it possible to remember thousands of characters. This pattern does not exist in the telegraph-code system.

The module system also allows for flexibility when the number of characters has to be increased. It was no problem for the Chinese to design character number 10,000 after character number 9,999. A telegraph dispatcher would have to rework the entire system the moment he added a fifth digit.

Modules

According to the definition given above, modules are interchangeable building blocks that are put together in varying combinations to make the written characters. The details from the rubbing of the *Lotus Hand Sutra* illustrate how it is done (Figs. 1.1 and 1.9–1.12).

Several characters in the details contain modules also found in characters of the motto (Fig. 1.12). The module representing "word" (*yan*) occurs in the motto in the characters for "variation" (*bian*) and "explain" (*shuo*). In the rubbing detail (Fig. 1.1), the same component *yan* is seen in the characters indicating "read" (*du*; first vertical column at right, second character from top; hereafter 1/2), "recite" (*song*; 1/3), and "all" (*zhu*; 3/7).

A left-hand part, which means "man" (*ren*), occurs in the motto in the character for "transformation" (*hua*). The same *ren* module turns up in the rubbing in "practice" (*xiu*; 1/4) and "Buddha" (*fo*; 2/4). *Bi*, which stands for "spoon," is the right-hand part of the *hua* character and is also found in the rubbing where it is the right-hand part of "this" (*ci*; 3/6). The module representing "tree" (*mu*) at the left of "ultimate" (*ji*), the second character of the

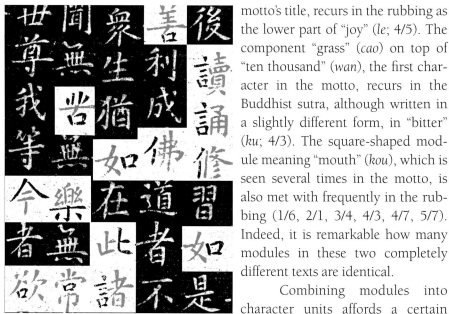

Fig. 1.9 Modules in (*right*) detail from *Lotus Hand Sutra* (Fig. 1.1), and (*below*) in Zhou Dunyi epigram (Fig. 1.2)

萬物生生，

而變化無窮焉。

周敦頤，

太極圖說。

motto's title, recurs in the rubbing as the lower part of "joy" (*le*; 4/5). The component "grass" (*cao*) on top of "ten thousand" (*wan*), the first character in the motto, recurs in the Buddhist sutra, although written in a slightly different form, in "bitter" (*ku*; 4/3). The square-shaped module meaning "mouth" (*kou*), which is seen several times in the motto, is also met with frequently in the rubbing (1/6, 2/1, 3/4, 4/3, 4/7, 5/7). Indeed, it is remarkable how many modules in these two completely different texts are identical.

Combining modules into character units affords a certain

freedom, but the possibilities are limited and governed by rules and conventions. The size of the unit sets a framework. All characters must be approximately the same size, so that they can follow one another smoothly through the lines. Therefore, combinations of modules resulting in a total of more than two dozen strokes are rare. Modules also never change their direction. No module can be built into a character sideways or upside down.

The rules about which positions in a character certain modules can occupy are less rigid. The *kou* module can move freely within the character composition. Yet for many modules the choice is restricted, too. The modules *yan* and *ren*, for instance, tend to stand in left-hand positions. If *ren* is used on the top of a character, it assumes another shape: its "legs" are spread such as in *jin* ("now"; Fig. 1.9; 5/5).

A major principle in creating new combinations is the exchange of one module for another. The left-hand module *yan* remains the same in *du, song,* and *zhu* (Fig. 1.9; 1/2, 1/3, and 3/7 respectively), while the right side in these characters changes. Yet again, combinations cannot be made arbitrarily; rules or conventions govern the available choices. The fifty thousand characters in the Chinese writing system include only a fraction of all the mathematically possible combinations that could be made using the approximately two hundred modules that exist.

Modules are the only parts from which characters are formed. In other words, all character units can be broken down into modules without there being any leftover pieces—spare odd components, or strokes—that are not accounted for in the system. If there still is a singleton, it must be the exception that proves the rule.

Different levels of complexity exist among modules. Complicated modules can incorporate other, simpler modules, as the module *yan* illustrates. Its lower square forms a module by itself, *kou* (mouth). On the other hand, a module may also constitute a character by itself, and *yan* is again a case in point (Fig. 1.10, 5/1). It is thus apparent that the module level in the five-level system is itself multilayered.

Moreover, Figure 1.10 shows that modules' shapes will adapt to a particular position within the composition of a character unit. In this section of the rubbing, the module *yan* occurs in three different positions, as an independent character (5/1), at the left-hand side of a character (2/2), and as the lower part of a character (1/5). In the first case the upper horizontal stroke extends far to the right, giving balance to the composition. When *yan* stands at the left, the upper stroke is much shorter on the right side, leaving room for the right-hand modules. Yet for reasons of balance, the left side of this stroke is shorter, too. When the module *yan* forms the lower part of a character, its overall proportion is more squat.

Another such example is shown in Figure 1.11, three characters with the module representing "woman" (*nü*), which stands once to the right (2/3), once below (2/4), and once to the left (3/2). Size, proportion, and balance are slightly different in each instance. In Figure 1.12 the same applies to the module indicating "force" (*li*; 3/1, 3/3), which, moreover, appears as an independent character twice (1/4, 3/4).

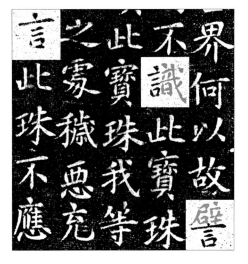

Fig. 1.10 (above) Examples of the module indicating "word" (*yan*), from *Lotus Hand Sutra* (detail of Fig. 1.6)

Fig. 1.11 (below) Examples of the module indicating "woman" (*nü*), from *Lotus Hand Sutra* (detail of Fig. 1.6)

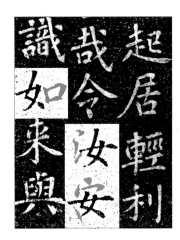

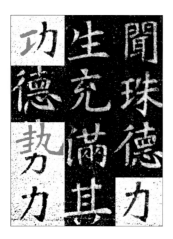

Fig. 1.12 Examples of the module indicating "force" (*li*), from *Lotus Hand Sutra* (detail of Fig. 1.6)

Fig. 1.13 Inscribed turtle plastron, *bingbian* 247, ca. 12th century B.C. Rubbing, ca. 13 × 13 cm. Institute of History and Philology, Academia Sinica, Taipei

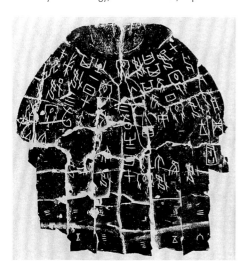

In the twenty-four examples of the two characters *shi* and *jie* (see Fig. 1.7), differences could be recognized in each individual character. It almost goes without saying that the same holds true for modules and even for single strokes. Thus, whoever moves a writing brush in China makes one aesthetic decision after the other, aiming to create harmony. A psychologist might tell us what that means for the formation of a personality and, perhaps, for the shaping of a national character.

Summing up all these observations about modules in the system of script, one may say that modules consist of several elements. They are interchangeable parts. They are combined into units according to rules and conventions. All units can be broken down into modules with no components left over. Modules also have different levels of complexity. Complicated modules may contain simple modules, and most modules can also be used as independent characters. Modules change their size and proportions according to their position in the units. And all modules are individually executed and hence display small differences in their shapes.

The Historical Dimension

The discussion so far has treated the system of Chinese script ahistorically, with examples taken at random from different periods. Yet there is, of course, a historical dimension to the module system. The Chinese script has not existed from time immemorial, nor was the module system fully developed at its inception.

The history of Chinese script may be divided into several phases, each of which is defined by the appearance of a new script type. Types of script differ from one another with respect to the number and the position of the strokes in lexically identical characters. Whenever a new script type appears, new writing materials are explored, the function of script widens at the same time, and the number of readers and writers increases, too.[7]

The first examples of script known in China are found on ceramic shards, bronze weapons, and on the so-called oracle bones. Oracle bone inscriptions (*jiaguwen*) are the most numerous ones, and they appear around 1200 B.C., in the latter part of the Shang period (about 1650–about 1050 B.C.). The inscriptions, incised on the scapulae of oxen (or occasionally sheep) and on turtle plastrons (Fig. 1.13), record questions that diviners in the service of the ruler posed to his deceased ancestors. The diviners recorded the answers as well, and the collected bones served as historical archives. Even on the oldest extant oracle bones the system of script was already fairly developed. Its more primitive stages are not yet known.[8]

Compared with the later types of script, the conspicuous feature of oracle bone script is its lack of standardization. It is not yet possible to define a repertoire of basic strokes, and many characters cannot be neatly broken down into components. In regular script the character meaning "come" (*lai*) is composed of one "tree" (*mu*) module and two "man" (*ren*) modules. A page from a dictionary of oracle bone script shows six variants of the *lai*

character (Fig. 1.14). None falls easily into distinct parts; rather, they are holistic graphic units.

On the spectrum of possible scripts—from a digital system like the telegraph code to a script in which all character units are individually designed—the writing on oracle bones is closer to the latter end. Many shapes still clearly derive from a pictorial origin, which accounts for their individual and holistic quality. The system could only work because the total number of characters was still limited. Less than five thousand lexically different oracle bone characters are known at present evidence.[9]

Nonetheless, up to two thirds of all oracle bone characters contain interchangeable parts.[10] Modules for words like "woman" (*nü*), "hand" (*shou*), "water" (*shui*), and so on are already used in the same way as in later script types. They occur in different characters in different combinations. On the turtle plastron in Figure 1.13, one finds three different characters with the left-hand module *nü*.[11] A module system thus existed in Chinese script even in the earliest known phase of its history.

A second early type of script appears in inscriptions cast on bronzes. The earliest bronze inscriptions, or *jinwen,* with a few characters date even further back than the earliest oracle bone inscriptions, but whereas the latter disappear soon after the Shang, bronze inscriptions continue as the dominant script type for about one thousand years. In the course of this period the module system becomes ever more pervasive.[12]

In the inscription on the so-called Water Basin of the Archivist Qiang (*Shi Qiang pan*; Fig. 1.15), who lived in the ninth century B.C., all characters are inserted into a grid pattern of vertical and horizontal lines, except for the last vertical line.[13] The characters thus are all approximately the same size. The structure of the more complicated characters can clearly be divided into separate parts. Most of these parts are modules, as they occur in different characters in different combinations. Yet there still remain a number of components with their own individual shapes. Several such unwieldy characters are seen at the beginning of the last line.

The unifier of the Chinese empire, the First August Emperor of Qin (Qin Shihuangdi), had seven inscribed stone steles erected in his realm during his reign from 221 to 210 B.C. These steles, the first such monuments in China, established the genre of historical inscriptions and set a precedent and a standard for thousands upon thousands of engraved stones that have been carved since that time. The original seven stones all seem to have been lost, but a recut of A.D. 993 of the stele placed on Mount Yi,

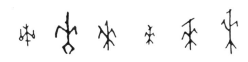

Fig. 1.14 Various forms of the character meaning "come" (*lai*), in oracle bone inscriptions (detail of a page from a dictionary)

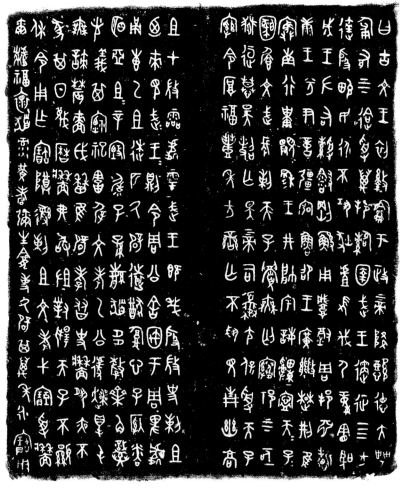

Fig. 1.15 *Water Basin of the Archivist Qiang,* mid-9th century B.C. Rubbing of the inscription, 22.2 × 19.8 cm. Private collection

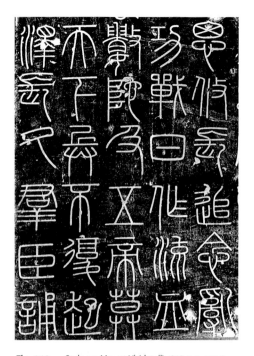

Fig. 1.16 *Stele on Mount Yi* (detail), 219 B.C., recut A.D. 993, Forest of Steles, Xian. Rubbing of stone inscription, 43 × 61 cm. Private collection

Fig. 1.17 *Stele of Yi Ying* (detail), A.D. 153, Temple of Confucius, Qufu, Shandong Province. Rubbing of stone inscription, ca. 24 × 15 cm

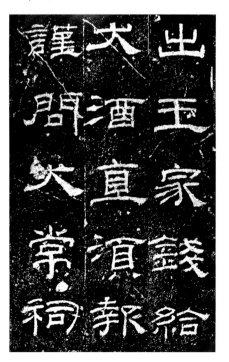

or *Yishan bei*, in Shandong Province in 219 B.C. is believed to preserve faithfully the style of the original writing (Fig. 1.16). The tectonic script type on the emperor's steles is called Small Seal Script (*xiaozhuan*). Its epigraphic dignity equals that of stone inscriptions of the Roman Empire.[14]

According to tradition, the emperor's chancellor, Li Si (died 208 B.C.), designed the Small Seal Script and unified the scripts employed in the various parts of the empire. Unification in the political realm thus had its parallel in the realm of script.[15] We are not told what "unification" of script meant in concrete terms, yet one can tell from looking at the script itself that unification must have included the standardization of character size and stroke shape. The Small Seal Script is set out on a strict grid pattern, the characters are uniform in size, the strokes are drawn in straight lines and in measured curves, and they are of an equal thickness throughout.

The module system is now fully developed. Rules have been laid down about which phonetic and which semantic parts each character must contain. Idiosyncratic characters have all but disappeared. All characters are built from distinct, interchangeable parts. The philologist Xu Shen canonized a repertoire of 540 components of the Seal Script in a dictionary presented in A.D. 100 and called *Explaining Graphs and Analyzing Characters* (*Shuowen jiezi*).

In the following years, when the Chinese adapted their script to new materials and new needs, they simplified the module system by reducing the number of modules, and the number of strokes in single modules. The major step was taken in the second century A.D. with the so-called Clerical Script (*lishu*), which had fewer than half the number of components of the Small Seal Script. Only much later was this reduced repertoire of parts canonized in a list of 214 so-called radicals, which served to classify and arrange characters in the comprehensive *Kangxi Era Dictionary* (*Kangxi zidian*) completed in A.D. 1716. The 214 radicals are still used in modern dictionaries, and most of them are modules in the above definition, except for a few simple ones that consist of one stroke only, and some complicated ones that can be broken down into smaller modules. Hence, beginning with the Clerical Script, the system of Chinese script has comprised about two hundred modules.

Moreover, the Clerical Script considerably simplified the composition of single modules. A detail of the inscription on the Stele of Yi Ying (*Yi Ying bei*) of A.D. 153 in the Temple of Confucius in Qufu, Shandong Province, illustrates the point (Fig. 1.17). The module *yan* (3/1) already displays the structure that is seen on the rubbing of the *Lotus Hand Sutra* (see Figs. 1.1, 1.10), whereas the same module *yan* is more complicated on the older stele from Mount Yi (Fig. 1.16; 5/6). Similarly, the module that indicates "water" (*shui*) is reduced to three dots on the Yi Ying stele (2/2 and 2/4). The abbreviated shapes of the strokes conform to the fairly swift movements of the supple writing brush, whereas the earlier *shui* module consisted of five even strokes in the shape of waves (Fig. 1.16; 2/5 and 5/1).

The fourth century brought a further and final simplification, as paper became generally available and the brush even more supple. The Clerical Script was now modified into Regular Script (*kaishu*), but the modification was not a dramatic one. Some modules became still easier to write. Yet there

was no significant change in the repertoire of modules or in the rules, such as which modules have to go into which character.

Figure 1.18 shows a piece in Regular Script by the calligrapher Wang Xizhi.[16] The strokes are now less curved and, still more important, all of them have standardized shapes and contours. The calligrapher no longer writes lines, as he still did in the Small Seal Script, but strokes. A complete standardization of strokes is achieved by now, and it is laid down in schemes such as the "Eight Laws in the Character *yong*."

Wang Xizhi's celebrated *Orchid Pavilion Preface* (see Fig. 1.5) displays a slightly cursive form of the Regular Script. Sometimes several strokes are combined into one. The master is also credited with having given the final formulation to the cursive Running Script (*xingshu*), and the fully cursive Draft Script (*caoshu*). Those lead into the realm of calligraphy written with special aesthetic ambition, and hence are not considered in this chapter.

Wang Xizhi and his peers set standards in character shape and composition that are still valid today. The three types, Regular, Running, and Draft Script, have been in use since the fourth century, and no other types of script appeared for more than a millennium and a half.

Only in the twentieth century has a new type of script been created in the abbreviated characters (*jiantizi*) that have been officially introduced in the People's Republic of China (and in slightly different form in Japan). In four double columns, Figure 1.19 juxtaposes old (columns a) and new characters (columns b). The reduction may seem dramatic, but there is a system to it. The character structure is preserved, because almost all changes take place at the module level. Three types of changes are most common. The number of strokes in a module can be reduced, as exemplified in columns 1 and 2. The module "metal" (*jin*) at the left side of a character traditionally consists of eight strokes (column 1a), but now is contracted into five strokes (1b). The module "word" (*yan*) is simplified from seven (2a) to two strokes (2b). In all characters with the modules *metal* or *word*, they appear in the same abbreviated form, yet the abbreviated modules always retain their familiar place in the character composition.

A second, less frequently used method to simplify characters is to exchange one module for another, simpler one, preferably one with the same pronunciation. The character representing "far" (*yuan;* columns 3a and b) is an example. In the top row, the phonetic part *yuan* is replaced with a simpler one, which is also pronounced *yuan.* The same applies to the character meaning "rely on" (*ju*) in the middle row. In the character in the bottom row—"advance" (*jin*)—a module of eight strokes has been exchanged for one with four strokes, which are pronounced, respectively, *zhui* and *jing.*

The third way to simplify characters is to discard one or several modules completely. This can lead to quite dramatic reductions in the number of strokes, as seen in columns 4a and 4b. The top-row character, "wide" (*guang*), is cut down to no more than three strokes. In its abbreviated form, the character "follow" (*cong*), in the middle row, consists of just the module that previously

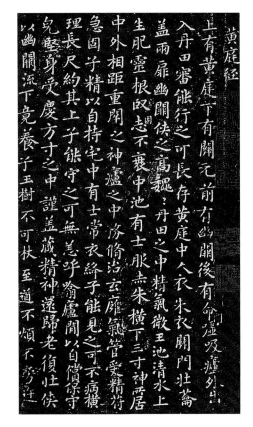

Fig. 1.18 Wang Xizhi (303–361), *Book of the Yellow Court, Book of the Outer View* (detail), A.D. 356. From *Bao Jin zhai fatie* (A.D. 1268). Rubbing, H. ca. 28.5 cm

Fig. 1.19 Characters in regular script and abbreviated characters juxtaposed (*reads left to right*)

1		2		3		4	
a	b	a	b	a	b	a	b
鈞	钧	記	记	遠	远	廣	广
釧	钏	訓	训	據	据	從	从
鉉	铉	討	讨	進	进	術	术

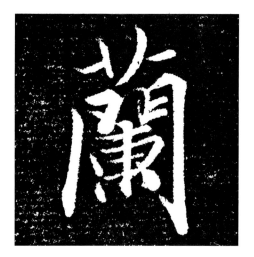

Fig. 1.20 The character for "orchid" (*lan*) in detail from Wang Xizhi's *Orchid Pavilion Preface*, A.D. 353. Rubbing. Museum für Ostasiatische Kunst, Cologne

Fig. 1.21 The character for "orchid" (*lan*), at the train station at Lanzhou, Gansu Province. Steel and glass

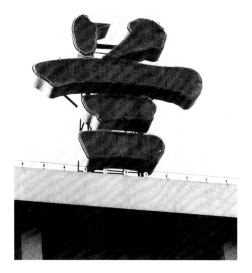

formed its upper right corner. The center module is all that's left of the character "art" (*shu*) in the bottom row.

The latest quantum leap in the development of the Chinese script thus left the module system as such intact. Most abbreviations in the new script type have taken place within the framework of the system. This continuity, among other things, facilitated the task for those who had to learn the new forms. Life has become simpler for designers and users of printing machines and computers as well.

Figure 1.20 shows the traditional character for "orchid" (*lan*) in the second line of Wang Xizhi's *Preface*. In the modern abbreviated form, the same character *lan*, made of steel and glass, tops the train station in Lanzhou in western China (Fig. 1.21). Window cleaners' work has become easier, too.[17]

Why Not an Alphabet?

Although much has been said thus far about the advantages of the module system, the question has to be asked whether the Chinese could not have made life more comfortable for themselves by discarding altogether even the nicest of module systems and using an alphabet instead.[18] There can be little doubt that an alphabet is far less cumbersome for the user. You only have to learn some two dozen different graphs. This process requires only a couple of weeks, not the many years that Chinese children have to spend memorizing several thousand graphs. Other than in the Chinese script, you can also immediately understand the meaning of a word when seeing it written for the first time (provided that you have heard it before). With an alphabet, typewriters and computers are easier to use, and newspapers are easier to print—although apparently not faster: like major Western newspapers, the *People's Daily* (*Renmin ribao*) comes out every morning in millions of copies.

Several reasons can be adduced to explain why the Chinese did cling to their system of characters. Characters are graphically more interesting and beautiful than the letters of an alphabet; the system is more compact, as more information is contained on one page of the *People's Daily* than on one page of the *New York Times* (Figs. 1.22 and 1.23). But there is another reason, a single overriding reason: the Chinese did not want to entrust their cherished texts to the fleeting sounds of the spoken language.

This, however, is precisely what the Europeans did. The letters of the alphabet are symbols of sound. Westerners only record in their script the ephemeral sounds of a word, not its meaning. Script in the West is thus linked inextricably to all the phonological changes and diversifications that are bound to occur in any language. Whenever the pronunciation of vowels and consonants changes, whenever there are new developments in grammar and syntax, the script must follow suit. Whenever a group of people speaking a particular dialect achieves political independence, their dialect may become a language in its own right, requiring a separate script and literature. When Latin ceased to be the universal European language after the fall of the Roman Empire, a variety of national languages and literatures evolved. Now

Europeans have to learn a new language every time they want to read something written five hundred kilometers away, or five hundred years before.

Not so in China. Characters are symbols of meaning. Because they record the meaning of a word, not its sound, the system of script did not have to follow slavishly all the phonological and other changes that occurred in Chinese, as in every other spoken language. Even the few examples in this chapter demonstrate that an educated Chinese can read most texts written in all parts of the empire at any time in history, be it hundreds, even thousands of years ago. Script in China thus became the most powerful medium for preserving cultural identity and stabilizing political institutions. And if one wonders why the bureaucrats in Brussels have not yet been able to reunite Europe, the answer may be that they use an alphabet.

The Chinese by contrast still use many thousands of characters, with which they are apparently happy. This is possible because they have developed the module system, which allows them to handle this mass. Only with a module system is it feasible to design, to use, and to remember thousands of distinguishable shapes. Only with a module system could the Chinese script fulfill its true function: to guarantee the coherence of China's cultural and political traditions. This awesome unity is unsurpassed in world history.

Fig. 1.22 (left) Front page of *People's Daily*, January 20, 1999

Fig. 1.23 (right) Front page of *The New York Times*, January 20, 1999

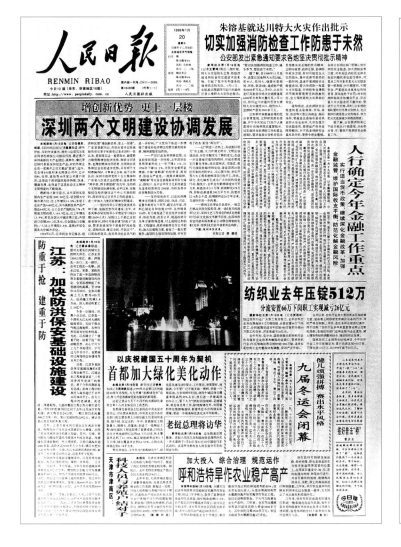

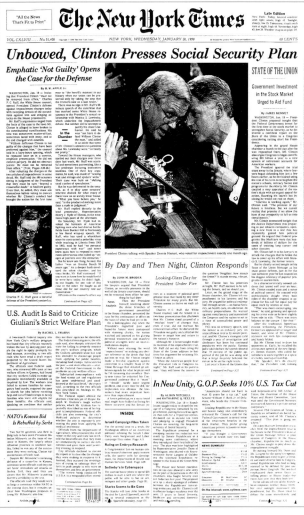

2 Casting Bronze the Complicated Way

Ritual bronzes are the most impressive and fascinating material remains surviving from Chinese antiquity. The intricately decorated vessels come in many shapes or types. Cast for and used by the early aristocracy of China in the Shang dynasty (about 1650–about 1050 B.C.) and in the Zhou dynasty (about 1050–256 B.C.), they were made to hold food and wine in ceremonial banquets prepared for the ancestors. These bronzes were the most precious objects in the religious and political life of their day.

Vessels and utensils of bronze were manufactured in several other regions of the ancient Eurasian world, in Mesopotamia, India, Greece, and Japan. Among the artifacts of all Bronze Age cultures, Chinese ritual bronzes stand out in at least three respects: their decoration, their technique, and their being grouped as sets. This chapter concentrates on these three aspects, which make Chinese bronzes unique among other bronzes in the world.

For decoration the bronze makers developed a modular system that allowed them to assemble countless combinations from a limited repertoire of motifs and compartments. They also devised a modular technical system for casting their vessels. These systems offered the best solution to the task that the ancient Chinese had set for themselves: to produce high-quality bronzes in sets. In order to understand why they made this effort at all, it is necessary first to look at where and when they cast their bronzes, and what they used them for.

Opposite:
Fig. 2.1 *Fangyi,* ca. 1200 B.C. H. 26.5 cm, Dimens. at mouth 13.3 × 11.1 cm, Weight 3.6 kg. Museum für Ostasiatische Kunst, Cologne

Unearthing Ritual Vessels

Thousands of ancient Chinese bronze vessels are known. New ones come to light almost every day. Yet the objects preserved in the earth can be only a fraction of all the bronzes that were ever cast. We shall never know how many

25

were destroyed in wars, melted down for weapons or coins, or lost in other ways. It is certain, however, that more bronzes were produced in ancient China than in any other comparable culture in the history of humankind.

The most significant bronze discoveries have been made at Anyang, Henan Province. Anyang's archaeological importance was recognized as early as 1899, when oracle bones were first unearthed there (see Fig. 1.13). The inscriptions with names of the rulers of the late Shang dynasty made it seem likely that their residence and their tombs lay under the ground somewhere in the Anyang area.

Before the 1930s, almost all bronzes were chance finds or came from clandestine excavations at Anyang and elsewhere in China. Chinese and foreign treasure hunters pursued valuable objects only, disregarding and even disguising their archaeological context. Peasants near Anyang probing and drilling the earth with long metal rods could tell what kind of material they had hit from the resistance they met. They are said to have been very good at it. Indeed, even more professional robbers still continue to loot tombs very successfully.

Many of the bronzes that came to light in this way reached the international art market. As spectacular pieces from Anyang were sold abroad, and oracle bones, too, left the country, the Chinese government tried to stop such diggings by controlling excavations there. The first campaign began in 1928, and more campaigns followed year after year. Work was interrupted in 1937 by the Sino-Japanese War but resumed in 1950. The Chinese archaeologists have uncovered far more than a thousand tombs and pits and the foundations of some large architectural structures, all dating from the late second millennium B.C., and they have brought to light great numbers and many varieties of artifacts. They have given the understanding of Chinese antiquity a new foundation, and they have added considerably to our views of the development of humankind in general. *Anyang* has become a household word among archaeologists all over the world.[1]

The Shang tombs excavated at Anyang vary greatly in size and in their furnishings. Small tombs consist only of a pit with a skeleton and perhaps a few ceramic pieces near the skull. If the social status of the occupant of the tomb warranted, bronze items may have been added. Some larger tombs contained the skeletons of retainers or slaves, and the largest ones were accompanied by pits for horses and a chariot (see Fig. 3.18). Their occupants must have been noblemen who had the right and the means to own such a chariot, and whose heirs were affluent enough to dispose of it under the earth.

The largest tombs, which were built for the Shang rulers, are cruciform in shape. They have slanting ramps on which the dead were borne down to the tomb chamber in the center. The overall length of these structures can amount to almost one

Fig. 2.2 Royal tomb no. 1004 at Anyang (13th–11th century B.C.), during excavation

hundred meters, with the tomb chamber extending more than twelve meters below the surface. Figure 2.2 is a photograph taken during the excavation of such a tomb. The royal tombs contained many skeletons of women, retainers, slaves, and horses, and they were surrounded by hundreds of smaller burials and pits with sacrificial victims, all of whom were called upon to serve their lord in the afterlife.

Among the bronzes found was a four-legged, rectangular food cauldron of the type *fangding* that turns out to be the largest bronze vessel ever unearthed in China (Fig. 2.3).[2] A three-character inscription on its inner wall dedicates it to the memory of a certain Mother Wu. Therefore it is called *Square Ding Dedicated to Mother Wu (Si Mu Wu fangding)*. Mother Wu must have been the consort of a Shang king, and the bronze was probably cast shortly before 1200 B.C.[3] It is 133 centimeters high and weighs 875 kilograms. Yet this *fangding* of Mother Wu was probably not the heaviest bronze object made in the Anyang period. Kings most likely owned even larger vessels.

In spite of such spectacular finds, the excavators' bounty in terms of bronze vessels was meager at Anyang, because all the royal tombs had been looted earlier. Some tomb robbers may have been active as early as the Western Zhou dynasty. They must have known exactly where to look, because they dug vertical shafts into the center of the tomb chambers. They probably melted down the bronzes of the Shang rulers that they brought to light, in order to make their own ritual vessels. Thus no inscribed bronzes were found in any of the tombs that might have helped to identify their respective owners.

Only a single unlooted royal tomb has been discovered so far. It was excavated in 1976. The pit, 7.5 meters deep, measured at the surface merely 5.6 x 4 meters. Postholes indicate that a ceremonial building was on top. A drawing of the floor of the tomb chamber shows bronze vessels neatly arranged along three walls of the outer coffin (Fig. 2.4). While several of them come in pairs, other bronzes have been found elsewhere in the tomb. Subsoil water had disturbed their original placement.[4]

This unlooted tomb has advanced the understanding of ancient Chinese bronzes in several respects. First of all, the occupant of the tomb can be identified. Inscriptions on many of the bronze vessels bear the name Lady Hao (fu Hao; see Figs. 2.25 and 2.26). Oracle bone inscriptions record that Lady Hao was the consort of King Wu Ding, the fourth Shang ruler at Anyang, who may have died shortly before 1200 B.C.[5] This gives a *terminus ante quem* for the many and stylistically varied treasures owned by the formidable Lady.

The find further demonstrates the enormous wealth of bronze in the possession of members of the Shang royalty. This relatively small tomb contained 210 ritual bronze vessels among a total of 468 bronze artifacts, not including bronze buttons. Together they weigh 1,625 kilograms.[6] If even a small tomb like Lady Hao's was that rich, the quantity and the sizes of bronze vessels in larger tombs must have been staggering.

The scientific excavations in Anyang of the late 1920s were only a beginning. Since then many more sites have been unearthed all over north and central China, giving a much clearer picture of the chronology and regional

Fig. 2.3 *Square Ding Dedicated to Mother Wu,* 12th (?) century B.C. H. 133 cm, L. 112 cm, D. 78 cm, Weight 875 kg. Historical Museum, Beijing

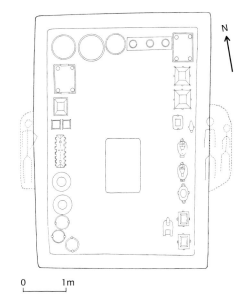

Fig. 2.4 Floor plan of the tomb of Lady Hao, ca. 1200 B.C.

0 1m

diversity. Anyang, although the capital of the Shang dynasty in its last phase, was one of several regional power centers with independent bronze traditions that influenced one another.[7] Some of them even predate Anyang. The earliest bronze vessels known so far were made in the sixteenth century B.C. and have been excavated at Yanshi Erlitou, near Luoyang.

The archaeological discoveries in recent decades have also greatly expanded our knowledge about post-Shang bronzes. After the Zhou dynasty overpowered the Shang around 1050 B.C., they and others continued over several centuries to make bronze vessels on a large scale. When, three centuries into their reign, the Western Zhou themselves had to retreat before intruding barbarians in 771 B.C., they buried many of their bronzes for safety in underground pits, apparently in the hope that they would come back someday and retrieve their possessions. They never did. Peasants and modern archaeologists now uncover their treasures instead. The largest hoard was found in 1976. It contained 103 vessels belonging to one Earl Xing of Wei (Wei Bo Xing) and cast by successive generations of his family (see Fig. 2.38). Because of its long inscription, the key vessel is the Water Basin of the Archivist Qiang (see Fig. 1.15).

The Function of Ritual Vessels

One simple explanation why the early Chinese produced bronzes in such abundance is that they had an unusually large quantity of raw material at their disposal. The copper and tin deposits in central and northern China were richer than any others exploited in the ancient world.[8] Chinese craftsmen were not constrained by a shortage of metal as were their colleagues in the Middle East and Greece. The Chinese could even allow themselves to sacrifice much of their metal and bury it underground for good.

Yet an abundant metal supply does not in itself explain why the Chinese actually made bronzes, or what they did with them. Written evidence provides some general information. The most important literary source, the *Record of Ritual* (*Liji*), which was one of the Classics, makes it clear that ritual was of utmost importance in ancient China. Yet the book contains no detailed prescriptions for how bronzes had to be used, and its presently known form was compiled about a thousand years after the end of the Shang.[9] The inscriptions on oracle bones that are contemporary with the Anyang bronzes tell of ceremonial banquets or ritual meals in honor of the ancestors. So many of these rituals were necessary that they had to be performed almost every day.[10] Yet there is no systematic description in the oracle bones of religious beliefs, liturgy, or the exact function of bronzes. The objects themselves remain our main source of information.

From the shapes of the vessels it is obvious that they were used to prepare and serve meals. Some excavated pieces still had traces of soot underneath and bones inside. Among the twenty-odd different types, a clear separation between vessels for liquid and those for solid food is evident,

and the variety of vessel types shows that the meals comprised various courses. Even in antiquity the Chinese lavished a lot of effort on the preparation of their food.

Yet the size of the bronze vessels, the value of precious metal tied up in them, as well as the sophisticated technique involved in producing them make it equally obvious that they could never have been intended for profane, everyday use but only for solemn, ritual occasions. Bronzes were rivaled only by jades in beauty and in the expenditure of labor required for their production. Bronzes and jades were the true monuments of Chinese antiquity.[11]

The Chinese centered their ritual around a ceremonial meal, as Jews and Christians do. They all knew that nourishing the body is a most essential matter, and they emphasized the seriousness of the act of eating and drinking by heightening it into a religious ritual. The ritual bronze vessels of Chinese antiquity thus played a role similar to that of chalice and paten in the Christian church. Yet whereas Christians reduced their ritual meal to bread and wine and consequently needed only two types of dish, the Chinese preferred a great variety of courses and therefore needed elaborate tableware.

Even more significant is the difference between the circle of participants in the respective rituals. The communities that began to convene around chalice and paten in a parish or a monastery since the early Middle Ages drew its members from all segments of the population. The ritual meal was open to all Christians irrespective of their blood relationship and even their social standing. By contrast, the ritual meal in ancient China was a family affair. It took the form of a ceremonial banquet in a particular family. Dedicatory inscriptions to ancestors on the vessels themselves, like the one to Mother Wu, confirm this. Indeed, such ritual may have been a relatively private matter. The extraordinary intricacy of the ornaments on bronzes suggests that they were appreciated close up.[12]

The purpose of the ceremonial family banquets was to ensure the goodwill of the ancestors and to invoke their aid in the struggle for survival and success in this world.[13] The rituals were performed in special ancestor halls.[14] The placing and orderly arrangement of the ritual vessels in tombs indicate that the owner of the tomb was expected to go on offering to his ancestors after his death. An inscription that later is frequently found on vessels in Zhou dynasty tombs voices this wish: "May sons and grandsons eternally use this vessel."[15]

The exceptional value of the bronze vessels further makes it evident that not all families could afford them. Only the rich and powerful could make them, own them, and use them. Bronze was a sensitive commodity, as weapons could be made from it. The ruling families monopolized its distribution, and they alone had the means to support the complex operations and the many workers necessary for casting the metal. In the aristocratic families bronzes were handed down through several generations. Bronzes in one tomb or hoard often came from different periods. To their owners they represented contact with family ancestors who had been powerful figures in their own days. The ritual vessels mirrored and therefore stabilized the

existing social order. Like crown jewels in the West, they were tangible regalia of political power.

In addition, bronzes served to define the social position of particular individuals. As the finds in Lady Hao's tomb show, individual family members could possess their own bronzes. They must have been cherished treasures. The quantity of vessels in the possession of a single person ranged from one or two to a few hundred, comprising specimens of many different types, and varying greatly in size, decoration, and quality.

This can only mean that the variety in the bronzes reflected an intricately graded system of political and social hierarchies within the aristocracy. Which vessels a certain nobleman displayed in ritual was not arbitrary. Elaborate rules are known from later times that governed what types and how many vessels were allowed for the holder of each rank in the nobility.[16] The myriad variations in quantity and quality of the vessels were a visible means by which the insider could identify the owner's standing within his family and the aristocratic elite.[17]

Thus the bronze makers had to achieve two goals. First, they had to provide large numbers of pieces to fulfill the ritual needs of noble families and their individual members. Second, each bronze had to be made in such a way that a great variety of distinguishable features could properly index the position of its owner in a complex social fabric. The bronze makers solved this dual task by developing module systems.

The Decorative System

Compartments

The first module system is the decorative one. With few exceptions all major vessels are decorated. There is a repertoire of distinct motifs, both zoomorphic and abstract. These come in almost limitless variations, and are combined into patterns of great intricacy. Typically the motifs fit into registers and compartments, resulting in a remarkable interplay between decoration and overall vessel shape. Because there is a repertoire of motifs, and because the decoration is organized in fields, one can talk about a system.

The following examples mainly belong to what may be termed the classical phase, a historically and geographically circumscribed time and area comprising the twelfth and eleventh centuries B.C. in Anyang and related centers of the Shang and early Zhou periods.[18]

Figures 2.1 and 2.5–2.10 show seven views of a wine container in the Museum für Ostasiatische Kunst, Cologne, which was probably cast in the twelfth century B.C.[19] It is only 26.5 centimeters high and weighs 3.6 kilograms. This rectangular type, looking like a house, is called a *fangyi*. It consists of a slightly inward-slanting foot, a body, and a detachable lid in the shape of a roof surmounted by a knob. Vertical flanges at the corners and at the centers of each side of the body and roof and a horizontal flange on the ridge of the vessel articulate its silhouette. Undecorated horizontal bands

Figs. 2.5–2.10 (opposite) Cologne *fangyi*
(details of Fig. 2.1)

Fig. 2.5 Front
Fig. 2.6 Back
Fig. 2.7 Left side
Fig. 2.8 Right side
Fig. 2.9 Front of lid
Fig. 2.10 Side of lid

2.5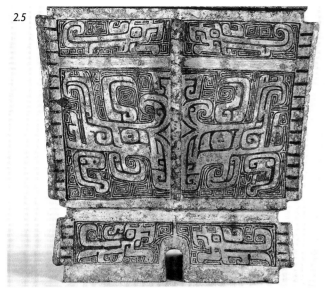

2.6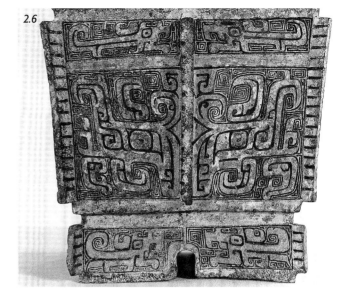

2.7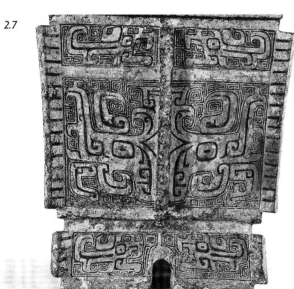

2.8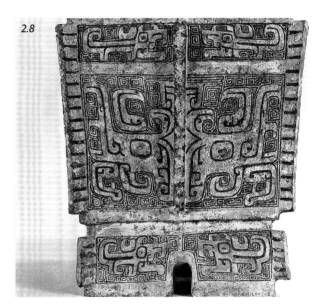

2.9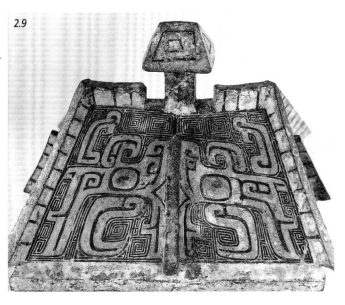

2.10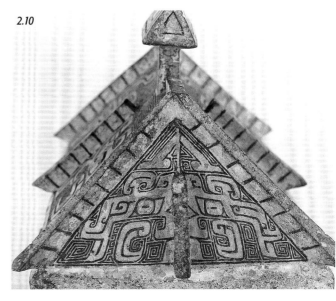

separate the foot from the body and a large register on the body from a narrow one above. Its distinctive profile, the division into main parts, and the partition of the decoration into rectangular compartments give this vessel a tectonic quality.

The compartments defined by the vertical and horizontal divisions contain fabulous animals. A pair of creatures confronting one another is represented in profile on the foot as well as the upper register of the vessel's body. Each creature consists of distinct anatomical parts (Fig. 2.5). The eye is immediately recognizable. A sharp beak points downward, one paw extends forward, a horn behind the eye is in the shape of a backward-lying C, and a body with a split or curled tail extends to the side. Such small creatures are often called dragons.

In the main register two animals in profile are joined in such a manner that they form a face that can also be viewed frontally. The central vertical axis runs over the ridge of the resulting creature's nose. The face's parts resemble those that compose the beasts below and above: again the eye is readily identifiable; a horn is above it and a jaw below; and under the body hangs a paw with an upward-pointing claw. This face is the most prominent motif on the bronzes. It is not known what the Shang people called it, but later Chinese antiquarians named it *taotie*.

The right half of the *taotie* is a near-mirror image of the left half but not an exact one. In particular, one always finds small but give-away variations in the spiral background. Upon close inspection all corresponding spirals—those in the curl of the horns or jaws, for example—turn out to be dissimilar. The same is true for the back of the vessel, which has the same decoration, but upon detailed comparison discrepancies are evident everywhere (Fig. 2.6). This proves that neither the entire decorative pattern nor parts thereof were reproduced mechanically but rather executed by hand.

As observed in the first chapter, the sizes and proportions of modules in written characters change according to the spaces available. The anatomical parts of the *taotie* do the same. The *fangyi* has an oblong cross section, front and back are 13.3 centimeters wide, and the sides measure only 11.1 centimeters. Accordingly, the facial features of the *taotie* on the sides of the vessel are slightly narrower than those on front and back (Fig. 2.7). The eye sockets are lacking as are the additional projections that grow from the body beneath the tail. The creeping animals in the registers below and above have shorter bodies than their counterparts on front and back. Again, the opposite side of the vessel, although basically similar, differs in every detail (Fig. 2.8).

The front of the lid is filled with an upside-down *taotie* (Fig. 2.9). Accommodating the trapezoidal field, the body runs parallel to the vessel's slanting sides and the paw hangs down lower than the jaw. In the tight triangular gable fields at either side of the lid the *taotie* is altogether smaller and more squat (Fig. 2.10). The eye socket appears again, but one part of the animal, its paw, had to be omitted altogether.

The angular spirals between the anatomical parts provide a most ingenious and flexible device to smooth out such differences. The thickness of their lines always remains the same, making for a homogeneous texture, but

there is great leeway in the number of windings within any spiral, and consequently in the spirals' absolute sizes and their total number and placement. Thus, the spirals can evenly fill spaces of every given size and shape.

Comparing several sides of the same vessel, one always perceives a certain homogeneity in execution. One man was likely responsible for the decoration of the entire vessel. The rendition of details such as the spirals, and the minor compositional alterations by which the artisan adapted the animal forms to the given fields, put his aesthetic judgment and skill to the test. If he did his job well here, the entire vessel looked accomplished.

Figure 2.11 shows three more *taotie*. As usual, the symmetrical pair of eyes is most prominent. The eyes may have a horizontal slit or a dot for the pupil, and may or may not lie between two eyelids that meet in pointed tips. Nostrils can be recognized at the lower end of the central nose ridge, but it does not always extend to the upper boundary. One *taotie* has eyebrows, and in the other two, heart-shaped ears sit to the left and right of the eyes. In all three *taotie* the upper and lower jaws below the eyes are filled with two opposing teeth, leaving no doubt that these *taotie* are composed of two side views of an animal bending its snout down. The bodies continue outward and from them hang feet, with two or three downward-pointing claws and one upward-pointing claw or toe, as well as a hook extending backward. In one case the horn is growing into a small creature in its own right with its

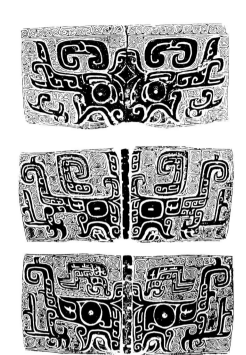

Fig. 2.11 Rubbings of three *taotie* faces

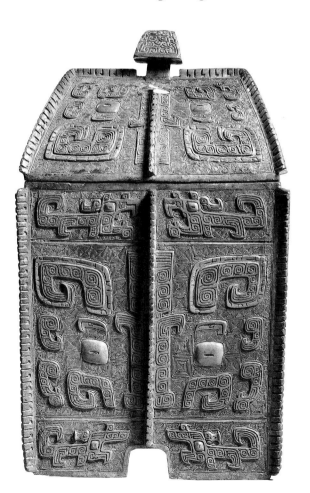
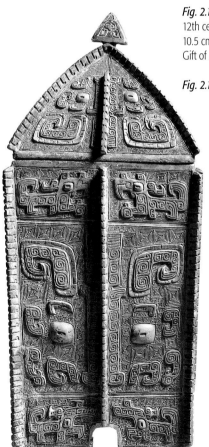

Fig. 2.12 (far left) *Fangyi* (front view), ca. first half 12th century B.C. H. 25.4 cm, Dimens. at mouth 14.6 × 10.5 cm. The Metropolitan Museum of Art, New York. Gift of Arthur M. Sackler

Fig. 2.13 (left) New York *fangyi* (side view of Fig. 2.12)

own eye and miniature horn, emulating the prodigious creativity of nature that lets parts of a body grow into a new organism.

Even these very few examples of the *taotie* illustrate a great diversity. Yet this fascinating, endlessly varied creature is always composed of a limited number of distinct anatomical parts, hardly ever more than ten. These are the nose, eye, eyebrow, ear, horn, upper and lower jaw, body, and front paw with claws. In any particular *taotie,* one or the other of these motifs may be missing. Eyebrows, ears, and the body are quite often left out.

The composite character of the *taotie* is most obvious in a particular group of bronzes, on which the face is clearly separated into its parts. Figure 2.12 shows the front view of a 25.4-centimeter-high *fangyi* (Metropolitan Museum of Art, New York) that probably was cast in the first half of the twelfth century B.C.[20] As in the Cologne *fangyi,* the foot and the upper register of the body are decorated with opposing dragons. A *taotie* is also the principal motif in the main register on the vessel's body, and another large, upward-facing *taotie* decorates the lid. Set into a background filled with spirals are the creature's separate, individual anatomical parts: a nose ridge with nostrils, eyes, eyebrows, ears, horns, mouth, and front paw. The body is missing. All these parts have distinct shapes and clear-cut contours, which do not touch one another. The fact that it was possible to dissolve the *taotie* and leave its features floating in a sea of spirals makes it legitimate to describe it as an assemblage of distinct parts.

The left and right sides of the symmetrical decoration in this vessel again display slight differences overall, especially in the spirals, but the variations are finer and more controlled than those in the Cologne *fangyi.* On the narrow sides of the rectangular body this designer, too, had to compress all anatomical parts a bit (Fig. 2.13). He did so in an aesthetically very satisfying way, mostly through sensitive use of the spiral ground. In the triangular gable field of the roof he again omitted the paw of the upside-down animal.

From the *taotie* faces seen so far, it is evident that not only are the number of its anatomical parts limited but they turn up in certain variants or types, whose number is restricted, too. It is difficult to find more than ten different types of, say, eyes, jaws, or horns.[21] Multiplying the number of anatomical parts by the number of types of each part, one arrives at the complete repertoire of only a few dozen decor motifs from which thousands of *taotie* were composed during the late Anyang period.

The anatomical parts of the *taotie* may be regarded as modules in a decorative system. By and large they conform to the definition of the module applied to the system of script: they are composite, interchangeable parts combined into units, in this case the *taotie.* Rules and conventions govern these combinations. Certainly not all theoretically possible combinations are made, nor can the respective positions of the parts within the *taotie* be randomly assigned. The horn, for example, is always found above the eye, never at its side. Moreover, as the Cologne and the New York *fangyi* show, the sizes and proportions of the modular body parts were adapted to the sizes and shapes of the decorative fields.

The almost limitless variations in the *taotie* have intrigued scholars for decades. Again and again they have tried to classify the various forms, hoping to recognize relationships and find a coherent system governing this vast body of shapes. Figure 2.14 shows a page from one such classification by the eminent Swedish sinologue Bernhard Karlgren.[22] If, in the future, somebody feels the urge to establish still another classification of ancient Chinese bronze decor, it might be helpful to take into account its essentially modular character.

Attempts have been made to identify species and subspecies within the brazen fauna, sometimes applying the nomenclature devised two thousand years later by Song-dynasty antiquarians. If *taotie* are not taken as discrete units but rather as composites, such classifications appear somewhat meaningless, because the lines of distinction between beasts are not clear-cut. The two most numerous creatures in the classical Shang period—*taotie* and dragons—are siblings. Both are composed of elements chosen from the same decorative repertoire.

It is often discussed whether a *taotie* is a head seen from the front or a bicorporal, split-up animal with its two halves spread laterally. Although the latter reading is the correct one, the modular character of the *taotie* renders this point somewhat irrelevant.[23]

The issue of the iconography of the *taotie* is even more hotly debated.[24] Famous and influential has been the stance taken by Max Loehr. He doubted that the decorations on Shang bronzes had any ascertainable meaning at all, but instead saw them as the result of an autonomous development of form that led from an assemblage of meaningless spirals to full-fledged faces.[25] In a similar vein, Robert Bagley analyzed the intimate relationship in the evolution of casting technique and of design, and stressed that technical factors go a long way to explain why the bronzes look as they do.[26] These lines of argument fascinate through their rigor and elegance.

Still, even if particular features of the bronze decor can be shown to be the outcome of stylistic or technical evolution, this does not preclude a dimension of meaning. The functional and social context in which the bronzes were used prompts the conclusion that their compelling decor carried meaning for those who made and saw it. On the other hand, it is equally extreme to postulate that every motif and feature of the decor should be assigned a specific iconographic significance, and to assume that every variation in the *taotie* is fraught with symbolism.

Looking at the decor as a modular system opens a perspective beyond the dilemma of meaning: there is a certain playfulness in combining modules; some modules may be left out when there is not enough space in a given field. And there is leeway in designing the anatomical features; the different execution of eyes, paws, or even horns have no zoological or iconographical significance. They merely serve to achieve the variety of forms that the users expected.

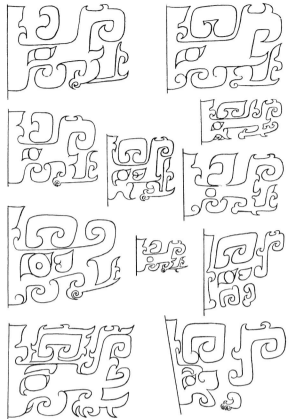

Fig. 2.14 Types of *taotie* faces

Vessels

The analysis of the system of script distinguished different levels of complexity within the tier of the module. A similar phenomenon is found in the bronzes. The decorative system has two distinct levels. On the level discussed so far, the compartment is the unit. The units are filled with various motifs, among which the *taotie* is the most frequent and prominent one. Its anatomical parts are the modules. Then there is another, more complex level, at which compartments become modules and an entire vessel is the unit.

Below and above the dissolved *taotie* on the Metropolitan Museum *fangyi*, horizontal registers, each with twin dragons, adorn foot and neck (see Figs. 2.12, 2.13). While the dragons above have birdlike beaks, the dragons below do not. The horns of the dragons above take the shape of a comma, those below that of a bottle. Jaws and horns of the *taotie* in the center are altogether different.

The body of another *fangyi* (Sackler Gallery, Washington, D.C.; Fig. 2.15) has three similar registers. The little beasts on the foot run away from one another and the *taotie* in the center is not dissolved. The dragons on the neck register, however, are strikingly similar to the pair of dragons on the neck of the Metropolitan Museum *fangyi*. Although there are small differences in the outlines, in the ornaments on the body, and in the surrounding spirals, a greater resemblance exists between the two pairs of dragons on these two distinct vessels than between any of the other pairs on either individual vessel. This points to an interchangeability of decorative compartments within vessels.

Similar decorative compartments can be used for vessels of completely different shapes. Dragons in rectangular fields, like the ones on the two *fangyi*, even occur on a curved surface, such as on the foot rim of a ewer of the type *you* (Fig. 2.16). It has to be acknowledged, however, that there are always small variations between those little dragons. If every contour and each spiral is scrutinized, none turns out to be completely identical with any other.

A square wine jar of the type *fanglei* in the Shanghai Museum, made in the first half of the twelfth century B.C., is 53 centimeters high and weighs 29.6 kilograms (Figs. 2.17, 2.18).[27] The vessel is built up in four main parts, an inward-slanting foot, a bulging body, a rounded shoulder, and a straight neck. The lid is missing. Two loop handles surmounted by animal heads sit on the shoulders at the sides of the vessel, and a third low on the body in front. As in *fangyi*, vertical flanges at the corners articulate the vessel's silhouette; foot, body, shoulder, and neck are separated by undecorated horizontal bands.

The main portion of the body beneath the shoulder is divided into three horizontal registers. Central flanges run from the foot all the way up to the neck, dividing the registers into symmetrical halves. As usual, the resulting compartments on all four sides of the jar are filled with animal decoration in relief above a ground of square spirals. The precision in the execution of detail is amazing.

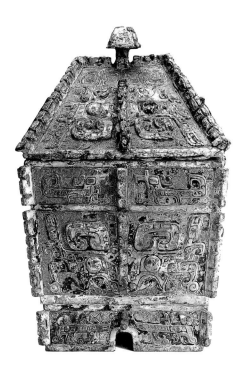

Fig. 2.15 *Fangyi,* 12th (?) century B.C. H. 26.2 cm, Dimens. at mouth 15.2 × 11.7 cm, Weight 3,694 kg. Arthur M. Sackler Gallery, Smithsonian Institution, Washington, D.C.

Fig. 2.16 *You,* 11th (?) century B.C. H. 36.5 cm, W. 27 cm, Weight 9.67 kg. The Freer Gallery of Art, Smithsonian Institution, Washington, D.C.

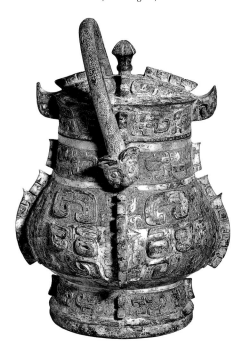

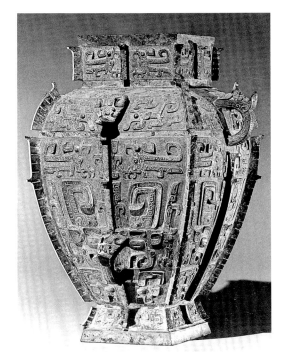

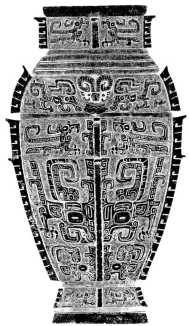

Fig. 2.17 (left) *Fanglei,* first half 12th (?) century B.C. H. 53 cm, Weight 29.6 kg. Shanghai Museum

Fig. 2.18 (right) Rubbing of Shanghai *fanglei* in Fig. 2.17

A *fanglei* in the Sumitomo Collection in Kyoto (Fig. 2.19) closely re-sembles the *fanglei* in Shanghai in size and shape.[28] The beasts on the shoul-ders also look similar, yet instead of the pair of birdlike creatures on the neck of the Shanghai vessel, the Sumitomo vessel's neck sports twin dragons joined into a *taotie,* and the beasts on the foot have also been changed. Very alike again are the large *taotie* faces in the middle registers of the vessels' bod-ies. Sheer playfulness and slightly different proportions of the available com-partments account for variations such as in the eyebrows or the paws. The Sumitomo piece has a second *taotie* in the upper register of the body. The particular proportions of this register are the raison d'être for the additional vertical dragons in the corners: they are there to fill the space. The corre-sponding register on the Shanghai *fanglei* contains birds similar to the ones on the vessel's neck. A nose ridge is added in the middle of this rather elon-gated field. The lower register of the body of the Shanghai vessel has another *taotie,* but two baby dragons appear on the Sumitomo piece.

Fig. 2.19 *Fanglei,* 12th (?) century B.C. H. 62.7 cm. Sen-oku Hakuko Kan, Kyoto

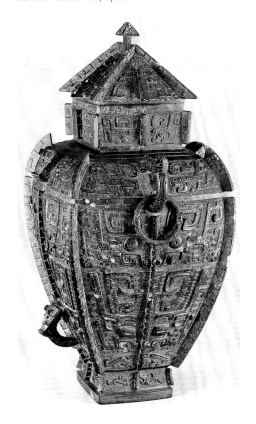

Such comparisons between related vessels demonstrate the limited room for creativity open to a designer. Before he even starts, the structure of the entire vessel—its shape, proportions, and size—have already been fixed. Only in exceptional cases was an artisan asked to modify a traditional type. Normally he had to operate within a tight framework, and the means em-ployed to fill a given compartment became his major concern. His preferred method was to exchange established motifs. He treated them as modules and adapted them to the particular shape and proportions of the compartment into which he needed to fit them.

Even in filling compartments the freedom of the designer was con-strained. Certain iconographic considerations may have confined his choice, although it is hard to say to what degree they did. The variations in the deco-ration of the vessels surely had yet another benefit: their owners and users

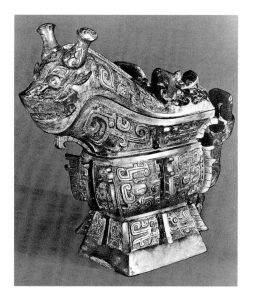

Fig. 2.20 *Ya Chou gong,* 12th (?) century B.C. H. 31.8 cm. Idemitsu Museum, Tokyo

could tell them apart. This may have been helpful in rituals involving great numbers of vessels in a complicated liturgy.[29]

The pervasive system of compartments encompasses all bronzes considered so far. Yet some vessel shapes, those reminiscent of animals, do not conform to the geometry and symmetry of the system. They originated in areas other than Anyang, probably in the south.[30] Among them are vessels of the *gong* type, which are shaped like a sauceboat. In an example from the Idemitsu Museum, Tokyo (Fig. 2.20), the asymmetrical lid takes the form of a monstrous animal, while the symmetrical lower part has been divided into regular decorative units.[31] In other instances, the lower part of the *gong* still lacks this compartmentalization.[32] Both subtypes were found in the tomb of Lady Hao, which demonstrates how alien shapes were adapted and drawn into the rigid system of decorative compartments that reigned at Anyang.[33]

The Technical System

Joining Molds

One essential fact about the decorative compartments merits further attention: the borders of these fields concur with the borders of mold sections made for casting the vessels. This brings us to the second remarkable feature of Chinese bronzes when considered within a world perspective: the unusual and complicated technique of casting.

In all other parts of the globe, the bulk of Bronze Age artifacts are either hammered or cast by the lost wax process. By contrast, the Chinese cast their bronzes in negative clay molds constructed of several pieces. They placed a core into this negative mantle and poured the bronze into the space between the mantle and the core.

Fig. 2.21 Casting a *fangding*

Figure 2.21 shows a schematic drawing of the mold assemblage for a rectangular cauldron such as the *Square Ding Dedicated to Mother Wu.* The four-part outer mold is put together at the four sides of the vessel. The decorative pattern appears in the negative in these outside slabs. Inside the vessel and between its four legs are two core pieces that are separated by the horizontal bottom of the vessel. If the vessel were cast upside down, as is generally assumed, the larger and heavier portion of the core would have rested below.

Building up the negative form by fitting together sectional molds once again necessitated the development of a system. The mold pieces had to be related by means of size, shape, and decoration. The divisions were determined by the given form of the particular vessel type. Many types have strong vertical divisions. It was natural to set the

decoration within the compartments formed by these divisions, causing the units of decoration to be inextricably linked to the vessel shape. Nowhere else in the world did Bronze Age man develop such a sophisticated and coherent system of design and casting technique.[34]

Casting metal from molds made of two halves is a simple technique used all over the world. The Chinese cast great quantities of coins and blades for their weapons in this way. Figure 2.22 shows one half of a two-part clay mold from the Han dynasty that was used for casting rows of coins in one pour. In addition to such rather simple bivalve molds, Chinese craftsmen in the Anyang period had already developed the technical capability to make molds that were much more elaborate.

Fig. 2.22 (above) Piece of a clay mold used for casting coins, Han dynasty (206 B.C.–A.D. 220). Henan Province

Two joined parts of a mold, which also excavated at Anyang, correspond to one of the four body walls of a *fangyi* vessel (Fig. 2.23). The seam runs down the central axis. Each of the two halves contains three decorative fields, one above the other.[35] This demonstrates that the borders of mold sections usually correspond to borders of decorative compartments, but that one section tends to encompass several

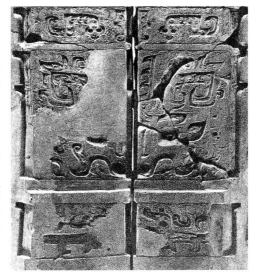

compartments. Mold pieces are modules in a technical system. They are composite, interchangeable parts combined into units. The units are the complete negative mantles into which the bronze is poured.

It has often been pointed out that this accomplished method of bronze casting was only possible because the bronze makers could avail themselves of a highly developed ceramic technology. Certainly, long and specialized experience in the handling of clay was required to form the delicate decor, to fit the molds together properly, and to prevent them from cracking during the pour. For making molds, the casters favored fine-grained, low-lime and low-clay loess because of its high porosity and its dimensional stability in drying and firing.[36] Similarity of vessel types also attests to the close relationship between ceramic and bronze manufacture. The Neolithic potters had already achieved remarkable richness and variety in the repertoire of ceramic types. Many of their vessels had clearly defined, distinct parts that the potters must have formed separately and then joined together. They also created new vessel shapes by combining those segments.

Molds prompt the intriguing question of whether the decoration was engraved by hand or formed mechanically through impressions. The question is important because it bears on issues such as standardization, printing, reproduction, and creativity. The earliest bronze vessels show decoration in simple thread relief lines only, as seen in the decorative band of the tripod in Figure 2.24. To produce such lines the craftsman incised them directly into the

Fig. 2.23 (left) Piece of a clay mold used for casting a *fangyi,* 12th (?) century B.C.

Fig. 2.24 (below) *Ding* tripod, 15th–14th century B.C., Panlongcheng. H. 54 cm, Diam. 40.7 cm, Weight 9.6 kg

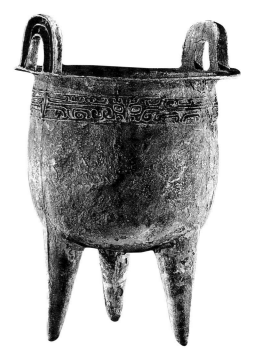

Fig. 2.25 Cast inscription in a *gu* beaker from the tomb of Lady Hao, ca. 1200 B.C. H. (inscription) ca. 5 cm

Fig. 2.26 Rubbings of inscriptions in *gu* beakers from the tomb of Lady Hao, ca. 1200 B.C.

Fig. 2.27 Method of producing an inscription in a bronze vessel

2.25

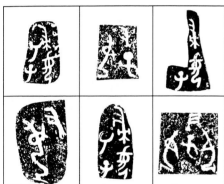

2.26

2.27

Casting Inscriptions

Figure 2.25 shows an inscription cast inside the foot of a wine beaker of the *gu* type from the tomb of Lady Hao; Figure 2.26 displays rubbings of more such inscriptions.[37] The intaglio characters must have been cast from a relief form on the core part of the mold. How did it get there in the positive? It would have been very cumbersome and completely impractical to scrape the core down until only the characters stood out. The duct of the strokes in the characters also reveals that they were incised into soft clay in one movement.

A scribe must therefore first have incised the strokes of the characters with a sharp instrument into a small block of clay. He may then have set this into a small frame of its own, as the drawing in Figure 2.27 suggests. From this template the caster then took a negative impression and inserted it into a prepared section of the core of the mold.[38]

Given the fact that conversion was known and used by the bronze casters, one might have expected that they would have exploited its potential to duplicate mechanically inscriptions, motifs, and decorative fields. They did not do this, however. Again, the inscriptions show it.

The inscriptions for many lidded vessels were cast twice—once inside the body and once inside the lid. The caster who took the negative impression from the intaglio characters that were incised into a clay template by a scribe could easily have taken two impressions instead of one, but he did not do so.

The sauceboat-shaped vessel in the Idemitsu Museum has inscriptions in its body and its lid (Figs. 2.28a–b). The two texts are identical, but the layout and the shapes of the characters are not. The inscription starts with an easily recognizable *ya* character bounded by a square. It appears once at the upper right and once at the upper left side of the inscription, which means that the text begins once with the right column and once with the left. The makers of the vessel took the trouble to have the text written twice. It was then duplicated separately, once for the body and once for the lid. The same applies to some very long texts.[39]

Mechanical duplication is not found in the decoration of Shang bronzes either. In the case of square vessels it would have been possible to take two impressions in soft clay of the front side of the finished model and use them for both the front mold and the back mold. Yet this was not done in the cases of either the Cologne or the New York *fangyi*. In fact, no evidence has been found that it was ever done in Shang times. Close scrutiny of any Shang bronze will invariably reveal slight differences between front and back, or between other corresponding parts.

This is the same phenomenon demonstrated concerning script: all modules and units are individually executed by hand and therefore display small variations in their shapes. In the case of handwritten characters,

mechanical replication is not possible. In the case of cast bronze decoration, however, it is. Yet apparently the foundries did not keep a stockpile of decor motifs duplicated in clay, or of mold pieces in standardized sizes that fit into ready-made clay models or clay mantles of standard dimensions. Instead the mold makers formed every mold piece anew. They may have used some mechanical means to cut their molds to a preliminary form and size, but every part of the mold assemblage and every single decor motif was given a final shaping by hand.

The result looks aesthetically pleasing to us, as it presumably did to Shang artisans. No one *taotie* face is an exact duplicate of any other, nor does one half of the face ever duplicate the other half. This parallels the universal experience that no two human faces are absolutely identical. Humans, with their astonishing capacity for recognizing and remembering faces of large numbers of people, can equally enjoy viewing ever new and varied brazen faces.

Moreover, working by hand offered the designer the chance to smooth over small irregularities that might have crept in, and also to introduce intentionally small changes and additions. Although his freedom was limited, he could still come up with unusual variants that held the potential for further changes and developments, such as the horn turned into a dragon seen in Figure 2.11.

There may have been reasons other than aesthetic ones that explain why the Shang casters did not make full use of their technical possibilities and did not take all the mechanical shortcuts available to them. Were the technical problems, after all, more intricate than we imagine? Was it out of religious respect? Was full employment one of their concerns? We do not know.

Cloning Vessels

Several hundred years passed before the possibilities for mechanical duplication and repetition inherent in the sophisticated bronze casting technique were realized. Pieces were then produced that were virtually identical. A basin of the type *jian* in the Freer Gallery of Art in Washington, D.C. (Fig. 2.29), and a *jian* in the Pillsbury Collection in the Minneapolis Institute of Arts (Fig. 2.30) are examples. The two basins carry inscriptions indicating that they were cast in the state of Jin before its demise in 453 B.C.[40]

The basins' bodies are each decorated with three horizontal bands filled with interlaced animal designs. This kind of decor, which has its origins in the late Western Zhou period, differs from Shang decor in several respects. Although it is still composed of animal forms, distinct creatures cannot be easily identified. The body parts merge into a homogeneous pattern that continues in uninterrupted bands without vertical divisions. The traditional bilateral symmetry is replaced by radial symmetry, "masks" pointing downward and upward in alternating succession.[41] These properties of the decor all but conceal that the decorative bands actually consist of repetitive sections. Meticulous investigation will reveal that the sections are completely identical, which indicates that they must have been reproduced mechanically.[42]

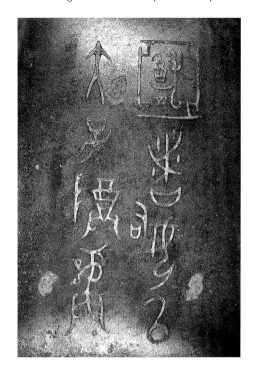

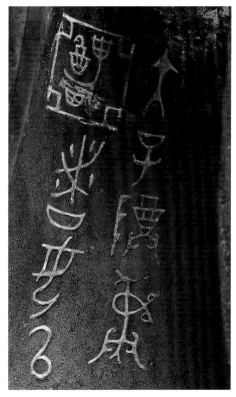

Fig. 2.28 Inscription on body (*above*) and lid (*below*) of *Ya Chou gong* (Fig. 2.20). Idemitsu Museum, Tokyo

Fig. 2.29 *Jian* basin, before 453 B.C. H. 22.8 cm, W. 51.7 cm, Weight 9.27 kg. The Freer Gallery of Art, Smithsonian Institution, Washington, D.C.

The process is thought to have involved the following steps: a workman first carved a decor unit into clay in the positive. The piece was fired hard and then served as a pattern block. Figure 2.31 shows a clay piece from Houma with an elaborate animal mask in the positive. Most likely it is such a pattern block. Another craftsman then took repeated impressions from the block in soft clay and inserted them, one next to another, into a prepared mold mantle of slightly larger dimensions than the intended vessel (Figs. 2.32, 2.33). While "wallpapering"—as Robert Bagley has called it—the interior of the mantle in this way, he could adapt the malleable clay to its curved surface, but almost invariably he had to shorten the last unit to fit into the mantle's circumference. Scrutiny reveals this break in the regular spacing of the decorative units. It will also be seen that at times impressions taken from two different pattern blocks were used in alternation, or that one large pattern block had itself been generated from smaller pattern blocks. When the two basins from Minneapolis and Washington were placed side by side, it was demonstrated that the same pattern blocks had been employed for the decoration of both vessels.

The two *jian* and many similar vessels are believed to have been cast in a foundry at Houma, Shanxi Province. It is the site of ancient Xintian, the capital of the state of Jin from 585 B.C. until 453 B.C. The foundry was

Fig. 2.30 *Jian* basin, before 453 B.C. H. 22.8 cm, W. 51.7 cm. The Minneapolis Institute of Arts

probably dissolved at the end of this period after having been in operation for about a century. Bronze casters at Houma were not the first and only ones to use pattern blocks, however. The technique was known by the sixth century B.C., if not earlier, and not only in Jin but also in Chu and other states.[43] Yet Houma is by far the largest foundry site that has been archaeologically identified. In an area of several square kilometers, more than thirty thousand fragments of molds, models, and other debris have been found. Excavation began in 1957 and the significance of the discoveries was soon recognized, yet the material remained all but unpublished and inaccessible. Only about three decades later did systematic study begin.[44]

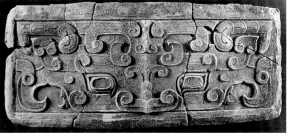

Fig. 2.31 Pattern block, before 453 B.C. Excavated at the foundry at Houma, Shanxi Province. Baked clay, 18 × 42 cm

It has now become clear that Houma was a center of mass production on an industrial scale, capable of turning out rapidly a great variety of bronzes in large numbers. As the decorated fragments reveal, the factory drew on stylistic sources of an astonishing diversity, including revivals of Shang zoomorphic and spiral patterns, late Western Zhou dragon interlace, animal

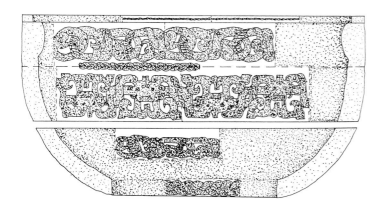

combat designs from the steppe nomads, and even more far-fetched motifs such as griffins from central or western Asia.[45] The stippling and dotted ornamentation in some bronze patterns probably imitated exotic granulation in gold.[46] Apart from the stylistic range, the output at Houma also greatly varied in quality: extremely exquisite pieces stood next to ordinary, even inept products. Yet in most cases the pattern block technique was used for the decoration.

Fig. 2.32 (left) Clay stripes in a mold mantle for casting a *jian* basin

Fig. 2.33 (right) Section of a mold mantle for casting a *jian* basin

The wide range in style and quality of its products allowed the factories to cater to a wide range of customers. While the ruler of the state of Jin was certainly entitled to the finest pieces, the foundry also churned out rather cheap consumer goods for its clientele lower down the social scale. In addition to casting valuable pieces on demand, the factory may have stockpiled products and offered them to whoever wanted to buy. The foundry did not produce for local consumption only. Archaeological finds of bronzes in distant locations that seem to have been cast at Houma could testify to a wide market. Exotic features, such as animals in combat, may have appealed to customers who were familiar with such motifs from their own stylistic traditions.

This unprecedented versatility resulted from new applications of the modular principle. By introducing pattern blocks and treating them as modules, the later bronze makers accomplished decisive advances. First, they embraced the stylistic tradition that had disentangled decoration from vessel shape. As a rule they did not fit decorative motifs into rectangular fields that conformed to sections in tectonic vessel designs. Rather, they usually let the decoration cover the body of a vessel in a continuum of repetitive modular units.

Discarding the interplay between decoration and vessel shape gave the artisans freedom. They could bend and trim the negative clay impressions taken from a pattern block and fit them into mold mantles for casting vessels of varying shapes and sizes. Thus they were able to select several distinct patterns for decorating one and the same vessel, but they could as easily adorn dissimilar vessels with the same pattern. A bowl of the *dui* type in the Freer Gallery, Washington, D.C., has one main register of interlace animal design running around the vessel, and a second, narrow register around the neck. The lid is undecorated except for three ducks sitting on top (Fig. 2.34).[47] A lidded *ding* tripod in the Musée Guimet in Paris has three feet instead of one circular foot, handles that spring from the top edge of the bowl instead of annular handles, and, on the vessel's lid, not only the ducks, but a ring and an additional register from which three crouched animals appear in high relief (Fig. 2.35).[48] In spite of the numerous differences between these two vessels, their main registers are completely identical, indicating that they may have been cast from mold impressions from the same pattern block.[49] The ducks on the two lids may have come from the same bivalve molds. This once more goes to show how parts of vessels and decorative units functioned as modules.

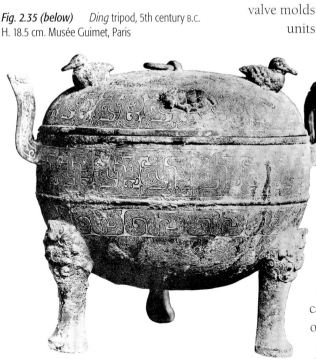

Fig. 2.34 (above) *Dui* lidded bowl, 5th century B.C. H. 15.5 cm, W. 16.2 cm, Weight 1.05 kg. The Freer Gallery of Art, Smithsonian Institution, Washington, D.C.

Fig. 2.35 (below) *Ding* tripod, 5th century B.C. H. 18.5 cm. Musée Guimet, Paris

Most important, the later bronze casters developed the potential for replication that is inherent in any module. They finally did what they had had the technology to do long before: they took more than one impression from the same piece of clay. When speculating about the reasons why the Shang-period casters did not do this, we mentioned the intricacy of technical problems as one possible obstacle. With pattern blocks, technical problems were far less complicated. Their small size, uniform dimensions, and flat shape must have encouraged the artisans to try making multiple impressions.

Those artisans paved the way for techniques of mechanical reproduction in large numbers, which boosted efficiency, speed, and production volume to unprecedented dimensions. The casters who duplicated decor sections mechanically with the help of pattern blocks finally exploited a potential for mass production that had existed since Shang times. It included manufacturing all but identical vessels. Today this would be called cloning.

After this excursion into the later centuries of the Bronze Age, the modular systems of Shang-period bronze makers must be addressed once more. The discussion so far has analyzed a decorative system of fields and a technical system of molds, but there is a third level: a system of sets of vessels.

Rarely are ritual bronzes singletons. Bronzes were cast, used, and buried in sets. Sets normally comprise vessels of different types, as well as several examples of each particular type. Yet the units that an owner assembled in a set were not necessarily produced together. Some may have been cast for him, some he may have inherited, and some may have been gifts. Therefore, rather than technically, sets should be defined functionally, as the total assemblage of all units required for a certain ritual occasion.

Although known in theory, these facts have not always been on the minds of students of Chinese bronzes. Because almost all pieces in Western and Japanese collections were acquired individually, they were also studied as such. Only after controlled excavations began in China were the limitations of this view realized. Focusing instead on the issue of sets has opened new perspectives concerning the technique of casting bronzes, on the function and history of the bronzes, and on the social status of their owners.[50]

In trying to study Shang bronze sets, however, one meets with difficulties. The evidence from excavations is not sufficient. As mentioned before, all but one of the royal tombs at Anyang were looted sometime before they were scientifically excavated. Hence, what would have been the most important evidence is irrevocably lost. Moreover, even if a tomb is found intact upon discovery, its contents are rarely published in their entirety and in enough detail to answer all questions about its sets of ritual vessels. This also applies to the only unlooted royal tomb at Anyang, that of Fu Hao. Some observations about the Lady's bronze sets are possible, nevertheless.[51]

Among the 210 ritual bronzes unearthed from Lady Hao's tomb are more than 20 different types, most of which are represented more than once. Several pairs of vessels are seen on the published floor plan (see Fig. 2.4), and many other groups were found. The largest assemblage of one type consists of 53 *gu* beakers. Figure 2.36 shows them drawn to scale.[52] The second-largest group consists of 40 *jue*—three-legged wine vessels with long, open spouts on one side and pointed projections on the other.[53]

The elegant silhouette of the *gu* beakers is made up of three distinct zones: an outward curving foot, a slender waist, and a trumpet-shaped upper part, with a gracefully flaring lip. The vessels bear inscribed dedications to three or

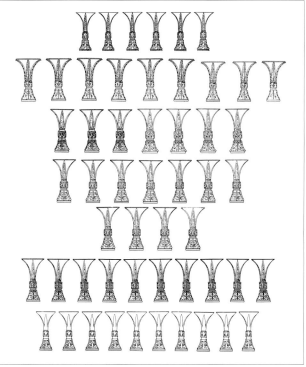

Fig. 2.36 Total complement of fifty-three *gu* beakers from the tomb of Lady Hao, ca. 1200 B.C.

Fig. 2.37 Eight *gu* beakers from the tomb of Lady Hao, ca. 1200 B.C. Beakers *a–d* (subgroup 5): H. from 28.2 to 28.5 cm; beakers *e–h* (subgroup 6): H. from 26 to 26.3 cm

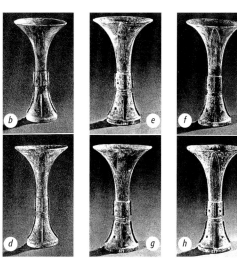

four different individuals, at least 22 of them to Lady Hao herself. Chinese archaeologists have divided the 53 beakers into six subgroups, which are distinguished by their inscriptions and variations in shape and proportions. The beakers from each subgroup look similar, but are not identical. Beakers *a* through *d* on the right in Figure 2.37 belong to subgroup 5. They are on average two centimeters higher and have slightly squatter proportions than the four beakers of subgroup 6 (*e* through *h*).

Vessels of one subtype bearing the same inscription were probably made together. The pieces are uniform in shape and size. Apparently the casters attempted and achieved a fair degree of standardization. When they produced a first, rough form of the model, they may have used tools such as jigs to shape the curved contour of the beakers into the clay, possibly on a potter's wheel.

When it came to decorative patterns, mechanical shaping ended and forming the clay by hand began. None of the decorative patterns were duplicated mechanically. A detailed study of other *gu* beakers from Anyang, which were taken to Taiwan by the Academia Sinica, has confirmed that no two *gu* were cast from the same set of molds.[54] Hence, even in the same subgroup, each vessel differs slightly from the others.[55] Each vessel is an individual. The phenomenon is comparable to the twenty-four character pairs *shijie* discussed in chapter 1: a great number of units, similar to one another but distinct in execution.[56]

Rules and conventions must have governed which types of vessels and how many units of each type were appropriate for a set. Certainly the composition of particular sets reflected the social position of the owner, his personal history and that of his family. The nature and importance of the ceremony may have determined the content of a set, too. However, the rules do not seem to have been rigid.[57]

Changes in the composition of sets over time indicate turns of events in ritual practice and in society in general, for which there may be no or little other historical or textual evidence. Most noticeable is a shift in the middle of the ninth century B.C., which is evident in the pieces belonging to Earl Xing of Wei in the hoard find of 103 vessels mentioned earlier (Fig. 2.38). Venerable, graceful wine-vessel types, such as *gu* and *jue*, have been all but

Fig. 2.38 Ritual vessels belonging to Earl Xing of Wei, mid-9th century B.C.

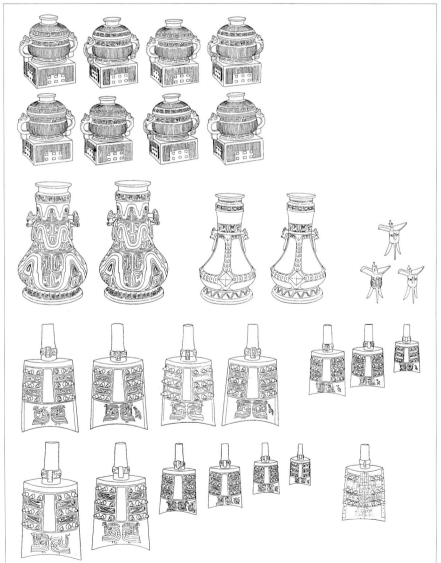

abandoned for large wine flasks of the *hu* type (only three little *jue* are left). New food vessels such as tureens of the *gui* type—round, two-handled basins on square pedestals—have come into use, as have bells.[58] The changes in the vessel repertoire are so dramatic that one insightful art historian has spoken of a "ritual revolution."[59]

Among the bells of the *zhong* type that the earl owned were fourteen pieces from four sets inscribed with his name. Bells are a most poignant case of ritual bronzes being made in sets. In all other parts of the world a bell or, at the most, a few bells are used to give signals. The Chinese, however, assembled many bells to create one composite musical instrument. Sets of bells could vary in numbers of units, but the sizes and, correspondingly, the pitch of each unit had to be calculated carefully. If it was done properly, harmony resulted.[60]

The self-conscious awareness that ritual bronzes were to be used in sets increased after the ritual revolution. Later sumptuary regulations prescribed how many ritual bronzes an aristocrat of a particular rank was entitled to own. The complicated rules changed with time and place, and the archaeological evidence from earlier centuries does not agree neatly with the later texts. Yet unvaryingly, all sets included an odd number of *ding* tripods, and the next lower even number of *gui* tureens.[61]

Nine tripods and eight tureens also formed the core group of the most extravagant set of ritual bronzes that has come to light so far. It was deposited after 433 B.C. in the tomb of a Marquis Yi of Zeng (Zeng hou Yi). The

Fig. 2.39 Ritual vessels from the tomb of Marquis Yi of Zeng, after 433 B.C.

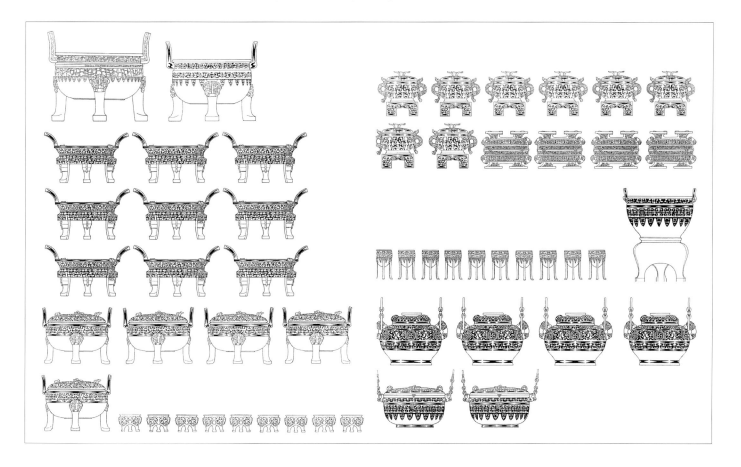

total weight amounted to more than ten metric tons, the largest quantity of bronze ever unearthed from a single Chinese tomb. The drawings in Figure 2.39 show the most important vessel groups.[62]

Not included in the drawing are the sixty-five bells that were hung in the ritual chamber of the tomb on a three-tiered wooden rack supported at its ends by bronze maidens (Fig. 2.40). This assemblage of bells was composed of seven or eight different chime sets together spanning five octaves. Its music must have been overwhelming.[63]

Division of Labor

The division of labor in bronze casting merits some final remarks. There are no contemporary written sources telling us how the work in Shang foundries was organized, yet, again, the bronzes themselves allow us to draw pertinent conclusions. Certainly it required an awesome operation to make these sophisticated products. It has been estimated that two to three hundred craftsmen were needed to produce an eight-hundred kilogram vessel such as the *Square Ding Dedicated to Mother Wu.*[64] Doubtless a still larger pool of laborers was required for mining and smelting the metal in the first place.[65]

Casting bronze the complicated way involved division of labor. One can envisage a spectrum that extends from a holistic production on the one hand to a subdivided production on the other.[66] An example of a purely holistic creation would be the carving of a figure out of a tree. This can be done by a single man in a linear sequence of steps. During each step he can still experiment spontaneously. The final shape of the sculpture cannot be foreseen, and even shortly before finishing, the maker can still introduce major changes or improvements. Michelangelo chiseling *David* out of a marble block is an example of a holistic process.

Chinese bronze casting is close to the opposite end of this spectrum. Here, the production is compartmentalized into single steps and units. These steps can also be viewed as modules—modules of work in a system of production. Most of them could be completed simultaneously and in great numbers, because the final shape of the product had been precisely determined before work began. While some workers prepared the bronze, others carved the molds, which must have been a particularly time-consuming stage in the production process. One craftsman may have been responsible for carving all the mold pieces required for one vessel, but if an entire set of vessels was cast, which was the normal case, many workers could simultaneously make the necessary molds. Chinese bronze vessels were the result of a coordinated effort of several specialists, each of whom was responsible for a standardized part of the process.

Standardization, coordination, and predictability are essential aspects in such a production system. Individual creativity, by contrast, is curtailed and only possible within a strict framework, because even small changes in one module may endanger the success of the entire process. No participant in this process can single-handedly change the shape of the

product or decisively influence its quality. Division of labor favors uniformity, albeit on a qualitatively high level. If somebody has been carving *taotie* faces for twenty years, his performance will not easily be surpassed by somebody who in the same time had to perform all kinds of other tasks as well. Here lies one of the reasons why Chinese craftsmen have always, and in all fields, reached and kept an amazingly high standard of quality.

Even in Neolithic times, the making of large quantities of ceramic vessels of varied shapes must have necessitated a certain division of labor. Over the centuries labor became ever more compartmentalized, as the production process was divided ever more minutely. The adoption of the pattern block technique allowed the complete separation of the carving of the decoration from mold making. This entailed reorganization of the workshop and encouraged efficiency of production.[67]

Division of labor was also the best way to produce great numbers of bronze vessels, and this was precisely what was required. To have religious and political life function properly, the Shang aristocracy may have needed in, say, the twelfth century B.C., sets of ritual bronzes totaling several thousand units. The bronze makers met the demand by devising modular systems. Modular products lend themselves to a division of labor. They are most smoothly and efficiently fabricated in a production system in which the work is compartmentalized.

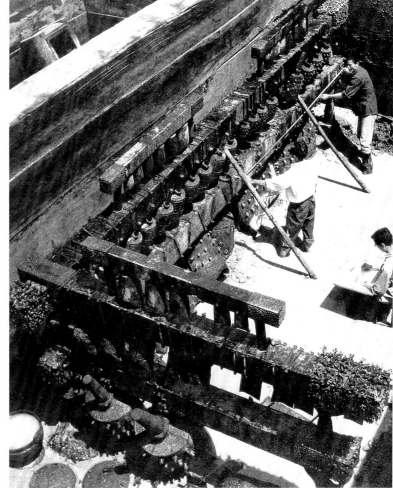

Fig. 2.40 Bells in the ritual chamber of the tomb of Marquis Yi of Zeng, after 433 B.C.

Another essential difference between a holistic and a subdivided production is that the latter requires strict control. Managing huge quantities of bronze, clay, and firewood involved logistical problems of great magnitude. No less demanding was the organization of the workforce. Control of each step in the production process and control of all participating workers must have been among the most difficult problems that had to be solved in manufacturing the bronze vessels. None of the specialists working in tandem could take overall responsibility. The metalworkers could not be expected to know how to prepare different kinds of clay. Yet there had to be people who could oversee and direct the entire production process.[68]

Thus, above the artisans there must have existed a group of coordinators. Shang bronze casting must have been an early instance of the dichotomy between the specialist, who executes the work, and the generalist, who controls the specialist from above and tells him what he must do. This dichotomy between specialist and generalist seems to be a leitmotif in Chinese social history down to the present. In our time, it is the communist cadre who takes the role of the generalist and tells the professional specialist what he has to do.

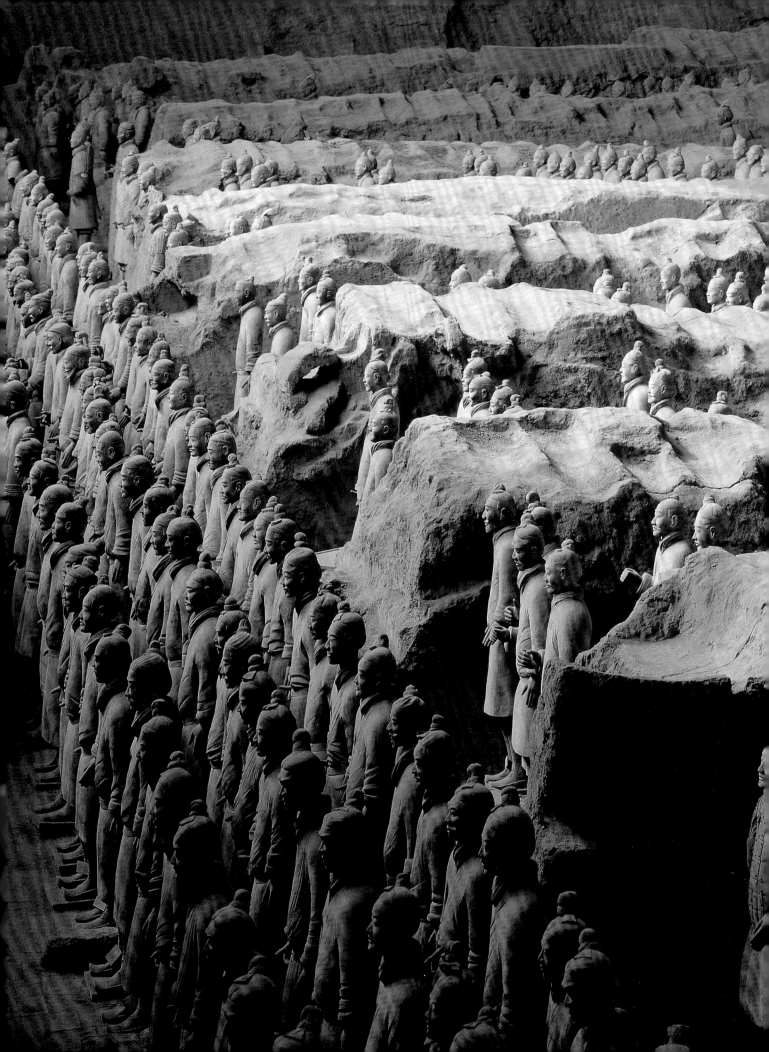

3 A Magic Army for the Emperor

Of the many sensational archaeological excavations made since the founding of the People's Republic of China in 1949, the most sensational of all was the discovery of the terra-cotta army near the tomb of China's First Emperor. The First Emperor was one of the most powerful men in Chinese history and, indeed, in world history. Originally the king of the state of Qin, he ruthlessly obliterated the other states of his day and unified the realm in 221 B.C., thereupon calling himself Qin Shihuangdi, the First August Emperor of Qin. The pattern of empire he established lasted for more than two millennia into the present century, and the name of his dynasty, Qin, is said to have given its name to China.

In March 1974, subterranean pits containing the emperor's terra-cotta army were discovered in Lintong County, Shaanxi Province, some thirty-five kilometers east of Xi'an, the provincial capital. The excavated figures have been restored and now stand in situ in their original battle formation (Figs. 3.1, 3.2).

Since the site opened to the public on October 1, 1979, a never-ending line of visitors have made their way there. Some two million arrive every year, of whom about 17 percent are foreigners. To accommodate this traffic an international airport was built, opening in 1991. Having come to light again, the

Opposite:
Fig. 3.1 The Magic Army, 221–210 B.C. Pit no. 1. Museum of the Terra-cotta Army for the First August Emperor of Qin, Lintong County, Shaanxi Province

Fig. 3.2 Columns of infantry soldiers

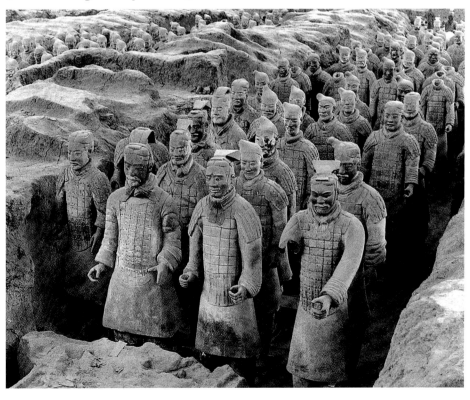

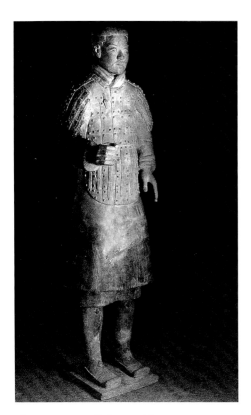

Fig. 3.3 Armored infantry soldier. Terra-cotta, H. 190 cm

Fig. 3.4 Charioteer. Terra-cotta, H. 190 cm

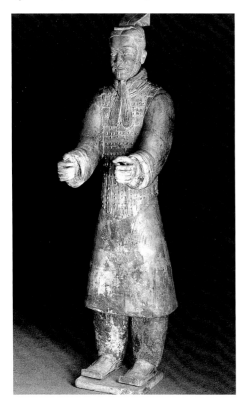

terra-cotta army has played a part in changing the economic fabric of Shaanxi Province.

Millions of visitors have also seen selected terra-cotta figures in exhibitions outside China. In 1976 two warriors and one horse were shown in Japan. For an exhibition originating in New York in 1980, eight figures came to the West for the first time.[1] Since then terra-cotta figures have traveled to one foreign country or another almost every year.

The most extraordinary fact about this archaeological find is a quite simple one: buried were not a few, or even a few dozen, lifelike soldiers but several thousand. About two thousand figures have been unearthed so far, and it is estimated that there are more than seven thousand altogether.

The figures are not only lifelike but life-size, of various types, including armored and unarmored infantrymen, standing and kneeling archers, cavalrymen with horses, charioteers, petty officers, and commanders. Armored infantrymen appear most often. Each held a spear or halberd in his right hand, and some possibly held a sword in their left hands (Fig. 3.3). The charioteers wear caps that indicate their rank as officers and extend both arms forward to grasp the reins (Fig. 3.4). The standing archers, with turned bodies, are dressed in simple and light uniforms that allowed for speed and maneuverability (Fig. 3.5). The kneeling archers wear waist-length suits of scaled armor that simulates leather; their arms are flexed for cradling the crossbow (Fig. 3.6). All details of the clothing, the armor, and the faces are modeled with great care, down to the stippled tread of the sole of the archer's sandal.[2]

The lifelike quality of these warriors must have been even more striking when they were still painted with their original colors, which indicated precisely the different parts of their dress. When these figures are unearthed, their colors are still visible. Upon excavation, however, most of the pigment adheres to the surrounding earth and not to the figures. Moreover, once exposed to air, the lacquer in which the pigments are embedded tends to crumble rapidly, reducing the colors to powder. Only traces last thereafter. Only recently has a method been found to stabilize the polychrome coating.[3] Because the problems of conservation remain unsolved, excavation work now proceeds at a slow pace.

The following discussion of this army, which the emperor commissioned for his tomb, will consider three questions: What was done? Why was it done? And how was it done?

What Was Done?

The Necropolis

The Grand Historian Sima Qian (born 145 B.C.) gives a detailed account of the tomb in his *Records of the Historian* (*Shiji*), which he completed in 91 B.C.[4] Work began as soon as the future emperor ascended the throne as king of Qin in 247 B.C., when he was thirteen years old. It is believed that the king, as was customary, put his chancellor in charge of designing the royal tomb

and supervising construction. This was Lü Buwei (died 235 B.C.), who had been a trusted adviser to the king's father.

In 237 B.C., Lü Buwei fell from grace, and Li Si (ca. 280–208 B.C.), one of the ablest men of his time, followed as chancellor. He was instrumental in implementing the unification of the empire and in forging its administrative structures. He is personally credited with creating the stately, tectonic Small Seal Script for the imperial steles that were set up to glorify the emperor's unification of the realm. As mentioned in chapter 1, these steles set a precedent for the millions of stone steles that followed in succeeding centuries (see Fig. 1.16). It seems that Li Si also took extraordinary measures to prepare a worthy tomb for his ruler. It was probably he who, in 231 B.C., turned the area around the tomb into a government district with its own administrative center, named Liyi (District of Li) after the nearby Mount Li. The people in this district were responsible for the construction and later for the maintenance of the imperial necropolis.[5]

After the king became emperor in 221 B.C., the design for his tomb seems to have been expanded to a much larger scale. As the series of military campaigns had come to an end, large numbers of conscripts became available, and more than seven hundred thousand men from all parts of the realm were recruited to build the emperor's palace and his tomb. Most of them were forced laborers, slaves, and prisoners, "men punished by castration or sentenced to penal servitude," in the words of the Grand Historian.[6] Work on the terra-cotta army probably started at this time.[7]

In 212 B.C., Li Si had thirty thousand families resettled to the district,[8] but when the emperor died two years later construction stopped at once, even though his tomb compound was not yet finished. The laborers at the palace also ceased work to join the men at the tomb. All seven hundred thousand of them heaped earth on it during the following year.[9]

Today a large tumulus still occupies the center of the compound.[10] This artificial hill has the shape of a truncated pyramid, with a base of approximately 350 meters. The original height is said to have been about 115 meters. Erosion has taken its toll and reduced the tumulus to its present height of 76 meters, or less. The exact location of the emperor's tomb was thus known throughout history, even after the walls and halls above ground had decayed, since nobody could overlook the tumulus. Figure 3.7 is a photograph made by the early French explorer Victor Segalen in 1914, in which the stepped profile of the tumulus is still clearly visible.[11]

Bushes and trees planted since adorn and protect the hill because Chinese archaeologists have decided not to excavate the tomb in our time. Knowing what wonders wait for them once they open the ground, they also know that they would be unable to preserve properly what they might find.

In a famous passage, Sima Qian tells us of the tomb's content:

As soon as the First Emperor became King of Qin, excavations and building had been started at Mount Li, while after he won the empire more than seven hundred thousand conscripts from all parts of the country worked there. They dug through three subterranean streams and poured molten copper for the outer coffin, and the

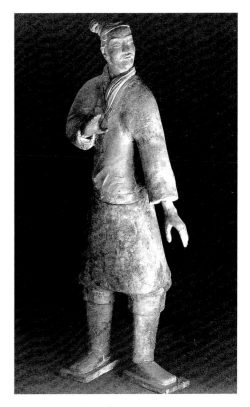

Fig. 3.5 Standing archer. Terra-cotta, H. 178 cm

Fig. 3.6 Kneeling archer. Terra-cotta, H. 122 cm

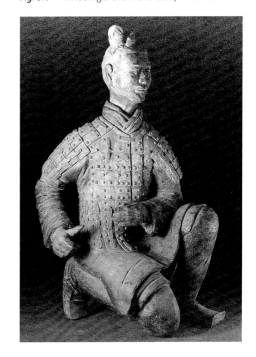

tomb was filled with models of palaces, pavilions and offices, as well as fine vessels, precious stones and rarities. Artisans were ordered to fix up crossbows so that any thief breaking in would be shot. All the country's streams, the Yellow River and the Yangzi were reproduced in quicksilver and by some mechanical means made to flow into a miniature ocean. The heavenly constellations were shown above and the regions of the earth below. The candles were made of whale oil to ensure their burning for the longest possible time.

The Second Emperor decreed, "It is not right to send away those of my father's ladies who had no sons." Accordingly all these were ordered to follow the First Emperor to the grave. After the interment someone pointed out that the artisans who had made the mechanical contrivances might disclose all the treasure that was in the tomb; therefore after the burial and sealing up of the treasures, the middle gate was shut and the outer gate closed to imprison all the artisans and laborers, so that not one came out. Trees and grass were planted over the mausoleum to make it seem like a hill.[12]

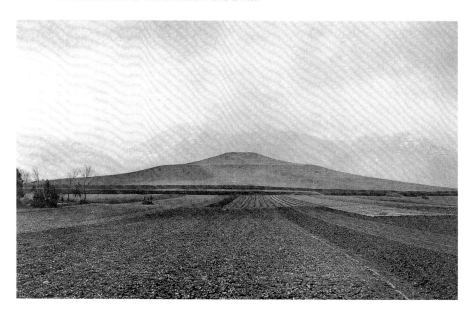

Fig. 3.7 Tumulus in the necropolis of the First Emperor (photograph made in 1914 by Victor Segalen)

The tomb thus contains a microcosm, an ideal model of the realm over which the emperor had ruled and intended to continue to rule after his death. Doubtless it will be difficult for any future excavator to preserve quicksilver streams and heavenly constellations. Indeed, the tomb may have been looted long ago. The Grand Historian talks about the destruction wrought upon the Qin empire and its capital Xianyang in 206 B.C. by General Xiang Yu: "Xiang Yu led his troops west, massacred the citizens of Xianyang, killed Ziying, the last king of Qin, who had surrendered, and set fire to the Qin palaces. The conflagration raged for three whole months. Having looted the city and seized the women there, he started east."[13]

General Xiang Yu is also said to have dug up the emperor's tomb.[14] At the same time he may have destroyed the underground pits housing the terra-cotta army. Excavations have revealed that they have been burned.

Above ground the rectangular layout of the imperial tomb resembled that of a palace with an outer and an inner wall (Fig. 3.8). Except in a very

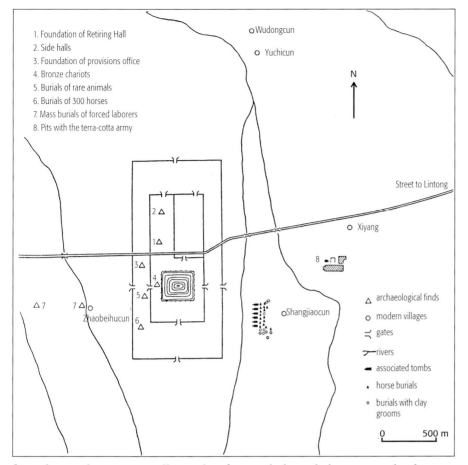

1. Foundation of Retiring Hall
2. Side halls
3. Foundation of provisions office
4. Bronze chariots
5. Burials of rare animals
6. Burials of 300 horses
7. Mass burials of forced laborers
8. Pits with the terra-cotta army

N

Wudongcun

Yuchicun

Street to Lintong

Xiyang

8

△ archaeological finds
o modern villages
⊐ gates
⌐ rivers
▬ associated tombs
▪ horse burials
o burials with clay
 grooms

Zhaobeihucun

Shangjiaocun

0 500 m

Fig. 3.8 Plan of the necropolis of the First Emperor

few places, these two walls made of pounded earth have completely vanished. The walls measured 8 meters in width, and they are believed to have had an original height of 8 to 10 meters. The inner wall was 1,355 meters long and 580 meters broad. The outer wall was 2,165 meters long and 940 meters broad. Watchtowers guarded the four corners, and gates opened at the four sides.

The compound contained buildings of many sorts, making it a necropolis, a city for the dead. Several foundations of mighty architectural structures have been located and excavated. About 53 meters north of the tumulus lay a large square hall, enclosed by a covered corridor 57 meters wide and 62 meters deep (no. 1 in Fig. 3.8). It was the retiring hall (*qindian*) and contained the emperor's garments, headgear, armrests, and walking staffs. Once every month these relics were taken in a procession to an Ancestor Temple of the Absolute (*jimiao*). After having received due sacrifices and veneration, the emperor's personal objects were carried back.[15] The Ancestor Temple of the Absolute was dedicated to the First Emperor only. It is believed that it was situated to the south of the necropolis and connected to it by a road.[16]

According to literary sources, in earlier times a retiring hall and a temple hall (*miao*) belonged to an ancestor-temple compound in the capital, where all the rulers of one lineage received sacrifices. Transferring the retiring hall to the necropolis and making it the ceremonial center there was a means to augment the importance of the ruler's posthumous presence.

North of the retiring hall, but still within the inner wall, foundations of more buildings have been identified (no. 2 in Fig. 3.8). These may have been side halls (*biandian*), where the visiting members of the imperial family put on mourning dress and prepared for making sacrifices.[17]

Apart from these special occasions, routine sacrifices of food and drink were made three or four times a day. These and other activities were administered by an office organized like the imperial household agency at the capital. Cooks prepared the sacrificial food. At the west side of the necropolis, between the inner and outer walls, the remains of three buildings have been located, and inscriptions on ceramic shards found there identify them as the provisions office (*siguan*; no. 3 in Fig. 3.8). Ceramic drainage channels, stone pillar bases, iron tools, and objects of daily use have been found here.[18]

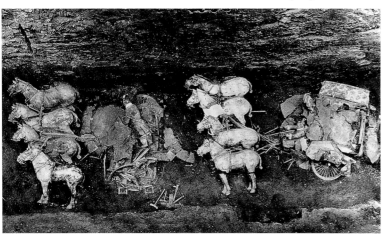

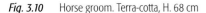

Fig. 3.9 Bronze chariots in situ

About 20 meters west of the tumulus and 7.8 meters below ground, two bronze chariots, each drawn by four bronze horses, have been unearthed (Fig. 3.9; no. 4 in Fig. 3.8). They had been waiting there for the Imperial Lord who, at some point in time, may have wanted to leave through the nearby gate and be driven around. Large quantities of hay were deposited for the horses. Although the chariots were badly damaged by earth that had fallen into the pit, it has been possible to restore them to their original splendor. They are about half the size of real chariots. The exquisitely made models exemplify the techniques of chariot building and horse harnessing in great detail. One of the chariots consists of 3,462 individual parts.[19]

Beyond and slightly to the south of the western gate of the inner wall, burials of thirty-one rare birds and animals in clay coffins lay in rows (no. 5 in Fig. 3.8). In addition to the skeletons, the coffins contained clay dishes for food and collars attached to the animals. Clay wardens guarded them.[20] In life, the precious animals probably inhabited an imperial pleasure garden or the animal enclosures in the Supreme Forest (*shanglin*), the extravagant hunting park where the emperor kept rare specimens of flora and fauna from all over the world.[21]

Fig. 3.10 Horse groom. Terra-cotta, H. 68 cm

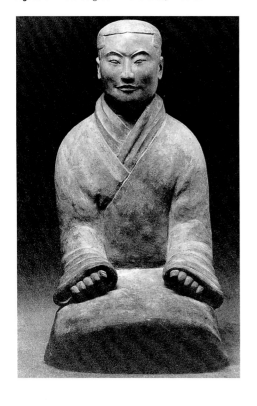

An area about fifteen hundred meters long and fifty meters wide, to the east of the outer wall near the present village of Shangjiaocun, holds three hundred to four hundred pits, close to one hundred of which have been surveyed. Each pit either contains the skeleton of a horse or the life-size terra-cotta figure of a kneeling groom, or both (Fig. 3.10). The grooms are of exquisite quality and resemble the figures of the army. The horses lie facing the center of the tomb. Most of them seem to have been buried alive. Some of the horses, however, have slashed limbs, indicating that they were first slaughtered before they were placed in wooden coffins. Inscriptions on ceramic shards prove that the animals came from palace stables.[22]

Test excavations in the southwestern corner of the necropolis revealed an L-shaped pit, more than one hundred meters long and nine meters wide. Another some three hundred skeletons of horses were stacked in it

and accompanied by terra-cotta grooms (no. 6 in Fig. 3.8). This pit must also represent one of the imperial stables.

Human skeletons have also been found in the necropolis of the First Emperor. A few meters to the west of the pits with horses and clay grooms near Shangjiaocun, a row of seventeen pit tombs with ramps and wooden coffins has been located, each of which bears the remains of one person, either male or female. Objects of gold, silver, jade, and lacquer and fragments of silk indicate their high social rank. It seems that they had all been put to death and their limbs severed.[23] It is not clear yet whether these people asked to follow their lord to the grave, whether they were sacrificed in religious rituals, or whether they were the victims of political intrigue. The Grand Historian tells us that the son of the First Emperor, after he usurped the throne, ordered the executions of numerous princes and princesses as well as ministers loyal to his father. Others were pressured into asking to be allowed to follow their former lord in death and to be given a resting place in his tomb "at the foot of Mount Li."[24]

More than one hundred human skeletons lie in mass burials about 1.5 kilometers west of the tumulus near the village of Zhaobeihucun (Fig. 3.11; no. 7 in Fig. 3.8). Except for three women and two children, most of them were men aged between twenty and thirty. They were workers at the necropolis who may have been sentenced to death. At least twenty-six men were accompanied by small individual clay tablets with a written record. Eight of them show stamped-seal impressions of the government office to which the dead workers had belonged. The other eighteen shards have short inscriptions noting each man's name and his native place. Ten men were forced laborers working off debts (*juzi*). Sometimes their rank, which had an influence on their sentence, is specified. The inscription shown in Figure 3.12 identifies a man who came from a faraway village in present Shandong Province. It reads: "Forced laborer Sui, rank *bugeng*, from Dongjian Village, Dongwu City."[25] *Bugeng* was stage four in an ascending series of twenty ranks.[26] Hence laborer Sui was a petty officer, probably working off the redemption of a punishment. These are the earliest tomb inscriptions found in China so far and reflect the bureaucratic control over the workforce.

The Army in Its Pits

The most spectacular burial outside the tomb proper is, of course, the terracotta army (no. 8 in Fig. 3.8).[27] The Grand Historian does not mention it, nor does any other historical source. Its discovery in 1974 came as a complete surprise. There is a cluster of four separate pits 1,225 meters east of the outer wall. Pit no. 1, which is 230 meters long and 62 meters wide, contains the main army in battle formation with more than 6,000 figures of warriors and horses. Pit no. 2, with various cavalry and infantry units as well as war chariots, has been explained as representing a military guard. The small pit no. 3 is the command post, with high-ranking officers and subordinates and a war chariot drawn by four horses. Several of the figures lack heads, which are believed to have been stolen by grave robbers as early as the Qin or the Han period.[28] Pit no. 4 did not contain any figures and was probably left

Fig. 3.11 Mass graves

Fig. 3.12 Burial inscription on clay shard, ca. 19 × ca. 14 cm

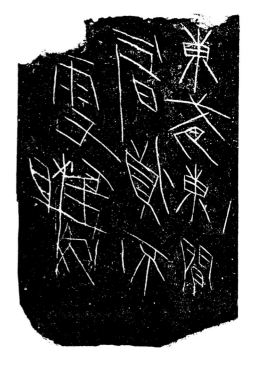

Fig. 3.13 Plan of the four pits

Fig. 3.14 Ground plan (*top*) and cross section (*bottom*) of pit no. 1

unfinished by its builders. Together, the four pits seem to represent a complete garrison: pit no. 1, the right army; pit no. 2, the left army; pit no. 4, the middle army; with the headquarters in pit. no. 3 (Fig. 3.13).[29]

The pits' architectural structures were devised for solidity and permanence (Fig. 3.14). The outer walls and the walls between the eleven parallel corridors in pit no. 1 consist of pounded earth. The earthen walls were originally held in place by wooden frames that also supported the roof beams. The roof, in turn, carried a layer of reddish mortar and a layer of earth three meters thick. The floor was also made of pounded earth as hard as cement, and altogether covered by some 256,000 tiles. It has been calculated that about 126,940 cubic meters of earth were moved to excavate the pits, and that 8,000 cubic meters of timber were needed.[30]

The solid wooden construction must have been finished before the figures were put into place; otherwise their installation would have been too dangerous. At the front side of the pit, ramps have been identified down

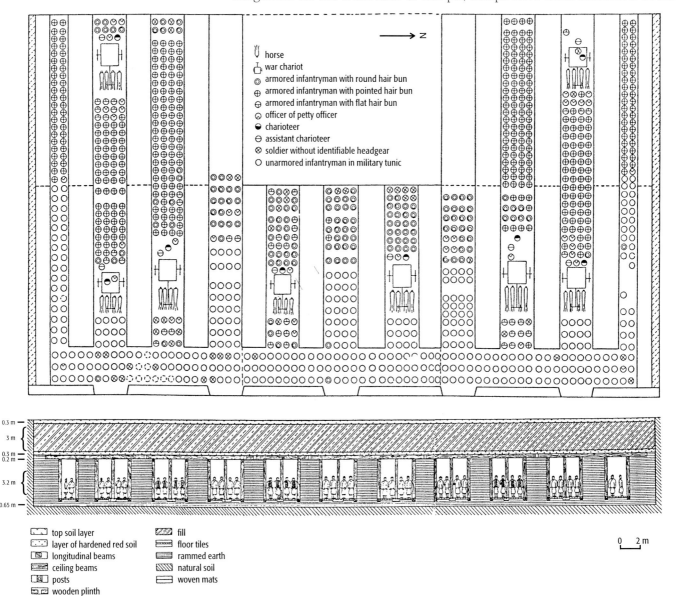

ꭹ horse
⌓ war chariot
◎ armored infantryman with round hair bun
⊕ armored infantryman with pointed hair bun
⊕ armored infantryman with flat hair bun
⊘ officer of petty officer
◖ charioteer
⊖ assistant charioteer
⊗ soldier without identifiable headgear
○ unarmored infantryman in military tunic

top soil layer
layer of hardened red soil
longitudinal beams
ceiling beams
posts
wooden plinth

fill
floor tiles
rammed earth
natural soil
woven mats

which the figures were hauled into the long, probably torch-lit corridors. This prompts an intriguing thought: nobody, not even the First Emperor, ever saw the terra-cotta army in its entirety. The breathtaking view of the now world-famous columns of soldiers only became possible after excavation in 1974 (see Fig. 3.1). Obviously, the army did not need to be seen to serve its purpose. It was enough that it was there, like inner organs concealed in a human body.

Beams and tiles provide clues for dating the terra-cotta army. The Grand Historian mentions that timber for the emperor's palace and his tomb was shipped from the region of present-day Sichuan and from the state of Chu.[31] The sturdy pine wood in the subterranean pits is believed to have come from these southern parts of the empire, and this probably happened only after unification, when the emperor had the finest material from all parts of the country at his disposal. Chu was subjugated only in 223 B.C.

Stamped characters in many of the floor tiles identify their makers. The character meaning "metropolitan" (*du*) is an abbreviation for "Metropolitan Boats" (*duchuan*), a factory under the commander of the capital (*zhongwei*). The character for "palace" (*gong*) is an abbreviation for "Palace Water" (*gongshui*), a factory that was part of the imperial manufactures (*shaofu*) and responsible for all kinds of waterworks. Both factories seem to have made tiles only after the unification.[32]

Of the mighty timber construction only traces of ash remain. As mentioned, it is believed that general Xiang Yu, when looting the First Emperor's capital Xianyang in 206 B.C., also set his necropolis on fire. The burning beams collapsed and subsequently the earth slid down and smashed all the terra-cotta figures. None has come to light intact.

The army in pit no. 1 was set within the corridors in rows of four soldiers, many of them clad in heavy armor, all modeled in clay. In six of the corridors, wooden war chariots, each drawn by four terra-cotta horses, are spaced in regular intervals among the infantry. The army is facing east. Three rows of warriors form the vanguard, two rows protect the army at its sides, facing north and south respectively, and a rear guard of three rows faces backward.

The movements of this awesome fighting machine would have been controlled by audible signals from drums and bells, which have been found at the site. When the drum sounded once, the magic army moved forward, on the second drum roll, it attacked. On the sound of the bell, the troop stopped, and when the bell rang again, it retreated.[33]

The figures were kiln fired between 900 and 1050 degrees centigrade.[34] At this relatively low temperature, the unglazed clay remains porous and is called "terra-cotta," literally baked earth. Although several kilns for making tiles and other utensils have been explored in the area of the necropolis, no kiln for firing the figures has yet been excavated.[35] About two hundred meters to the southeast of pit no. 1, fragments of terra-cotta figures indicate a kiln site that is estimated to have been large enough for firing two horses or six warrior figures at a time.[36]

After firing, painters applied a lacquer coating colored by brilliant pigments. Lacquer is a natural resin obtained in small quantities by preparing

the sap acquired by tapping various lacquer trees (*Toxicodendron vernici-flua*).[37] The trees grow in tropical and subtropical areas, and were native to southern China. As lacquer is highly resistant to water, heat, and acids, it is well suited for protecting objects and is also amenable to surface decoration. Carefully made war gear from many areas in East Asia often bore a lacquer coating to protect it from rot and rust. Chinese examples from the centuries preceding the unification of the empire include armor made principally of lacquered leather.[38] Most of the armor molded on the terra-cotta soldiers represents leather armor. With their lacquer coating, the terra-cotta figures became more durable and seemed even more "real." [39]

To completely coat thousands of large clay figures in lacquer is an astounding achievement in itself, but certainly not beyond the imagination of an emperor, whose son once considered lacquering all the city walls of his capital.[40] In some areas of the figures, such as the faces, two separate coatings were applied. The mineral pigments were also mixed with lacquer and painted with a brush on top of the coating. The geometric patterns are very intricate, like those of the textiles of the period.[41]

The terra-cotta figures carried real weapons, such as spears, halberds, dagger axes, swords, crossbows, and arrows. Almost five hundred weapons and more than ten thousand scattered arrowheads have been found in pit no. 1. Save for four iron pieces, all weapons were cast of bronze. Some of the blades are still razor sharp.[42]

Fig. 3.15 Lock of a crossbow from pit no. 1. Bronze, H. 16.2 cm, W. 3.6 cm, L. 8 cm

The lock mechanism of the crossbows is ingeniously devised (Fig. 3.15). After the archer discharged his arrow he brought the lock back into the original position by quickly jerking the bow backward. The four mechanical parts are cast with such precision that they fit together perfectly. The tolerance for error lies within fractions of a millimeter. It was this precision that helped the Qin state overpower the rival feudal states.

Yet precision alone was not enough. It had to be matched by the ability to produce large quantities of weapons. The Qin could do this, too. Indeed, their weapons industry was another early example of mass production in China. It is known from inscriptions on the weapons that many came from state factories capable of churning out huge numbers of technically perfect products (Fig. 3.16).[43]

Mass production of weapons started in Qin long before the time of the First Emperor. Inscriptions began to appear in the middle of the fourth century B.C., the law decreeing that each weapon had to be inscribed.[44] For more than a century these inscriptions identified the chancellor as supervisor of weapons production, testimony to the importance attached to the weapons industry. The weapons carried by the terra-cotta army date from the early years of the king's reign to 228 B.C. As later weapons have yet to be found, they may all have been used by real warriors before being entrusted to the hands of the clay soldiers (Fig. 3.17).

Fig. 3.16 Inscriptions on blades borne by the terra-cotta warriors

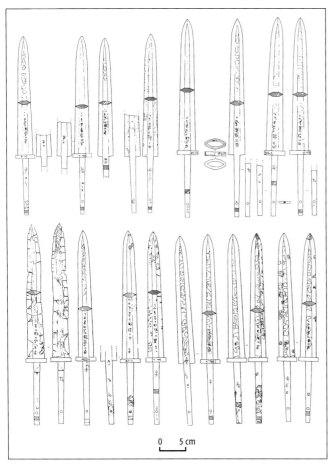

0 5 cm

As late as 239 B.C., the chancellor was still named as the supervisor, but at this date the names of individuals from lower ranks in the production hierarchy began to appear on the weapons as well. The inscription on one such blade reads: "17th year [230 B.C.]. Government Workshops, produced by master Yu, worker Diao." The characters for "Government Workshop" (*sigong*) occur once more on the other side of the blade and on the guard as well. Engraved on the shaft is the serial number: "Series *zi*, five-nine."[45]

The Government Workshops produced not only weapons but also carriages and utensils for everyday use. Their products are among the first in China on which an individual inscribed his name. It would certainly be naive to try to detect budding individualism here, nor do the names indicate any personal pride on the part of the maker. These inscriptions had only one purpose: quality control.[46]

This visit to the First Emperor's necropolis has shown that it was laid out like the palace of a living emperor, with the private quarters under the tumulus and a main hall above with various palace offices, a pleasure garden, horse stables and carriages, tombs of family members and loyal retainers, and with a mighty army, ready to attack any intruder.

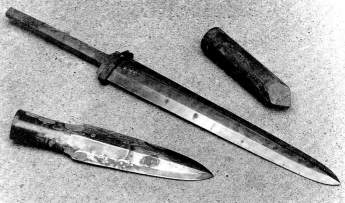

Fig. 3.17 Three bronze weapons from pit no. 1: (*front*) W. 3.7 cm, L. 17.5 cm; (*middle*) W. ca. 3.1 cm, L. 35.3 cm; (*top*) L. 10.6 cm, Diam. 2.5 cm, W. of wall 0.2 cm

Why Was It Done?

This question calls for another, closer look at the historical situation. Unification of the empire doubtless was the single most outstanding event of the period, if not of Chinese history.[47] Many other efforts preceded, accompanied, legitimized, and glorified this event. Building the imperial tomb was one of them. This political context explains the grand scale of the project and the unusual efforts lavished on the terra-cotta army. Moreover, and more specifically, the builders of the necropolis were continuing a time-honored tradition of royal tomb building. The First Emperor or his chancellors may have wished to reinforce this tradition, or to give it a new direction, but they could not abandon it, and did not want to do so. Two separate sets of factors thus determined the design of the necropolis, the historical situation and a tradition of furnishing rulers' tombs.

Standardizing Society

Of all the emperors that ever considered themselves to be the mightiest man in the world at a particular time in history, the First August Emperor of Qin was perhaps the only one who was right. His power was rivaled but not matched by the ruler of the Maurya dynasty in India—which was just past its prime under Emperor Ashoka (about 274–232 B.C.)—and perhaps by the nascent Roman Empire. The Romans, however, had yet to face the battle at Cannae in 216 B.C., a severe setback on their way to achieving eventual supremacy over the Mediterranean Sea. When the king of Qin unified China in

221 B.C., he could hardly have had any knowledge of those empires in other parts of the ancient world. Yet he brought under his control all the civilized world known to him, and thereby—unknown to him—created the mightiest empire on the globe, the largest in both area and population.

During the Period of the Spring and Autumn Annals (*Chunqiu*; 722–481 B.C.), the area of China, although in name still under the control of the rulers of the Zhou dynasty, was split up into rivaling feudal states engaged in constant warfare. Indeed, the following period (453–221 B.C.) is called the Period of the Warring States (*Zhanguo*). The Qin established their power base in the eighth century B.C. in what had been the original heartland of the Western Zhou. This allowed them to view themselves as the Zhou's legitimate heirs. The First Emperor even claimed to succeed the Yellow Emperor and other mythical rulers of remote antiquity. In the middle of the fourth century, the feudal state of Qin was still rather small, but then it expanded forcefully in all directions. Only seven states were left when the First Emperor became king of the Qin state in 247 B.C. The young king soon pursued a policy of the iron fist. In 230 B.C. he embarked on a decade-long series of military campaigns, conquering the remaining feudal states one after the other. Within two years after his principal rival, the culturally superior southern state of Chu, succumbed in 223 B.C., Yan and Qi, the last northern states, had also fallen.

Many factors came together to allow for Qin's success. Among the technological advances made during the previous centuries, smelting, forging, and casting iron had developed apace. (In the West, iron was not cast until the fourteenth century A.D.) Farmers began to use iron ploughs, which allowed them to break the earth deeper and faster, thereby boosting agricultural production. Blades for spades and hammers were also fabricated of iron.[48]

Metal technology was equally vital for producing weapons, the very tools by which the Qin destroyed their neighbors. Crossbows and other deadly weapons in the hands of the terra-cotta soldiers show how successful the Qin were in this domain. Yet other feudal states had made advances in iron and weapon technology as well. The crossbow was actually invented in Chu, and the swords of the states of Wu and Yue in the lower Yangzi region were praised throughout the realm for their supreme quality. Qin, however, surpassed all other states when it came to organizing masses of people and coordinating their efforts toward ambitious goals, in the civil as well as the military sphere.

In the civil sphere, law and order were Qin's major values. Households were organized in units of five and ten and were held jointly responsible for misdoings committed by any member. A law code promised draconian punishments but also equal justice to everyone. The code, fragments of which archaeologists have discovered written on bamboo slips, has been ranked among the most influential legal systems in world history.[49]

The Qin administrators knew how to foster efficiency through standardization. They developed commerce by regulating weights and measures and the axle lengths of carts; they forged a monetary union by standardizing coins; and, as seen in chapter 1, they created a uniform system of script.

Extensive building activity also testified to the Qin's capability in successfully organizing huge labor forces. After ascending the throne, the First Emperor embarked on a number of large construction projects that served to consolidate political, commercial, and cultural unity, and to glorify his achievements. He connected existing portions of walls built by some feudal states thereby anticipating in effect what has become the most famous of all Chinese monuments: the Great Wall. A network of highways radiating from the capital of Xianyang linked together faraway places in the new empire. One such road that has been archaeologically identified led from Xianyang straight north over a distance of eight hundred kilometers into present-day Inner Mongolia. Canals were renovated and newly dug, completing a system of waterways from the Yellow River in the north to the Huai River in the south. The emperor had a giant palace, called Apanggong, built for himself, which, although destroyed soon after construction, has been remembered since as the epitome of ostentatious architecture. Last, but not least, the emperor could look forward to moving into the greatest necropolis China had seen to date.

The Qin were also more successful (and probably more ruthless) than their competitors in forging efficient military organizations. They pushed to the limits a process that changed warfare fundamentally: the deployment of mass infantry. This momentous development has its parallels in the West. In his epic poems of the eighth century B.C., Homer extols the virtues of the aristocratic warrior whose strength, skill, and courage decide the outcome of the battle. Achilles slaying Hector with his spear and then dragging the corpse behind his chariot through the dust is one of the most memorable scenes from the dawn of European history.

In the fifth century, however, the Greeks prevailed over the Persians thanks to their development of the phalanx, which was composed of infantry citizen-soldiers trained to act together.[50] Large bodies of infantry, in addition to cavalry, also formed the core of Alexander's fighting forces when he set out to win the Orient in the fourth century B.C. With their infantry legions, the Romans conquered the Mediterranean world. The flexible, disciplined, and obedient cohorts of anonymous mercenaries marching under a unifying command proved invincible.

In China, infantry existed as early as the Shang period. Oracle bone inscriptions mention forces of up to 13,000 men.[51] Fighters on horse-drawn chariots accompanied the foot soldiers and directed their movements. The precious chariots were status symbols to the aristocrats and consequently they were buried next to their owners' tombs (Fig. 3.18). After the Shang, this type of warfare continued and the number of chariots increased. The state of Jin mustered 700 of them in a battle of 632 B.C.[52] It has been estimated that an army with chariot warriors would not have far exceeded 10,000 men in the seventh century, and that it may have reached a maximum of about 50,000 men in the sixth century.

Then, after the mid-sixth century B.C., the size of armies increased dramatically and they consisted mostly of infantry formations. In the Period

Fig. 3.18 Burial of horse-drawn chariot, Shang period, Xiaomintun

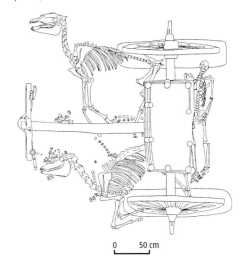

0 50 cm

of the Warring States, infantry armies could deploy several hundred thousand men in the field, because soldiers were now recruited from lower social levels, especially from the rural population and from larger territories.[53]

Conscripted men in those armies could not possibly possess the martial skills that the aristocratic fighter acquired through years of training and constant testing in hunts. Nor could the lower-class warriors boast expensive equipment such as a technically sophisticated chariots, custom-made armor, and ornamented weapons. Nevertheless, the infantry armies won out through sheer mass, standardization, organization, and discipline.

These soldiers' uniforms were not fancy but they were efficient. The same can be said for the standardized, mass-produced weapons. An army was organized into a composite body of units, each with its different weapons and tasks: vanguard and rear guard, hand-to-hand fighters, crossbow archers, spearmen, and swordsmen fought simultaneously in a force marked by its "division of labor." Single fighters and groups of fighters became interchangeable, modular units.

Discipline and absolute obedience were the supreme virtues of the soldier. Outstanding individual courage and unchecked bravery were not called for. One story tells of a bellicose soldier who, before battle began, charged over to the enemy lines and returned after having killed two of the foe. His commander had him executed on the spot for disobedience.[54]

The commander directed all movements and actions of the mass army. He took all the credit for victory, and all the blame for defeat. His authority was absolute, mirroring that of the ruler of the state. The commander's standing was based, in part, on his knowledge of military treatises. He was a master of texts and did not even need to excel as a fighter himself. Above all he was an integrator of men and an organizer.[55] His role, in some respects, resembled that of a manager or even a bureaucrat.

The shift from warrior elite to mass army occurred in all the feudal states in China, but most radically in Qin. Qin forged a social order in which civil administration and military structures converged. The rise of an individual in a system of aristocratic ranks, the amount of land allotted to him by the state, or his salary as an official depended on the number of enemies he had killed as a soldier.[56] The organization of the civilian population into units of five for mutual surveillance and liability also applied to the military sphere. Members of one unit were held mutually responsible for one another's performance in battle.[57]

Seen in this context, the terra-cotta army is a monument glorifying Qin's superiority in military organization. At the same time, this advanced war machine, which proved so irresistible to its neighbors, is a model of Qin society itself.

None of this, however, yet explains why the figures were buried underground, and why they were made of terra-cotta. As far as we know, this was the first terra-cotta army. To appreciate what that meant, one must take a look at the tradition of burials installed alongside and around Chinese royal tombs.

Fitting out Burials for Rulers

From the earliest dynasties down to the mausoleum for Mao Zedong built in 1976, tombs for their rulers have been a major concern of the Chinese. The Han dynasty rulers, for example, are said to have spent one third of the state revenue on imperial tombs.[58] As seen in the preceding chapter, the Shang constructed gigantic tombs, and their belief in an afterlife necessitated the burial of dozens of humans and horses with the lord of the tomb. The Zhou continued this practice, and the number of horses and humans interred increased with time. The pits around a sixth-century B.C. tomb in the capital of the northern state Qi in present Shandong Province have a combined length of 215 meters. They contained the skeletons of probably more than 600 horses, 228 of which have been excavated.[59]

The early rulers of the Qin State, like their rivals in other parts of China, indulged in the construction of large tombs. Thirteen tombs have been found in a cemetery in Fengxiang County near the ancient city of Yong, the capital of the Qin State from 677 to 384 B.C. Tomb no. 1, which is believed to

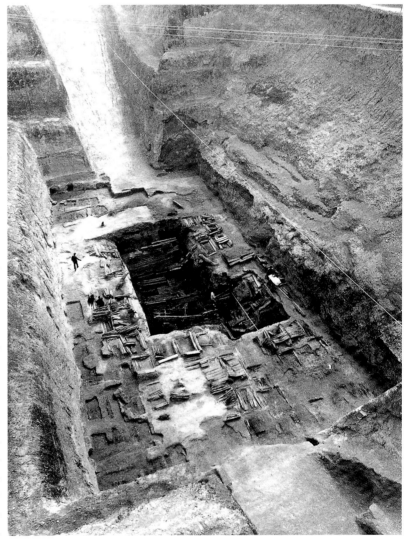

Fig. 3.19 Tomb of Duke Jing of Qin (577–537 B.C.)

belong to Duke Jing (577–537 B.C.), is the largest tomb in pre-imperial China known so far (Fig. 3.19). The pit of this gigantic structure, including the ramps, is 287 meters long. Skeletons of 166 men and women buried together with the duke have been identified. Another 20 skeletons were found in the earth used to fill the pit. The excavators had to dig 24 meters down to reach the bottom, after which they were so exhausted that they were not able to publish a report.[60]

By this time a trend was under way in China that eventually led to fundamental changes in tomb contents and methods of construction. Ultimately, the very concept of what a tomb should be began to change. Vessels made specially for burial replaced bronze vessels that had actually been used in ritual, and objects of lesser quality or cheap copies in clay became acceptable as burial items. These substitutes were called spirit utensils (*mingqi*). The first such items occur in the late Shang dynasty, and their numbers increase after the eighth century.[61]

Similarly, real humans and horses were sometimes replaced by figures of humans and horses. Early examples made of ceramic or wood occur in the sixth century B.C., and the custom gained acceptance during the Period of the Warring States.[62] The largest numbers of tomb figures that have been preserved are made of wood and

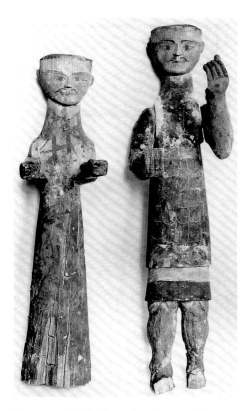

Fig. 3.20 Wooden figures from the state of Chu, 4th century B.C.

found in burials in the state of Chu. Figure 3.20 shows two examples from Changsha, Hunan Province, excavated in 1936–37.[63]

These changes in the character of the objects that went into a tomb were followed by changes in tomb construction. Early tombs constitute a building type in its own right that had little in common with above-ground architecture. They are basically pits, the larger and deeper ones being accessible by ramps. In the Period of the Warring States, however, tombs began to acquire features of dwellings used by the living. By the Han dynasty a distinct tomb architecture existed, making use of bricks and hollow tiles and featuring doorways, a chambered layout, and vaults.[64]

An early example of a chambered tomb is that of Marquis Yi of Zeng (after 433 B.C.). Found intact and excavated in 1977–78, it yielded fifteen thousand artifacts, including as mentioned earlier, an enormous quantity of bronzes (see Figs. 2.39, 2.40). The tomb has four chambers built of wooden logs and connected through small doors. Each chamber has a different content and function. The central chamber with the famous set of sixty-five bells and ritual vessels is modeled on a royal ceremonial hall. Then there is an armory with various weapons and chariot trappings, a harem with the coffins of thirteen female attendants, and the private or retiring quarters of the lord of the tomb, containing the coffins of the marquis himself and of eight more of his female companions in death. Painted on the lord's inner coffin were two doors and a window.[65]

As tombs began to resemble dwellings of the living, they also came to contain more utensils of daily use, such as dishes. In addition, miniature models, usually made of clay, substituted for actual items that the buried person had needed or cherished in life, including stoves, granaries, and animals.

A shared pattern of thought is evident in burying effigies instead of living beings, clay copies instead of bronze vessels, and in laying out a tomb like a house. All this turns a tomb into a replica, a model of reality. The tomb represents, idealizes, and perpetuates the reality of life on earth. By making ideal versions of the world, the tomb designers of the first millenium B.C. created the first paradises in Chinese art.

At the time of the First Emperor, the shift in the function of the tomb was not yet complete. His necropolis represented his palace, and the main chamber under the tumulus contained a replica of the universe. Pits represented imperial stables, with models of imperial chariots and an army in replica. Yet not everything was a substitute: the pit stables contained the skeletons of real horses and real nobles and forced laborers were buried in the necropolis.[66]

Apparently, man-made replicas were not seen as being less effective than real things or living beings, nor did material or size matter. Terra-cotta grooms guarded the burials of real birds and horses. Half-size bronze chariots and bronze horses were as useful as life-size clay soldiers with real weapons and clay horses drawing wooden chariots. All served their emperor equally. Why then did the builders of the necropolis choose terra-cotta figures for the army instead of real soldiers?

Pragmatic considerations may well have influenced this decision. Rationalists surely pointed out that dead men and horses, chariots, bronze utensils, and weapons buried underground simply could not be used anymore, and that burying them was wasteful rather than pious. Humanitarian feelings probably also came into play. The great humanist Confucius (551–479 B.C.) lamented the practice of burying people and professed ignorance about the workings of the netherworld.

Yet the Qin rulers had traditionally liked large companies in their graves: 166 human skeletons were in the tomb of Duke Jing, and 177 persons accompanied in death Duke Mu (659–621 B.C.).[67] Human sacrifice was widely practiced in the Warring States Period, and although a king of Qin attempted to ban the practice in 383 B.C., princes and workers were still slaughtered at the First Emperor's necropolis.[68] As the Grand Historian and others tell us, the First Emperor was a cruel megalomaniac, ordering all artisans and laborers to be imprisoned in his grave and buried alive after they had finished their jobs.[69] Had he been convinced that this was the best way to protect himself in his tomb, he might conceivably have sacrificed seven thousand men.

There must have been other reasons why the emperor preferred figures to real soldiers, and why they were not made of wood but of clay, which may never have been used before for life-size sculptures. As no written sources are extant, one must deduce these reasons by examining the army itself and asking what its makers set out to achieve. Apparently they pursued three goals: the army had to be durable, it had to be finished within a reasonable time, and it had to look "real."

The emperor was obsessed with immortality. Unlike his palace in life, his posthumous residence was to last eternally. What he needed, therefore, was everlasting protection. He and his advisers may already have been sufficiently accomplished archaeologists to know that human bodies decay fast, even in sturdy tombs. Certainly, figures made of clay would be more durable than humans of flesh and blood, and also more durable than wooden figures. Subsequent history has proven this reasoning right. The army is still extant—at least so far. The clay figures were smashed but did not burn during the conflagration of the necropolis. Nor did they decay in the water that seeped into their subterranean hideout. Only after men who no longer believed in the figures' magic power began to unearth them did their final, perhaps irrevocable, decay begin.

The workers also met their deadline—almost. Although the emperor fervently tried to acquire the elixir of immortality in his lifetime, the makers of his army did not take any chances. Working on a tight schedule, they filled three of the four pits in the subterranean garrison with figures, which shows that they had given themselves only a few years to complete everything. Clay was the most expedient material to do this.

Clay is found in loess, and large areas of China's northern plains are covered with layers of loess, three hundred meters deep in some places. Where loess has been washed by water in the course of the millennia it may become enriched with clay and suitable to be formed and fired. Clay-bearing

loess was and has always been available in China in almost limitless supply and could be formed into bricks or tiles or pots.[70] At the time of the First Emperor, wood was more abundant in China than today; nevertheless, it was probably cheaper and logistically easier to use wood for firing rather than for carving. Clay can be brought into a certain form more quickly; it does not require metal tools to do so, and it also lends itself better to division of labor. If the emperor's artisans had ventured to carve thousands of life-size soldiers in wood instead, their task would have been more laborious, and they might not have finished in time.

A lifelike appearance of the army must have been an urgent concern of the emperor. Probably only insofar as the army looked "real" could it successfully fulfill its magical function. No written evidence explicitly confirms this assumption, but the history of religious sculpture after the Han dynasty makes it evident that realism and the efficacy of magic went hand in hand.[71]

The wish to equip the clay soldiers with real weapons that had proven their usefulness in earlier battles must have been the main reason why the figures were made life-size. Yet for the entire army to look real, two more features were essential: numerical significance and credible variety. In order to be convincing as a fighting force, the number of soldiers had to be considerable, approaching or equalling that of a real army. On the other hand, enough variety among figures was needed if they were to be more than lifeless mannequins. But the makers of the army worked hard and ingeniously to achieve these goals, and clay was the material best suited for the task.

The emperor's order thus might have read, "Make me a magic army. It must never decay but protect my residence for eternity. It must look like a real army in all respects. Only then will the magic work!"

Fig. 3.21 Drainage pipes from Qin palace no. 1, ca. 350–206 B.C. Long pipe: L. 56 cm, Diam. at ends 26–27 and 21–22 cm; Knee-shaped pipe: Diam. at ends 27 and 20.2 cm

Fig. 3.22 Legs of a terra-cotta warrior

How Was It Done?

The logistical problems in procuring material and men must have been considerable. A sufficient supply of clay, firewood, lacquer, and pigments had to be constantly available at the necropolis. Although none of the workshops and kilns have been located so far, the figures were presumably formed, fired, and painted near the pits to avoid costly and hazardous transportation of the semifinished or finished products. Only a well-observed sequence of steps in the production process and a tight schedule could guarantee that work went smoothly.

No less demanding was the task of organizing the labor force. Once the workers were recruited, they had to be fed and given shelter. Their efforts had to be coordinated and the results supervised. Moreover, the makers of the terra-cotta army were but a small group among several hundred thousand busy men at the site. There is no doubt that all this activity necessitated detailed planning and an organizational framework.

The Workforce

What kind of workers could possibly have had the experience necessary to fire such large clay figures in such quantities? The answer: the makers of drainage pipes! An impressive drainage system made of clay was found under the provisions office in the necropolis and under the Qin palace. Figure 3.21 shows two pieces excavated from the pounded-earth terrace that formed the substructure of Qin palace no. 1. Both pipes have round cross sections of different sizes at each end. The diameter of the knee-shaped tube is 26–27 centimeters at one end and 21–22 centimeters at the other. The larger tube is 56 centimeters long. In size and proportion these tubes resemble the legs of the terra-cotta warriors (Fig. 3.22). The technique used to make the drainage pipes must have been similar to the technique for making circular torsos, legs, and arms from slabs of clay rolled into tubes.

Inscriptions confirm this observation. The foremen of the palace workshops used to stamp their names on floor tiles and roof tiles. Some of the same names have been discovered on the terra-cotta figures.[72] This indicates that the makers of the terra-cotta army, rather than being sculptors, were potters who knew how to manufacture ceramic architectural parts.

The inscriptions on the terra-cotta figures also enhance our understanding of the organization of the workforce. When the first 1,383 warriors and 132 horses were excavated, archaeologists gathered preliminary statistics. They counted 477 inscriptions. The characters had either been incised with a stylus or stamped before firing, mostly on inconspicuous parts of the body. Two hundred thirty inscriptions consist of serial numbers only. Most frequently, one finds the numbers five (40 times) and ten (26 times). This indicates that the figures were counted in groups of five and multiples of five, as was customary with real men in civil and military administration.[73]

Altogether, on 249 figures the names of 85 different foremen appear. Eleven of them preface their names with the character meaning "palace" (*gong*). Once again, this is an abbreviation for the Palace Water factory and also is seen on floor tiles of the pit. The foremen in this factory usually stamped the inscription into the soft clay with a seal, for example: "[Foreman] Jiang of the Palace" (*gong Jiang*; Fig. 3.23).

A second group of 23 foremen put a place-name in front of their names. In all but three cases it is the capital Xianyang. One such inscription reads "[Foreman] Ge of Xianyang" (*Xianyang Ke*; Fig. 3.24). This type of inscription is always incised and never stamped, which makes it somewhat less official than a seal imprint. It is believed that these masters came from local factories.

The third group is the largest, comprising 48 men who neither added the name of a factory nor a place-name to their own names. Most of these names occur only once. Those men probably also belonged to either one of the first two groups.

The inscriptions reveal that staff members from state factories and workers from local workshops pooled their efforts in one big project. This is common in later periods, too, for example in Han-dynasty lacquer workshops

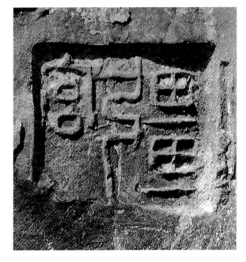

Fig. 3.23 Impression of seal of Foreman Jiang of the Palace Workshops

Fig. 3.24 Inscription of Foreman Ge from Xianyang

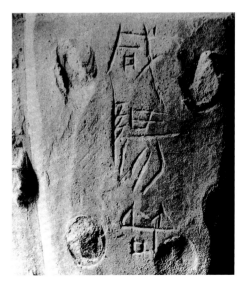

or Qing-dynasty porcelain factories. Typically, workers from state factories set standards of quality and enjoyed a somewhat better position than private workers. They were allowed to use seals and were given a higher proportion of the work. The names of the eleven men from the palace workshops are found on 87 figures; two of them made 21 figures each. By contrast, together all 23 local foremen produced only 56 figures.

Yuan Zhongyi, the chief excavator of the terra-cotta army, has described stylistic differences between the figures made by the two groups. Not surprisingly, the figures from the palace factories are more static, their bodies more sturdy, and their expressions stern and heroic. They also show a more consistent level of workmanship and greater stylistic uniformity. Figures from local workshops are more varied in their postures and faces, and tend to be more realistic. Yuan Zhongyi even talks about the styles of individual masters.[74]

It was hardly artistic pride, however, that caused the foremen to put signatures on the figures they had made, nor did those who commissioned the figures look at signatures in this way. As in the case of the weapons, quality control was the sole purpose of the inscriptions. The numbers served to verify how many figures had been completed; the names guaranteed the quality of craftsmanship. If the overseers found a figure to be faulty, they were able to track down a man whom they could hold responsible. Precise laws specified the fines in such cases.[75]

The foremen did not work alone, of course. They probably had the status of masters (*gongshi*), and each of them controlled a team of perhaps ten workers.[76] The 85 foremen identified so far would then have directed 850 men. Since many terra-cotta figures have not yet been excavated, presumably more names of foremen will come to light. The total workforce may have comprised a thousand men. Assuming they set up shop only after the unification of the empire in 221 B.C. and continued until the emperor's death in 210 B.C., they would have completed more than 7,000 figures in eleven years, or close to 700 figures in one year, which is quite conceivable for a workforce of about a thousand men. Yet in the first years the workers certainly produced less than the average, due to their lack of experience. Firing figures of such dimensions was tricky, especially as the thickness of the clay walls varied considerably, and in the kiln the figures shrank in size by about 10 percent. Presumably there were frequent misfirings.

Assembling the Figures

Valuable as they are, the inscriptions do not say what the workers actually did, which can only be inferred by closely examining the figures. The foremen and their many subordinates worked within the framework of a well thought out production system. Each of the figures of the standing warriors weighs between 150 and 200 kilograms, and normally consists of seven major parts: a plinth, the feet, the legs below the garment, the torso, the arms, the hands, and the head.[77] The workers first modeled each part separately and then fitted them together (Fig. 3.25). They luted the arms to the body with wet clay, then inserted the prefabricated head into the opening at

Fig. 3.25 Sections of a standing terra-cotta warrior

0 20 cm

the neck where they secured it with wet clay, too. Because the figures are assembled from set parts, they have the appearance of mannequins.

When fabricating cylindrical parts, such as torsos and arms, the workers first kneaded clay into thick slabs that they then rolled into tubes. In other cases they built up the circular forms from coils of clay. They also formed the wet clay in molds composed of dried or fired clay. Although not employed for all parts of the body, molds were an important means by which to standardize and speed up production. The molds for the plinths may have been made of wood in the shape of a flat open box, a simple device the workers would have known from making tiles. The basic form of a head was put together from two halves formed in hemispherical molds (Fig. 3.26). Usually the seam runs vertically over the head in front of or behind the ears. Figure 3.27 shows the two halves of a head that broke at the seam. Still visible is the imprint of the hand of the worker who pressed the wet clay into the negative mold. Heads of horses were similarly formed with paired molds.

Once the basic form of the figures was completed, the workers took additional clay to shape details such as those on the shoes and the armor. The greatest care was lavished on the heads. The workers attached or reworked by hand the headgear, hair, ears, eyebrows, eyes, mustaches, and lips. Some parts, like the ears, were formed in molds first. Similarly, the ears and forelocks of the horses were preformed in standardized shapes.

A division of labor certainly existed. The signatures indicate that one foreman and his team were responsible for making an entire figure up to the point when it was handed over for firing. Beginners in the team or laborers of little skill could perform simple jobs like preparing and mixing the clay or forming the plinth. Experienced team members may have concentrated on more delicate tasks such as modeling the faces. The firing was undoubtedly a job for specialists, as was painting the fired figures.

Correct timing must have been vital. The different parts of the body had to be joined when the clay was neither too hard nor too soft. The heavy torsos, for example, could only be hauled onto the legs after they had dried to such a degree as to be sufficiently firm. On the other hand, reworking had to be done while the clay was still somewhat damp. The members of the team had to set up their schedule accordingly. Probably they could solve these problems more easily when they worked on several figures simultaneously. One explanation for the frequency of serial numbers that are multiples of five could be that five figures were made at a time.

Thus, there were no long assembly lines with many workers, each performing one small operation. Rather, the team under each foreman formed its own small, self-contained assembly line that saw a figure through all the production stages. Nevertheless, the teams worked according to similar blueprints. All workers assembled their figures from the same small number of basic parts. There were variations, to be sure. The shoes could be fixed to the plinth, for example, and the lower legs could be made from rolled slabs or coiled clay. Yet the basic structure remained the same.

Fig. 3.26 Two terra-cotta heads, each composed of two halves formed in molds. The left and right halves are then joined to become the complete head.

Fig. 3.27 Two halves of a terra-cotta head

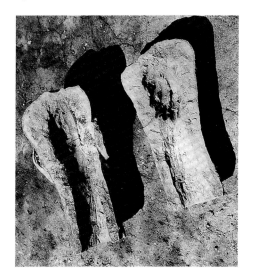

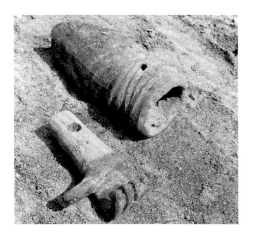

Fig. 3.28 Terra-cotta hand prior to insertion into the cuff and joining by a plug

Fig. 3.29 Terra-cotta hand with stretched fingers, composed of two halves formed in molds, then joined to form the complete hand

Fig. 3.30 Terra-cotta hand with bent fingers, composed of two halves formed in molds, then joined to form the complete hand

Uniformity is also evinced in the measurements. The respective parts of each clay body have similar dimensions, although oversize limbs or heads appear from time to time. The overall height of the standing soldiers, including the plinth, varies between 180 and 195 centimeters, the length of the feet from 25 to 29 centimeters, the circumference of the torsos from 85 to 107 centimeters, the breadth of the head from about 19 to 23 centimeters, and the length of the face, normally, from 19 to 20 centimeters.[78] The soldiers thus are large, but life-size. This is confirmed by the fact that they carry real weapons, and it is also apparent in comparison to the size of the clay horses. The variations in all measurements remain within a consistent range.

Even more important, only a small and quite limited repertoire exists of different types for all parts of the figures. The authors of the archaeological report have, for example, identified three types of plinth, two types of feet, three types of shoes and four types of boots, two types of legs, eight types of torso, and two types of armor, each category having three subtypes. The most elaborate repertoire exists for the heads, for which the report identifies eight different types.[79] The components of the face are also standardized and the number of types is limited.[80]

In spite of this uniformity of the body parts, the army still conveys an overall impression of extraordinary variety, for two reasons: first, although standardized, the parts are joined together in a multitude of combinations. This allows for large numbers of units that differ from one another. Following the authors of the report in distinguishing eight types of heads, and further, identifying various types of eyebrows, lips, mustaches, and so forth, one soon arrives at a huge number of possible combinations. Second, the workers went over the figures and their parts by hand. They had to do this anyway in places where they luted parts of the body with wet clay. Again, the possibilities are exploited most fully in the faces. The makers reworked the physiognomical features when attaching small parts such as eyebrows or mustache, and they added further structure through the use of small incisions. In this way they achieved the truly endless variety that was necessary to make the army appear real.

We are not, however, dealing with portraits, as the English text of the report wants us to believe.[81] By definition, a portrait must attempt resemblance of an individual in a comprehensive creative process. A production method that divides figures and faces into standardized parts does not operate within the holistic concept of a personality that cannot be divided—the "individual."

Yet it was precisely the creative achievement of those who designed and made the terra-cotta army that they developed a system that allowed them to assemble the figures from a limited number of clearly defined parts. These parts of the body are modules according to the definition presented before, as a final look at the hands will confirm.

The workers formed the hands separately and then inserted them into the open sleeve, sometimes affixing them with a plug. Figure 3.28 shows the perforations for such a plug in the cuff and the wrist. Among the approximately fifteen thousand hands of the terra-cotta soldiers, there are only two main types: hands with extended fingers, and hands with bent fingers. The standing warrior shows these two types (see Fig. 3.3).[82]

Hands with a flat palm were made in two molds. A break can reveal the original joints. The joint often runs horizontally through the hand and the fingers.[83] Both parts were fitted together while the clay was still soft, and probably bonded by liquid clay or slip. One mold could also be used to form the back of the hand and the fingers and another mold was employed for the inner palm and the lower part of the thumb (Fig. 3.29).

Hands with bent fingers are half open in order for them to hold a weapon or another object (Fig. 3.30). Palm and fingers could first be made separately in molds and then joined together.[84] Or two molds were used, one for the palm with the thumb, and one for the back side of the hand and its bent fingers up to the second joint. The fingertips were then modeled separately and joined to the rest of the hand.[85]

Some thumbs were formed separately in a bivalve mold. In Figure 3.31, the joint is visible on the backside of the thumb at the left. In the example on the right, the joint runs parallel to the thumbnail. Still visible in both cases are the fingerprints of the worker who pressed the soft clay into the negative mold.

The angle at which the finished thumb was affixed to the hand varied. Thus it was possible to make different types of hands for different functions, as the hand of the kneeling archer (see Fig. 3.6) demonstrates. Moreover, varying with the angle of the arm, the same hand type could be used for different functions. The standing archer also has the familiar hand with stretched fingers (see Fig. 3.5). A chariot driver holds the reins in a hand with bent fingers (see Fig. 3.4). Although there are only two basic types of hand, all hands look different because they have been worked over before firing. Figure 3.32 allows us to gauge the diversity.

The observations on the hands can be summed up thus: the hands are prefabricated parts; they are composed of several elements; their measurements are standardized; the number of types is very limited; and the same type of hand can assume a different function in a different context. Hence the hands are modules. The same applies to the other parts of the body of the warrior figures.

Only the use of modules made possible the most extraordinary feat of the terra-cotta army: the enormous quantity of diverse figures. Only by devising a module system could their makers rationalize production to such a degree that, with the material and time available to them, they were able to meet the expectations of the emperor—the creation of a magic army that would protect his tomb for eternity.

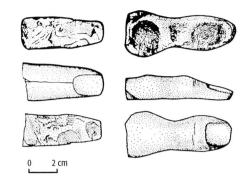

0 2 cm

Fig. 3.31 Terra-cotta thumbs

Fig. 3.32 Hands of various terra-cotta warriors

4 Factory Art

Much of what today is called Chinese art was produced in factories. The ancient ritual bronze vessels could never have been made in such great numbers by individual masters. Manufacturing them required large-scale operations that involved organized groups of hundreds of workers. Dozens of teams of workers constructed the terra-cotta warriors. By assembling a great number of parts in different combinations they made a huge fighting force.

An operation of this kind might be called a factory rather than a workshop, which is a small establishment run by a master craftsman. Factories are larger operations directed by managers who may not necessarily be craftsmen themselves. Managers procure the material and the tools, organize the workers and supervise their performance, calculate the output of the factory, and control its finances.

Factories often have a sizable workforce that can be easily enlarged or reduced in size, allowing for a flexible response to the demands of the patron or the market. The employees tend to work year round in a structured way. Their working hours are determined, and they are expected to perform a certain amount of work and to complete a certain number of items in a fixed amount of time.

Division of labor is essential in a factory. All the workers have specialized skills, although many of these skills will be limited in scope. Different workers and groups of workers tend to specialize in their particular tasks. A single worker may perform only one step in the production process; groups of workers may complete only one part of the product. But they all collaborate and work simultaneously, thereby speeding up the process of production. Any production process that involves making objects out of parts or modules lends itself to—indeed, demands—a division of labor.

In China a further distinction is drawn between factories operated by the state and those that are run privately. In the case of the terra-cotta army,

some figures were made in state factories and some in local shops. On the whole, government factories were larger and produced the better goods. This is true for almost all periods and for products in all the major materials, including lacquer, bronze, silk, and ceramics.

A factory does not by definition have to use machines. Indeed, it is one of the characteristic features of traditional Chinese production processes that they are performed by hand rather than mechanically. The organization of the work, however, anticipates that of modern factories.

Information about early Chinese factories is not easily gained. No inscriptions or contemporary written sources give any clue how ancient ritual bronzes were made. Only by looking at the objects themselves can one draw conclusions about the organization of the production. A few centuries later, inscriptions on bronze weapons provide some specific evidence about hierarchies and quality control in Qin state factories. Inscribed serial numbers and names of foremen on the terra-cotta warriors clearly indicate a division of labor. Yet these inscriptions are all very short and do not specify what the different workers actually did.

Two centuries later still, the division of labor is clearly documented on a group of inscribed lacquerware—fine dishes, cups, and boxes. The inscriptions detail the names of all participants in the production process and their respective responsibilities. This lacquerware was made in state factories.

This chapter will examine these inscribed lacquers of the Han dynasty (206 B.C.–A.D. 220), and also later bronzes and silk. Armed with the information thus gained, we will then make a big jump in time to investigate the manufacture of porcelain during the seventeenth and eighteenth centuries, the period when a worldwide market emerged. Their methods of production enabled the Chinese to dominate the international trade and change the ceramic history of the world. It will also be seen how the West tried to catch up with China.

Lacquer

Lacquer is among the materials the use of which the Chinese pioneered and early developed to a high degree of perfection. The lacquer coating of the terra-cotta figures was noted in chapter 3, but lacquered utensils were probably known in China as early as the Neolithic period. Processing lacquer is very labor-intensive. First the workers form a core of the object to be made. They often use wood, but may also choose hemp or other flexible materials. The lacquer is painted on this core. The first coating is only fractions of a millimeter thick, but it takes several days to dry. Curiously, lacquer dries in a relative humidity of 70 to 80 percent, and at temperatures of 25 to 30 degrees Celsius. After the first coating has dried, a second follows, and thereafter possibly a third. In later periods lacquered objects with as many as several dozen layers are common.

The workers may also mix one of several pigments into the liquid lacquer, which they can then use as paint. Lampblack and cinnabar are most

suitable. The final coating, however, is colorless and acts like a protective skin. When the artisans have applied the last layer, they polish the surface to make it lustrous and shiny. They may then attach fittings made of bronze or another material.

One of the most accomplished groups of lacquered utensils of the Han dynasty was discovered in the famous tomb no.1 at Mawangdui, Hunan Province. It contained the well-preserved corpse of Princess Dai, who died shortly after 168 B.C.[1] Figure 4.2 shows a lacquered tray from the western side compartment of the tomb with a set of dishes, five plates, two cups with handles (or "ears"), and two cylindrical beakers, one of them with a lid. Like the Shang bronze vessels, Han-dynasty lacquered dishes came in sets.

Lacquered objects were luxury goods. An often-quoted passage from the *Discourses on Salt and Iron* (*Yantielun*) claims that for the price of one fine cup made of lacquer, you could get ten bronze cups. This must have been true only for exquisitely decorated pieces, and perhaps just in the first half of the first century B.C., when the *Discourses* was written.[2] In spite of being "high-tech" luxury products, lacquer utensils were used widely and the simpler ones may actually have been rather cheap commodities.[3]

Factories controlled by the state made the best lacquered objects. They worked for the imperial household and for other government offices and were capable of supplying astounding quantities of these luxury goods. An inscription on a basin made in A.D. 9 states that it belongs to a series from the Imperial Palace Changlegong with serial number 1450-4000.[4] Emperors used the precious items as presents to princes and other members of the elite at court. All such courtiers needed ostentatious tableware for the many festive banquets that they held in their quarters. How many and what kind of dishes one could muster must have been of significance. The Han elite

Fig. 4.2 Lacquered tray with lacquered dishes, shortly after 168 B.C., from tomb of Princess Dai at Mawangdui, Hunan Province. Tray 60.2 × 40 cm

defined and displayed social status through luxury tableware, just as the aristocracy in medieval Europe would, and as the Shang elite had done before.

Besides members of the court nobility, civil servants stationed at the borders of the empire and chiefs of foreign tribes could also expect to receive such tokens of imperial favor. Excavations first made in the 1920s and 1930s—by Russian archaeologists of tombs of Hun nobles in Noin Ula in northern Mongolia (not far from Lake Baikal), and by Japanese archaeologists in Lolang, near Pyongyang in North Korea—have brought to light numerous pieces identified by their inscriptions as products of Han-dynasty state factories. Those particular factories were situated in the military commanderies Shu and Guanghan in modern Sichuan Province. Many other inscribed pieces have since been unearthed in such faraway places as Qingzhen, Guizhou Province, and Wuwei, Gansu Province. The products of the Sichuan factories traveled thousands of kilometers to be distributed all over the Han Empire and beyond.[5]

Inscriptions on these lacquered items often provide exact information about the division of labor in the state factories. One such piece in the Linden-Museum in Stuttgart is a lid for a lost cylindrical beaker of a type also known from Mawangdui (Fig. 4.3).[6] The lid measures 10.3 centimeters in diameter. Its single, continuous inscription around the lid reads:

Fig. 4.3 Lacquered lid, 4 B.C. H. 3.1 cm, Diam. 10.3 cm. Linden-Museum, Stuttgart

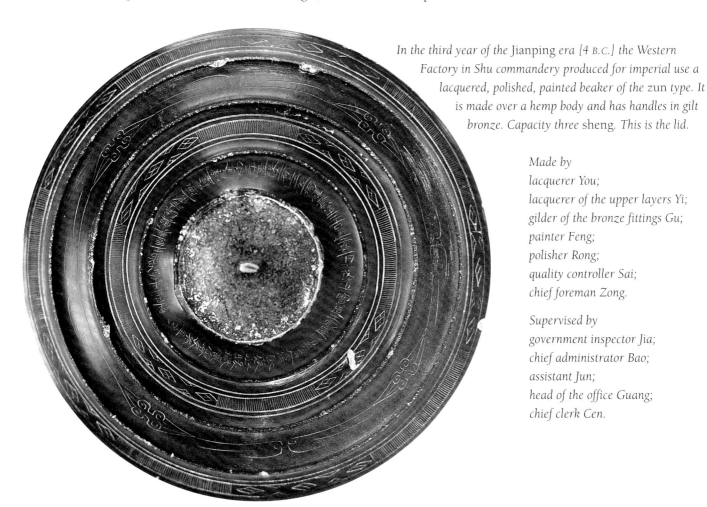

In the third year of the Jianping *era [4 B.C.] the Western Factory in Shu commandery produced for imperial use a lacquered, polished, painted beaker of the* zun *type. It is made over a hemp body and has handles in gilt bronze. Capacity three* sheng. *This is the lid.*

Made by
lacquerer You;
lacquerer of the upper layers Yi;
gilder of the bronze fittings Gu;
painter Feng;
polisher Rong;
quality controller Sai;
chief foreman Zong.

Supervised by
government inspector Jia;
chief administrator Bao;
assistant Jun;
head of the office Guang;
chief clerk Cen.

Similar inscriptions have been found from the years 85 B.C. to A.D. 102, indicating that a government-controlled lacquer industry flourished during this period. The inscriptions allow one to draw conclusions about the division of labor in lacquer production, the organization of the workforce, and the bureaucracy in the state factories.[7]

The Chinese archaeologist Wang Zhongshu has compared inscriptions on ten such lacquer objects, all of which were made in the same Western Factory in Sichuan as the Stuttgart piece, but a few years later, in A.D. 3 and 4.[8] Thirteen different names and jobs are listed in the inscriptions. Eight of them identify workers. Like the lid in Stuttgart, three of the ten pieces have a hemp core instead of a wooden core. Only twelve names are listed on those pieces. They lack the name of the woodworker (*sugong*); no name is given for the worker who prepared the hemp core.

The greatest variety of names is found among the *xiugong*, those who lacquered the lower layers; each of the ten objects carries a different name. The pieces were passed on to the lacquerers of the upper layers (*shanggong*; seven names), the gilders of the bronze fittings (*huangtugong*; six names), the painters (*huagong*; nine names), the polishers (*diaogong*; five names), and finally to the quality controllers (*qinggong*, two names) and the chief foremen (*zaogong*; two names). Because lacquerers of the lower layers and painters were the most numerous among the artisans, the production steps with which they were concerned must have been the most labor-intensive, whereas the last two stages in the chain needed only two people each.

Some of these names show up in several different positions. A man with the name of Tan made the upper layers of lacquer and also worked as a painter. A worker, Feng, prepared the wooden core, made the bronze applications, painted, and polished, and a chief foreman, Zong, seems to have helped out with the lower layers.[9]

Through these inscriptions, one can even follow the career of individual workers. The woodworker Feng, who doubled as painter, gilder, and polisher, can be traced from 4 B.C. to A.D. 8. Chief foreman Zong was active for eighteen years, from 4 B.C. to A.D. 14.

As is true for the terra-cotta army, all the individuals whose names are recorded on the products of the factory probably were not simple craftsmen, but the foremen of a team. They could never have finished the thousands of pieces the factory put out with their own hands alone. Rather, they must have directed teams of workers, for whose performance they were held personally responsible.

Five of the thirteen positions listed on each product from the Sichuan lacquer factories are those of bureaucrats—the government inspector (*hugong zushi*), chief administrator (*zhang*), assistant (*cheng*), head of the office (*yuan*), and chief clerk (*lingshi*). Beginning in 23 B.C., the government inspector is mentioned in the first position, suggesting that, from that time on, the state tightened its grip over the production.

The ten pieces in Wang Zhongshu's list regularly display the same names in the group of the supervisors. In all cases, the government inspector was a Mr. Zhang, the chief administrator a Mr. Liang, the assistant a Mr.

Feng, and the office head a Mr. Long. In A.D. 3 and 4, a Mr. Kuan and a Mr. Bao, respectively, occupied the position of the chief clerk.

This shows, not surprisingly, that the production involved many more workers and foremen than administrators. Only one administrator was needed on each level, yet they frequently changed positions. Comparing the names listed in 4 B.C. on the Stuttgart piece with those mentioned on pieces made in A.D. 4, one will find that the gilder, Gu, the painter, Feng, the polisher, Jung, and the chief foreman, Zong, were still active eight years later. The cast of bureaucrats, however, had completely changed. None of the same supervisors was around anymore.

Bronze

Han-dynasty craftsmen working in metal also did their job with customary skill and efficiency. They produced high-quality bronze objects, which they embellished with silver, gold, and precious stones. Typically they worked either in factories run by the government or in local workshops, and, as usual, the former produced better quality goods. The state factories were required by law to present a specified number of pieces each year. The law also stated that vessels of the same type had to be identical in size, length, and width. Quality standards were rigorously enforced.[10]

Fig. 4.4 Incense burner, 137 B.C. H. 58 cm, Diam. at base 13.3 cm, Diam. at mouth 9 cm

The state factories generally made bronze objects in series, each of which comprised large numbers of units. A hoard of twenty-two bronze vessels uncovered in Gaoyaocun, near Xian, in 1961 gives an idea of the numbers involved. The bronzes are believed to have been deposited before the arrival of the troops of Wang Mang in A.D. 8–9. Among them were ten large inscribed basins of the type *jian*, each having a diameter of over 60 centimeters. The inscriptions list the serial number of the particular basin as well as the total number of the basins in the series. Eight basins were made for the Supreme Forest (*shanglin*), the vast imperial park, which was dotted with palaces.[11] The inscription on one basin reads: "Bronze basin of the type *jian* for the Supreme Forest. Content five *dan*, weight 125 pounds. Made in the fifth month of the fourth year *yangshuo* [21 B.C.] by worker Zhou Bo. Number 82 in a series of 240 pieces."[12]

Another basin, made in 18 B.C. by worker Zhou Bo, was number fourteen in a series of eighty-four. The year before, a certain Zhou Ba, who, judging from his personal name, may have been a brother or cousin of Zhou Bo, had completed three hundred basins.[13]

Adding up the total figures given for each series in the inscriptions on these eight basins results in 1,258 bronze basins, all produced for the Supreme Forest

within seven years, between 24 and 18 B.C.[14] The figure is impressive, but the actual production must have been even larger, since the pieces preserved in the hoard can only be a random sample.

Each inscription on the bronzes from the hoard at Gaoyaocun gives only one name of the maker. Again, founder Zhou Bo and his colleagues were probably masters or foremen. Later inscriptions list more names on single bronze objects, testifying to a division of labor similar to that for the lacquered objects. A group of foremen and a group of supervisors together shared responsibility for the quality of the product.

Some bronze objects came from the same Western Factory as the lacquered pieces discussed above. Although the names of bronze workers and lacquer workers are usually different, in at least one case the same bureaucrat seems to have supervised both productions. The Palace Museum in Beijing owns a wine cup with a tray in gilded bronze made in the Western Factory in A.D. 45. Its inscription lists a chief administrator Fan.[15] On a lacquer cup made seven years later in the same factory, administrator Fan is met with again.[16]

Under the direct supervision of the palace administration, some factories' tasks included making choice pieces of exceptional quality in small quantities for members of the imperial family. One such item is an exquisite incense burner of gilded bronze, resting on a shaft in the form of bamboo, measuring 58 centimeters in height (Fig. 4.4). It came to light in 1981 in a small tomb about 30 kilometers northwest of Xian. The tomb, which lies next to the Maoling, the yet-unopened mausoleum of Emperor Wu (r. 140–187 B.C.), may belong to the emperor's elder sister. Nearly identical inscriptions are engraved on the foot of the incense burner and on the lower ring of its lid.[17]

The inscriptions identify the section of the palace for whose use the burner was made, give the name of the object and its weight, mention the factory and the date of the bronze's production, and record the date when the piece entered the palace, including its inventory number. The inscription on the lid reads:

> Bed chamber service of the Household Office for the Palace Weiyanggong. Incense burner on a bamboo [shaped] stand made of gilded bronze. One item. Total weight ten pounds [jin], twelve ounces [liang]. Made by the Palace Agency [neiguan] in the fourth year [137 B.C.]. Transferred [to the palace] in the tenth month of the fifth year [136 B.C.] as number 3.

Inscriptions of this kind made housekeeping easy.

Silk

Simply speaking, a textile results from intertwining, at right angles, two types of threads, warp and weft. If the weft crosses over and under the warp in a completely regular sequence, the fabric is plain weave. If the weft is made to float over or under two or three warp threads, a small irregularity will be visible. By deciding on the exact locations of these irregularities, and by aligning them in a certain sequence, a pattern can be made.[18] Patterns thus are the visible result of numerous calculated combinations of the two

82 *Ten Thousand Things*

Fig. 4.5 Diagram of a weaving pattern for a relief-figured polychrome silk; showing warp and weft

basic agents, warp and weft. It is playing in a basic binary system (Fig. 4.5), which can then be enriched and elaborated by dyeing colors and applying many other kinds of techniques.

In every tiny step of the process, weavers have to plan ahead. Before they can start, they have to determine the exact sequence of the intended combinations. This requires creativity, imagination, experience, and precision in managing the great numbers of threads. Once the loom has been set up for pattern weaving and production has begun, changes are all but impossible. One step follows after the other from beginning to end in the predetermined order.

Weaving with a loom also invites reproduction. It favors symmetrical design and geometrical patterns like meanders and lozenges, and it lends itself to repetition. The repetitive use of the same units is the common procedure in designing even the most complex textile patterns. It is also easy and common to duplicate an entire piece of fabric. The loom just has to be loaded with new threads and set into motion again. If its movements are mechanized and the same thread is used, the second fabric will be all but indistinguishable from the first.

These basic principles, which were developed and explored as early as the Neolithic age in various places all over the world, apply to weaving with every kind of material. People have generally used fibers from plants as raw material that they could spin and reel into threads suitable for weaving. The Chinese, in addition, tried something extraordinary. They domesticated and reared silkworms (*Bombyx mori*) on the leaves of mulberry trees, and experimented with the filaments of the cocoons. These filaments have amazing properties. They can reach a length of 900 meters and more, yet their diameter is merely in the range of 6 to 30 microns (thousandths of a millimeter).[19] Their tensile strength and elasticity is unparalleled, but because they are so very fine, vast numbers are required to make a fabric. Consequently the production of silk is more complicated and time-consuming than that of any other kind of textile. Reeling, spinning, weaving, and dyeing are all very delicate and labor-intensive operations.[20]

When the Chinese dared to take up this challenge sometime in the Neolithic age, they may not yet have known that the benefits they could reap would be manifold. They secured the finest material for their clothing. It was beautiful, lustrous, and supple, could be dyed with gorgeous colors and embellished by using many other techniques, and it was light and adaptable to many purposes. The delicacy of the material, however, called for complex equipment and weaving techniques, inviting construction of machines for reeling and weaving, thereby advancing mechanical engineering in general. Significantly, the Chinese word for loom—*ji*—came to refer to any kind of machine.[21] Making silk also forced the Chinese to manage a complex production process and coordinate the efforts of large groups of participants in factories. Because the Chinese developed silk technology so early and used it so pervasively, it has assumed a paradigmatic significance among their systems of production. Again, it seems appropriate that the Chinese chose the word *wen*, which means woven fabric, to designate their concept of culture.

Silk technology was already well advanced in the Shang period. Impressions on excavated Shang bronzes reveal that they were wrapped in fine silk.[22] For instance, traces of silk have been identified on more than fifty ritual bronzes from the tomb of Lady Hao.[23] Like bronze, silk was a luxury commodity whose use was monopolized by the aristocratic elite. Probably weavers had to supply silk to all members of the nobility for garments and other purposes. The customers expected sizable quantities and likely asked for variety at the same time. The makers responded by devising rationalized schemes of production and by weaving various patterns (and possibly by dyeing with different colors).

Again like bronze, silk was made in factories in which seasonal occupation was abolished and administrators supervised the workers. The tasks of founders and weavers were comparable, but the discipline that was expected of the silk workers may have been even more rigorous than that required in bronze foundries.[24] The regular movements of the loom dictated the rhythm and speed of the production. Through more thorough mechanization, Shang-dynasty weavers must have achieved more perfect reproductions than Shang-dynasty bronze casters.

By the Han period, a state-run silk industry that provided luxury products for the court existed in various parts of the empire. Seven hundred serving boys were busy in a big private household during the first century B.C.,[25] and the workforce in one government factory numbered several thousand male and female artisans.[26] The silk workers accomplished amazing feats. In addition to plain weave they made patterned, monochrome damask, embroidery, and various types of brocade, including polychrome woven fabric. They also created polychrome patterns by printing and painting directly on the textiles.[27]

The most important group of Han-dynasty silks has been found in the tomb of the same Princess Dai who owned the lacquer dishes illustrated in Figure 4.2. The items in her wardrobe vary enormously in terms of patterns and weaving techniques as well as colors. One particular undergarment of plain silk, with a length of 160 centimeters, is so delicate that it weighs no more than 48 grams (Fig. 4.6).[28]

Fig. 4.6 Undergarment in plain silk, shortly after 168 B.C., from tomb of Princess Dai at Mawangdui, Hunan Province. L. 160 cm, W. (across sleeves, cuff to cuff) 195 cm

Throughout the history of imperial China, silk production remained a major industry and one of the country's economic mainstays. In fact, because silk was highly valued and silk factories employed vast numbers of people, silk contributed to the prosperity of entire regions and, for example, made Suzhou one of the richest cities in the empire. As with the manufacture of lacquer and other commodities, private and state silk factories existed side by side. As always, the latter excelled in producing the greatest quantities and the highest quality.

Silk produced under government control also served as currency. Officials were given certain amounts of silk as salary, which in turn fostered standardization of sizes and quality. In particular, there was enormous demand for brightly colored court robes. Traditional paintings illustrate how dozens and even hundreds of officials display their sumptuous dress in court ceremonies. At the same time, silk was available to private buyers. Indeed, silk clothing was very common. Luxury goods and wide distribution were not mutually exclusive in imperial China.

People in other countries admired and envied the Chinese for their fine silks. Isolated traces and fragments of silk from as early as the sixth and fifth centuries B.C. have been found in tombs in Europe.[29] Beginning in the Han dynasty, silk was traded in considerable quantities westward along the so-called Silk Road. The Romans even called the Chinese the "silk people" (*seres*), and some historians believe that the import of silk drained the financial resources of the Roman Empire, contributing to its fall.

Thus warned, Europeans struggled to produce silk themselves instead of importing it. In the first centuries of our era, imported raw silk was woven

in the Near East in countries such as Palestine, Syria, and later in Byzantium. There is a famous story that, around A.D. 552, Emperor Justinian received two itinerant monks who came from China with the eggs of silkworms concealed in their walking staffs. They had had to make it through the desert before the eggs perished.[30] True or not, Byzantium did develop a silk industry that had far-reaching trade into western Europe.

Wherever Europeans succeeded in producing their own silk, it contributed to economic prosperity, as it did in Venice, Florence, and Lucca in the thirteenth century, or in Lyon, which from the sixteenth century onward grew into a center of European silk industry. In the eighteenth century, the Prussian king Frederick the Great turned an estate near Berlin into a home for silkworms. Those, however, seem to have found it too cold there, and died.

By mastering the manufacture of silk, Europeans learned more from the Chinese than skills for making a high-tech luxury good. They also found that producing these goods required organized production in factories. This knowledge contributed to the rise of modern mass-production techniques in the West.

Ceramics

Ceramics is another area in which the Chinese did astonishing things. Their extended, diverse experience in working with clay was one of the factors that allowed them to develop the complicated bronze-casting technique with sectional molds. The terra-cotta army was another outstanding demonstration of proficiency in ceramic technology. But the crowning achievement in this field was the invention of porcelain, which has become commonplace all over the world and synonymous with China. Today, easterners and westerners alike sip coffee or tea from china cups.

It is no accident that porcelain belongs to the range of goods for which the Chinese developed mass-production methods involving modular systems. The Chinese started early. In prehistoric times they already displayed remarkable skill in working with clay. It is sometimes said that the most beautiful Neolithic pots in the world are found in China. That they are also the most numerous comes as no surprise. A wide array of shapes, typically with articulate silhouettes, is known in third-millennium B.C. pieces of the Dawenkou and Longshan cultures in Shandong Province.[31] The vessels consist of distinct parts, which were made separately and then joined together. Many other sites in eastern and central China dating from the fourth and third millennia B.C. testify to this deliberate and controlled method of constructing ceramic objects.[32]

Assembling segmented vessels requires parts with standardized shapes and measurements, and standardization is best achieved by mechanical duplication. There is evidence that this was done as early as the Neolithic period. For example, the legs of a tripod could be formed by repeated molding over the same core. Thus, the two fundamental principles of assembling objects from parts and of mechanical replication were in place at the very beginning of the Chinese ceramic tradition.

This was the starting point on the road that, after many centuries, was to lead to the perfection of porcelain. A milestone was reached in the Shang dynasty, when Chinese craftsmen managed to make pottery with a white body. They also achieved controlled glazing in their kilns. By the seventh century A.D., potters had learned to fire ceramic at temperatures of about 1,200 degrees centigrade, at which heat it becomes white and hard. It can be called porcelain. From the tenth century, porcelain, when fired, could be so thin that after due sintering and densification it became translucent. Experiments with metallic oxides generated various colors in glazes. Then, in the fourteenth century, a technique was mastered that, during firing, preserved the decoration that had been painted under the glaze using a blue cobalt oxide pigment. This "blue-and-white" became the most successful ware in the ceramic history of the world.

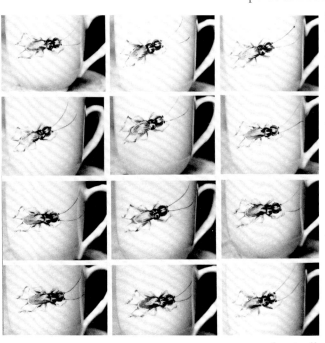

Fig. 4.7 Twelve cups with cicada decoration made in 1995 at a factory in Jingdezhen

Favored by an abundance of suitable raw materials, the city of Jingdezhen in northern Jiangxi Province evolved into the porcelain capital of China. Even now, the city produces an estimated one million pieces every day.[33] Figure 4.7 shows some cups made in 1995. The painter who decorates them with cicadas first uses a small stamp (Fig. 4.8) to print the outlines of the insects' bodies on the rounded surface of the cups. This preliminary design has yet to include all of the insect's six feet and its two antennae. The artisan only adds those when he paints freehand over the outlines, completing every single cicada in a slightly different way. This combination of shaping mechanically up to a certain point and then reworking individually by hand has always been one of the typical features of production processes in Jingdezhen, and, indeed, in Chinese artistic traditions.

In the late fourteenth century, some Jingdezhen kilns had begun to cater exclusively to imperial demands. Two centuries later, Jingdezhen was one of the largest, if not *the largest*, industrial cluster in the empire, and perhaps in the world. Kilns numbered in the hundreds. Records show that in A.D. 1577 the palace ordered 174,700 pieces.[34] Government officials from the central and the local bureaucracies organized and supervised the production. Their demands were so strict and oppressive that at times the workers rioted. Potters are even known to have destroyed their own products in desperate protest.[35]

Fig. 4.8 Rubber stamp (*left*) with outline design of cicada; used to decorate cups made in 1995 at a factory at Jingdezhen (*right*)

 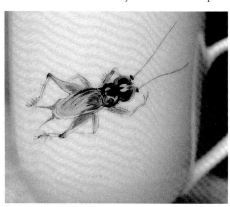

All workers were recruited from the area. According to a local gazetteer, 557 master potters from one district (*xian*) worked for the imperial kilns in A.D. 1578. They were organized in over twenty departments. One particular kiln had 4 masters with 39 assistants, 16 master potters with 86 assistants, 4 master painters (likely for the underglaze blue) with 19 assistants, 3

master color workers (probably enamel painters) with 3 assistants, 5 masters for writing the marks (with no assistants at all), 3 masters with 24 assistants for making the saggars, or capsules into which ceramic pieces are placed during firing, and finally a force of laborers under a single master for mixing the clay.[36]

The required daily output was fixed and depended on the size of the vessels. Potters throwing large vessels had to finish ten a day; potters specializing in smaller vessels threw fifty a day; bowls and saucers had to be formed at a rate of one hundred a day. Certain factories and kilns specialized in certain shapes. Thirty or more kilns fired only large storage jars and fishbowls.

A fruitful interaction existed between imperial and private kilns (*min-yao*).[37] The imperial kilns worked for the palace, their noblest task being to provide ritual vessels (*jiqi*) for state ceremonies. Exact rules set forth the types of vessels and how many of each type had to be displayed for a certain occasion. Figure 4.9, a diagram from *Collected Statutes of the Great Ming Dynasty* (*Da Ming huidian*) compiled in 1587, shows the arrangement prescribed for the sacrifice at the Circular Mound (*huanqiu*) of the Altar of Heaven (*tiantan*).[38]

The imperial kilns were less numerous and were allotted the finest raw materials and the most skilled workers. They fired approximately three hundred blue-and-white pieces at a time, while the operators of a comparable private kiln stacked one thousand pieces tightly together for one firing. The latter therefore had a somewhat inferior output, but they saved on fuel. If the imperial kilns were unable to fulfill a particular order from the court, private kilns could help out. This resulted in an exchange of designs and thus the private kilns kept abreast of the highest quality standards, even if, for economic reasons, they and their customers chose to settle for less most of the time.

Fig. 4.9 A page from *Collected Statutes of the Great Ming Dynasty* (1587; chapter 87, page 35), showing ceremonial vessels displayed at the Altar of Heaven. H. 34 cm. Gest Oriental Library and East Asian Collections, Princeton University

Toward the end of the sixteenth century, momentous changes occurred in the porcelain production at Jingdezhen. With the final decline of the Ming dynasty, imperial orders ceased in 1620. Yet the growing class of urban merchants made up for the loss. As their wealth increased, the new customers demanded ever greater quantities of the luxury commodity porcelain. They also asked for new themes in the decoration, especially those with a literary flavor, such as scenes from popular novels and landscapes.[39]

Export Porcelain

As it happened, European traders appeared on the scene at that very moment. Portuguese and Spaniards were the pioneers in the sixteenth century, but they were elbowed out by the Dutch in the early 1600s. The British followed suit and surpassed the Dutch in the eighteenth century. Unlike the Roman Catholic explorers from southern Europe, the pragmatic northern Europeans harbored no ulterior religious motives. Single-mindedly and efficiently, they pursued their mercantile goals, delivering a textbook case of the famous symbiosis between Protestant ethics and capitalism. The Dutch organization was the Verenigde Oost Indische Compagnie (VOC). From its base in Batavia, it built a trade network that spanned all of East Asia as far north as Nagasaki in Japan.

In terms of value, export porcelain never accounted for more than about 2 percent of the Asian trade in all products. However, the numbers of pieces that reached Europe were staggering, and they had a tremendous impact, changing the ceramic history of the world.

Ceramics from China had traveled westward since the Tang dynasty. Shards have been found at many places in the Arab world, at the residence of the caliphs in Samarra, near Baghdad, and in Fustat, near Cairo. Shards recovered on the West Coast of Africa testify to the far-reaching trade during the Ming dynasty, when Chinese blue-and-white was known and imitated in Persia, Syria, and Turkey. The largest and most important surviving group of Chinese export ware is the complement of more than ten thousand fine ceramics in the collection of the Ottoman sultans. This vast assemblage came to Istanbul mainly during the fifteenth to the eighteenth centuries, and remains in the Topkapi Sarayi Museum today.[40]

The piece believed to have the longest history in a European collection is a celadon bowl from the castle of the counts of Hesse, now in the Staatliche Museen in Kassel, Germany (Fig. 4.10). A certain count Philipp von Katzenelnbogen acquired it during his pilgrimage to the Holy Land in 1433–34. After his return, he had a precious gold mounting made for it, and it was used as a chalice.[41] Westerners obviously admired the glazed ceramics from China greatly, and sometimes even ascribed magical qualities to them. Although they knew they were made of earth, they did not know what kind of earth, nor how they were made.

When intercontinental trade expanded in the sixteenth century, porcelain became a commodity that was traded around the globe. The Chinese

Fig. 4.10 Chalice, late 14th to early 15th century; mounting between 1434 and 1453. Longquan porcelain, celadon bowl with gilded silver mounting, H. 20.6 cm, Diam. 16.8 cm. Staatliche Museen, Kassel

immediately achieved worldwide superiority in the ceramics market, because porcelain surpassed all Western ceramics in technique and design. The Europeans were fascinated by its qualities: that porcelain could be shaped at will and decorated in many ways; that it could be easily and efficiently cleaned after use; that it was at once hard, durable, and resonant; and that its beauty was like a gem—smooth, white, gleaming, and translucent.

Because of their methods of production, the Chinese were well prepared to flood the entire world with porcelain. They had the capacity to offer almost unlimited quantities of this wonderful merchandise. Thus, for the first time, Europeans experienced the ramifications of mass production in China.

The number of pieces manufactured for the European market can be inferred from surviving orders and loading lists. The earliest recorded annual order by the Dutch was placed in 1608, for 108,200 pieces. In 1644, the number was 355,800.[42] After the establishment of Manchu rule in 1644, war raged on in southern China for several decades and Jingdezhen suffered significant destruction around 1675, causing trade to decline. A few years later, however, the kilns had been rebuilt and Jingdezhen came back into full operation. The Dutch, who had turned to Japanese producers during this period of turmoil, began to order again. Porcelain dealers in Batavia in the 1690s estimated that they received shipments of two million pieces from China every year.[43]

Export continued to flourish throughout the eighteenth century, as testified to by the exact figures in Dutch records. In 1756, a single order from Holland requested, among other items, 100 fish dishes, 200 soup bowls, 200 cupboard sets, 1,000 teapots, 1,000 cuspidors, 1,000 caudle cups with saucers, 1,400 milk jugs, 2,000 double dinner plates, 8,000 boullion cups, 10,000 chocolate cups, 14,000 Dutch double coffee cups with saucers, 40,000 coffeehouse cups with and without saucers, and 130,000 large Dutch-type coffee cups with saucers.[44]

During this year, six ships of the VOC arrived at Canton. In a single trip, each could bring back about 150,000 pieces of porcelain.[45] The Dutch company was the largest of its kind, but England, Sweden, Denmark, and several other countries also took part in the porcelain trade. The English share in the export market is believed to have equalled that of the Dutch around 1700 and even surpassed it after 1730. The various and sometimes very detailed historical records allow a rough estimate of the total number of pieces produced by the Chinese for export during the seventeenth and eighteenth centuries, which must have been in the range of several hundred million.[46]

Trade slowed only after 1770, again partly due to reasons internal to China, but also because by then Europe was producing enough of its own high-quality porcelain.[47] Not wanting to be overrun completely by the avalanche of export ware from the Far East, the Europeans tried hard to join the lucrative porcelain business themselves. In order to conquer at least a portion of the European market, they started their own production. It is well known that Augustus the Strong, Elector of Saxony and King of Poland, ordered Georg Friedrich Boettcher to "reinvent" the secrets of making porcelain, and that Boettcher did so in 1709. Augustus then established his factory

Fig. 4.11 Pencil drawing of two milk jugs and two types of chocolate cups dispatched from Holland to Canton in 1758. 26.5 × 14 cm

at Meissen. Production in other countries soon followed suit. The Chinese, in turn, produced copies of European porcelain, which were, for the most part, technically superior.

The Europeans also made ceramics that only superficially resembled porcelain, for example in Delft. The Chinese copied these, too, as a plate in Delft style exemplifies (see Fig. 4.1). Yet the Chinese designer apparently was not quite sure what the church spires in the background were for, so, to be on the safe side, he hid two more of them in the foreground grass.[48] To avoid such calamities, the Europeans ordered porcelains made to exact specifications (Fig. 4.11), for which they sent instructions for shapes and designs, and sometimes even models carved in wood.[49]

The Geldermalsen

Students of porcelain history have investigated in detail how Europeans managed to cope with the intricate technical problems of making porcelain. We also have been taught a great amount about the many fascinating ways in which Chinese and European porcelains influenced each other stylistically. Yet producing porcelain posed not only technical and design problems but also the challenge of organized mass production. In this respect, too, Europe learned much from China. Westerners who wanted to know more about Chinese systems of porcelain production could tap three types of information: the pieces themselves, illustrated albums, and eyewitness accounts.

The porcelain pieces themselves provided the most tangible evidence. In 1752, on her voyage from Canton to Amsterdam, the Dutch freighter *Geldermalsen* sank (Fig. 4.12). In 1985, the British captain Michael Hatcher hauled the freight of more than 150,000 pieces to the surface again. The cargo was sold at auction in Amsterdam by Christie's in 1986 (Fig. 4.13).[50]

In the National Archives in The Hague, a copy of the packing list of the *Geldermalsen* has been preserved. In addition to 171 dinner services, it lists 16 different types of dishes. The most numerous are 19,535 coffee cups with saucers, 25,921 slop bowls, and 63,623 teacups with saucers.[51]

It is almost certain that the porcelain cargo loaded on the *Geldermalsen* in the winter of 1751 had been made shortly before. Except for a certain amount of inferior-quality blue-and-white that was to be discharged in

Fig. 4.12 Porcelain from the *Geldermalsen* wreck on the ocean floor

South Africa, the *Geldermalsen* porcelain is believed to have come from Jingdezhen.[52] These pieces therefore offer a rare opportunity to investigate the decorative patterns used at a particular time. All of them have decoration in underglaze blue, and probably many were made in the same factory.

Considering that this comprises a mass of some 150,000 pieces, the decorative repertoire is extremely limited. It is made up almost completely of a few flowers and trees, and simple landscapes. The only other motif, namely fish, is found only on a small part of the total. Yet there is a system to the decoration. For the sake of clarity, the following analysis of this system will confine itself to circular fields—in cups, bowls, and plates.[53]

The simplest decoration of a circular field is found on teacups. In the center of the cup, only a few petals are shown and these look well from any angle (Fig. 4.14). The following series of examples demonstrates how, by adding more and more details, this most basic pattern develops into landscapes, which can be seen on the saucers at the rear of the photograph.

The coffee cup in Figure 4.15 has a larger and more elaborately drawn flower, which can now be clearly recognized as a peony. The flower also has assumed an orientation, with its stalk below the petals.

The peony nearly fills the entire central roundel of the so-called Batavian bowl in Figure 4.16. The painter added more leaves and gave the petals an indented outline and the stalk a double contour. Yet the flower still floats in an undefined space, as a two-dimensional pattern viewed from above.

Fig. 4.13 The *Geldermalsen* porcelain at Christie's, Amsterdam, prior to auction in 1986

The next painter depicted two peony flowers and added a second plant—a pomegranate with three flowers—on his soup plate (Fig. 4.17). He gave its stalk shadings and knots. Most significantly, he added a few tufts of grass, indicating the ground. What so far was merely a pattern has developed into a scene, thereby bringing three-dimensional space into the composition. Its vertical orientation is now unmistakable: it can only be viewed face-on, so that the stalks can grow upward.

The painter of the saucer in Figure 4.18 simplified the peony, but he added a rock, a willow, and a fence. He has turned the flower arrangement into a small garden, in which only the close-up peony is out of scale.

The saucer in Figure 4.19 is decorated with a chrysanthemum, rather than a willow, and a bamboo stalk is in the place of the peony. The next saucer (Fig. 4.20) combines a peony with a rock and two bamboo stalks.

The painter of a soup plate assembled a maximum number of motifs: peony, willow, bamboo, a fence with a chrysanthemum, and a jagged garden rock rising prominently in the center of the composition (Fig. 4.21).

These last four pieces demonstrate that motifs in the garden scenes are interchangeable, and that the number of motifs can be greater if the size of the decorative field warrants it. The following illustrations show how painters turned a garden scene into a landscape.

The saucer in Figure 4.22, with a diameter of 10 centimeters, has two pines, one larger than the other. At their base lie a few rocks with grass. The ground is indicated by layers of parallel horizontal strokes. While the composition is simpler than that of the previous decorations, here the painter has unified the scale. Since the pines could be growing somewhere out in the landscape, this scene may no longer depict a garden.

On the slightly larger saucer in Figure 4.23 (diameter 11.5 centimeters), the composition is more elaborate. This juxtaposition shows the liveliness of the design on the micro level, so to speak. Even a tiny expansion of the composition affects every motif and almost every stroke.

There is more space between the two pines in Figure 4.23. Their trunks are a bit thicker and the painter has given them volume by using short horizontal strokes. Two outlines continue to the tip of the branch bending toward the left at the top of the larger pine. A prominent rock with bamboo stalks behind it lies at the left of this tree. The ground vegetation is painted less summarily than that on Figure 4.22, and the horizontal layers of strokes occur in three groups instead of two. Although the painter of the saucer in Figure 4.23 had to fill up a slightly larger area, he did not enlarge his motifs in proportion. Rather, he used motifs of approximately the same size, spaced them out, drew them in greater detail, and added some new motifs. Yet this composition does not grow mechanically. Although the design is more complicated, the painter still used fewer pine-needle clusters (seventeen versus nineteen). Because the painter drew all motifs by hand, he had a certain flexibility in where to place them and how to execute them. He exercised his judgment as a designer in every composition, and almost every single stroke.

Save for one band at the rim, the painter of Figure 4.24 covered the entire inner surface of this still larger saucer, which has a diameter of 12

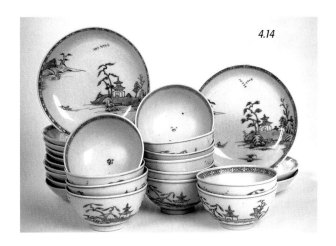

4.14

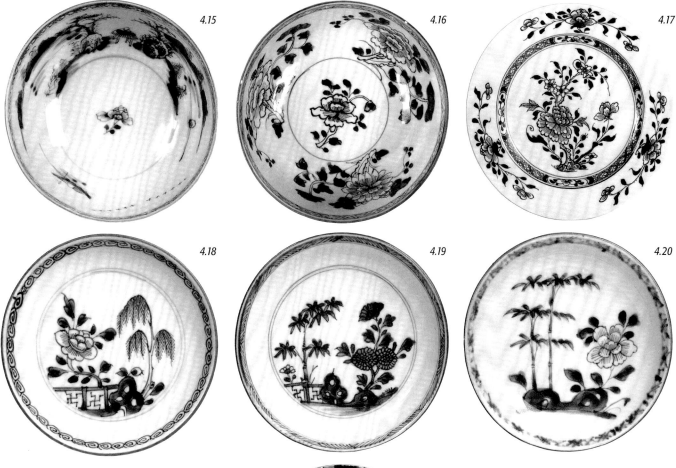

4.15

4.16

4.17

4.18

4.19

4.20

4.21

Figs. 4.14–4.29 Examples of the blue-and-white porcelain from the *Geldermalsen*, ca. 1750

Fig. 4.14 Twelve teacups and saucers. Diam. of cups 11.5 cm, Diam. of saucers 17.5 cm

Fig. 4.15 Coffee cup. Diam. 15 cm

Fig. 4.16 "Batavian" bowl. Diam. 19 cm

Fig. 4.17 Soup plate. Diam. 23 cm

Fig. 4.18 Saucer. Diam. 13 cm

Fig. 4.19 Saucer. Diam. 13 cm

Fig. 4.20 Saucer. Diam. 11.5 cm

Fig. 4.21 Soup plate. Diam. 23 cm

centimeters. As he had more space available, he was able to assemble his motifs into a small landscape. He let two thickly needled pines dominate the scene, and also included the familiar latticework fence with the oversized chrysanthemum. Yet a small-scale pavilion with a double roof suggests to the viewer that the site is to be viewed from some distance. Another cluster with rocks and vegetation at the upper right is completely new. The viewer perceives it as being far away, and interprets the space in between as water, even before recognizing the few tufts of reeds at the right rim of the saucer. Thus, this little composition has become a real landscape with foreground and background.

The saucer in Figure 4.25 marks a step in the design of diagonal landscape compositions. The painter has added garden rocks and wave lines in the foreground. He further unified the scale by making the trees smaller and the hut larger. The background, where he added a second pavilion, is more distinct.

The composition on the saucer-dish in Figure 4.26 develops from right to left. The foreground promontory, with a pavilion under trees, is placed at the lower right side, the background with rocks and vegetation at the upper left. The foreground is pushed up a little, making the whole scene more spacious. The fisherman in his boat and the chevron of birds add to the suggestion of a wide space. This is exactly the same landscape scene as already seen in Figure 4.14. In the center of the corresponding cup one finds the few tiny peony petals that started this series, which has led step by step from that simple motif to this full-fledged landscape.

This is not the most complex version, however. In the dish in Figure 4.27 the painter has introduced more details in his foreground garden. A man sits alone in a pavilion, which juts out over the water. Equal care was lavished on the background promontory. The plate has added value in its gold enamel, applied after the first firing.

Landscapes developing diagonally from right to left are very common in the circular decorated fields on the *Geldermalsen* porcelain, and they vary in many ways (Fig. 4.28).

The series of cups, bowls, saucers, and plates has shown that a system was followed for the decoration of this mass of porcelain. One can identify a limited repertoire of distinct motifs—such as peonies, pavilions, fishing boats, or rows of flying birds—and these motifs can be called modules.

The modules in themselves are composite parts made up of strokes, lines, and simple elements like leaves. Because all modules are executed by hand, differences are bound to appear, even in otherwise identical compositions. This built-in flexibility is an enormous asset, because it makes the modules adaptable. When executing a particular motif, a painter can adjust its shape to the surrounding motifs. He can also accommodate his motifs to decorative fields of different sizes by varying the degree of elaboration.

The painter combines his motifs into compositions—the units. In building them, he has a certain freedom as to which and how many modules he selects. Some modules are interchangeable and some can be eliminated completely. There is no rationale for why certain garden scenes contain bam-

Opposite:
Figs. 4.22–4.27 Examples of the blue-and-white porcelain from the *Geldermalsen*, ca. 1750

Fig. 4.22 Saucer. Diam. 10 cm

Fig. 4.23 Saucer. Diam. 11.5 cm

Fig. 4.24 Saucer. Diam. 12 cm

Fig. 4.25 Saucer. Diam. 13.5 cm

Fig. 4.26 Saucer-dish. Diam. 17.5 cm

Fig. 4.27 Dish. Diam. 39.5 cm

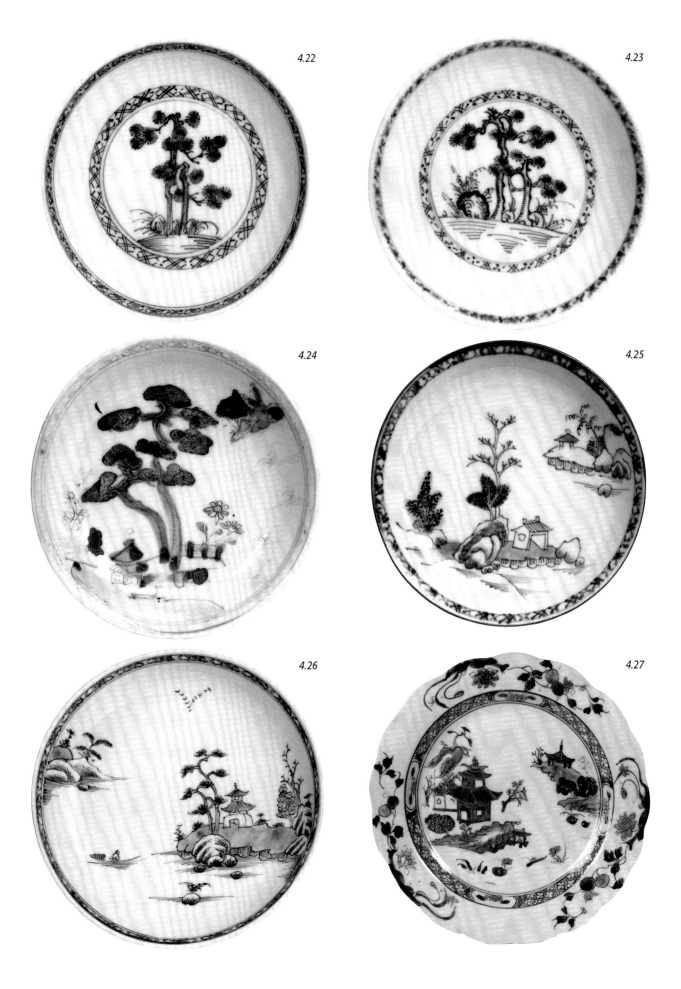

4.22

4.23

4.24

4.25

4.26

4.27

boo and others peonies. Still, in assembling his compositions the painter is bound by rules and conventions. For example, no chrysanthemum is seen without a fence and no bamboo lacks its garden rock; a pavilion must never be in the background if none is in the foreground.

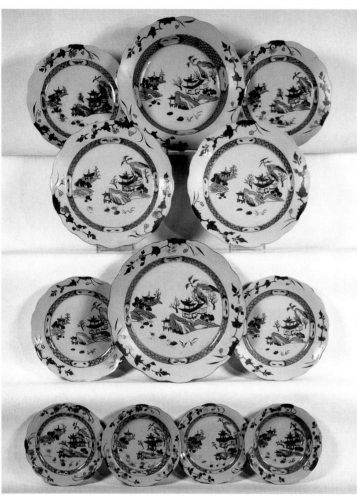

Fig. 4.28 Plates from a dinner set. Diam. from 22.5 to 39.5 cm

The distinct character and adaptability of each module permits the painter to combine it with others on very different surfaces. The same pine trees painted in the center roundels of the saucers in Figures 4.22 to 4.24 also occur on the curved outsides of the bowls that accompany those saucers. For the latter, the trees have been adapted to a decorative field of a completely different shape. Even on globe-shaped teapots one meets the familiar willows, garden rocks, fences with chrysanthemums, and oversized peonies as well as the distant promontories with pavilions (Fig. 4.29).

The adaptability of motif modules proved to be a boon when it came to sets. It allowed the painters to achieve an aesthetically satisfying unity among porcelain pieces of different sizes and shapes, and it enabled the user to identify pieces that belong together. Ranging in diameter from 22.5 to 39.5 centimeters, the plates assembled in Figure 4.28 exemplify this.

Since antiquity, tableware in China has been made and used in sets. The ritual bronzes of the Shang period came in sets and so did the secular lacquerware of the Han dynasty. When a Song emperor gave a party in his palace garden, all dishes were arranged on the table in regular rows,[54] and the ceremonial ware that Jingdezhen provided for state ceremonies during the Ming came in sets, too (see Fig. 4.9). The use of tableware in sets emphasizes the character of a meal as a social event. Sets also make sense economically. The makers prefer sets because they lend themselves to a more rationalized production than do single pieces. Traders like them because customers tend to acquire greater numbers of pieces if they buy them in sets rather than one by one. These simple laws of economics remained equally significant when it came to exporting porcelain to the West.

The custom of using tableware in sets began to spread in Europe in the late medieval period as eating habits became more civilized. Yet European dinner sets did not match their Chinese counterparts with regard to the system of types and shapes, the unity of decoration, and the sheer quantity of pieces. The use of dinner sets to advantage was again something Europeans seem to have learned from the Chinese.[55]

The 171 dinner services mentioned at the head of the *Geldermalsen* packing list, however, made up only a small portion of the ship's porcelain cargo. It is not clear how many pieces those sets comprised. A comparable shipping invoice of 1750 lists sets with up to eighty-four items.[56] As was typical for export ware of ordinary quality, retail sets would probably have been assembled for sale from the bulk of the *Geldermalsen* porcelain, had its

shipment arrived in Amsterdam in 1752 as planned. This is what the auctioneers at Christie's used when, after some delay, they proceeded with the sale in 1986. Custom-made porcelain, decorated with the coat of arms of certain families, was always ordered in sets, each on average comprising two hundred pieces.[57]

Another advantage of the modular system of porcelain decoration was that it allowed for painters of many levels of skill and experience. When looking at the series of decorative patterns that lead from the simplest motif to the complex composition, one might conceivably follow step by step the progress of an apprentice in the factory. Having first learned how to paint a few petals, he might have been promoted to flower arrangements, garden scenes, and in the end, landscapes. In this way new painters could enter the production line smoothly and perform valuable tasks from the very beginning.

Finally, there is the issue of iconography. Apparently, the repertoire of motifs was extremely limited. There are no surprises among those 150,000 pieces in the *Geldermalsen* cargo. Sunflowers or lions do not turn up. A fair degree of iconographic variety is achieved nevertheless, because certain motifs like bamboo or peonies are interchangeable, as are whole decorative fields. Yet it would be futile to seek an iconographic purpose behind the combinations of motifs and scenes. Decoration on coffee cups does not differ from that on tea bowls.

Nonetheless, an overall iconographic dimension does pertain to the decor of the *Geldermalsen* porcelain. All motifs embody values of the literati, the educated Chinese officials. Bamboo and rock are symbols of an official's upright character and steadfastness. A fence with a chrysanthemum is a specific allusion to a poem by Tao Qian (365–427), the archetypal recluse, who left office voluntarily to enjoy the rural life. Countless other more or less successful officials took refuge from the burdens of their duties at their country homes. A landscape was the symbol of a world without worries—a paradise. In politically adverse situations, scholar-officials spent leisure time with poetry and the arts, and found comfort in the life of simple fishermen. This iconography admits no reference to specific historic events, or to figures and episodes that could be construed as touching on politically sensitive issues.

For a Chinese user, the decor on porcelain dishes imbued them with a literary aura. On a less specific level, the same iconography had a universal appeal. Westerners who did not recognize the allusion to Tao Qian's poem were still able to appreciate the positive values embodied in these decorative patterns, the beauty of serene flowers, and the atmosphere of quiet scenery. The apolitical and unhistorical character of the decoration on much Chinese export porcelain is another reason why it was so successful all over the globe, in mansions of Dutch merchants as well as the household of Martha Washington at Mount Vernon.[58]

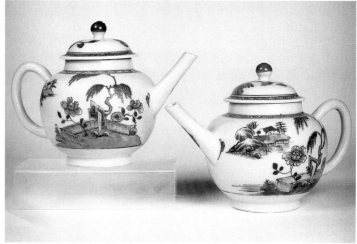

Fig. 4.29 Two globe-shaped teapots, blue-and-white ware. W. 21 cm

Albums and Eyewitnesses

In addition to the pieces themselves, illustrations provided a source of information from which westerners could learn about the mass production of porcelain in China. Albums containing as many as fifty leaves, each depicting a distinct stage in the production process, were the most common format in which such documentary evidence was found. The sequence usually begins by showing how the raw material is retrieved from somewhere in the hills. Then, step by step, the painters of the album leaves present how the material is shaped, glazed, fired, painted, and finally sold.

China has a long pictorial tradition of illustrating the stages of particular production processes. Other products whose production has been illustrated are cotton, salt, tea, paper, and ink. The first albums of this type, made under imperial patronage, were those devoted to illustrations of the cultivation of rice and the manufacture of silk (*gengzhitu*). The fact that the Chinese chose to develop such subject matter at all demonstrates, once more, how intensively they thought about the division of labor.[59]

From the eighteenth century on, some porcelain albums made their way to Europe. European traders even commissioned Chinese craftsmen to paint such albums, from which they certainly hoped to learn something about the production process. Figures 4.30 to 4.34 show five of the twenty-three leaves from an album that was probably painted for export in the second half of the eighteenth century. The text is a commentary written in French in 1821.[60]

Figure 4.30 represents step nine: two workers mix the porcelain material, while in the center of the hut a potter throws a vessel on a large wooden wheel. Rows of pots have been left to dry on wooden boards under the roof of the hut. The boards are later carried to racks in the back of the building.

In Figure 4.31 (step 12), a worker embellishes plates. He is paring the foot ring and will perhaps carve a pattern into the body before the two workers at the front dip the pieces into the glaze. No underglaze-blue design is applied in this case.

After further preparation, the glazed pieces are placed in saggars, then into a kiln, where they are fired (Fig. 4.32; step 15). A worker on a ladder pokes through a hole into the kiln with an iron hook. He opens one of the saggars to check on the firing process. He can gauge the temperature from the color of the fuel.

The fired ware is then transported to the paint shop (Fig. 4.33; step 18), where five workers are busy applying the overglaze colors. They work simultaneously on different plates, some painters

Figs. 4.30–4.34 Five of twenty-three leaves from an album illustrating porcelain manufacture, 2nd half 18th century. Ink and color on paper, each leaf 37.5 × 30.5 cm. Schloß- und Spielkartenmuseum Altenburg, Saxony

Fig. 4.30 (below) Step 9: Mixing clay and throwing bowls

Opposite:
Fig. 4.31 (top, left) Step 12: Paring foot rings and glazing

Fig. 4.32 (top, right) Step 15: Cutting firewood and checking kiln temperature

Fig. 4.33 (bottom, left) Step 18: Painting overglaze decoration, with protesting worker

Fig. 4.34 (bottom, right) Step 22: Packing barrels and weighing silver

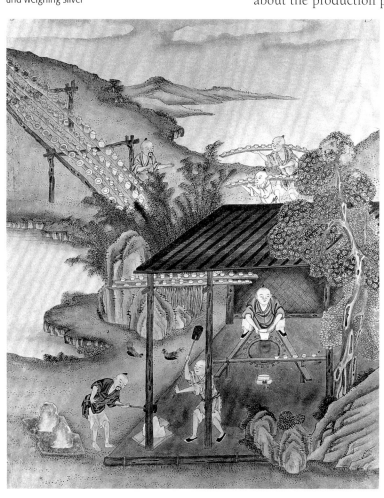

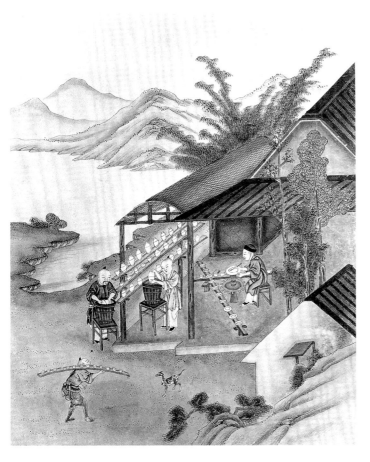

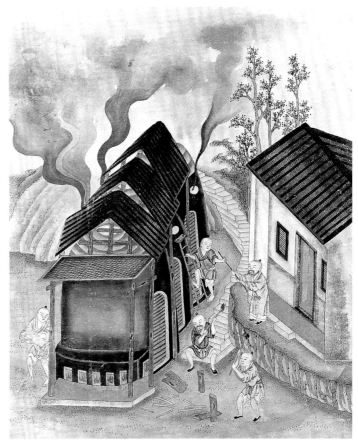

decorating the roundels while another one adds detail to the rim. In the foreground, two men, restrained by two others, are engaged in argument. One may be a worker protesting the large number of pieces he has to replace because they were found to be faulty.[61]

After a second firing, the finished dishes are packed into barrels that await transport (Fig. 4.34; step 22). The head of the factory weighs the silver he has received from the merchant. The corresponding leaf in another album depicts European traders handing two sacks of money to the Chinese dealer.[62]

Charming as they are, these albums were not suitably explicit to answer all the questions of curious European porcelain makers. The Chinese painters followed conventions that had been established by the imperial albums that glorified the production of rice and silk under a benign ruler. But the purpose of those was to portray the workers as a happy lot in pleasant surroundings, not to illuminate technical details. Even the explanations that accompany the illustrations in the porcelain albums were only moderately instructive.

Nevertheless, the albums made the point that porcelain production in China was a highly systematized, sequential process, and that it involved a strict division of labor. In order to learn more about the inner workings of this system, the Europeans had to tap a third source: eyewitnesses.

The most detailed account was given by the French Jesuit missionary Père François Xavier d'Entrecolles (1664–1741). His various reports from China, which were included in the famous Jesuit collection *Lettres édifiantes et curieuses de la Chine,* dealt with all kinds of themes, such as the raising of silkworms and the inoculation for smallpox. In 1712 and 1722 he wrote two long letters on porcelain production in Jingdezhen, relying in part on information from Christian converts in the porcelain trade. The Jesuit Jean Baptiste du Halde included the two letters in his monumental and influential *Déscription de la Chine,* which was published in Paris in 1735–39 and soon translated into other languages.[63]

D'Entrecolles describes vividly how at night smoke and flames rising from the countless kilns made the entire city of Jingdezhen look like one huge furnace with many vent holes. He gives painstaking accounts of the origin and quality of the raw materials; he talks about the construction of the kilns, the shapes of the saggars, and the properties of the colors for overglaze enamels; he comments on the economy of the porcelain trade, and draws attention to ecological problems like the depletion of trees in the area, and the challenges entailed in disposing of the great masses of faulty and broken pieces.

Most astute are d'Entrecolles's observations on the techniques of mass production. He personally knew the inside of the factories, as he often went there to preach. (Most aptly, he explained to his audience that God had fashioned the first man out of earth.) He describes with great accuracy how molds are used to standardize and duplicate shapes, how large pieces are assembled from prefabricated parts, and how the work is divided among rows of potters and painters.[64] One piece is said to go through the hands of seventy individuals, being worked at by twenty of them before even entering the kiln.[65] Decent jobs are also allotted to the blind and crippled, who gain their livelihood by grinding pigments.[66]

A number of painters work in any given factory. One does nothing but paint the rims of the pieces; another traces the outlines of flowers, which a third one paints; still others specialize in birds, animals, and landscapes.[67] The missionary notes that those Christians employed at kneading the clay could hear Mass only when they were able to provide a substitute worker, because even the briefest absence would have disrupted the production process.[68]

Père d'Entrecolles also sent samples of Chinese raw materials back to France, where they were analyzed by the eminent physicist René-Antoine Ferchault de Réaumur (1683–1757).[69] Obviously, European interest in Chinese methods of porcelain production was never merely an academic affair.

China in Europe

Masses of porcelain like that from the *Geldermalsen*—indeed, those from all the many shipments that had transpired since the beginning of the seventeenth century—made Europeans aware of the Chinese proficiency in producing large numbers of pieces. At least to Western eyes, they were of astonishing quality. Europeans who ordered albums that illustrated the separate steps in a production process, and Père d'Entrecolles, who familiarized himself with chain production in Jingdezhen, must have realized that the secret lay in the Chinese methods of mass production. D'Entrecolles wrote his letters at the very time that Augustus the Strong was organizing the first European porcelain factory at Meissen.

It seems no accident that it was during the seventeenth and eighteenth centuries, which saw the rise of state factories in France and the beginnings of the industrial revolution in England, that Europe admired China intensely and was intent on learning from it. A case has been made that the introduction of the civil service system in eighteenth-century France and Britain, and the substitution of written for oral examination, was inspired by the Chinese model.[70] The same reasoning may apply to the French *manufactures* set up by Jean-Baptiste Colbert (1619–1683) and run by the state, the tight regulations of which guaranteed a high standard of workmanship. In Europe, the invention and introduction of machines led to the substitution of mechanical operations for manual work on a large scale. Yet machines were not the only factor that brought about the industrial revolution. The organization and control of the workforce and the techniques of division of labor were also essential.

In 1769, Josiah Wedgwood (1730–1795) established at Staffordshire, England, the first porcelain production in Europe to enforce factory discipline and make full use of division of labor. Each of his workers had to be expert in only one part of the production, which was a revolutionary concept at the time.[71] Wedgwood derived the idea from his reading of the letters of Père d'Entrecolles.[72]

How the acquaintance with Chinese export porcelain and such accounts as that of d'Entrecolles changed ceramic production in Europe needs further investigation. It might reveal that the Chinese model was, to a much greater degree than previously thought, responsible for the surge of modern mass-production techniques in the West.

5 Building Blocks, Brackets, and Beams

Much of Chinese architecture is made of wood, and much of wooden architecture is of post and beam construction. In this type of construction, the weight of the building and, above all, its roof, are supported by vertical wooden columns rather than by the walls between them.

Post and beam construction has a long history in China. It is older than porcelain, lacquer, and bronzes; older even than the Chinese script. Over thousands of years, incalculable numbers of wooden buildings have been erected all across that vast land and beyond its borders, notably in Korea and Japan.

Post and beam architecture has three main advantages: it is economical since wood grows—or, more accurately, grew—in abundance in China, and because it is easier to transport and to work with than stone. Timber is also very strong. Pound for pound, the white cedar wood that the Chinese have used most frequently has about four times the tensile strength of steel and its resistance to compression is about six times that of concrete.[1] Third, post and beam construction lends itself to the development of a modular system. This again engenders many advantages, one being versatility. It can be adapted to many architectural functions and is suitable for various climatic conditions.

Foguangsi Main Hall

The analysis of the pervasive post and beam system begins with a close look at one prominent example, the main hall of the Buddhist monastery Foguangsi. It was erected in A.D. 857 about two hundred kilometers southwest of today's Beijing in the sacred mountains called Wutaishan in a remote area of Shanxi Province. It is the second oldest wooden building still standing in China.[2]

The rectangular hall rests on a substructure of stone at the rear of a courtyard (Fig. 5.2). Due to the mountainous terrain, the buildings in the

Opposite:
Fig. 5.1 Workmen restoring the Hokkiji pagoda, May 1974

Fig. 5.2 Front view of Foguangsi main hall, A.D. 857, Shanxi Province

courtyard are not aligned in the usual north–south orientation, but rather from east to west. As the visitor approaches the main hall from the west, he mounts a flight of steps and faces the impressive thirty-four-meter-wide front of the building (Fig. 5.3). Its seven bays are separated by wooden columns. In the five center bays, doors open into the interior. The corner bays have latticed windows above brick walls between the columns. The center bay is slightly wider than the other six, the corner bays are a bit narrower than the center ones. The height of the pillars increases almost imperceptibly from the center to the corners, and all pillars lean inward slightly. These features add to the impression of an imposing magnitude. The visitor's path leads straight toward the central bay. Above the door a wooden plaque hangs in front of the bracketing (see Fig. 5.7). Written in large characters is the name of the hall: MEDITATION MONASTERY OF THE TRUE FACE OF BUDDHA RADIANCE (*Foguang zhenrong chansi*).

As the ground plan shows (Fig. 5.4), the building is strictly symmetrical. The hall is four bays deep, totaling 17.66 meters. Thick brick walls running along the sides and rear embed the columns and are interrupted only by

Fig. 5.3 (left) Foguangsi main hall, front elevation

Fig. 5.4 (right) Foguangsi main hall, ground plan

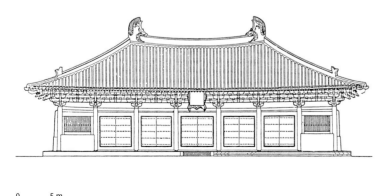

0 5 m

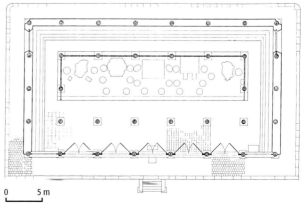

0 5 m

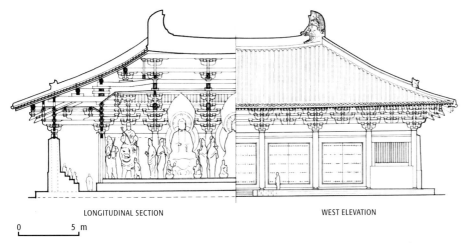

LONGITUDINAL SECTION WEST ELEVATION

0 5 m

two more windows at the far end of each side. These walls protect the interior from the severe cold of a Shanxi winter.

The fourteen columns in the interior form a rectangle of five-by-two bays. A large altar platform more than one bay deep fills the entire width of this inner space. Various colossal icons from the Buddhist pantheon are seated or stand upon the platform in symmetrical and hierarchical order. The principal Buddha occupies the center, resembling an emperor on his throne receiving his subjects in audience. In the empty space in front of the platform the liturgy can take place and the supplicant may make his obeisance. A space about one bay wide between the platform and the side and rear walls further allows the devout Buddhist to walk around the platform in order to pay further respect to the elevated figures.

The building merely provides a shelter for the holy icons, protecting them from the elements and allowing the visitor to approach and venerate them in a solemn and ordered way (Fig. 5.5). These functions also determine the construction of the interior.

The drawings of the front elevation (Fig. 5.3), longitudinal section (Fig. 5.5), and interior construction (Fig. 5.6) show the four distinct zones within the elevation of this hall. The foundation is made of stone and earth.

Fig. 5.6 Foguangsi main hall, interior view

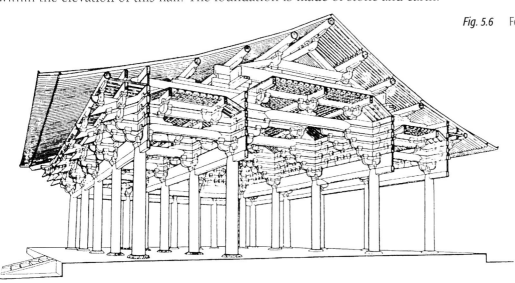

It comprises the substructure and terrace, and also includes the stone bases for the columns. The terrace elevates the building, thereby adding to its dignity and protecting it from water running on the ground. The feet of the wooden columns rest on the stone bases and do not extend into the terrace, which helps the building withstand the potentially devastating sudden shocks of an earthquake. The entire structure may sway in an earthquake, but it is unlikely to collapse.

Above the stone bases rises the building proper. The main body of the single-storied structure is determined by the height of the circular columns. The tops of the twenty-two outer columns are connected by a frame of tie beams in the walls. Another stabilizing frame also connects the columns in the interior.

On top of the column network begins the third zone, the bracketing (Fig. 5.7). The brackets project vigorously out from the wall plane and carry the weight of the roof down into the columns. The bracketing zone is so large that, measured from the top of the columns to the eave purlin at the exterior, its height equals about half that of the columns. Massive bracketing clusters atop the columns alternate rhythmically with simpler intercolumnar units. Transverse cross beams connect the columns in the wall plane to those inside. The brackets above the interior columns build up in four tiers that project toward the center of the building, and eventually support robust cross beams that span the two-bay-deep central area. The resultant unobstructed space can accommodate the platform with the holy icons, whose heads and halos can reach high above the level of the column tops.

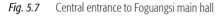

Fig. 5.7 Central entrance to Foguangsi main hall

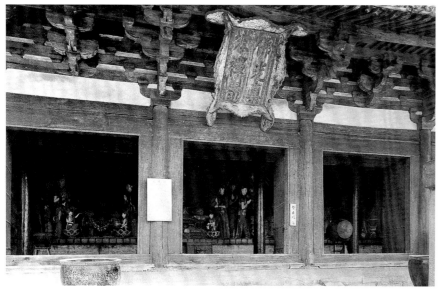

The majestic hipped roof makes up the fourth zone. The roof frame is composed of rough logs that are concealed from view by the delicate grid of a reticulated ceiling. Running parallel to the ridge pole, the purlins are spaced at regular intervals, either just above the rows of columns or exactly in between. The purlins support rafters that in turn carry the heavy tiles.

The dead load of the tiles in East Asia is considerable.[3] Their weight ranges from 280 kilograms per square meter in small structures to 400 kilograms in large ones. Western tile roofs weigh only about 100 kilograms per square meter. The heavy roof load is required to give the building its necessary inertia in a storm. A Chinese post and beam structure is far more seriously affected by gusty winds than a typical Western stone structure because its body is lighter and is not anchored in the ground.

The various wooden members in this sophisticated structure are not joined with nails but with mortises and tenons. This lack of rigidity imbues the entire building with a precarious stability, at once amazingly flexible and robust. Again, the main purpose is to protect the structure during

earthquakes. The builders apparently hoped that the internal friction of the many joints would absorb and dampen the earthquake's shocks. They seem to have been right: the hall has been standing more than eleven hundred years in "sturdiness and masculine grace." [4]

The Five Levels in the System

The main hall of Foguangsi is a fine specimen in the pervasive and all-encompassing system of Chinese post and beam architecture. The system comprises several levels of increasing complexity. One can distinguish the five levels of bracketing, bays, buildings, courtyards, and cities, each of which merits a closer look at its technical aspects as well as some economic and social implications. [5]

Bracketing

The bracketing is a complicated and, to Western eyes, peculiar part of post and beam structures. It is made up of blocks, brackets, and beams. Figure 5.8 presents a series of schematic drawings that illustrates an idealized sequence from simple to complicated units. [6]

Fig. 5.8a shows the simplest type. This unit consists of a vertical post, a horizontal beam, and a bracket. Between the vertical post and the horizontal lintel whose weight it carries, the cushioning bracket has been inserted, thus avoiding undue stress at a single point. The contact surface is increased and the length of the lintel's unsupported span is reduced.

In Fig. 5.8b a square block has been added. Its lower half is molded to reduce its cross section to match that of the column below. A transverse beam also rests in this block. Its end cuts through the wall plane.

Three bearing blocks (*dou*) are inserted between the bracket arm (*gong*) and the wall purlin in the next stage (Fig. 5.8c). The new blocks are smaller than the single block below them. The bracketing system as a whole is commonly known as *dougong*.

In Figure 5.8d a second block-bearing bracket arm has been set into the lower block at a right angle to the wall plane, thereby forming a cross with the first bracket arm. The second arm supports the transverse beam, which, for reasons of balance, now extends out of the building considerably beyond the wall plane.

In the next drawing (Fig. 5.8e), the transverse bracket arm that extends from the wall carries at its outer end an additional longitudinal arm with three bearing blocks. A purlin running beneath the eaves is

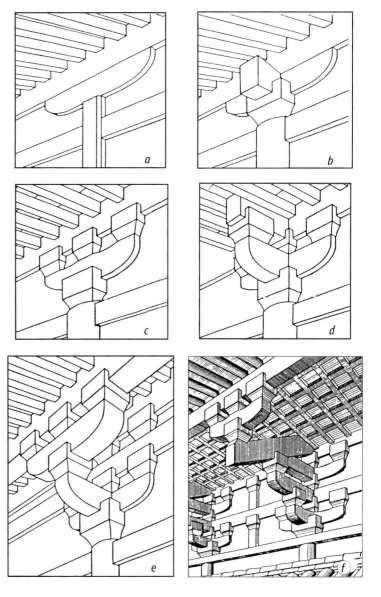

Fig. 5.8a–f Schematic drawing showing the development of bracketing

inserted into the blocks. Here, for the first time, the roof is supported beyond the plane of the wall. Within the wall plane itself, the bracketing develops in two vertical tiers.

As the bracketing units become more elaborate, they extend beyond the wall plane in additional steps, and more tiers are added vertically. Only one new type of beam is added (Fig. 5.8f). This diagonal beam, called *ang*, runs parallel to the slanting roof.

The last two drawings in the series (Figs. 5.9, 5.10) illustrate an example of the bracketing units that are set atop the outer columns of Foguangsi. On the exploded drawing (Fig. 5.10), one can count twenty-one square blocks, eight bracket arms, eleven horizontal beams (eight longitudinal and three transverse), and two diagonal *ang* arms.

Fig. 5.9 Foguangsi main hall, bracketing cluster

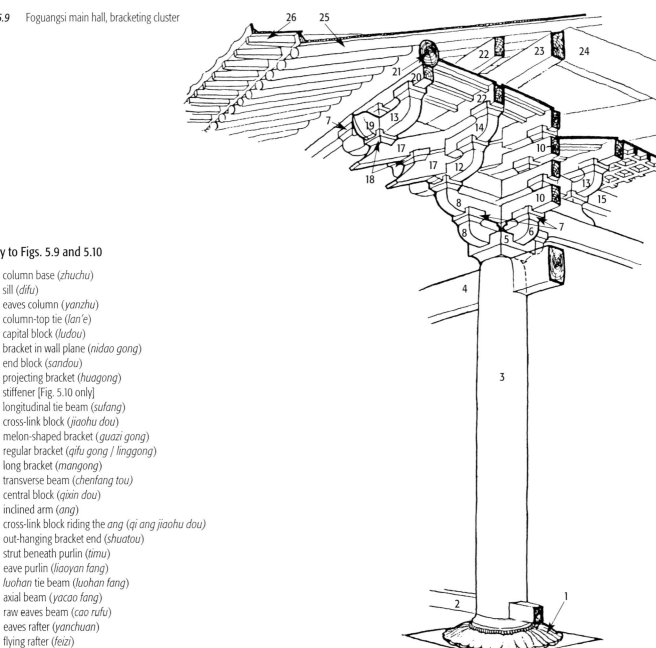

Key to Figs. 5.9 and 5.10

 1 column base (*zhuchu*)
 2 sill (*difu*)
 3 eaves column (*yanzhu*)
 4 column-top tie (*lan'e*)
 5 capital block (*ludou*)
 6 bracket in wall plane (*nidao gong*)
 7 end block (*sandou*)
 8 projecting bracket (*huagong*)
 9 stiffener [Fig. 5.10 only]
10 longitudinal tie beam (*sufang*)
11 cross-link block (*jiaohu dou*)
12 melon-shaped bracket (*guazi gong*)
13 regular bracket (*qifu gong / linggong*)
14 long bracket (*mangong*)
15 transverse beam (*chenfang tou*)
16 central block (*qixin dou*)
17 inclined arm (*ang*)
18 cross-link block riding the *ang* (*qi ang jiaohu dou*)
19 out-hanging bracket end (*shuatou*)
20 strut beneath purlin (*timu*)
21 eave purlin (*liaoyan fang*)
22 *luohan* tie beam (*luohan fang*)
23 axial beam (*yacao fang*)
24 raw eaves beam (*cao rufu*)
25 eaves rafter (*yanchuan*)
26 flying rafter (*feizi*)

The above sequence of figures makes it clear that even complicated bracket clusters contain just four basic types of wooden members: blocks, bracket arms, and horizontal and diagonal beams. (The odd auxiliary piece, such as a stiffener, may be added here and there.) Each of the four main types exists in a small number of variations or subtypes. Bearing blocks, for example, come in a handful of sizes, the largest of which are tenoned into the tops of columns, with smaller ones sitting on various bracket arms higher up.

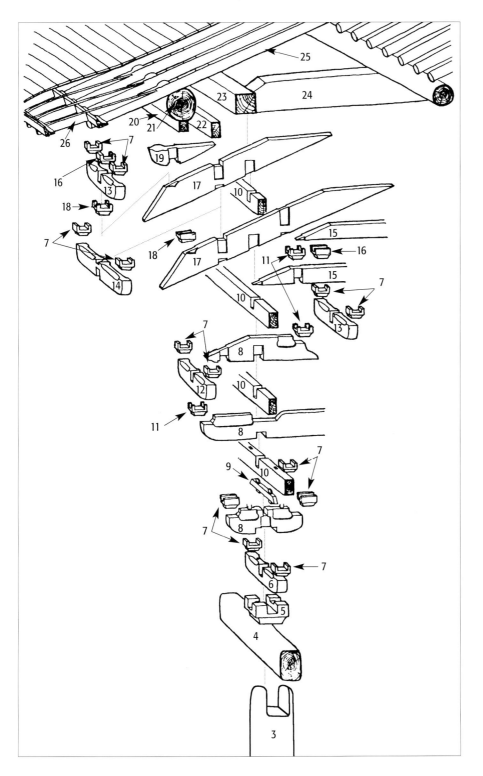

Fig. 5.10 Foguangsi main hall, explosion drawing of bracketing cluster

Their mortises differ depending on whether they support a single bracket arm or two crossing arms. Similarly, there are a handful of bracket arm types, selected for various positions in the cluster.

Each of these prefabricated members has a distinct and relatively complicated shape—much more complicated than, say, bricks. They are assembled in different combinations according to the position and function of the respective units in the building. In Foguangsi, for instance, two types of units are in the planes of the outer wall: one is on top of the column head, and a rather more simple unit occurs between the columns. The units above the interior columns are more elaborate than those above the exterior columns, and the most complex ones are those in the corners. Altogether seven different types of bracketing units are found at Foguangsi.[7]

Larger clusters within one building are not formed by enlarging the members proportionally but by increasing their numbers. All additional wooden members are selected from the same small repertoire of four basic types, all of which clearly lend themselves to standardized production on a large scale, and which can be used in various buildings. How far the standardization goes in actual practice will be investigated later in this chapter. For the moment, suffice it to sum up that blocks, brackets, and beams are, in a word, modules.

The complicated bracketing system is necessary for several reasons. Above all it serves to protect the construction from the elements: earthquakes, rain, and sun. As mentioned above, mortise-and-tenon construction imbues a wooden structure with flexibility and sturdiness, which helps it withstand earthquakes. The internal friction of the many joints in the bracketing zone is vital for dampening and disseminating the force of sudden shocks, especially horizontal ones.

Because a bracketing system allows the roof to extend far beyond the wall plane, it protects the wall from rain. As the columns are wooden, and therefore sensitive to moisture, this is necessary. Wattle and daub walls are often made of willow branches, which are then covered with mud and white plaster, materials that are also vulnerable to heavy rain and snow. Since worshippers do not like to get wet when standing in front of the doors, the overhanging roof protects them and the walls from rain as well as from piercing sunlight at noon, when it is most intense. Beyond their practical function, the slanting and often slightly curved roof shapes have an aesthetically pleasing effect. They lend an imposing yet graceful silhouette to the entire building.

Supporting a wide overhanging roof in this way was one of the principal structural problems that the Chinese builders faced, and it was aggravated by the necessity for it to bear the heavy weight of their tiles. Developing a bracketing system to solve this problem makes sense structurally, but it also proves to be the most economical solution. Assembling the supporting structure from a great number of small members instead of from large beams allowed the builders to make best use of the available timber. Because they reduced the need for long beams, they did not have to cut so many large trees, and therefore did not have to wait so long for their trees to grow to the required size. By decreasing the length of unsupported spans,

horizontal beams could be thinner and the trees correspondingly younger when harvested. And since the builders used many small blocks and brackets, less wood was wasted. As an additional benefit, the overall weight of the structure was decreased, which again allowed all parts to be reduced in size and weight and led to further savings.

The Chinese builders thus made best use of the timber resource. They could erect larger structures and more buildings with a given amount of raw material. Their method, however, was very labor-intensive and demanded a high level of skills. Faced with the choice of using either more wood or more labor, the builders chose the latter. The Chinese have never shied from investing human labor and intelligence on a large scale in order to make up for limited natural resources.

Bays and Buildings

The next level of complexity in the post and beam system is the bay (*jian*). In the elevation (see Fig. 5.3), a bay is the span between adjacent frame supports. On a ground plan (see Fig. 5.4), it is the rectangle enclosed by four columns at its corners. Longitudinal tie beams connect the columns from above, where they cut through and become part of the bracket clusters.

The level that follows the bay is the building itself. The simplest structure—a small pavilion, for example—consists of only one bay. Most buildings, however, comprise several bays, which are grouped in rows, and primarily follow rectangular ground plans. The standard building is the hall, typically a symmetrical, oblong structure on a platform, like the main hall of Foguangsi. Yet the Foguangsi hall is an exception in that, for topographical reasons, it faces west. Normally Chinese halls face south with their ridge pole running from east to west. The long southern side has an odd number of bays, causing the central door to lie on the main axis.

The reasons for facing halls toward the south are, as so often in China, both practical and symbolic. A southward orientation makes for maximum exposure to the bright, warm sun. The wide overhanging roof will still allow the rays of a low winter sun to reach the building, while in the summer it shields against the burning heat from above. In the archetypal hall—the palace hall—the ruler exercised government from his throne in the north. Facing south, he received his subjects in audience in accord with Confucius' famous metaphor comparing the moral ruler to the Pole Star.[8] An emperor who looked out from his palace hall in Beijing, the northern capital, had virtually the entire empire before his eyes.

The bay system allows great flexibility. It is easy to add or take away one bay or one row of bays, thereby changing the size of the building, as the ground plans in Figure 5.11 demonstrate. The relation of bay to building is that of module to unit.[9]

When the number of bays increases, the size of the bays grows in proportion as does the size of all wooden members. An organic relation between

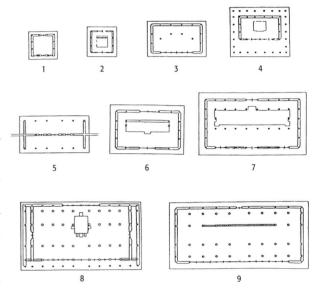

Fig. 5.11 Ground plans of various halls

1 Zhenguosi, Ten Thousand Buddhas Hall, A.D. 963
 Pingyao, Shanxi Province
2 Qingliansi, Main Hall, 1102
 Jincheng County, Shanxi Province
3 Kaishansi, Main Hall, 1033
 Xincheng, Hebei Province
4 Jinci, Holy Mother Hall, 1023–32
 Taiyuan, Shanxi Province
5 Changling, Mausoleum of Emperor Yongle,
 Gate of Awesome Grace, 1409
 Changping County, Hebei Province
6 Shanhuasi, Hall of the Three Dieties, 1128–43
 Datong, Shanxi Province
7 Fengguosi, Daxiongbao Hall, 1019
 Yixian, Liaoning
8 Imperial Palace, Hall of Supreme Harmony, 1695
 Beijing
9 Changling, Mausoleum of Emperor Yongle,
 Hall of Awesome Grace, 1409
 Changping County, Hebei Province

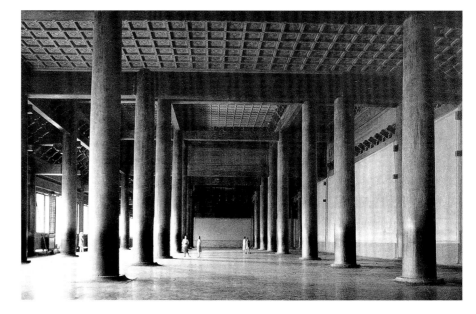

Fig. 5.12 Changling, Mausoleum of Emperor Yongle (r. 1403–24), Hall of Awesome Grace, 1409. Changping County, Hebei Province

the building and its parts is thus achieved. In large structures all parts are large. The main hall in Changling, the mausoleum of Emperor Yongle (r. 1403–1424), is nine bays wide and five bays deep, measuring 66.75 by 29.31 meters (no. 9 in Fig. 5.11). It is one of the two largest wooden buildings in China (the other being the Hall of Supreme Harmony, Taidian, in the Beijing palace, no. 8 in Fig. 5.11). The columns in the interior are enormous (Fig. 5.12).[10]

The flexibility of the ground plan in the bay system is further enhanced by the flexibility in the elevation that any post and beam construction enjoys. As the walls between the columns of a bay do not carry weight, they may have windows or doors or even be taken out altogether. This allows much freedom in adapting a building to different needs.

Figure 5.13 shows the ground plan of the Golden Hall (Kondô) of the Tôshôdaiji monastery in Nara, Japan. It was built shortly after the Chinese immigrant priest Jianzhen, or Ganjin in Japan, founded the monastery in A.D. 759, and it closely follows Chinese models. Like the main hall of Foguangsi of a century later, the plan of the Golden Hall is seven bays wide by four bays deep, with five doors at the front. In contrast to the Chinese hall, however, the front wall in the Japanese building is set not between the first row of columns but between the columns one row back. Thus, an open porch one bay deep runs all across the front (Fig. 5.14). The difference from the Chinese hall may be due to different ritual needs. In the Japanese hall the participants in the liturgy, who are not allowed to enter the

Fig. 5.13 Ground plan of Tôshôdaiji, Golden Hall, after A.D. 759, Nara Prefecture, Japan

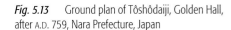

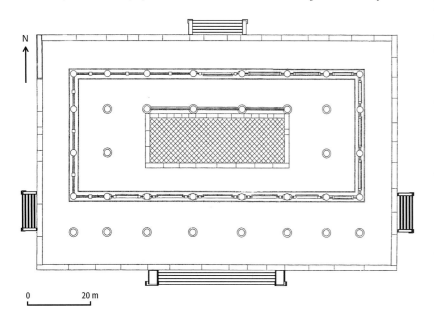

0 20 m

building proper, can at least witness the ceremony while being protected by a decent roof.[11]

The same ground plan may also be used for quite different functions. For example, plan 5 of Figure 5.11, which measures five by two bays, would be suitable for an oblong hall. Yet in this case there are no longitudinal walls at front or back. The single wall, which has been set between the columns of the middle row, is interrupted by three doors at its center, which turns the structure into a gate.

Courtyards

The next level of complexity is that of the courtyard. Much as ritual bronzes and lacquer dishes come in sets, Chinese buildings do not stand alone but are assembled in courtyards. Once more, the relation of building to courtyard is that of module to unit. A courtyard is laid out according to certain principles. It is symmetrical and enclosed by a wall. As a rule it faces south. Its main building is a hall at the rear with an open space in front of it. Secondary buildings at the eastern and western sides face the yard. One enters the courtyard through a gate to the south, and approaches the main building by means of the central axis.

The standard type of courtyard, with buildings at the four sides, is called a fourfold yard (*siheyuan*; Fig 5.15). Since evil spirits are believed to find it hard to turn corners, the gate leading to the street is often placed at the side so that they may not enter the yard. Neighbors and passersby are also conveniently prevented from peeping inside. This basic compound can grow by adding more buildings and more courtyards, but such additions will also conform to the principles of axiality and hierarchy.

The enclosed courtyard is the dwelling space for the family—that particularly noteworthy unit in China's social fabric. Large courtyards are inhabited by extended families, including various clients and servants in addition to the family proper. Different members of this group are allocated their own respective portions of the compound. Grandparents and women tend to live in the back, servants in the secondary buildings at the sides. A functional difference also exists between front and rear. The first courtyard has a formal and official character. The master of the house resides and receives his guests in the main hall. The rear court has a private character and is reserved for the family. The architecture of the courtyard thus mirrors and, at the same time, helps stabilize social relationships among its inhabitants.

Monasteries and tombs are also laid out as courtyards. As the visitor enters from the south, he proceeds along the central axis toward the main hall, which houses the principal icon in a monastery or the ancestor tablet in a tomb. At the rear, the visitor finds the living quarters for the abbot, or, with tombs, the posthumous private quarters of the lord under his tumulus.

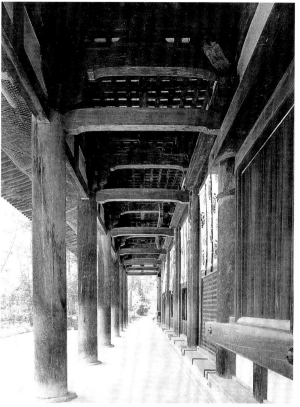

Fig. 5.14 View into porch of Tôshôdaiji, Golden Hall

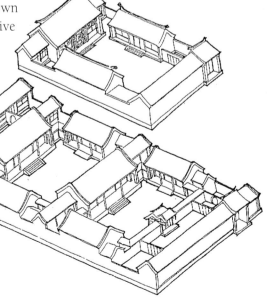

Fig. 5.15 Single courtyard and double courtyard

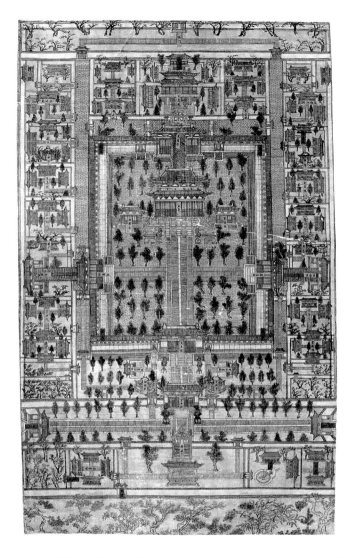

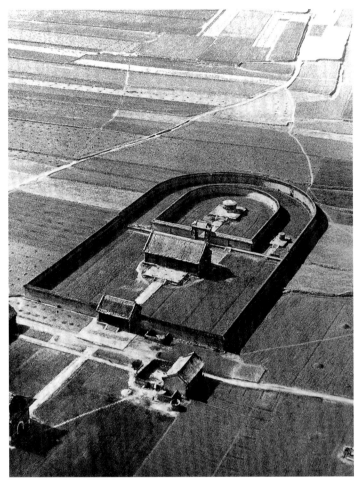

Fig. 5.16 (left) Old plan of Chongshansi, A.D. 1482, Taiyuan, Shanxi Province

Fig. 5.17 (right) Tomb compound, Qing dynasty (aerial photograph)

An old plan of the Buddhist monastery Chongshansi built in 1482 in Taiyuan, Shanxi Province, shows rows of small secondary yards on either side of the main yard (Fig. 5.16). The main hall stands toward the rear of the central court.[12] Figure 5.17 is an aerial view of a typical tomb precinct.[13] The largest courtyard in China is that of the Imperial Palace at Beijing, with its lateral rows of buildings at both sides of the main axis. From the air it looks like a computer chip (Fig 5.18).

The Imperial City

Courtyards are assembled in systematic fashion within cities, the grandest examples of which are the imperial metropolitan centers. Most famous among them is Chang'an, the modern Xian (Fig. 5.19).[14] The capital was first laid out in A.D. 582, a year after the Sui dynasty subjugated its rival, the Northern Zhou dynasty, and thus paved the way to the final reunification of the empire in A.D. 589. For three centuries Chang'an served as the glamorous metropolis of the mighty Tang Empire. With considerably more than one million inhabitants, in its time it was the largest city on the globe. Measuring

8,652 meters from north to south and 9,721 meters from east to west, its approximately square shape covered an area of more than 80 square kilometers.[15] The city was divided into a rectangular grid pattern by avenues. The main axis, the Great Vermilion Bird Avenue (*Zhuque dajie*), led from the middle gate in the southern city wall straight north for more than five thousand meters to the administrative center, the August City (*Huangcheng*) and, behind it, the Supreme Palace (*Taijigong*).[16] This avenue was 150 to 155 meters wide, while the width of the other great avenues ranged from 35 meters to over 100 meters, each of the larger ones leading to one of the great gates in the city walls.

The grid of avenues cut the city plan into 110 blocks or quarters (*fang*), each of which was squared in by its own wall and had its own auspicious name. The rectangular blocks were arranged in rows like bays in a building, and, as in a building, all rows together made up the rectangular ground plan. The blocks thus worked like modules. The small repertoire of types was distinguished by different sizes. The smallest blocks lay in the two rows immediately adjacent to the Great Vermilion Bird Avenue and measured between 500 and 590 meters from north to south by 500 meters from east to west. The largest blocks east and west of the Imperial City extended up to 838 meters by 1,125 meters. Gates gave access onto the blocks. Each of the smaller blocks in the four rows next to the Great Vermilion Bird Avenue had only two gates each, one east and one west, connected by a street (*jie*). All other blocks had two additional gates, in the north and south, connected by a second street. The streets were about 15 meters wide and crossed in the center of the block, dividing it into four quadrants. A cross of two smaller streets divided the quadrants into wards (*qu*). A standard city block thus had sixteen wards, which were further subdivided by alleys (*xiang*).

Each ward contained one or several courtyards, depending on their size and function. Inside were public agencies, monasteries, ancestor temples, and countless larger and smaller residences, the latter taking up more than 80 percent of the entire area of the city. The similarities in the layout of the courtyards made it easy to exchange functions—for instance, to convert a private residence into a monastery or a monastery into a government office.

Like every assemblage of modules, the Chang'an city plan also featured a few irregularities. In the southeastern corner was a lake and, in the north, immediately to the east of the Supreme Palace, some city blocks were cut to an unusual size in order to provide an avenue leading up to the Palace of Great Brightness (*Daminggong*), which was begun in A.D. 634 outside the northern city wall.[17] Another

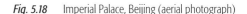
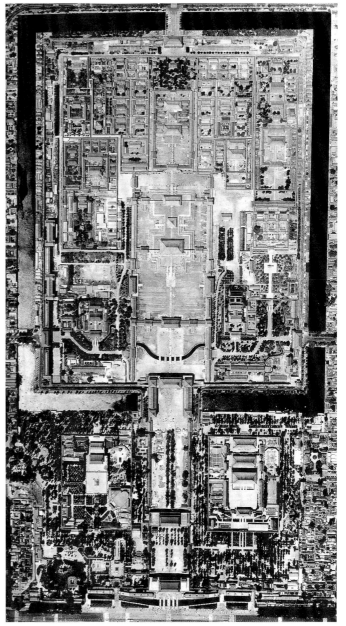

Fig. 5.18 Imperial Palace, Beijing (aerial photograph)

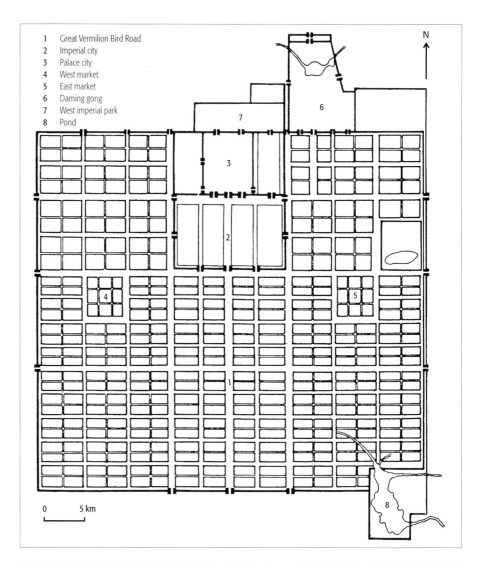

1 Great Vermilion Bird Road
2 Imperial city
3 Palace city
4 West market
5 East market
6 Daming gong
7 West imperial park
8 Pond

0 5 km

Fig. 5.19 Urban plan of imperial Chang'an

Fig. 5.20 Urban plan of imperial Rome

special case was the two large markets in the east and the west, which hosted shops selling all kinds of goods for everyday use as well as exotic products, restaurants, drugstores, wine houses, and pawnbrokers. The walled-in markets could not, however, serve as public spaces where people gathered to form and voice a political opinion. Nor was there any other space provided for such activity. The public square that is a crucial element in the urban plan of many European cities, and which played a vital role in their political life, did not exist in the tight grid pattern of the Chinese capital.[18]

The contrast of the absolutely rational plan of the Chinese capital to the plan of imperial Rome sprawling over seven hills is striking (Fig. 5.20). The Chang'an plan served as a model for other metropolitan centers in subsequent dynasties and was emulated in Korea and Japan. Even today, for instance, visitors to Beijing may sense that the planners of a metropolis in which north and south—and where one is located within the whole—are always discernible intended life to be ordered and stable.

History of the Post and Beam System

So far, our analysis of post and beam architecture has paid little attention to the historical dimension. The system has been described as if it were timeless. Obviously, it was not. Post and beam construction has its origin and story, and its components and levels developed in different epochs. Most of the examples mentioned so far date from the Tang period, the seventh to ninth centuries A.D., when post and beam construction reached maturity and all parts of the full-fledged system were first joined in organic unity. The following look at the earlier development of Chinese architecture focusses on the salient points in history when each of the five levels of the system described so far first came into existence.[19]

The oldest known wooden architecture in China was excavated at Hemudu near Ningbo, Zhejiang Province (Fig. 5.21). The site has been dated by the carbon-14 method to about 5000 B.C. It yielded remnants of wooden structures that stood on rows of stilts, the beams joined in simple mortise-and-tenon fashion. Thus some sort of timber construction existed in the Neolithic period, when wood still had to be cut with tools made of stone.[20]

Fig. 5.21 Beams from Neolithic site at Hemudu, ca. 5000 B.C.

The hall, that most typical and important building type in East Asia, was the first component of the system to appear. It has been in existence since the Shang period, as demonstrated by the reconstruction of a palace hall at Panlongcheng, Hubei Province (Fig. 5.22), which has been dated to the sixteenth century B.C. The symmetrical structure, which rested on a platform made of pounded earth, was 38.2 meters wide and 11 meters deep, including the open porch that surrounded the building on all four sides. The long side faced south, probably onto a courtyard. The hall was not yet a post and beam structure, as its walls were built up of pounded

earth that enclosed thin, closely spaced posts. Neither bay system nor bracketing existed, and the problem of how to prevent the rain from beating on the walls had yet to be solved by providing a wide overhanging roof. However, a second, smaller roof was added beneath the main roof, the existence of which archaeologists infer from the presence of rows of small holes for the supporting posts.[21]

A double courtyard in an eleventh-century B.C. palace of the Western Zhou rulers has been unearthed near Qishan, Shaanxi Province (Fig. 5.23). The symmetrical compound faces south and, to east and west, was flanked by rows of eight rooms. The first yard measures twelve meters from south to north and likely served public functions. The rear yard was more intimate. A covered corridor divided it into two squares, each of which measured eight meters on a side. The main hall stood between the two courtyards and, like all the other buildings, was a post and beam structure, although its pounded walls may still have carried some of the roof weight. The columns in the grid of six by three bays were fairly regularly spaced.[22] Thus, by the eleventh century B.C., the three middle levels of the five-level system—bay, hall, and courtyard—were in place. The lowest and the highest levels—bracketing and city plan—had yet to be developed.

From the middle of the first millennium B.C. onward, bracketing gradually became elaborate. No original examples survive from this early period, and textual evidence is vague, but visual evidence exists on various decorated objects.[23] Engraved on some bronze vessels of the sixth to fifth centuries B.C. are pictorial scenes that include depictions of buildings with small bracket units between column tops and the roofs.[24] Bracket arms were also illustrated on lacquer utensils from the period.

Objects of bronze or clay incorporate three-dimensional miniature bracketing. Delicate bracket arms with two blocks support the corners of a late-fourth-century B.C. bronze table from the tomb of King Cuo of Zhongshan Kingdom.[25] Countless ceramic models of towers and other buildings in tombs prove that the basic bracketing unit of block plus arm plus three small blocks existed by the later Han dynasty (Fig. 5.24). Even the ends of the diagonal arm *ang*, which runs parallel to the sloping roof inside a building, are said to be identifiable in some miniature bracket units.[26]

The earliest surviving full-size specimens of Chinese architecture are twin stone towers, called *que*, flanking the entranceway to a tomb. Figure 5.25 shows one such tower in Sichuan Province at a tomb belonging to a certain Gao Yi,

Fig. 5.22 Reconstruction of palace hall at Panlongcheng, 16th century B.C.

Fig. 5.23 Reconstruction of palace with a double courtyard at Qishan, 11th century B.C.

a local official who died in A.D. 209.[27] The stone structure reproduces wooden prototypes in such detail that modern scholars deemed it worthwhile to take the exact measurements of the bracketing.[28] They discovered two systems of measurement, an absolute one and a proportional one. In the main part, called mother tower (*muque*), the height of the horizontal portion of transverse bracket arms and of the horizontal beam that they support is the same in each case: 12.2 centimeters. The width of a horizontal beam amounts to 10.8 centimeters. (In this stone structure this can only be measured at the corners.) The ratio of height to width in the mother tower, therefore, is 1.13 to 1. In the smaller child tower (*zique*), the height of the corresponding members is always 9.2 centimeters, and the width 8.3 centimeters. While the absolute measurements are smaller in the child tower, its proportions remain roughly the same: 1.11 to 1. This indicates more than just standardization of wooden members within one building. If mother tower and child tower are taken to be two separate buildings, it becomes evident that there is a grading of buildings according to size. The absolute measurements between buildings vary depending on their grade, but the proportional measurements remain constant. This principle was developed to great sophistication a thousand years later in the treatise *Yingzao fashi* (*Building Standards*), as will be shown.

Considerable standardization of timber must indeed have existed by the Qin dynasty, because at that time the Chinese were already building grandiose structures. The ostentatious Apang palace of the First Emperor became legendary (unlike his terra-cotta army hidden under the earth). Archaeologists believe that they have identified the terrace on which it stood. It is 1,300 meters long and 500 meters wide. Another palace of the First Emperor in the city of Xianyang has been excavated. Although much more modest in scale, it is still impressive with its three stories, wall paintings, and underground drainage systems. The palaces of the Han emperors, too, struck contemporaries with awe, and we can still sense why from descriptions of the period.

Based on texts and archaeological evidence, historians of architecture have made elaborate drawings with reconstructions of imposing buildings that have long since vanished. They look convincing because they come in the guise of exact architectural plans: the medium is the message. However, as the discrepancies among some of them indicate, those reconstructions have to be taken with a grain of salt.[29]

The great capital cities of the Han dynasty had broad avenues that crossed at right angles, but they had yet to form a regular pattern. The metropolitan grid only evolved after the Han period, reached uniform shape in Sui- and Tang-dynasty Chang'an, and was the last of the five levels in the system to develop.[30]

Fig. 5.24 Model of watchtower, second century A.D. Lead-glazed ceramic, H. 90 cm, Diam. of basin 65 cm. Linden-Museum, Stuttgart

Fig. 5.25 *Que* tower at the tomb of Gao Yi, Sichuan Province, A.D. 209

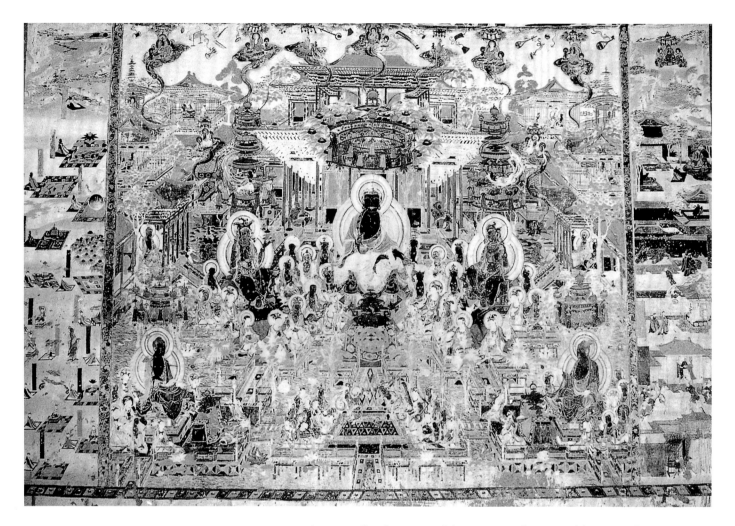

Fig. 5.26 *Western Paradise* (detail), 8th century A.D., Dunhuang, cave 217. Wall painting

An overall coherence of the system of post and beam architecture was thus achieved by the Tang dynasty.[31] It can still be studied in standing buildings in China and Japan. However, none of the great Tang-dynasty palace compounds still exist. The earliest wooden buildings in China—the remote Foguangsi main hall of A.D. 857 and the still earlier, small main hall of Nan-chansi (before A.D. 782)—do not represent the highest achievements of their time, and the original courtyards in which they stood are lost. The earliest intact monastery courtyard is that of Hôryûji near Nara in Japan, which was begun in its present form in A.D. 670. This monastery is home to the oldest standing wooden buildings in East Asia and, indeed, the world.

But Hôryûji was a modest precinct compared to some of the 120 Buddhist monasteries in Chang'an, not to mention its Palace of Great Brightness. One can still form an impression of those compounds through contemporary depictions of Buddhist paradises, which were thought to look like palaces. Many are shown in wall paintings in the grottoes of Dunhuang (Fig. 5.26). A painter does not have to worry about the two most painful constraints of every architect: the laws of gravity and those of economy. Painted architecture can be exuberant and fantastic, rising weightless into the sky. Yet even the idealized Dunhuang scenes provide the architectural historian with valuable evidence for the design of buildings and construction details.[32] In those painted paradises we can visualize the lost splendor of Tang-dynasty architecture.

A close look at two timber pagodas, one in Japan and one in China, will reveal how blocks, brackets, and beams were fitted together in particular buildings.

The pagoda of the monastery Hokkiji, south of Nara, in the Yamato heartland of ancient Japan, belongs to the phase in the history of Buddhist architecture when Japanese builders were still closely following Chinese models (Fig. 5.27). Therefore, it is an apt illustration of Chinese construction of the period. The pagoda was probably begun in A.D. 685 and finished in 706. Thus, it is slightly later than the present Hôryûji nearby, but still earlier than the oldest standing wooden buildings in China.[33]

The pagoda is a three-storied tower (*sanjû no tô*) on a square ground plan of three-by-three bays (Fig. 5.28). Four columns on the axes make an inner square. In its center, a mighty octagonal mast runs upward through the entire structure. This is the "heart pillar" (*shinbashira*) and stands for the world axis—the *axis mundi*—rising from the tomb of the Buddha, which is represented by a cavity for relics in the central foundation stone.[34]

Fig. 5.27 Three-storied pagoda of Hokkiji, A.D. 685–706, Nara Prefecture, Japan

As the elevation shows (Fig. 5.29), the building stands on an earthen foundation reinforced at the sides by stones. As in Foguangsi, the columns of the ground floor rest on stone bases. Four columns stand in the wall plane in each of the two lower stories,. The central bays are slightly wider than the corner bays. As they progress toward the top, the stories become successively smaller. Only three columns stand in the third story's wall plane. The roofs of the two lower stories slope on all four sides, while a pyramidal roof covers the third story. From its tip rises a heavy metal spire with nine disks, symbolizing the nine heavens. It is supported by the heart pillar inside.

The pagoda is not large. One side of the ground floor measures 6.42 meters. The overall height of the structure amounts to 24.26 meters, including the spire with a height of 7.32 meters.[35] The wide outward extension of the roofs is remarkable. (Fig. 5.30). The outer corner of the first-floor roof extends more than five meters out from the corner of the building, a distance approaching the width of the building's front wall!

A robust bracketing makes this possible. Its blocks and beams are rather large, which is typical for this early phase. Two kinds of units are used in all three stories: one above the columns in each wall plane, and one at each of the corners. Only the lower part of the bracketing, which has somewhat peculiarly shaped blocks (again a typical feature in some early buildings in Japan), is visible in the

0 5 m

Fig. 5.28 Hokkiji pagoda, ground plan

Fig. 5.29 Hokkiji pagoda, elevation

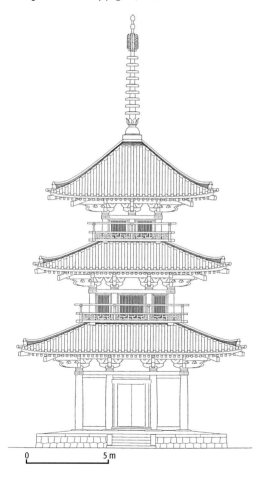

0 5 m

elevation. While the width of the front decreases on the second and third floors, the bracketing is not scaled down proportionally. Instead, less space is left between the units. The blocks of the second-story corner units touch those of the middle units, and less space remains in the center. At the third floor, there is room for only one unit, rather than two units, between the corners.[36]

As the bracketing units have to be pushed together in the two upper stories, it seems that the blocks and beams are all of uniform dimensions. If that were so, the workmen could have cut each single wooden member to size before deciding at which particular place of the building they were eventually to use it. They could have prefabricated all parts required for the entire structure at a convenient place and then on-the-spot assemblage would have taken only a short time.

In fact, this was not the case. In the 1970s, when exact measurements of every single wooden member were taken, it turned out that each piece differs slightly from the others. To cite but one example: the length of the capital blocks in the first story varies between 468 millimeters and 482 millimeters, resulting in leeway of up to three percent. In the third story the variations range from 442 millimeters to 455 millimeters, which is a comparable variance.[37]

What the four numbers also reveal is that all measurements are slightly less in the upper story. One cannot see this in the drawing of the elevation, and it is doubtful that an observer standing in front of the pagoda could see it. To him it would look as if the blocks in the upper stories were of the same size as those in the lower stories, requiring the upper-story blocks to be pushed together slightly. The tiny differences in the actual sizes of the bracketing members have only an aesthetic effect. The smaller blocks appear farther away, hence the pagoda appears taller than it actually is.

These observations tie in with the observation made in chapter 1 on the twenty-four handwritten pairs of the characters *shijie* (see Fig 1.7), namely that small differences occurred in the execution of each module and unit. In the pagoda, too, each block and each bracketing unit was individually executed and differs slightly from all others.

By merely looking at the elevation and the ground plan, it is hard to imagine the interior structure. The corner columns of the three stories do not stand one on top of the other, and the corner columns of the third story do not stand directly above the inner columns of the second or first stories. How then is the weight of the upper stories transmitted down to the lower stories and to the ground? The walls are of no help, as they do not carry weight in post and beam buildings.

The cross section shows the solution (Fig. 5.31). The diagonal beam *ang* (*odaruki* in Japanese) runs through the wall plane at the same angle as the slanting roof. This beam is one of the most effective members of the bracketing system. It rests on a longitudinal tie beam in the wall plane above the top of a column. The tie beam acts as a fulcrum, and the *ang* as a lever arm. Inside the building the lever receives the weight of the column from the story above, and toward its upper end takes more weight from vertical posts

close to the central mast. Outside the wall, the lever, near its lower end, holds a bracket supporting the eave purlin. The weight that pushes the diagonal beam down inside the building is transformed at the outside into an upward thrust that helps counterbalance the weight of the heavy tiled roof. These ingeniously designed lever arms thus balance the various weights in the entire pagoda.[38]

The builders accepted the fact that their complicated interior framing obstructs access to the upper two stories, but those were meant only to be seen from the outside. No staircases lead up, and nobody will ever sit on the verandas, which are too tiny, anyway.

The cross section of the building also reveals that the central mast is almost freestanding. Structurally it is not connected to the rest of the building through any horizontal beams. Indeed, this independent axis is not pierced at any place.

Again, the builders rarely used nails to build their sophisticated structure, and the feet of the wooden columns do not reach into the earth but merely rest on their stone bases. The flexibility of this post and beam structure has allowed it to withstand the sudden shocks of many earthquakes and the violent gusts of countless typhoons.

From 1972 to 1975 a team of restorers disassembled the entire structure, then put it back together again. Earlier major overhauls had been made in A.D. 1262, 1678, and 1904/05.[39] Working with the precision of dentists, the modern restorers removed decayed parts from the columns and beams and inserted new pieces of wood into the cavities (Fig. 5.32). They burned a stamp with the date "*shôwa* 48" into the new parts so that, after decades or centuries, the next restorers will know which parts were added in 1973.

Figure 5.33 shows the third story seen from above as it was reassembled during restoration. In the corner of the outer frame (at the lower right in the photograph), one recognizes the socket that will receive the diagonal *ang*. The corner is marked by an arrow in the plan (Fig. 5.34) and section (Fig. 5.35) of the third story. Figure 5.36

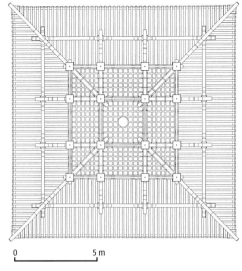

0 5 m

Fig. 5.30 Hokkiji pagoda, plan of first-story roof

Fig. 5.31 (left) Hokkiji pagoda, section

Fig. 5.32 Hokkiji pagoda, cavities in a column on the ground floor

0 5 m

Fig. 5.33 (right) Hokkiji pagoda, third floor seen from above during restoration

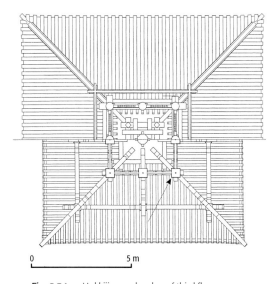

0 5 m

Fig. 5.34 Hokkiji pagoda, plan of third floor

Fig. 5.35 Hokkiji pagoda, section of third floor

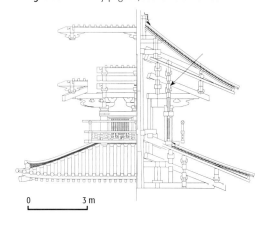

0 3 m

shows the same spot from the side. A horizontal beam jutting out from the corner is supported by a so-called cloud-shaped corbel and cut to a slant at the end. This part will support the diagonal *ang* beam. Figure 5.37 is a close-up of the socket.

Figures 5.1 and 5.38 to 5.41 show how this corner is built up. First the carpenters lower the *ang* into its place (Fig. 5.38). They then place the next horizontal beam on top of the *ang* (Fig. 5.39), after which they position a second horizontal beam, which crosses the first beam at a right angle, again on top of the *ang*.

The deeply mortised block on top is ready to receive the next beams (Fig. 5.40), the first of which fits again snugly (Fig. 5.41). None of the blocks or beams nor their orientation is interchangeable. The workmen have fixed small tags on them that identify each particular member and its respective orientation. A carpenter checks their position. Marked on his stick are the correct heights of each of the superimposed beams and blocks at this particular corner (see Fig. 5.1).

Parallel to the restoration work on the Hokkiji pagoda, the pagoda at nearby Hôrinji was completely rebuilt. This pagoda, which was destroyed by lightning in 1944, is very similar to the one at Hokkiji. Figure 5.42 shows an *ang* at one of the corners of the Hôrinji pagoda. At its lower end it will receive a block like the one shown in Figure 5.43. The workmen put pink powder on the beam and inserted the block. When they remove it, they can tell from the spots in the powder where the block did not touch the beam tightly. They then strip the block further until it fits perfectly. Again, they work like a dentist perfecting the exact height of a filling. The margin of tolerance is a fraction of a millimeter.

This close look at the Hokkiji pagoda demonstrates that its builders cut the wooden members individually and reworked them by hand. Thus all members differ slightly from one another. The carpenters used traditional

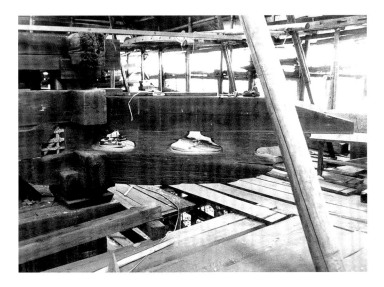

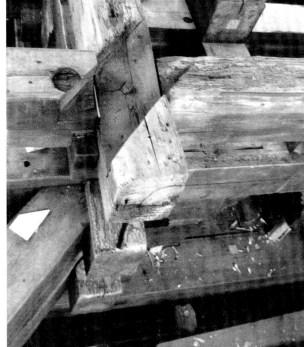

Figs. 5.36–5.39 Hokkiji pagoda during restoration

Fig. 5.36 (above, left) A corner of third floor

Fig. 5.37 (above, right) A socket at a third-floor corner

Fig. 5.38 Workers lowering *ang* beam into socket

Fig. 5.39 Workers lowering longitudinal beam onto *ang* beam

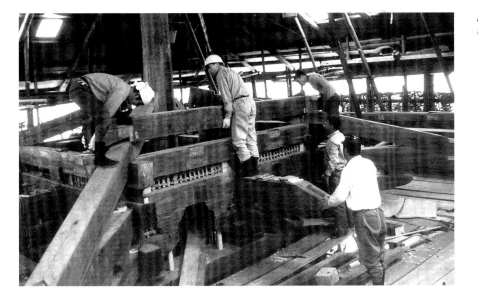

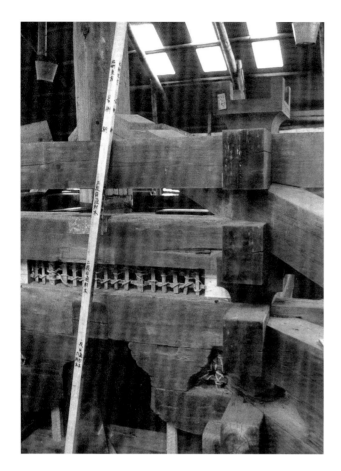

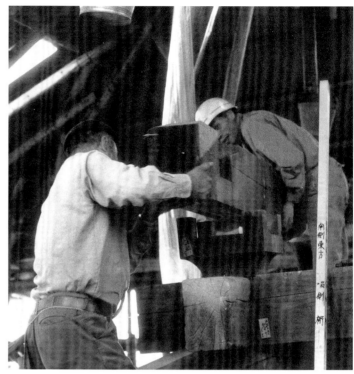

Fig. 5.40 (above, left) Hokkiji pagoda, block on top of two crossing longitudinal beams

Fig. 5.41 (above, right) Hokkiji pagoda, workers lowering longitudinal beam into block

Fig. 5.42 (right) *Ang* beam at Hôrinji pagoda (reconstructed 1973–74), Nara Prefecture, Japan

Fig. 5.43 (below) Hokkiji pagoda, block on top of *ang* beam

instruments that have not changed for centuries (Fig. 5.44), as a medieval handscroll confirms (Fig. 5.45). The tools apparently were not precise enough to cut similar blocks and beams to exactly the same dimensions. For example, handheld saws could not compensate for the differences caused by the grain of wood, as high-speed, circular saws can. Yet precise contact between all wooden members is of immense importance in a structure that relies on joinery instead of nails. Any sloppiness in one joint is bound to have repercussions and multiple adverse effects throughout the entire building. All final adjustments, therefore, can only be made on the spot. This is a well-known phenomenon in modular systems: components are mechanically shaped up to a certain level of perfection but the finishing touches are still made by hand. Yet throughout the centuries it has been the ambition of builders to entrust to mechanical factors an ever-growing role.

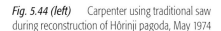

Fig. 5.44 (left) Carpenter using traditional saw during reconstruction of Hôrinji pagoda, May 1974

Fig. 5.45 (right) Medieval carpenters (detail from *Kasuga gongen genki-e*, A.D. 1309, first scroll, third section. H. 41.0 cm)

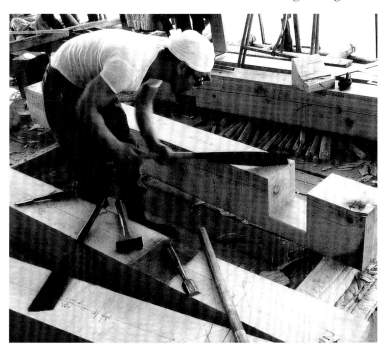

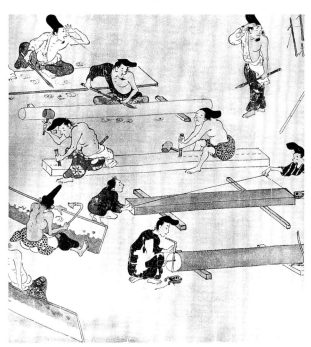

Yingxian Pagoda

The timber pagoda in Yingxian County, Shanxi Province (*Yingxian muta*; Fig. 5.46) is the main building in the Fogongsi (Buddha Palace Monastery).[40] The pagoda is dedicated to the Buddha Shâkyamuni, whose giant statue dominates the interior of the ground floor. The structure has five stories, each with a group of Buddhist icons. It represents a celestial empire in five levels.[41] The 67.31-meter-high octagonal tower is the oldest standing wooden pagoda in China, and it is believed to be the tallest premodern post and beam structure in the world.[42] Begun in A.D. 1056, it was probably commissioned by Emperor Daozong (r. 1055–1101) of the Liao dynasty in memory of his father, who had died the year before. Construction was finished in 1093 or 1095.[43]

The building rests on a sturdy terrace of stones and large bricks. The diameter of the timber construction is 30.27 meters at the base, equalling

almost half the structure's height. As the ground plan shows, the columns of the ground floor are hidden in thick walls made of pounded earth (Fig. 5.47). Eight of them form an inner octagon and twenty-four an outer one, the latter with three bays on each side. Between them, the two octagonal walls form a corridor that is 2.38 meters wide. In addition, an open porch runs around the full circumference of the pagoda at ground level; its own roof rests on an outer line of twenty-four additional columns.

Like the Hokkiji pagoda, the stories taper toward the top. Structurally, however, the pagoda in Yingxian differs considerably (Fig. 5.48). There is no central mast inside the building, and the diagonal lever arm *ang* that plays such a crucial role in balancing weights in the Hokkiji pagoda is here reduced in size and importance, to such a degree that it has almost become a decorative member, and from the third story upward it disappears completely.

The basic plan of inner and outer octagons continues through the stories all the way to the top. Various radial girders connect the two octagonal structures into rings that are stacked one on top of the other like disks. For the most part, their centers are empty. From the second story upward each story consists of four such superimposed rings (Fig. 5.49). The first ring is a short mezzanine with no bracketing in its center. Diagonal struts in the rectangular frame compartments enhance their stiffness and help prevent any lateral displacement. At the outside, the roof rafters of the lower-level story extend up to the mezzanine story above.

On top of the mezzanine lies a ring of brackets and radial tie beams that extend outward, where they support a balcony that runs around the entire

Fig. 5.46 (left) Fogongsi timber pagoda, A.D. 1056–1093/95, Yingxian County, Shanxi Province

Fig. 5.47 (right) Timber pagoda at Yingxian, ground plan

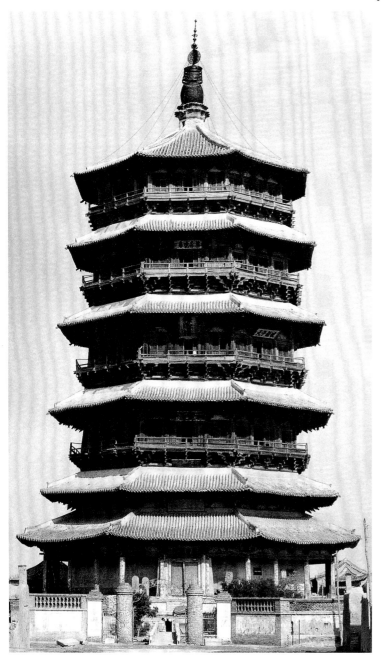

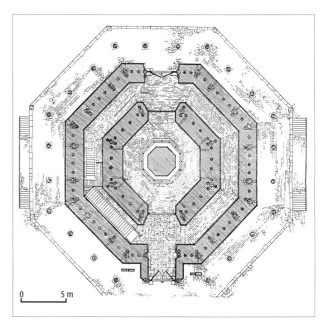

0 5 m

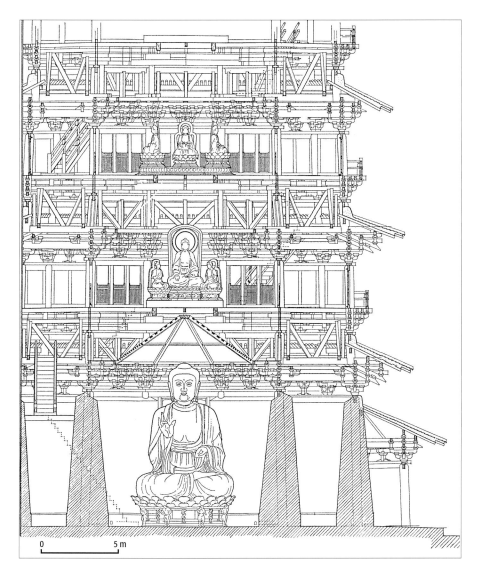

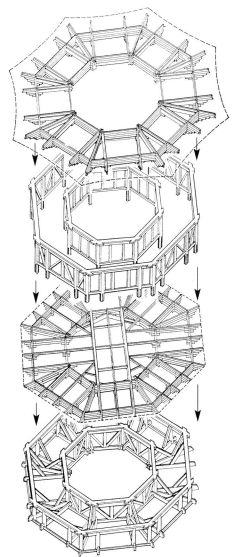

Figs. 5.48 and ***5.49*** Timber pagoda at Yingxian

Fig. 5.48 (left) Section

Fig. 5.49 (below) Explosion drawing showing the four rings that make up one story

building. This second ring is the only one of the four that has any timber structure at its center: a few robust tie beams run across the interior octagon. They carry the wooden floor and the platform for the icons of the layer above.

The level above is the story proper. Its height is determined by the height of the columns. The ground-floor arrangement—eight columns for the inner and twenty-four for the outer octagons—is repeated here. This creates the necessary room for the holy figures. The smooth surface of the floor allows worshippers to venerate the icons while walking around them in solemn circumambulation. While the interior octagon is sufficiently spacious for this, visitors may also move through the corridor between the inner and outer octagons, or step out on the veranda and enjoy the view over the monastery, the city, and the surrounding land. The sight becomes more breathtaking at every story.

The fourth ring is once more a zone of brackets and radial girders. They tie the columns beneath together into a robust framework. Again, no beams are in the center. The larger-than-life-size icons thus comfortably reach into this zone, or even up into the next mezzanine, where the sequence begins anew.

In the Yingxian pagoda, an empty cylindrical space created by a stack of rings replaces the solid pillar in the Hokkiji pagoda, which makes good sense iconologically. From the center of this heart pillar, the pivot of the universe, the Buddhas radiate their power in all directions. Therefore, in other pagodas, configurations may be sculpted or painted all around the pillar. In the Yingxian pagoda the figures no longer have to be affixed to the outer sides of a mast. As the pillar is void, they can dwell in its very core. The configurations float in the skies, as it were, one above another.

The Yingxian solution also makes excellent structural sense. The alternating, superimposed empty disks function like the vertebrae and cartilage in a spinal column. Nature devises such constructions to combine sturdiness with flexibility. At the same time, it aims at minimizing material tissue and weight. Working along the same principles, the builders of the Yingxian pagoda devised a structure that has withstood earthquakes and high winds for many centuries.

The builders chose high-quality larch wood and used timber economically. Wherever they could, they opted for many small wooden members instead of a few large ones. The largest members occur in small numbers only; the smaller the members, the greater their quantity.

The most massive pieces of wood in the entire pagoda are the six-rafter beams (*liuchuanfu*), so-named because each is sufficiently long to cover the distance between six rafters. Pairs of such beams run parallel in a north-south direction to bridge the open space within the interior octagon. They render its frame stable and rigid, and help hold the wooden floor and the platform above. The builders used only ten such tie beams, two each for the second, third, and fourth stories, and four beams in two tiers in the uppermost story. The largest six-rafter beams are those at the second story, which have cross sections of 65 by 40 centimeters and are 12.94 meters long.[44] Probably only one of them could be cut from any single tree trunk.

The second-largest wooden members in the pagoda are the columns on the ground floor, which have a diameter of about 60 centimeters; the taller ones, in the inner octagon, are 9.05 meters high. The columns in all other stories also have diameters of approximately 60 centimeters or slightly less, but the tallest ones measure only slightly more than three meters. While there are 280 of these, a single tree could certainly yield several of such columns.[45]

The bracketing is complicated and varied (Fig. 5.50). A layer of brackets above the inner columns and one above the peripheral columns support the roofs outside. The bays of the inner octagon have bracket sets on top of the corner columns and different sets between the columns. The three-bayed walls of the outer octagon incorporate different bracket sets, depending on whether they crown the corner columns or the columns in the wall plane, or if they rest between the inner columns. This applies to all five stories. Still other brackets support the porch and the verandas of the upper four stories. Altogether 416 bracket sets are found in the pagoda, 54 different types of which have been identified.[46] This is a far cry from Foguangsi with seven different types of bracket sets, not to mention Hokkiji with only two types.

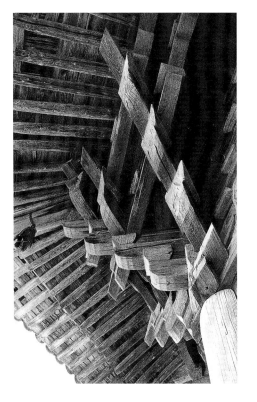

Fig. 5.50 Timber pagoda at Yingxian, bracketing cluster, third story

Sixteen types of wooden members of different shapes were used in the bracketing.[47] This large variety is due to the size of the pagoda, its octagonal structure, and its period of construction. The simplest bracketing units comprise twenty-six members, the most complicated units eighty-six. Altogether the pagoda is assembled from some thirty thousand separate wooden parts.[48]

As one moves toward the top of the pagoda and the size of each story diminishes, the story's parts become smaller as well. The diameter of the central octagonal space measures 12.94 meters at the second story, but only 11.64 at the fifth. The heights of the columns, the spaces between them, and the widths of the corridors also reduce.

Bracketing accommodates this reduction in absolute dimensions in two ways. First, some of the bracket sets at the higher stories include fewer parts and are thereby less complicated and smaller. Second, the dimensions of wooden members tend to be slightly reduced at the higher stories. These two principles are both evident in a comparison of the brackets on top of the exterior columns at the first and fifth floors (Fig. 5.51). The first-floor set is considerably more complicated. It boasts six superimposed tiers of blocks, as opposed to the four tiers of the fifth floor. Thus the overall height of the clusters from the column top upward amounts to 243 centimeters as opposed to 190.5 centimeters. The lateral extension is also more pronounced at the first floor. The bracket arm for the second tier of the cluster extends 85 centimeters outside and inside. At the fifth floor it reaches out only 74 and 71 centimeters, respectively. This results in the same aesthetic effect as that of the Hokkiji pagoda. Because the single members are smaller in the upper stories, they seem to be farther away and the tower appears higher than it is.

However, not all measurements diminish continually toward the top. The extension of the bracketing under the verandas actually increases from 120.5 centimeters at the second story to 127 centimeters at the fifth.[49] As mentioned, the diagonal lever arm *ang* disappears completely after the third story. Such inconsistencies may be due to changes in the original plan. It would not be surprising to see modifications and alterations during a period of construction that lasted almost four decades. Amazingly, the possibility of a plan change is hardly ever taken into consideration by historians of Chinese architecture.

An additional uncertainty arises from the fact that too few measurements are known so far. Although the Yingxian timber pagoda is one of the best studied monuments of traditional architecture in China, of the many identical bracket clusters in any particular story, only the measurements of a randomly chosen one have been published. There must be small differences as in the Hokkiji pagoda. We do not know what kind of tolerance exists between, say, the eight similar blocks on top of the eight columns of the inner octagons. In recent years, researchers have measured the exact length, height, and depth of blocks and beams, but the results still await publication.

In spite of inconsistencies and uncertainties, there can be no doubt that the builders of the pagoda strove for and achieved a high degree of standardization. The largest bracket arms are 27 centimeters high and 18 centimeters broad; the smallest are 24 centimeters high and 16 centimeters

Fig. 5.51 Timber pagoda at Yingxian, sections of exterior bracketing: atop a fifth-floor column (*top*); and atop a first-floor column (*bottom*)

broad. Most frequent is a cross section of 25.5 centimeters by 17 centimeters. Regardless of deviations in absolute measurements, the ratio height to breadth always remains 3:2.[50] Most of the larger beams are cut to size according to a similar ratio. Standard bracket arms require standard blocks. In most of the many thousand blocks in this timber tower, the upper square measures between 28 and 30 centimeters in length. Only the blocks directly above the columns are larger.

The eminent historian of architecture Chen Mingda spent a lifetime studying the Yingxian pagoda, and he recognized numerous additional rules that the builders apparently followed in computing the measurements. Dividing the width of the 17-centimeters-wide standard bracket arm by 10, Chen Mingda arrived at a unit of 1.7 centimeters, which he called a "section," or "*fen.*" He proceeded to show that all dimensions in the pagoda are multiples of this one basic unit of measurement. From the first to the fifth story, for example, the overall extension of the eaves decreases from 570 to 470 *fen* at regular intervals of 25 *fen*. The standard height of a story is 520 *fen,* while the height of the fifth story equals seven eighths of this height, or 455 *fen;* the upper roof and the pinnacle are said to measure 585 *fen,* which is one and one eighth the size of the standard story height.[51]

Even if standardization were paramount in the construction of the Yingxian timber pagoda, one must not assume that blocks, brackets, and beams could have been prefabricated with such precision that they could be inserted immediately in their respective places. Instead, as was the case for the Hokkiji pagoda four centuries earlier, each individual wooden component still needed further refinement by hand. This production process may explain the long period required for construction but, due to the use of this painstaking method, the pagoda has remained upright for nine hundred years.

Building Standards: Yingzao Fashi

When Chen Mingda established the section *fen* as the tenth part of the width of a bracket arm, and when he used it to calculate the measurements of the entire Yingxian pagoda, he based his computations on a text (as Chinese historians always like to do). This text was the famous manual on building standards, the *Yingzao fashi.*[52]

A manual can serve useful roles within a module system. Above all, it can describe the system. It is part of the definition of a module that its size, shape, and use are standardized. By describing—and possibly illustrating—the modular components, by stating their measurements, and by codifying the different ways in which modules are combined into units, a manual enhances the standardization process, assisting the system to remain more stable. Description becomes prescription.

Second, a manual is also a most suitable means to disseminate the standards. As long as a certain module system is worked out and used in only one institution or factory, it may not be necessary to write down the particulars. Once this has been done, however, the system can more easily be

disseminated, and the more widespread a modular system is, the more economical its use will be. A manual thus serves to develop further the particular strengths of a modular system.

Third, a manual can give instructions on how to solve logistical problems, how to plan the division of labor, and how to organize the workforce. It thus can facilitate bureaucratic control of the production process. This may have been precisely the foremost aim of the three earliest known manuals of architecture, two of which are all but lost.

One is the *Classic of Wood Work* (*Mujing*), written by the master carpenter Yu Hao (active A.D. 965–995), of which only a quotation survives.[53] Another text is a first version of the manual *Yingzao fashi*, completed in A.D. 1091 by the Department of Construction, but it has vanished completely.[54] The third text, which is a new version of *Yingzao fashi*, was presented to the Song-dynasty emperor in 1103 by an official by the name of Li Jie (died 1110). His text almost disappeared, too, and only two pages of the 1103 edition are believed to survive.[55] Throughout the centuries the text was rare and little known. The version that has been handed down dates to a revised edition of 1145.

In the twentieth century, however, *Yingzao fashi* has become the most famous and influential treatise for the study of traditional Chinese architecture. A new edition compiled in 1925 ushered architectural research into the modern age.[56] Understanding the text and testing its validity against existing buildings has since been a major pursuit for Chinese architectural historians, foremost among them being Liang Sicheng (1901–1972) and his school. Yet *Yingzao fashi* was not the only text of its kind, and the uncertainties in its transmission through the centuries make all references to existing structures and to actual building practices somewhat tenuous. The one exemplary building that perfectly matches the text no longer seems to exist. After this cautionary note, however, we have no choice but to turn to the text ourselves in our quest to learn more about standardization in Chinese architecture. After all, *Yingzao fashi* is voluminous, detailed, and eminently technical. There is no substitute.

Li Jie was not a builder himself, nor had he risen from the working class. His father was head of the Ministry of Revenue. Li Jie relates that he learned the builder's skills from reading books but also from extensively interviewing carpenters.[57] He made a career in the Department of Construction, became its vice-director in 1102, and later its director. Under the auspices of the state, the department prepared and supervised building activity in the capital. From 1098 on, Li Jie was responsible for the construction, enlargement, or restoration of many major buildings. These included a residence for five princes, one of them the later Emperor Huizong, various other palace buildings, the ancestral temple of the dynasty, a Buddhist temple in honor of Emperor Huizong's mother, the administrative offices of the metropolitan prefecture, a new office building for the ministry, a campus for the national university comprising 1,872 columns, and the main city gate.

In 1097 Li Jie received an imperial order to reedit the manual of building standards. Systematically, in thirty-four chapters, he presented a

wealth of detailed information about the terminology, techniques, and economics of all kinds of construction. After two introductory chapters on general terminology, Li Jie describes in chapters 3 through 15 methods of construction for moats and walls, plus stoneworking, carpentry, joinery, wood carving, bamboo crafting, and roof tiling. He then discusses mortar and plaster for walls, paints for decoration, and bricks and tiles. Ten chapters (16 through 25) follow on work norms, which are specified for the materials and techniques discussed before. After three more chapters on measurements and weight of materials (26 to 28), six chapters of valuable drawings conclude the book.[58]

Yingzao fashi confirms that the system of Chinese architecture is meant to be coherent and all-encompassing. At the beginning of chapter 4, the author sets forth a system of proportions that has as its basic measure the *fen*. As one *fen* is very small, Li Jie introduces two more measurements. Fifteen *fen* make a unit (*cai* or *dancai*), and twenty-one *fen* make a full unit (*zucai*). All dimensions of any wooden member in any building mentioned in *Yingzao fashi* are multiples of a *fen*.[59]

Hence, the *fen* section could also be called a module, although in a different sense of that term. Here, module would not be an interchangeable part but rather a standard unit, similar to the module concept developed at the Bauhaus in the 1920s.

Figure 5.52 shows a single bracket arm. Li Jie used such arms to explain his system. The arm is 15 *fen* high and 10 *fen* wide. The mortise in the middle, which is intended to receive another arm at a right angle, has been cut very deep. To strengthen the arm, a stiffener will be added on top after the second arm has been inserted. The stiffener is 6 *fen* high and 4 *fen* wide. In both wooden members—the arm and the stiffener—the ratio of height to width is thus 3:2. The combined height of the 15 *fen* (equalling one unit) of the arm and the 6 *fen* of the stiffener amounts to the 21 *fen* of the full unit. Arm and stiffener therefore contain the measurements of both unit and full unit. The height of any bracket arm in a given building equals one unit.

The author of *Yingzao fashi* then lists the parts in a post and beam structure, starting with the bracketing. He identifies four types of blocks, five types of bracket arms, and two types of *ang*. In each case, he provides a detailed description of the part's shape and gives its exact measurements in *fen*. He also describes bracket clusters (which, in his time, were not yet called *dougong*, but *puzuo*). He places them in a sequence of increasing complexity, starting

Fig. 5.52 Scheme showing the eight grades of brackets in *Yingzao fashi*

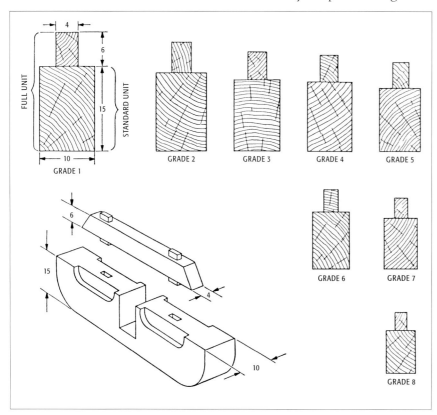

from what he terms four-tier clusters and progressing to eight-tier clusters. Figure 5.53 reproduces his illustration of five- and six-tier clusters. Then follow descriptions of various horizontal beams and other wooden members. All measurements, such as the height of columns, the width of bays, and the length of cross beams, are given in multiples of *fen* sections or *cai* units. In this way a web of measurements emerges that permeates and links all parts of a building.[60]

The matter is still more complicated, however. Sections, units, and full units are relative rather than absolute measures. They vary according to the grade (*deng*) of a building, of which there are eight, and every building belongs to a particular grade. The largest buildings, halls with a front of nine or eleven bays, are built in grade one, in which one *fen* is fixed at 0.6 Song-dynasty inches equalling 1.97 centimeters.[61] Hence a bracket arm 15 *fen* high and 10 *fen* wide measures 29.6 by 19.7 centimeters. At the upper left in Figure 5.52 is depicted the cross section of a grade-one bracket arm and its stiffener.

Grade-two buildings are halls with fronts of five or seven bays. In grade two, all measurements are proportionally smaller than those in grade one by about 9 percent. A *fen* in grade-two buildings measures 1.8 centimeters. In the lowest grade, the eighth, which was suitable for pavilions and canopies, all dimensions are half those for the first grade. One *fen* equals 0.3 Song-dynasty inches (0.99 centimeters).[62]

The classification of buildings into grades is not merely predicated on size but on status and hierarchy, as well. This has a long tradition in China. In antiquity, the classic Confucian *Record of Ritual* (*Liji*) distinguishes four grades of halls according to the number of steps leading up to them: nine for the Son of Heaven, seven for high aristocrats, five for great officers, and three for ordinary officers.[63] Li Jie also defines four categories: palace hall (*diantang*), mansion hall (*tingtang*), house (*yuwu*), and pavilion (*tingxie*).[64]

In a palace hall, all wooden members are proportionally larger and the number of bays is greater. Palace halls do not have hip-and-gable roofs but hipped roofs that convey an imposing appearance from afar. Bracket clusters, complicated as well as large, convey the sense of importance to an approaching visitor. Inside the roof frame, the viewer will find certain kinds of tie beams used only in a palace hall.[65]

The main hall of Foguangsi is a palace hall, although a modest one with only seven bays across the front. It is also a grade-one building. One *fen* equals about 2 centimeters. The cross section of its bracket arms measures 15 by 10.25 *fen* (30 by 20.5 centimeters). Its most complicated bracket clusters are of the seventh *puzuo* grade. The height of the pillars is 250 *fen* (499 centimeters), close to the width of the central bay (252 *fen*; 504 centimeters). The height of the interior space from floor to ceiling is 440 *fen* (880 centimeters), double the width of the outer bays, 220 *fen* (440 centimeters), as required for a palace hall.[66]

The matter is indeed complicated. Four distinct scales of grading have been encountered: (1) the eight grades derived from the dimensions in the cross section of the bracket arm; (2) a sequence of growing complexity from four- to eight-tier bracket clusters; (3) four categories of buildings based on

Fig. 5.53 Diagonal lever–arm *ang* in five-tier and six-tier bracketing clusters (*puzuo*); from *Yingzao fashi*

Fig. 5.54 Hierarchy of buildings in a courtyard

function and status; and (4) different sizes of buildings according to the numbers of bays in front, from one to eleven.

All four scales proceed from the simple to the complex. There is a loose correspondence among them as well as much overlay and meshing.

The system of measurements in *Yingzao fashi* even extends to the courtyard but not to city planning, which may have been beyond the duties of the author. In determining the proportions and hierarchy of structures within a courtyard, the builders went back to the eight grades. A triple courtyard demonstrates the principle (Fig. 5.54). The main building is the audience hall between the second and the third yard. Assuming that it is built in grade one, its ear (or side) halls as well as the large halls standing on the main axis in front and behind, along with the side buildings flanking the main courtyard, all become grade two. The ear halls of the grade-two building are grade three, as are the front gate and the side buildings flanking the first courtyard. The side halls of the gate are grade four. Rules of this kind give the designer security. He knows how to distinguish the rank of buildings in the hierarchy and he can be sure that he is making all the proper choices.[67]

Specifying measurements in relative rather than absolute terms is a basic principle of Chinese architecture. The length of certain tie beams is measured according to the number of rafters they span. One speaks of a four-rafter beam rather than specifying its actual dimensions. The size of a building is given as a multiple of bays.[68] One says that Foguangsi's main hall measures seven by four bays rather than that it is 34 meters wide and 17.66 meters deep.

The author of *Yingzao fashi* was not the first to measure architectural parts in relative rather than in absolute terms. The above-mentioned *Classic of Wood Work*, written a few years earlier, set forth a system of three grades. However, judging from the surviving portions of the text, that system must have been much simpler than the one set forth in *Yingzao fashi*.

The concept of proportional measurements has a long history and may have its roots in anatomical theory. A Japanese historian of Chinese architecture, Tanaka Tan, has drawn attention to a commentary, written around A.D. 600 on a celebrated medical treatise, the *Yellow Emperor's Inner Classic*.[69] In order to measure the length of bones, the commentary explains, bodies must be classified in three grades (*deng*) based on size. The medium size is standard. Each size is divided into 75 *fen* of equal length. This anatomical section is also a relative measure that varies according to the grade or overall size of the body. The sophisticated system allowed one to locate the network of arteries in bodies of various dimensions, and to find the exact points where to insert the needles for acupuncture. It is worth noting that the terms *deng* and *fen* used in the medical commentary are the same as those used in *Yingzao fashi*.[70]

The comprehensive classification and standardization of parts, from the simple bracket to the courtyard, and the pervasive system of measurements and grades, made building a rational affair. All participants operated within a definite framework. Before starting a structure, they merely needed

to agree on a few points, such as its grade and the number of bays. An exact list of the necessary timber and all other materials could then be drawn up. The carpenters, however, worked in a division of labor that specialized in parts of a building, so they did not need to refer to *Yingzao fashi*, because they already knew the craft of building.[71]

Li Jie's prospective readers, then, were his fellow officials. *Yingzao fashi* taught them how to calculate the costs of a building, and how to compute the time needed to finish work. Li Jie touches on this issue in his introduction before even delving into his main text. His ten chapters on work norms allow his readers to figure out exactly how much time the workers will need for any task given them.

The system for measuring work is again proportional. The standard unit is one workday (*gong*). It lasts from dawn to sunset. Winter days are 10 percent shorter than spring and autumn days. Summer days are 10 percent longer. The work of three conscripts or soldiers equals that of two artisans, and they are paid accordingly.[72] To make one standard block of the sixth grade takes 0.5 workdays. For each higher grade, 0.1 workday is added, and each grade lower means 0.1 workday less.[73] To make a fifteen-foot-high pillar with a diameter of 1.1 feet, including the carving of mortises, takes one workday. When the diameter increases by one inch, 0.12 workday is added. When the height increases by 1.5 feet, 10 percent of the respective workday must be added. In the case of square pillars all figures are 20 percent less.[74] Such precise specifications reveal how *Yingzao fashi* set out to measure human labor in the same ways it measured material. The intent was an organized production in which the two systems were perfectly interlocked.

Historically speaking, the compilation of *Yingzao fashi* happened in the aftermath of the social reforms of the great administrator Wang Anshi (1021–1086). His aim was to return the state finances to a sound basis. Part of this effort was directed at monitoring and reducing expenditures on public buildings. By prescribing standards of measurements and periods of work, *Yingzao fashi* contributed toward this goal.

This manual of building standards confirms the conclusions drawn earlier from reading the inscriptions on Han-dynasty lacquerware. Above the level of workers was the level of manager officials, who organized and controlled mass production in China. With *Yingzao fashi*, Li Jie paved the way to an ever more efficient production of standardized wooden members in the following centuries.[75] But he did even more: by formulating and codifying his sophisticated and pervasive system of measurements in the realm of architecture, he set a paradigm that cannot have gone unnoticed in other fields. It was a milestone in the history of mass production in China.

右唐人摹太宗文皇帝枇杷子帖眞蹟一卷

肖王導于法書中自是一體淳化祕閣帖載

宗以神武定天下而天縱字學乃與羲獻

先英姿天日雄略霆電藹然見于尺牘間尚

其萬一世近得之親見書精稔于士習筆篆

本可稽雖摹豈易得也得帖不著歲月軸玉

是先君手裝與後來所得御府帖無小異若

而可寶云

6 The Word in Print

Opposite:

Fig. 6.1 Page from *Collectanea Printed by the Hall of Martial Eminence in Movable Type,* printed by Kim Kan, begun A.D. 1773 (detail of Fig. 6.4)

Printing on paper began in China in the middle of the first millennium A.D. The technique has spread all over the world and is known and used everywhere, following a pattern similar to the spread of the silk and porcelain manufactures. Yet print is even more essential to the modern world than those two commodities. We would not know what sort of wine to buy without printed paper labels on the bottles, and we could not pay for them without paper money, which the Chinese invented, too.

Prints are the most numerous things ever made in China. If one counts a book as a unit, the quantity of all units produced surpasses that of bronzes and buildings. If one counts a page in a book as a unit, and then adds religious amulets, bank notes, stamps, and so forth, the total would easily surpass even the number of units in textiles and ceramic tableware.

Although printing is one way of giving permanence to the spoken word, advanced techniques have made printing so efficient and cheap that printed products can be made for consumption on a single occasion. Most newspapers and entrance tickets are thrown away after they have been read once. In this respect, printed goods are similar to food, which is also produced for single consumption.

Indeed, the aspect of mass production in printing is so dominant that its possible dimension as art almost fades before it. Even a student of Chinese art will be hard-pressed to name instantly the masterworks of printing that might stand out from the enormous quantities produced through the centuries. This is not to deny that traditional Chinese books were made with aesthetic aspirations and that they can be ravishingly beautiful. Yet, if one is pressed to name some outstanding achievements of Chinese bookmaking, what comes to mind are examples that impress by their quantity, such as the giant eighteenth-century *Encyclopedia,* which will be dealt with presently. To

create masterpieces of celebrated aesthetic merit is not the principal aim of printing. Rather, the invention derives its greatness from the technique itself.

Studying the diverse techniques addressed in the preceding chapters, one sees over and over a tendency to mechanize the production process. This has been carried further in printing than in most other fields. Once a press has been set up, relatively little manual work is needed to finish each item.

Reproduction is also carried further in printing than in other fields. In all the techniques dealt with so far, modules were reproduced in great numbers, but reproduction rarely led to perfectly identical pieces. The characters *shijie* in the Buddhist sutra, the *taotie* masks on Shang bronzes, and the blocks in the Hokkiji pagoda all differ slightly from one another. Yet, as mechanization advanced, the physical differences between modules diminished.

Printing is by definition a form of mechanical reproduction. Producing only one single sheet of paper from an individual block does not do justice to printing's true potential, which is to reproduce a given graphic pattern in great numbers. The printing technique makes it possible to do this to such a degree of precision that the reproductions become all but indistinguishable from one another.

Printing thus surpasses the techniques investigated so far. It involves greater numbers of units, is more highly mechanized, and the resulting reproductions are more similar to one another. Nevertheless, the intrinsic similarities between printing and the techniques discussed previously outweigh the differences. Printed items are mass produced, the production process requires division of labor, and printing spread from China to Europe just as silk and porcelain did. Module systems were also involved. The invention of printing with movable type was a triumph of modular thought.

Looking back at the topics of the previous chapters from the vantage point of printing, it becomes all the more obvious that what is of primary importance in the making of bronzes, lacquer dishes, porcelain bowls, and timber frame buildings is the very great numbers of the products. The main effort in all these fields was directed toward the high-quality reproduction of identical or similar units rather than the creation of a singular, outstanding piece.

Printing the Encyclopedia

As printing with movable type is quintessentially a modular process, it hardly comes as a surprise that the Chinese invented it or that they practiced it on a large scale. As usual, some of the most ambitious projects were organized under imperial auspices. During the Qing dynasty, an Imperial Printing Office was set up in the Hall of Martial Eminence (*Wuying dian*), at the southwestern corner of the great palace compound in Beijing (see Fig. 5.18). Its superintendent usually was a minister or a prince in the imperial household.[1] The office contained a department of overseers of works (*jianzao chu*) and a proofreading department (*jiaodui shuji chu*). The former had a staff of twenty-three officials and eighty-four workers and was charged with

the actual production of the books. It ran a copper-type storehouse, a binding shop, and a printing shop. If need arose, additional workers were hired from outside the palace. The proofreading department was headed by high-ranking officials and was supported by a staff of some three dozen proofreaders, assistant proofreaders, and correctors.

The most colossal enterprise of the office is also its most famous: the printing of the *Encyclopedia*, the *Synthesis of Books and Illustrations, Past and Present* (*Gujin tushu jicheng*). The *Encyclopedia* aimed to establish a complete compendium of human knowledge by exhaustively collating and quoting information from literature in all fields. It followed in the footsteps of earlier such enterprises in China. The largest project of this kind that the world has ever seen is the early-fifteenth-century *Great Dictionary of the Yongle Period* (*Yongle dadian*). Its 22,937 chapters were not printed but written by hand, and by the eighteenth century were almost completely lost. The new *Encyclopedia* contained 10,000 chapters (plus a table of contents in 40 chapters), totaling some 800,000 pages with more than 100 million characters.[2] A draft was first prepared in the palace under the auspices of Emperor Kangxi from 1701 to 1706, but the entire work was ready to be printed only in 1726, under Kanxi's successor, Yongzheng. Conceivably, this enterprise also encouraged the compilation of new large-scale encyclopedias in Europe, such as Diderot and d'Alembert's *Encyclopédie*, first printed between 1751 and 1765, and the *Encyclopaedia Britannica*, first published in a modest form during the period from 1768 to 1771.

The elements of the movable type used for printing the Chinese *Encyclopedia* were engraved onto copper. A column contains twenty characters, which come in two sizes: large type (about one centimeter square) for the text, and small type, about half the width of the larger type, for commentary and notes. Two complete type fonts thus had to be prepared, and for each character a certain number of duplicates was carved, from ten up to a hundred.[3]

On the sample page shown in Figure 6.2, the small type is used in both the fifth and sixth lines from the right for short philological glosses that quote variants in other versions of the text and in the left margin of the page.[4] Minute irregularities in the grades of black ink tones are evident between the characters on the page. Some appear more heavily inked than others because the type stood out slightly higher, a feature that is even more pronounced in pages printed with wooden movable type (see Fig. 6.4). Moreover, when one examines such a page from the side, the characters often appear to wobble a bit in the columns. These are indications of movable type, whereas the surest indication for block printing is a crack in the wood that shows on the printed paper.

The type all differ slightly from one another. It has been said that the overall quantity of type used for the *Encyclopedia* amounted to a quarter of a million,[5] and that printing the *Encyclopedia* was "perhaps the greatest typographical feat that the world has seen."[6]

Fig. 6.2 Half page from the *Encyclopedia,* printed with copper movable type, A.D. 1726. Frame, 21 × 14.2 cm. The British Library, London

Producing the metal type was an enormous effort. Yet once available, they were not used to best advantage. Only sixty-four copies of the *Encyclopedia* were printed, and it seems that the Imperial Printing Office never used the type for printing other books. A few years later, in 1744, the copper movable type were melted down to make coins.

Kim Kan's System

While copper type remained an exception, movable type made of wood was more common.[7] In 1773 the Imperial Printing Office embarked upon its largest project in this technique, the printing of 134 rare books.[8] The superintendent of the office at the time was Kim Kan (Jin Jian; died 1794), a man of Korean origin who had learned the technique in his home country. Movable type was common in Korean printing, and in the fifteenth century the Korean government's office of publication was already known as a most successful organization. Its staff of more than one hundred employees worked in a division of labor according to strict rules and produced much-acclaimed editions of Chinese works.[9]

In preparation for his enterprise Kim Kan submitted memorials, or written communications, to the Chinese emperor. He laid out his plans and precisely listed the equipment he would need, starting with 253,500 type, followed by 10,000 blanks, 80 form trays, and other utensils down to 12 benches placed in front of 12 type cases. The superintendent also managed to convince the emperor that his staff of twelve had to be increased to one hundred.

In 1777 Kim Kan submitted to the emperor a manual describing systematically and in precise language the techniques he was using.[10] He divided the production process into a sequence of steps and illustrated them in a manner similar to that of albums that explain and exemplify the production of porcelain (see Figs. 4.30–4.34). First he discusses how the equipment is made and then proceeds to describe the printing process itself.

The basic unit is a double page. Figure 6.4 shows a sample from one of Kim Kan's 134 books.[11] Each page was printed in two stages. First the rectangular grid with nineteen vertical columns was printed using a single block. Kim Kan illustrated what the result looks like (Fig. 6.3). Each column is exactly 5.88 inches long and 0.4 inches wide.* The entire grid thus measures 7.6 inches from left to right. The center column contains a "fish tail," a mark with a pointed lower edge, which helps later in folding the sheet accurately. Pages in traditional Chinese books are printed on one side only. Before binding, the sheets are folded down the middle so that the print faces out. The free ends of the sheets come to lie on top of each other and are sewn together while the folds form the book's outer edge. This is called "wrapped-back binding" (*baobeizhuang*).

Opposite (clockwise from lower left):
Fig. 6.3 Page grid as illustrated in Kim Kan's *Manual,* A.D. 1777. Frame, 19.2 × 12.9 cm. Gest Oriental Library and East Asian Collections, Princeton University

Fig. 6.4 Page from *Collectanea Printed by the Hall of Martial Eminence in Movable Type,* printed by Kim Kan, begun A.D. 1773. Frame 19.2 × 25.8 cm. Gest Oriental Library and East Asian Collections, Princeton University

Fig. 6.5 Page from Kim Kan's *Manual,* showing strips for a form tray, A.D. 1777. Frame, 19.2 × 12.9 cm. Gest Oriental Library and East Asian Collections, Princeton University

* For the purposes of this discussion, the word *inch* refers to the Chinese inch of the time, which is roughly equivalent to 3.25 centimeters.

宋　岳　珂　撰

歷代帝王帖

唐太宗枇杷子帖〔墨〕

枇杷子帖本唐高宗書淳化閣帖誤標爲唐太宗恭閣帖誤其王伷鎸蜀時折衷至當贊皆誤難以改正

欽定重刻淳化閣帖辨是蔣垂信千秋此標題既誤其跋與贊皆誤難以改正此標題下據後例各注書體行數又獨係姑並仍舊文謹識其誤

使至得所進枇杷子㢝深慰悅嘉果味獨冠時新但

川路既遙無勞更送今者梅炎藻夏麥氣迎秋香飄薾

坂之風鏡轉桂巖之月爲華之眼想足怡神延望白雲

寶眞齋法書贊《卷一》　一穋晉枝

載深離緒聊疏綠字此不多申諮二十九日

右唐人摹太宗文皇帝枇杷子帖眞蹟一卷字蹟略

肖王導于法書中自是一體淳化祕閣帖載焉惟太

宗以神武定天下而天縱字學乃與羲羲輩並驅爭

先英姿天日雄略霆電蔼然見于尺牘間尙可髣髴

其萬一世近得之親見書精稔于士習筆筆取似閣

本可稽雖摹豈易得也得帖不著歲月軸玉標錦尙

是先君手裝與後來所得御府帖無小異益信其眞

而可寶云

套格式

夾條頂木中心木總式

The center column also includes the book title and chapter and page numbers. By inserting movable type into the block, this information is printed together with the grid. In his illustration of the grid Kim Kan left the center column void because he was showing a sample page. Yet on the page of the real book the center column contains the title above the fish tail (Fig. 6.4). Below, one reads "chapter one, [page] one," and the name of the proof-reader. In other cases the name of the printing office or even the number of characters on the sheet may also be found here. The information in the center column helps to avoid confusion while the pages are printed and bound into a book, and facilitates quality control. Later it advises the reader which page and chapter in a particular book he is looking at.

In the second stage the printers print the text proper into the two blocks of nine columns on both sides of the center column. Technically, they could print line grid and text together, but dividing the production process into two stages makes it more transparent and easier to calculate material and man-hours for a certain project.

The second printing of the page is no longer done from a single block but from a surface composed of many separate small pieces of wood, the movable type. The printers carefully arrange all pieces in a chase, a pear tree–wood tray one-half-inch deep and measuring 5.88 by 7.6 inches on the inside. The latter two measurements equal, respectively, height and width of the rectangular grid on one double page.

In addition to the type with the characters, the form tray contains two other kinds of wooden blocks: vertical strips that separate the columns and keep the characters in place, and blanks. Each of these parts has the same depth, 0.7 inches. When placed in the half-inch-deep form tray, the composite movable blocks form a coherent surface that extends 0.2 inches above the rim of the tray.

By far the largest among the three groups of wooden parts is made up by the more than a quarter-million-character type. Kim Kan had them carved from the wood of jujube trees. Like the copper type for the *Encyclopedia*, the wooden type came in two sizes, one for the regular text and one for the commentary. The characters of the smaller type are narrower in overall proportion and their strokes are thinner than those on the large type. These small type are 0.2 inches wide as opposed to the 0.3 inch width of the large type for the text. Yet both type match in length: 0.28 inches. Twenty-one of them fit exactly into the columns with their standard length of 5.88 inches. Occasionally one meets with an exceptional piece of type. An example is a character in Figure 6.4, located in the middle of the fourth column from the right. Carved in intaglio, it marks the beginning of the commentary (*an*).

The strips between the columns come in two grades of thickness and in varying lengths. Average text columns, as seen on the left half of the double page in Figure 6.4, are separated vertically by one strip. It is 5.88 inches long and 0.1 inch thick, filling the space left by the 0.3-inch-wide type in the 0.4-inch-wide column. Such a strip actually straddles the line between two parallel columns, covering half an inch of each, and causing the row of characters to run down the center of the column.

No strips are necessary between solid commentary, as seen in parts of columns four, five, and six from the right of the sample page. The two parallel rows of commentary in small type, each 0.2 inch wide, completely fill the 0.4-inch-wide columns.

Wherever commentary borders on text, however, as in the upper half of column four, or between columns six and seven, strips have to be used again. These are of the thin variety, 0.05 inch wide. Thin strips also frame the right side of the text in column one and the left side of the text in column nineteen, the last column at the left of the page. Depending on the number of characters in one column, both thick and thin strips may range in length from one to twenty-one characters. Long strips can be assembled by combining several smaller strips of suitable length.

The third group of wooden blocks that go into the form tray, the blanks, are used for empty columns or empty parts thereof. They act as holders and, like the character type, they come in large and small sizes, measuring 0.3 or 0.2 inch in width. Like the strips, they vary in length from one character up to an entire column, yet the typesetter may fill a long space by combining several short parts, which conveniently reduces his repertoire. The *Manual* illustrates the strips and blanks from which he can choose (Fig. 6.5).

The form tray, with its orderly arrangement of wooden parts, is once again part of a modular system. One can even distinguish the five levels identified in the system of Chinese script in the first chapter: the small wooden blocks are the elements, which may have complicated shapes but cannot be divided further. The existence of a quarter million of them is the outstanding feature of this particular module system. Yet looking at them as pieces of wood in certain shapes instead of as characters, one finds only

Fig. 6.6 Unusual page layout from *Collectanea Printed by the Hall of Martial Eminence in Movable Type* (reprint of 1899). Frame, 17.6 × 25 cm.

about a dozen different kinds: small and large type, and a limited number of thin and thick strips and blanks.

The columns could be called modules. There are only two kinds—the center column and the others—and even these two variants do not differ in shape or size but only in what goes into them. The uniformity at the module level is a necessary balance for the extreme variety at the element level. Nevertheless, there are exceptions. Atypical pages may have six columns, horizontal columns, or no columns at all. If there is a need for diagrams, characters may even run from left to right and upside down. Figure 6.6 illustrates a sample page with such features. This page, however, is not found in Kim Kan's original edition, but in a reprint of 1899, which was done with blocks.

The page is the unit. Variations at this level are again reduced to an extreme minimum. All pages have the same size and the same rectangular frame; foldouts are an absolute exception. Uniformity at the unit level is a further check against the immense variety of elements.

A certain, finite number of units or pages are assembled into a series, which makes a book. All copies of a particular book have the same number of units. Beyond that, we lose ourselves in the realm of mass, where numbers become boundless. No reason inherent in his system forced Kim Kan to stop after having printed the 134 books the emperor had commissioned. He could have gone on.

The system that Kim Kan and many others developed and used for printing again reveals the familiar properties, advantages, and limitations of all modular systems. Its basic principle is the exchangeability of parts. The system is built up in several levels of increasing complexity, and allows virtually infinite variations but within a rigid framework. Uniformity is paramount, idiosyncratic solutions are allowed, but they are rare and easily recognizable as such. Nor do they endanger the overall validity of the system; rather they are confined to certain circumscribed areas within. Even the exceptional layout added in the reprint affects only the column grid. Size and form of the characters and of the overall page remain unchanged.

An artisan embarking on a particular task in a system he is familiar with will find that most choices have already been made for him. This immediately propels him into operation on a high level of craftsmanship. But his individual options are limited and channeled. He must exert his skill in striving for perfection within the given scheme. It is not his job to challenge it.

Like all module systems, Kim Kan's system allowed for an orderly and efficient production process. It enabled him to work with a large number of parts and, as usual, involved a division of labor. In the second half of his *Manual,* Kim Kan describes the printing process proper, and illustrates the setting of the text (Fig. 6.7).

In the rear of a busy workshop, three men climb on benches in front of large type cases from which they select the type. They assemble in a sorting tray all the type needed for a particular section of the text. The 14-inch-long trays (longer than the form trays, which measure only 9.5 inches) are handed over to the typesetters, who line them up on a table. The form trays

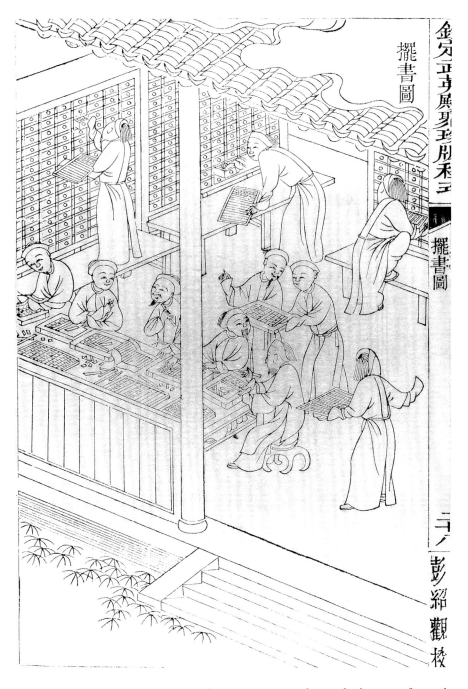

Fig. 6.7 Illustration from Kim Kan's *Manual* showing typesetters selecting and composing the type, A.D. 1777 (reprint of 1899). Gest Oriental Library and East Asian Collections, Princeton University

comprise another row closer to the typesetters, who pick the type from the sorting trays and arrange them neatly in the form trays, adding strips and blanks as needed. One worker refers to a book, perhaps a manuscript of the text that is being typeset.

Setting the text is thus also done in two steps: filling the sorting trays first, then filling the form trays second. Theoretically it would be possible to select type from the type cases and place them directly into the form trays. Yet, as with printing a page, the division into two steps facilitates control of the production process and helps to avoid errors and confusion. Kim Kan stresses that absolute exactitude is needed both for selecting the type and for returning them to their respective drawers. If it is done properly, he assures

us, one will not even be conscious of working with myriads of parts. "But if there is the slightest disorder, confusion will be unlimited." [12]

Kim Kan distinguishes five stages in the production. After the text is set, other workers, in a second stage, correct every unevenness in the form tray. Then a first print is made and proofread. Only then comes the printing proper, and finally the type are sorted back into the type cases.

The five stages of production follow one another in perpetual succession. Kim Kan calls it the "daily rotation method" (*zhuri lunzhuan banfa*). He specifies that one man can set two form trays of large characters or one tray of small characters per day. In his calculation, 24 trays will be composed every other day, in a ten-day period yielding 120 trays or pages with a total of 45,360 characters, which amounts to the equivalent of an average book. If a setter runs out of certain type when composing a text that repeatedly requires special terms, he should temporarily work on a book with different content until all type for the first book have been returned to the type cases. Following this advice guarantees a continuous rhythm of production.

As explained in the previous chapter, the architectural manual *Yingzao fashi* was designed to help administrators calculate material and man-hours required for specific buildings, rather than to tell craftsmen how to make them. Similarly, it was not Kim Kan's foremost purpose to teach the technique of printing with his manual. He meant to lay down standards that would allow the emperor's printing office to prepare reliable estimates in planning its projects, and to organize and control production.

Fig. 6.8 Woodblock with Daoist charm, 20th century, 40 × 25 × 1.4 cm. Private collection

Toward the Modern Age

Like the copper type of the *Encyclopedia* in the first half of the eighteenth century, Kim Kan's wooden characters failed to pave the way for widespread printing with movable type. Printing from wooden blocks remained the preferred method in China for almost another century. Its advantages were that it allowed for variety in the layout of a page, for a greater selection of script types, and for individuality in the calligraphic design. [13]

A woodblock for printing Daoist charms illustrates this freedom (Fig. 6.8). The carver used bold Regular Script for the four characters at the top (two at each side), and a slightly smaller type for the outside vertical columns. He crowned the center row with an illustration, below which he combined a squatter type with a fancy, ornamental style of script. He could not have done this easily had he worked with movable type. The traditional Chinese preference for block over single character parallels the modern preference for fax over telegraph.

To be sure, it was an effort to carve an entire new block for each page of a book. But once the labor had been invested, the owners could print additional copies from the durable blocks whenever demand arose, years, decades, sometimes even centuries later. They need not fear errors, which were

bound to occur with every new type set. Manufacturing tens or hundreds of thousands of type, on the other hand, required considerably more effort. The investment could only pay off through large-scale editions, yet these were not in demand. Nor did wooden type remain usable forever. Wear and tear cut their life short. Metal type was sturdier but required even more effort to make.

This began to change in the first half of the nineteenth century when Christian missionaries introduced and adapted to China printing techniques that were then being developed in the West. A steady stream of Bibles and other texts for distribution among the people was one of the means by which missionaries endeavored to evangelize China. The missionaries were used to the idea that books were printed with movable type. The technique made sense, for they were dealing with huge editions.[14]

Faced with the familiar problem of how to reduce labor, time, and expense when producing thousands of type, the westerners at first attempted to exploit the modular structure of Chinese script in the 1830s. For example, they cast two separate types for most characters that are composed of two parts, and then used them in different combinations. The divisible type, however, was not aesthetically appealing and soon abandoned.[15]

Attempts to rationalize type making through new materials and new processing methods were more successful. A major step was the introduction of electrotype. Forming metal type with the help of an electrolytic process allowed duplication of identical type and reduction of size without loss of clarity. In 1861, the Irish missionary William Gamble (1830–1886) introduced the technique at the Presbyterian Mission Press in Shanghai. After this, large-scale commercial publication and speedy printing of newspapers became possible in China.

Photocomposition, which completely did away with metal casting, was among the other important inventions that followed. Through optical methods, it also allowed the creation of any desired size from one master design. A phototype-setting machine was first used around 1925 in Japan.[16] Optical methods have been further developed since, and are integral to modern computer and laser-printing techniques. Today, Western and Eastern technologies have become inseparable. Yet even the most sophisticated methods of text processing still rely on the principle of movable type.

Tracing Back the Technology

Having looked at the monumental achievements in eighteenth-century printing in China, we will now trace the historical process that made it all possible back to its beginnings and even earlier.

When Kim Kan submitted his *Manual* on the use of movable type in 1777, he could look back several centuries for this technology. He referred to an author who had described the technique of movable type made of wood as early as A.D. 1313[17]—and he even followed him in the scope and design of his own account.

What may be the oldest extant book printed with movable type dates from about the same period. It is a chapter of the *Garland Flower Sutra*

(*Huayanjing*) printed in Tangut script, and now in the Gest Library at Princeton University. Tangut, which resembles Chinese, was first adopted in 1036 by the Xixia dynasty.[18] The oldest books to make use of movable type for Chinese characters also date from the fourteenth century, although they were not printed in China, but in Korea. A prominent example from 1377, now in the Bibliothèque Nationale in Paris, is the second volume of a treatise by the Korean monk Paegun (1299–1375), *The Essential Paragraphs of Buddhist Patriarchs Pointing Straight Toward the Very Heart.*[19]

The first celebrated reference to movable type dates back earlier still, however. It is a detailed description that the polymath Shen Gua (1031–1095) gives in his *Brush Jottings from Dream Creek* (*Mengxi bitan*).[20] He relates how, in the 1040s, a certain Bi Sheng formed characters in small pieces of soft clay that he hardened by baking. He produced several examples of each character and made more than twenty copies of the more frequent ones. For typesetting he used an iron plate with a coating of pine resin, wax, and paper ashes. Into this paste he pressed an iron grid whose dimensions equalled the intended margins and columns of a page. Within this grid he lined up his ceramic type.

To make them stick in the paste, he warmed the entire plate over fire. He alternated between two plates to speed up production. While prints were made from the first plate, the second one was being set. Because of the accuracy of Shen Gua's description, and because he relates that his own nephews inherited the font of ceramic type from the maker Bi Sheng, his report is considered reliable. The Chinese thus used movable type for printing about four centuries before Johannes Gutenberg. In the 1440s, he reinvented the technique in the city of Mainz, Germany, from where it rapidly spread all over Europe.

For reasons mentioned above, printing with movable type did not replace printing with wooden blocks in traditional China. Block printing remained the favored method up to modern times, and its history can be

Fig. 6.9 Frontispiece and beginning section of *Diamond Sutra* scroll, A.D. 868. Print on paper, frontispiece, 23.7 × 28.5 cm. The British Library, London

traced back several centuries before Bi Sheng. The oldest dated book surviving from China is printed from wooden blocks. It is a version of the Buddhist *Diamond Sutra*, which Sir Aurel Stein discovered in 1907 in the caves in Dunhuang in the desert of western China, and is now in the British Library (Fig. 6.9). Its format is that of a handscroll, the usual format for books at that time. The scroll is 27.3 centimeters high and more than 5 meters long and consists of seven sheets of printed paper that are pasted together. This book is all the more remarkable because its frontispiece illustrates the preaching Buddha, thus making it the oldest extant printed picture in the world. The colophon at the end of the scroll dates it to A.D. 868.[21]

A century older still are small paper rolls printed in Japan with verses from the *Great Dhâranî Sutra of Stainless Pure Light*.[22] Dhâranî are Buddhist invocations phonetically transliterated from Sanskrit into Chinese characters. Although they were not readily understandable to an East Asian reader, they had a rather sacred and somewhat obscure aura. In A.D. 764, a pious Japanese empress vowed to have one million of them made.[23] It took seven years. The Japanese prints certainly followed Chinese and/or Korean prototypes. They were placed into miniature wooden pagodas and distributed to ten major monasteries in the country (Fig. 6.10).[24] One million is a proud number, truly worth an imperial donation, and it is a credible number, too. A survey made in A.D. 1878 in the Hôryûji near Nara showed that this monastery still retained 43,930 of its original 100,000 pagodas.[25]

An even earlier printed scroll exists in Korea (Fig. 6.11). It was discovered in 1966 in a relic casket at a stone pagoda in the monastery Pulguksa, in Kyongju, the ancient capital of the Great Silla dynasty (668–935). The scroll, bearing a longer passage of the same *dhâranî* sutra, is about 6.6 centimeters high and more than 6 meters long. It is printed from twelve separate blocks

Fig. 6.10 Miniature wooden pagodas that contain *dhâranî*, A.D. 764–770. Three-storied pagodas, H. ca. 21.4 cm; thirteen-storied pagodas, H. ca. 80 cm. Hôryûji, Nara, Japan

Fig. 6.11 *Dhâranî* (detail), between A.D. 704 and 751, from a pagoda in Pulguksa, Kyongju, South Korea. Print on mulberry-paper roll, 6.6 × 620 cm

on paper made of mulberry bark. The plucky characters have a rough charm, stumbling somewhat through the columns. The print must date from before A.D. 751, because the Pulguksa pagoda was restored in that year. However, it cannot be very much older, because the *dhâranî* were only put into Chinese in A.D. 704. The text contains some peculiar characters, designed by order of Empress Wu Zetian, but this cannot be taken as an argument that the sutra was printed during her reign. While the formidable woman was forced to abdicate in A.D. 705, her characters were still in use for some time thereafter in China as well as Korea. Hence, the oldest extant printed text in the world known today was produced between 704 and 751.[26]

It is remarkable that the three earliest examples of printing come from China, Japan, and Korea. Although preserved somewhat accidentally, the finds show that the printing technique had spread all over East Asia by the eighth century, and that it probably originated earlier. The measured layout and regularity of the Chinese *Diamond Sutra* text of A.D. 868, as well as the sophistication in the design and the flowing lines of the illustration, indicates that by then woodblock printing on paper was already well developed. Some literary evidence suggests that printing may predate the eighth century, but convincing material evidence has yet to be found.[27]

It is equally worth noting that the three earliest specimens of printed texts are Buddhist sutras. Buddhism, with its missionary zeal, contributed decisively to the development and spread of the technique of printing. Devout Buddhists used holy texts as a prime means for disseminating their faith, and they did it on an even larger scale than the later Christian missionaries in China. To Buddhists, the copying of texts was a means toward acquiring merit. The more copies, the more merit, the ultimate merit being liberation from the circle of rebirth. Printing made it easy to produce multiple copies—it was fast, cheap, and more convenient than copying texts by hand. Moreover, it avoided all the mistakes a copyist might make, and that was of special importance in the case of sacred invocations. It was not deemed obligatory that every copy of a text be recited. Its mere existence conveyed bliss to donor and owner alike. This is one reason why Buddhist printers often strove for huge editions. In the second half of the tenth century, for example, the monastery Lingyinsi in Hangzhou produced some four hundred thousand printed items.[28]

It is no coincidence either that two of the three earliest texts were found in pagodas. A pagoda represents the Buddha's tomb and therefore should contain his relics. It often does. After the Buddha entered nirvâna eighty-four thousand relics were distributed. Staggering as the number was, there was no escape from the fact that it was a finite one. Relics were bound to become a scarce commodity, especially in regions far away from the Buddha's homeland. Yet a solution to the problem presented itself. Buddhist sages expounding the nature of the Buddha's body had long developed the idea that the body of holy scriptures is one form in which the Buddha exists.[29] Wherever the sacred scriptures are kept, the Buddha is present. Thus, when relics are not available, scriptures can take their place and be deposited

in a pagoda as well. The scriptures do not even have to be written by hand, for the word in print is also the body of the Buddha.

Still, it is amazing that printing on paper made its appearance so late. It would have been feasible technically much earlier, as the three necessary components to make a print—the printing block, ink, and paper—had been available for some time.

The printing block, the carrier of the design, is the most sophisticated of the three components, and a kind of printing block existed by the sixth century B.C. Ink is the amorphous substance that transfers the design from its carrier onto the surface that receives it. Ink was widely used in the centuries B.C. The tomb of Marquis Yi of Zeng of about 433 B.C. not only yielded ten tons of bronze artifacts, but also a complete inventory of the tomb's contents, written in ink on 240 bamboo strips.[30] Some kind of black pigment, which has been called ink, was available as early as the Shang dynasty.[31]

Of the three components paper was the most recent invention. It was known by the time of Emperor Wu of Han (r. 140–87 B.C.), but the earliest extant handwritten paper documents date from the second century A.D., and only by the fourth century had the use of paper become quite common.[32]

Printing on paper thus would have been possible at the latest by the second century A.D., when paper was utilized for writing documents. But the oldest securely dated prints on paper do not appear until five centuries later. The gap is hard to explain. Apparently society did not yet feel the need to disseminate the written word widely. Perhaps it was necessary to wait for Buddhists who, motivated by religious fervor to save mankind through their teachings, finally developed the technical potential that was there to be used.

On the other hand, printing with ink on paper has a long "prehistory" in China. It was preceded by an extended incubation period of printing on soft material, mostly clay. Tracing the roots of printing leads us back to the bronze casting technology of Chinese antiquity.

Printing in the Bronze Age

Chapter 2 investigated the casting of ancient ritual bronzes. This second look at the technique will reveal how bronze casting anticipated the technique of printing.[33]

Three principles fundamental to printing on paper had already been applied by the bronze casters. The first concerns the ornaments on ancient ritual vessels, many of which are, in effect, graphic patterns. When examining the different parts of a Shang dynasty *taotie* mask, one can use both photographs of real vessels and rubbings of their surfaces, which can look very similar. The black-and-white photographs of the sides of the house-shaped *fangyi* vessel in Cologne (see Figs. 2.5–2.10) do not differ much in appearance from a rubbing, such as the one taken from one side of the *fanglei* vessel in Shanghai (see Fig. 2.18). Both show the surface decor clearly in black and white.

Rubbings are a common means by which to reproduce the decoration on ancient ritual vessels, and the Chinese have made them for centuries.[34] One must bear in mind, however, that rubbings are only a convenient device to make bronze decoration visible. Nobody in the Shang period used rubbings for this purpose, as paper had yet to be invented. In addition, a rubbing tells little about the differences in height, for example, between the zoomorphic motifs and the background spirals. Nevertheless, the viewer feels that a rubbing, with its black-and-white pattern, gives a reasonably complete picture of the decoration on many vessels because, for a decorative pattern like that on the Cologne *fangyi,* height matters little; the decor is all but perfectly graphic. In other words, it plays on the contrast between two values only: positive and negative, on and off, *yin* and *yang.* On the actual bronze this is a contrast between intaglio and relief; on the rubbing it becomes a contrast between black and white.[35]

Photographic details equally make the point that, in a certain phase, bronze decor is binary (see Figs. 2.12; 2.13). The interchange between intaglio and relief is perceived as a quasi-graphic pattern, a play between positive and negative.

The second respect in which bronze casters anticipated later printing technique is that they created patterns by making impressions. This involved working with negative forms. Theoretically, the artisans could have engraved a decor into the metal of the finished bronze. However, they preferred to have a negative pattern completed in the mold before casting.

The casters had two possible methods for transferring the pattern into the mold. They either cut the decor directly into the soft clay of the mold in the negative, or they first prepared a model on which they carved the decoration in the positive. From that model they transferred the pattern by impressing it (or parts of it) into the mold. Once bronze casting technology reached a certain degree of maturity, the latter was the preferred method.[36]

The mold piece for a wall of a *fangyi* (see Fig. 2.23) illustrates that the pattern in the mold appears in the negative. Relief is converted into intaglio, and vice versa. Left and right are reversed as well. The casters did not have to pay much attention to the lateral conversion, as most motifs are perfectly symmetrical. Nevertheless, it is important to note that Shang bronze casters were already familiar with lateral conversion, which is indispensable in printing.

The shape of a mold section, such as the one for the *fangyi,* is quite similar to that of a wooden printing block (see Fig. 6.8). Both are rectangular boards, one side of which carries a negative relief pattern, which is reversed into positive on the finished product. Yet in spite of the similarity in appearance, two crucial functional differences remain. A mold section is not used to make an impression; rather the pattern is transmogrified into the bronze in its liquid state. Second, a mold section is not used repetitively, as is a printing block, nor is a model employed more than once to impress its pattern into the mold.

This changes with the advent of the pattern block a few centuries later. Pattern blocks are similar—although not identical—to printing blocks

in shape and function. The use of pattern blocks is the third respect in which bronze casters anticipated the technique of printing.

The pattern block was made of hard-baked clay and carried a positive design. Thin strips of soft clay were pressed onto this ceramic block, very much the way paper was later pressed onto a wooden block. In both cases, the block was stationary. By contrast, in European printing techniques the block is moved and pressed down on the paper.

Moreover, repetitive impressions were taken from the ceramic pattern block as they are from a wooden printing block. The two basins in the Pillsbury Collection in Minneapolis and in the Freer Gallery in Washington, D.C., exemplify how the caster "wallpapered" the outer mold with identical strips of clay, each carrying a negative impression from one and the same pattern block (see Figs. 2.29–2.33).

Yet one critical difference remains: impressions taken from a pattern block are three-dimensional; those from a printing block are two-dimensional. Nevertheless, introducing blocks for making multiple impressions was a momentous step on a road that led not only to further mechanization of bronze manufacture but to further development of printing technology as well, and, generally speaking, to ever more mechanized modes of reproduction in China.

Thus far, three principles have been identified in which bronze casters anticipated the technique of printing: they worked with graphic designs, they created patterns in the negative through impressions, and they used pattern blocks for multiple reproduction. The three principles are equally detectable in the inscriptions cast into the walls of ritual bronzes. Here the technical problems and their solutions present themselves even more strikingly. Even in the technical domain, script appears as a paradigm of Chinese culture.

Rubbings of inscriptions on *gu* beakers from the tomb of Lady Hao (see Fig. 2.26), or the characters cast into the foot of one of the beakers (see Fig. 2.25), are two-dimensional graphic patterns in an even purer form than the *taotie* face. The depth of the strokes in the bronze wall is of no significance. Operating with only two contrasting values, rubbings render their shapes adequately.

Second, as the diagram in Figure 2.27 demonstrates, making a template with an inscription involves taking impressions, which again entails conversion of positive into negative and left into right. With written characters, the caster must pay closer attention to lateral conversion than with *taotie,* because the latter are mostly symmetrical, whereas the former are not.

The third principle, the use of pattern blocks, also comes into play early. Figure 2.27 shows a piece of hard clay in a square frame, which is more akin to a pattern block than it is to a sectional-mold piece (such as that for the wall of the *fangyi* in Figure 2.23), because it is used to create an impression in another piece of soft clay rather than in bronze. To be sure, the square piece of hard clay still differs from a real pattern block in that it is not utilized to make multiple impressions. Yet the single clay impression, which is taken from this small block and then inserted into the wall of the

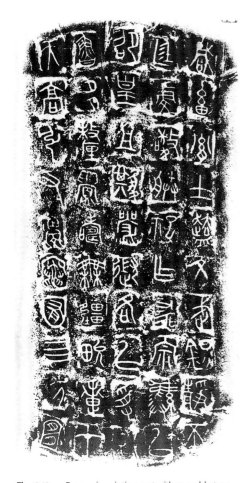

Fig. 6.12 Bronze inscription cast with movable type, in *Qin gong gui* vessel, 2nd quarter 7th century B.C. Rubbing, Diam. of vessel at mouth 18.5 cm. Museum of Chinese History, Beijing

Opposite:
Fig. 6.13 Hollow brick with stamped decoration, beginning 1st century A.D., Zhengzhou. Clay, 721.5 × 54.5 cm. The Art Institute of Chicago

Fig. 6.14 Detail of Fig. 6.13

core, is of momentous significance. Seen from the perspective of printing technology, it is a movable type.

This may seem surprising, but it becomes much less so in light of the inscription on the seventh-century B.C. bronze *gui* of a duke of Qin (*Qin gong gui*).[37] This inscription is cast into the body of the vessel and in its lid. Figure 6.12 shows a detail of the inscription with its rectangular grid of five vertical columns and ten horizontal rows. While each character is set into its own square, the squares follow each other in a slightly irregular sequence, which demonstrates that each character was first formed on a small, separate template of clay. Impressions were taken and inserted into the core: the Chinese had invented the principle of movable type during the Bronze Age!

Printing in Clay and on Silk

The skillful bronze casters of antiquity were by no means the only ones who explored protoprinting techniques in clay. Even Neolithic potters embellished and decorated their pots by stamping patterns into the clay while it was still soft.[38] Builders who, in the first century B.C., began to construct tombs from hollow tiles made of clay, decorated these tiles with stamps, too. Hundreds of tombs, containing thousands of tiles have been identified in Henan Province.[39] The decoration on these tiles is another splendid example of modular production and, once more, anticipates printing with movable type.

Figure 6.13 shows such a tile (Art Institute of Chicago), which was probably produced toward the beginning of the first century A.D., near present-day Zhengzhou, Henan Province. The maker pressed the designs into the wet clay with ten different stamps, using only one for each motif. Certainly, he had a repertoire of stamps with various figures, animals, carriages, trees, and assorted decorative patterns at his disposal in his workshop. In choosing which to use, he was apparently not much concerned with iconographic accuracy. He did not have a well-defined program that allotted a particular meaning to a particular motif at a particular place in the composition. Above all, he wanted to fill a given area in a pleasant and appealing manner. He did it playfully and fast. Some other tiles display rows of trees that tilt to one side, indicating the speed with which he worked.

The tile decorator also faced the task of how to fit repeated impressions into a register of a given length. It was the familiar problem encountered by the bronze caster who "wallpapered" the interior of a vessel's mold with repeated clay impressions taken from the same pattern block (see Fig. 2.32). Confident that the average viewer would not notice the resulting seam, the caster solved his problem simply by cutting off the remainder of the last clay strip. Similarly, the decorator of the Chicago tile probably started from the left to make the register with the five mounted riders. Having made three impressions left to right, he proceeded to do one more at the right end of the register, then backtracked to make the final impression to the left of the rightmost one. This last one he stamped deeper, thereby partly

obliterating the impression to the right, which he had done just before, hoping that the lord of the tomb would not complain about the truncated horse (Fig. 6.14).

For a pair of tomb tiles with garden scenes—which are also from Zhengzhou but date from the late first century B.C.—the tile maker again used a limited number of stamps. As he arranged the motifs very creatively, his two compositions look rather dissimilar (Fig. 6.15). A stamp for a roof with a trapezoidal shape occurs several times. Near the upper edge of the left tile, two partly overlapping impressions of this stamp result in a particularly wide roof. Further down stands a gateway with superimposed roofs; curiously, one of them is stamped upside down.[40]

Systematic comparison with a great number of other tiles would lead to a better understanding of the tile decorators' intelligent modular system. It is predictable that one would come to recognize workshops and to observe that one workshop used its stamps in miscellaneous combinations and compositions.[41]

Next to clay, textiles played an important role in the prehistory of printing. Once again, evidence dates back to the Neolithic period, when cloth was first decorated by means of stamps.[42] Various silk fabrics with patterns printed from stencils or blocks have come to light from among the many exquisite textiles in that unrivaled treasure trove of Han-dynasty material culture, the tomb of Princess Dai (died shortly after 168 B.C.) in Mawangdui, Hunan Province. A repetitive pattern on a particular piece of her gauze was printed in three successive stages in gold, silver, and gray (Fig. 6.16).[43] The lozenge pattern on another gauze is both printed and painted in seven different color tones altogether.[44]

The tomb, in the present-day city of Guangzhou belonging to the second king of the Nan Yue Kingdom (died about 122 B.C.), yielded both the two bronze relief-pattern stamps used to print the decoration on a silk fabric (Fig. 6.17), and the printed fabric itself. The larger stamp is 57 millimeters long, and is in the form of a symmetrical cloudlike pattern that closely resembles the one in Mawangdui. This indicates a remarkable standardization of printing patterns in the Han dynasty.[45]

Seen from the perspective of the development of printing technology, such textiles are of consequence because they bear the earliest imprints on a flat surface. Nevertheless, a crucial step remained to be taken. We have yet to deal with script, which comes in with seals. After clay tiles and textiles, they are the third most significant objects in the prehistory of printing in China.

Fig. 6.15 (right) Two bricks decorated with stamps of garden scenes, late 1st century B.C., opposite the entrance door at tomb no. 159, Zhengzhou, Nanguan. Clay, 126 × 40 cm

Fig. 6.16 (below) Silk gauze with decorative pattern printed in three stages, shortly after 168 B.C., from the tomb of Princess Dai at Mawangdui, Hunan Province

Fig. 6.17 (below, right) Relief stamp for printing textile patterns, before 122 B.C., from tomb of the Second King of Nan Yue. Bronze, L. 5.7 cm. Museum of the King of Nan Yue, Guangzhou

SILVER + GRAY + GOLD =

Seals appeared in fairly large numbers during the last centuries B.C. They were mostly rectangular or square, made of bronze or jade, and used to make impressions in soft material, generally clay. Hence, seals function like small pattern blocks, except that their designs are not of decorative patterns but of script. In secular official and private seals, a few characters arranged in a small grid of two or three lines contain the name of an office or individual, a title, or a motto. Religious seals may be engraved or cast with holy formulas, spells, or invocations.

Name seals were, and still are, used in East Asia to guarantee the identity of the owner and the authority of that person's actions. They function as handwritten signatures do in modern Western societies, but the difference is a symptomatic one. A signature is the visible result of the movements of the hand of a particular individual. As one's moves differ a bit each time, one's signatures also differ, if only slightly. Yet, the important point is that all versions of the name handwritten by the same person are believed to possess some unique and inimitable characteristics. The signature remains essentially the same, and it is immune to accidental changes caused by a specific situation, different writing materials, or the passing of time. The inimitable and permanent quality of the handwritten name is believed to be grounded in a supposedly immutable core of the writer's personality.

Somebody availing himself of a seal equally employs the unique, never-changing shape of his written name to prove his identity. But the permanence of this shape is not grounded in his unchanging identity as an individual but rather rests with the material solidity and permanence of a utensil, which remains the same in all situations and throughout time. Its neat design allows the owner to reproduce his name again and again in the same form, without even the slight variations accepted in handwritten signatures. Each impression is meant to look exactly alike.

The seal's ability to guarantee reproduction of a written shape without noticeable difference makes it suitable for legal purposes. A private seal in China represents a person in a nutshell; it is the authorized owner's juridical double. As observed earlier, seal impressions on the soldiers of the terra-cotta army identified and held responsible the individual master who supervised the production of a particular figure (see Fig. 3.23). The king of Nan Yue also needed seals as tokens of his authority. Three were buried with him in his tomb (Fig. 6.18).[46] Even a king of hell keeps at his side a boy who holds a box with the official seal (see Fig. 7.1).

One tends to think of seal impressions as being in red ink. They are well known from Chinese paintings and they appear on all kinds of official documents. Even the legend on current archaeologically recovered seals, such as those of the king of Nan Yue, are often reproduced in red on paper. One should remember, however, that early seals, at least through the Han

Fig. 6.18 Seal of the Second King of Nan Yue, before 122 B.C., from the tomb of the Second King of Nan Yue. Gold, H. 1.8 cm, L. 3.1 cm, Weight 148.5 g. Museum of the King of Nan Yue, Guangzhou

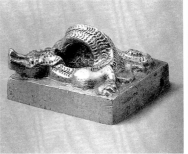
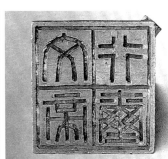

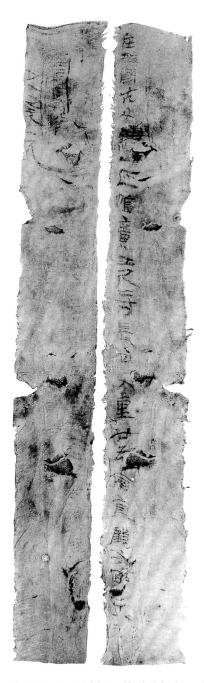

Fig. 6.19 Front (*right*) and back (*left*) views of a silk strip with seal impressions in black ink, ca. A.D. 100, kingdom of Rencheng. Ink on silk, L. 31 cm. The British Library, London

dynasty, were not made to be stamped on paper, which was not yet available. Almost all known impressions were made in soft clay, although impressions on silk exist, too.

Technically speaking, a seal is a small pattern block. Yet the same seal can be turned into a printing block simply by applying ink and stamping it on a hard surface where it leaves a flat print rather than making an impression. The earliest known example is a fragmentary red print of a rectangular seal on a piece of brocade from a fourth-century B.C. tomb in Changsha, Hunan Province. It is believed to be a mark of the producer, a woman whose name is handwritten in black ink at the edge of the silk. The seal authenticates her product and its quality.[47]

The same purpose was served by a seal in black ink on the back side of a strip of undyed silk in the British Library, discovered by Sir Aurel Stein in the refuse heap of a Han-dynasty military station on the westernmost stretch of the Great Wall (Fig. 6.19). The front of the silk strip bears handwritten information that specifies its origin, dimensions, weight, and price. It came from the kingdom of Rencheng, which was established in A.D. 84 close to the Pacific Ocean in present-day Shandong Province. The silk was produced there around A.D. 100, and then shipped thousands of kilometers to the desert post in western China.[48] These undeciphered seal impressions are momentous documents, as they are the oldest-known items of printed script on a flat surface in the world.

Because seals guarantee error-free replication of emblematic script, they also proved most welcome in religious practice. Spells, charms, and invocations must be written correctly to the dot, lest they lose their efficacy. A seal ensures that this does not happen. Daoist priests stamped them on the bodies of sick people to save them from the peril of death. They also used them in exorcistic rituals against evil spirits, wicked humans, and vicious animals, and directed seals into space to stave off nightmares and other imminent dangers.[49]

Daoists and Buddhists alike presumably made seal imprints on surfaces other than human skin, but it is not known when they started to do so. The famous seal with 120 characters that the fourth-century Daoist master Ge Hong recommended for safe passage through the wilderness was stamped in clay.[50] Impressions of religious seals on paper may have existed by that time, but it is only in the first half of the sixth century that a prototantric scripture testifies unambiguously about seals printed on paper and used as talismans.[51] One also reads that paper was sealed and then burned for the benefit of patients, who swallowed the ashes.[52]

Information Technology

Let us pause at this point in our investigation into the history of the printing technique to review what the Chinese had accomplished. Working with bronze, clay, and silk in various applications they had discovered some of the fundamental principles of printing, and developed them to a high degree of sophistication. Yet the Chinese were not the only ones in the world

to experiment with printing techniques. Well known are the engraved cylinder seals in the ancient Near East, which first appear in the second half of the fourth millennium B.C. When rolled over soft clay, they leave impressions of the design and the script engraved into them, similar to the impressions left by Chinese seals.[53] Romans are known to have worn signet rings that they impressed in wax.

At some point, however, the Chinese took an unheard-of step beyond what was known and practiced in the ancient world: they started to stamp seals on hard surfaces. For the Chinese, with their accumulated experience with imprinting three-dimensional media, this may have seemed a small step to take at the time. But it was a giant step for mankind.

So far, printed impressions in pattern blocks had faithfully reproduced in the negative three-dimensional designs that incorporated the depth of the engraved lines and their tiny walls. Printers working with a two-dimensional surface, however, disregarded all particulars of line height or depth. They were only interested in the fact that there was any difference at all between intaglio and relief. In order to make this contrast visible, they introduced a new ingredient that by itself had to be amorphous—the ink—which they brought into shape by applying it to the relief portions of the design carrier. Through pressure they transferred the inked shape onto the flat surface, thereby converting a three-dimensional matrix into a binary code with two values only: black and white. From then on, printing became the reproduction of a two-dimensional graphic code.

The reduction to the two-dimensional plane resulted in radical compression of the physical dimensions of a text. To realize what this means, imagine for a moment that *Ten Thousand Things* has been imprinted in bronze or clay. This tome would require sturdy shelves in the basement, and it would not sell well. Moreover, when the traditional book format of the handscroll gave way to successively folded leaves (another Buddhist invention), and later to stitched wrapped-back binding, it became possible to open a book immediately to any page. The reader now gained random access to the entire text.[54]

Printing on paper thus had tremendous and unforeseen consequences. It allowed the storage, retrieval, reproduction, and distribution of information, both written and pictorial, on an unprecedented scale and with unprecedented speed. It led to a shrinkage in space and time, and to a dramatic increase in the number of people who could access the information.

This quantum leap in the course of human civilization is strikingly similar to and in many details parallels the advent of digitized technology. Once again we experience sudden and spectacular advances in storing, retrieving, reproducing, and distributing script and images, and an enormous increase in the number of participants who can share networks of communication. The Chinese did it all once before. By printing on paper, they led the way to the information age.

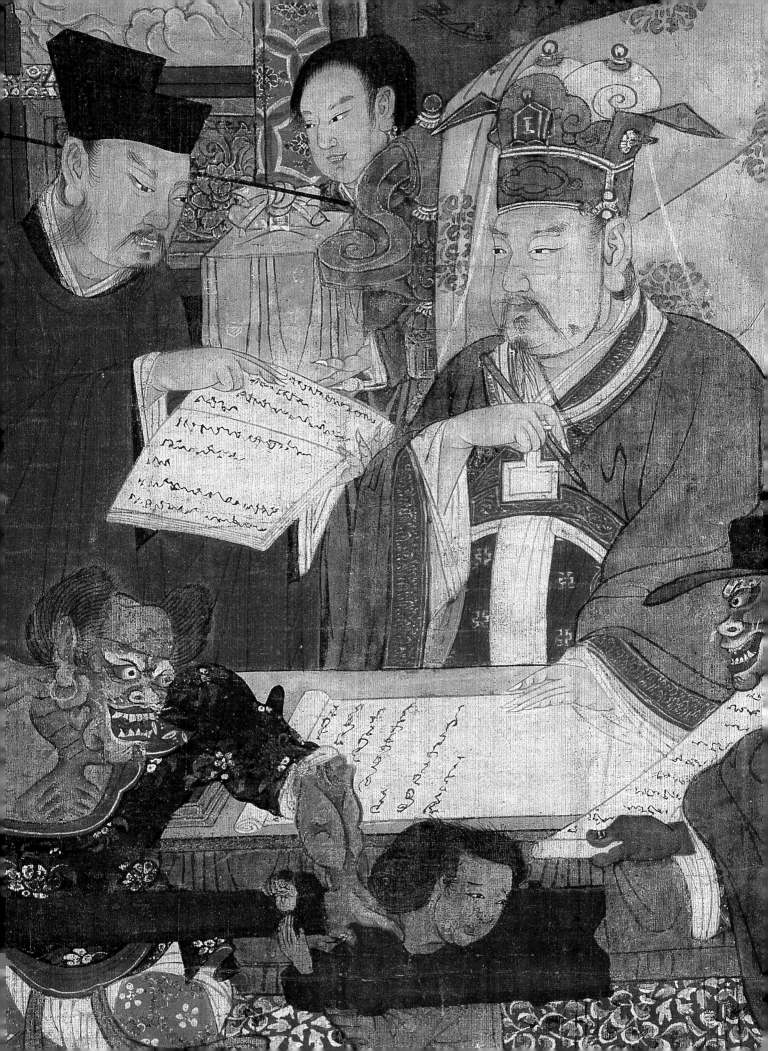

7 The Bureaucracy of Hell

This chapter deals with sets of paintings depicting the ten kings of hell. These suites were made during the thirteenth century in workshops in the town of Ningbo, which is in present-day Zhejiang Province. Most of the sets consist of ten separate paintings—one for each king.

Not surprisingly, hell in China is thoroughly modular. The paintings reveal modular structures in both technique and iconography. In terms of technique, the Ningbo workshops composed paintings using transferable, interchangeable motifs that conform to the definition of modules. Iconographically, the painters transformed the otherworldly Buddhist hells into courtrooms and the kings into bureaucrats by taking certain motifs and figure types from secular subjects and incorporating them into the depiction of hell. Motifs and figure types are not modules in a physical sense but interchangeable formulas that the painters used to make the reciprocity between secular and religious bureaucracy visible.

The backdrop to this is the Chinese bureaucracy, an awesome modular system, with countless agencies working in tandem in a division of labor. Its modular organization made bureaucracy so powerful that it could infiltrate hell. As there existed a structural similarity and interchangeability between agencies, it could seem plausible to the fearful believer that the earthly and underworldly bureaucracies worked in similar ways.

Before entering into the analysis of the modular structure of the Ningbo paintings, we must first descend into hell itself to meet some of the kings who reign there.[1]

A Set of Kings of Hell

The cartouche in the upper-left corner of a painting in Berlin of the seventh of the ten kings (Figs. 7.1, 7.7) bears this inscription:

On the seven-times-seventh day: the Great King of Mount Tai.

This somewhat enigmatic inscription refers to the Buddhist belief that after their death humans must go to hell (or rather to purgatory, as Christians would call it),[2] where they meet the ten kings, one after the other. Seven days after their death they pass before the first king, where they are detained, tortured, and judged according to their conduct during life. After two times seven days they meet with the second king, after three weeks with the third, and so on. After the seventh week, they would come before this king of Mount Tai. At this point they have a chance to leave the underworld. Yet if they are still found guilty, their circuit will continue, and they will pass before the eighth, ninth, and tenth kings after one hundred days, one year, and three years respectively. Only then will it be decided on which of the six paths of existence they will be reborn: as a god, titanic demon, human, animal, hungry ghost, or denizen of hell.

Fig. 7.2 (left) Workshop of Lu Xinzhong, *The Fifth King,* 13th century. Hanging scroll, ink and color on silk, 84.5 × 52 cm. Kôtôin, Kyoto

Fig. 7.3 (right) Workshop of Lu Xinzhong, *The Sixth King,* 13th century. Hanging scroll, ink and color on silk, 84.5 × 52 cm. Kôtôin, Kyoto

The central figure of the painting, identifiable by the character for "king" (*wang*) on his headgear, sits in a large armchair behind a desk, on which lies an open scroll. Before writing down his verdict, the king waits a moment in order to listen to his two attendants, who hold documents that record the good and bad deeds of the person on trial. The king, whose imposing appearance is emphasized by the grand armchair and the screen behind him, is represented as a Chinese magistrate, wearing a voluminous garment in sumptuous pastel-blue fabric. He has smooth, light skin and long fingernails. The boy behind his chair holds a square box covered by a cloth, in which the seal of office that guarantees the king's legitimacy is kept.

In the lower half of the picture defendants are tortured by wild, larger-than-life demons. One pulls a woman confined in a heavy wooden *cangue*, who looks back over her shoulder as her baby grasps the end of her skirt. At the sides, two other demons, their skin green and blue in color, torture three sinners who are tied by their feet to the top of a black post. Their hands and arms are nailed to the ground with iron daggers. Blood gushes out of their mouths and spills over their bodies. They turn and shiver in pain. Below is a "knife mountain," densely filled with vertical blades.

The composition is thus divided into two parts, an upper sphere of justice, where the judge/king reigns supreme, and the lower sphere, realm of torture and punishment, pain and fear. The serene dignity of the upper sphere is reflected in the clear straight lines of the screen and the balustrade, and in the large, strongly colored areas in the garments of the main figures. By contrast, no calm lines are present in the lower half of the painting. The color rhythms are hectic and the picture plane is broken up into small pieces. Moreover, the criminals and even the demons appear small when compared with the king and his assistants. His authority and the legitimacy of his verdict are beyond question.

As mentioned, the kings of hell paintings mostly come in sets of ten. The Berlin scroll belonged to the monastery Kôtôin in Kyoto, which still owns six paintings from that set,[3] one of which depicts the fifth king sitting, like his colleague in Berlin, in a large armchair, with a desk in front and a painted screen behind (Fig. 7.2). He is flanked by an official and an office boy. Three demons attend to the sinners below. The one in the center holds a woman and a man, perhaps a couple, tightly by their hair. The husband is confronted with a karma mirror, or mirror of misdeeds (*yejing*), which displays his former sins: he once hit a fellow on a boat and drowned him.[4] Two other men hide behind the mirror, while a fourth crouches to the right of the woman.

Before the sixth king (Fig. 7.3), two demons haul shackled sinners onto the knife mountain or throw them into a boiling pond. Before the eighth king (Fig. 7.4), the culprits are forced onto an iron block where their limbs are mutilated.

Only when the sinners reach the tenth and final king does their ordeal reach its completion, when they can finally leave the

Fig. 7.4 Workshop of Lu Xinzhong, *The Eighth King*, 13th century. Hanging scroll, ink and color on silk, 84.5 × 52 cm. Kôtôin, Kyoto

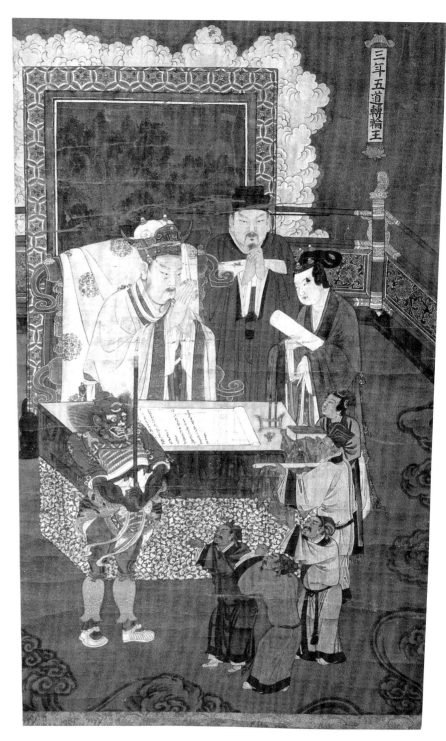

Fig. 7.5 Workshop of Lu Xinzhong, *The Tenth King,* 13th century. Hanging scroll, ink and color on silk, 84.5 × 52 cm. Kôtôin, Kyoto

underworld (Fig. 7.5). They present sutra scrolls that they may have copied during their lifetime in the hope that this meritorious deed would spare them pain after death. More probably, however, their filial descendants had these sutras copied. The merit thus gained could be directed toward the sinners suffering in hell.

The details in all the paintings from this set are very similar. The clouds around the screen, the vapors flowing in from the side, the balustrade, and (except in the last scroll) the rocks below all look alike.

The patterns on the borders of the screens and on the cloth skirts tied around the tables are absolutely identical. Obvious similarities appear in the facial features of the kings, including the depiction of their goatees and ear conchae. In all painted landscapes on the screens, the rocky crevices and leafy trees could well have been done by the same hand.

The Atelier of Lu Xinzhong

It is no coincidence that the kings of hell paintings from Ningbo come from a Japanese monastery. Indeed, none of the Ningbo scrolls seem to have survived in China. Chinese monasteries did not succeed in preserving works of art as carefully as monasteries in Japan, and the class of literati officials who patronized, screened, and transmitted China's cultural heritage looked down on these paintings because they considered them to be works of popular religious art. They did not include them in their art collections, and did not describe them in their catalogs. Thus Ningbo hell paintings were all but doomed to oblivion in China.[5]

Fortunately, during the Kamakura (1185–1392) and Muromachi periods (1392–1573), Japanese Buddhist believers, especially adherents of the Pure Land School, or *Jōdoshū*, imported hell paintings from Ningbo, which was then the most important commercial port for trade between China and Japan. Right up to the present day, hell scrolls from more than a dozen sets have been devotedly treasured and handed down in Japanese monasteries. If it were not for these, we would not know anything about hell paintings from workshops in Ningbo. One wonders what else has been lost.[6]

Many of the kings of hell paintings carry a signature.[7] The most frequent name is Lu Xinzhong.[8] In the Kôtôin set it appears below the cartouches near the edge of the scroll: "Painted by Lu Xinzhong" (*Lu Xinzhong bi*). The signature on another set, which today is in the monastery Eigenji, is less terse: "Painted by Lu Xinzhong, Flagstone Alley, Cartbridge Ward, Qingyuan fu" (Fig. 7.6).[9] Master Lu Xinzhong certainly provided the full address of his workshop in order to help potential buyers find it. He might, specifically, have had in mind export business with Japan.[10]

Fig. 7.6 Signature of Lu Xinzhong (detail of scroll of a king of hell). Signature: L. ca. 8 cm. Eigenji, Shiga Prefecture, Japan

Signatures of another master with the surname Lu, as well as signatures by two cousins or brothers with the surname Zhang indicate that the workshops in Ningbo were family enterprises. The Chinese term meaning "family" (*jia*) actually occurs in a signature.[11] It is also possible that the name *Lu Xinzhong* was used like a trademark by more than one workshop.

The signatures provide a clue for dating the paintings: Qingyuan fu is an old name for Ningbo that was in use between 1195 and 1277. Lu Xinzhong must have been active during this period.[12]

Production in Sets and Groups of Sets

The composition of a painting of the seventh king in the National Museum at Nara, Japan (Fig. 7.8), is very similar to that of the Berlin painting, but the repertoire of motifs is not as rich.[13] The Nara painting does not include the clouds surrounding the screen, the foggy vapors at the left, and the knife mountain below, and similar elements are missing from the other scrolls in the Nara set. The Kôtôin set has more extras, as it were, and one can deduce that this set was more expensive. The Nara scroll is also smaller than its

Fig. 7.7 (left) Workshop of Lu Xinzhong, *The Seventh King,* 13th century. Hanging scroll, ink and color on silk, 85 × 50.5 cm. Museum für Ostasiatische Kunst, Berlin

Fig. 7.8 (right) Workshop of Lu Xinzhong, *The Seventh King,* 13th century. Hanging scroll, ink and color on silk, 80.6 × 45.7 cm. National Museum, Nara, Japan

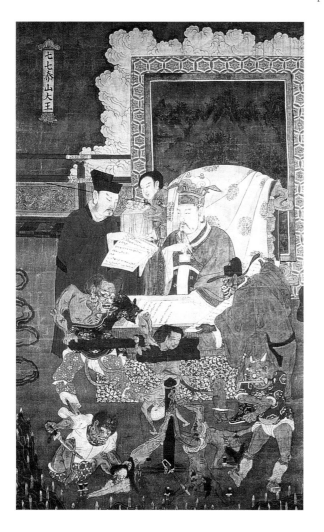
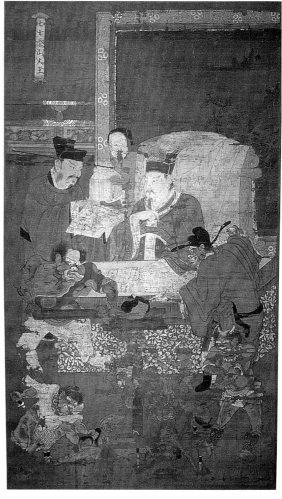

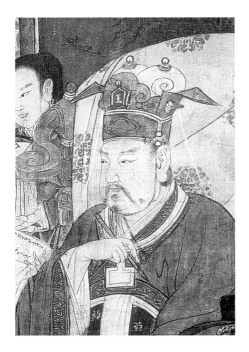 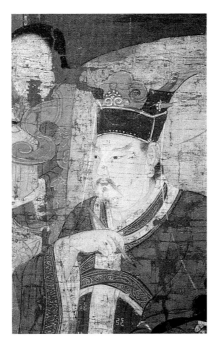

Fig. 7.9 (left) Head of *The Seventh King* (detail of Fig. 7.7)

Fig. 7.10 (right) Head of *The Seventh King* (detail of Fig. 7.8)

counterpart in Berlin by about five centimeters both in height and width, yet the respective figures are the same size.

A comparison of details in the Berlin and Nara scrolls reveals further disparities. All textile patterns differ—those on the frames of the painted screens, the furniture draperies, and the trousers and blouses worn by the demons. The panels in the balustrades vary, too. Differences are apparent in the kings' headgear, whereas almost the same set of lines was used for the faces, even for such details as the ear conchae. Yet the expression of the pupils set between the eyelids and of the softly swelling lips betray that the two faces could not possibly have been done by the hand of the same master (Figs. 7.9, 7.10). The demons shown pulling their sleeves up and

Fig. 7.11 (left) Demon in *The Seventh King* (detail of Fig. 7.7)

Fig. 7.12 (right) Demon in *The Seventh King* (detail of Fig. 7.8)

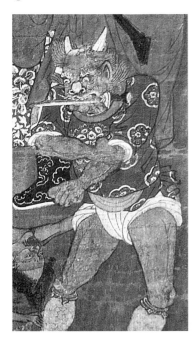 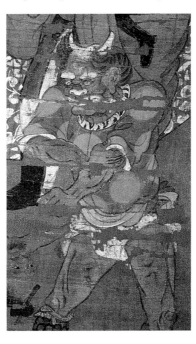

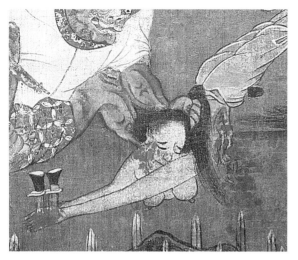
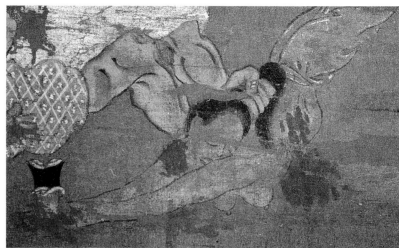

Fig. 7.13 (left) Female sinner in *The Seventh King*
(detail of Fig. 7.7)

Fig. 7.14 (right) Female sinner in *The Seventh King*
(detail of Fig. 7.8)

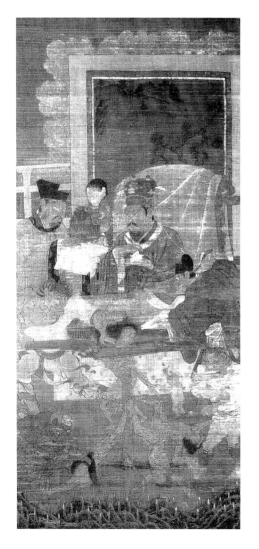

holding daggers in their teeth wear blouses on which the roundels nearly agree with regard to number and position, but not in terms of pattern. The folds in the textile correspond closely as well, but not exactly. The desk behind the demon continues farther to the right in the Nara scroll than the one in the Berlin scroll (Figs. 7.11, 7.12). Although not identical, the arm muscles of the two demons shown grabbing a woman by her hair are rendered according to the same scheme. The juxtaposition also makes the viewer aware that the unusually long pigtail covering the left shoulder of the Berlin woman has been retouched (Figs. 7.13, 7.14).

These observations show that the painters must have used stencils to establish the rough outlines of a motif. This gave them a firm compositional framework within which to operate. Yet their execution was still bound by rules and conventions, down to the number of brush strokes needed to delineate a sash. In this respect, their situation was similar to that of mold makers who prepared casts for bronze vessels, or painters of porcelain plates.

A painting of the seventh king, from a set formerly on loan to the Princeton University Art Museum, has been trimmed on the left-hand side, thus removing the cartouche (Fig. 7.15). It exhibits the same composition as the scrolls in Berlin and Nara, yet differences in the clouds, cloth patterns, and painted landscapes on the screen are evident. The execution overall is less accomplished than that of the first two sets.[14]

In a modest set preserved in the monastery Zendôji in Hakata, Kyûshu, only two tortured figures hang from the post in front of the desk of the seventh king (Fig. 7.16).[15] Whereas all the other scrolls measure between 81 and 93 centimeters in height, this one is barely 40 centimeters high. The overall execution is even coarser than that of the set formerly at Princeton.[16]

Paintings of the seventh king from the sets in the Kôtôin, Nara, Princeton, and the Zendôji all share the same composition, but they differ in the number of figures and motifs, and in quality. A similar disparity is equally apparent in a comparison of the other kings in these sets. The Kôtôin set is richest in motifs and is arguably the best in terms of execution. Lu Xinzhong's workshop, and perhaps those of other producers, deliberately modified the quality of the sets, depending on the different needs of their

customers. The Zendôji set must have been one of the cheaper models. Nevertheless, because of the similarity in their compositions, all the sets mentioned so far form one group, here designated as group A.

The workshops had many more models to offer. One scroll in a set in the Daitokuji monastery shows a woman in a *cangue* (Fig. 7.17), a motif that occurs only once in each set.[17] In this instance, the woman does not turn her head backwards toward her baby, and the post bearing sinners hanging upside down is absent. Two attendants stand at the king's right side instead of the attendant and boy seen in the other four examples. The official in front of the desk lets his scroll hang down rather than unrolling it between his hands. In spite of the conspicuous woman and baby, the composition of the Daitokuji painting thus differs considerably from what we have seen so far, which places this set in another group that we will designate as group B.

A painting in the Kanagawa Prefectural Museum (Fig. 7.18) closely resembles the Daitokuji painting.[18] Although less well preserved, its composition, the number of motifs, and even the execution are very similar to the Daitokuji example. Therefore, the Kanagawa set also belongs in group B.

As mentioned above, four of the original scrolls in the Kôtôin set are no longer extant, but the monastery replaced three, one of which is shown in Figure 7.19. Judging from his interest in luminosity and the bravura brushwork for the rocks depicted on the screen, the painter of the substitute

Opposite, bottom:
Fig. 7.15 Workshop of Lu Xinzhong, *The Seventh King*, 13th century. Hanging scroll, ink and color on silk, 86.2 × 39.1 cm. Formerly on loan to Princeton University Art Museum, Princeton, New Jersey

Fig. 7.16 (left) After Lu Xinzhong, *The Seventh King*, 14th century (?). Hanging scroll, ink and color on silk, 39.5 × 25 cm. Zendôji, Hakata, Japan

Fig. 7.17 (right) Workshop of Lu Xinzhong, *The Seventh King*, 13th century. Hanging scroll, ink and color on silk, 93.4 × 45.1 cm. Daitokuji, Kyoto

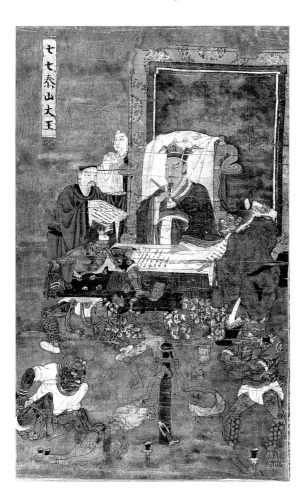

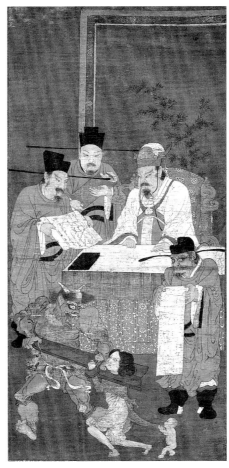

paintings must have been active during the Meiji period (1868–1912). For the third king, he took the Daitokuji scroll as his model, not realizing that the woman with the baby must occur only once in each set and that she already appears on the seventh painting, the one now in Berlin.[19]

The following five sets make up still another group—group C. The sets in this group are about two thirds the size of those seen so far, and they belong to Eigenji, Jôdoji, the Masaki Museum, the Kanazawa Library, and Hônenji.[20] Only those paintings from each set that represent the sixth king are illustrated here (Figs. 7.20–7.24). The cartouche on each of the five scroll reads:

On the six-times-seventh day: the Great King of Transformations.

The five compositions closely resemble one another. Again they show the woman with her baby, but in this group she is drawn toward the right rather than the left. It almost looks as if the painter had a stencil that he could flip over. At the left side of these compositions a demon stands with two sinners, a motif not encountered in the scrolls in groups A and B.

In each of the five paintings the figures of the woman, baby, and demon form one coherent group. In the scroll from the Eigenji set, this figural

Fig. 7.18 (left) Workshop of Lu Xinzhong, *The Seventh King,* 13th century. Hanging scroll, ink and color on silk, 92.5 × 44.5 cm. Kanagawa Prefectural Museum, Yokohama, Japan

Fig. 7.19 (right) Anonymous, *The Third King,* late 19th century. Hanging scroll, ink and color on silk, 84.5 × 52 cm. Kôtôin, Kyoto

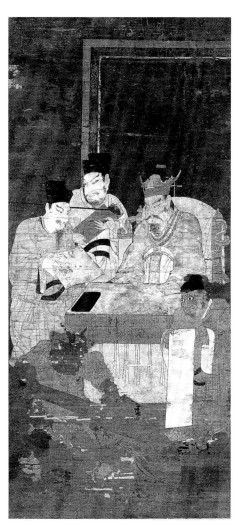

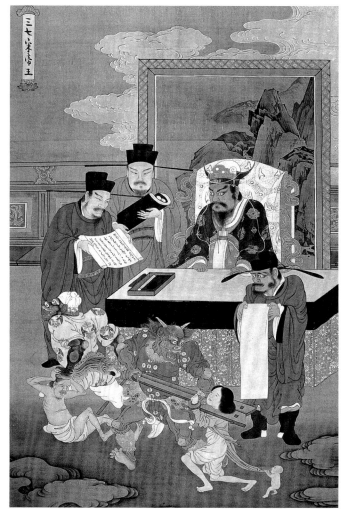

group overlaps the lower corner of the desk,[21] yet in the Jôdoji painting it does not.[22] On the damaged painting in the Masaki Museum, the position of the woman's head again differs slightly in relation to the corner of the desk.[23] Once more, while it looks as if the painter used a stencil to depict the entire group, he could reposition it on the picture surface.

Similar diversity occurs elsewhere. In the group at the left side of the paintings the demon's head reaches higher on the Eigenji scroll than it does in the Jôdoji version. In the Eigenji painting, more of the official's hanging sleeve is visible, the tip of his foot appears, and more of the screen's border is seen behind his right elbow. Apparently the entire figure has been pushed slightly to the right.

In the Eigenji, Hônenji, and the Masaki scrolls, this official points in an enigmatic gesture with his left hand. The painting in the Kanazawa Library reveals his purpose: he extends his hand toward a sinner, who offers a sutra scroll,[24] which allows the fortunate culprit to forgo torture in this particular hell. A badly damaged but nearly identical composition in the Hônenji also includes the fortunate sinner and, behind the official, the additional figure of the boy seen also in the Eigenji, Jôdoji, and Masaki compositions.[25]

The paintings in the Kanazawa Library and the Hônenji also have rocks depicted at their lower edges. The customers who ordered the sets must have paid more for these paintings, which have a greater number of motifs. Perhaps the workshop fixed the price according to the total number of figures in a set, and perhaps the proprietor told the customer that the figure with the sutra scroll represents his deceased father or other relative. Next

Fig. 7.20 (left) Workshop of Lu Xinzhong, *The Sixth King,* 13th century. Hanging scroll, ink and color on silk, 54.3 × 38.1 cm. Eigenji, Shiga Prefecture, Japan

Fig. 7.21 (right) Workshop of Lu Xinzhong, *The Sixth King,* 13th century. Hanging scroll, ink and color on silk, 58 × 40.2 cm. Jôdoji, Hiroshima Prefecture, Japan

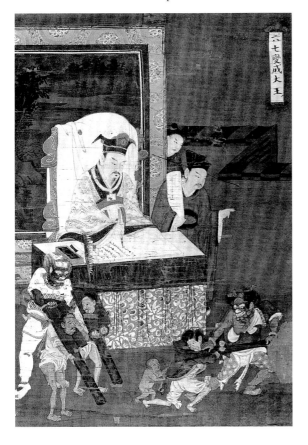
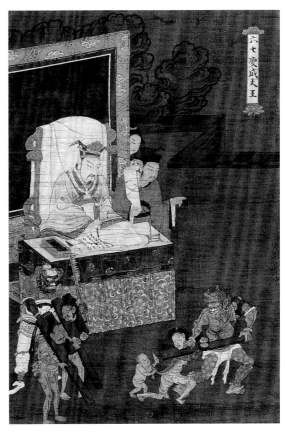

Fig. 7.22 (right) Workshop of Lu Xinzhong, *The Sixth King,* 13th century. Hanging scroll, ink and color on silk, 56 × 38.6 cm. Masaki Museum, Osaka Prefecture, Japan

Fig. 7.23 (below, left) Workshop of Lu Xinzhong, *The Sixth King,* 13th century. Hanging scroll, ink and color on silk, 58.6 × 37.9 cm. Kanazawa Library, Yokohama, Japan

Fig. 7.24 (below, right) Workshop of Lu Xinzhong, *The Sixth King,* 13th century. Hanging scroll, ink and color on silk, 53 × 36.4 cm. Hônenji, Takamatsu, Kagawa Prefecture, Japan

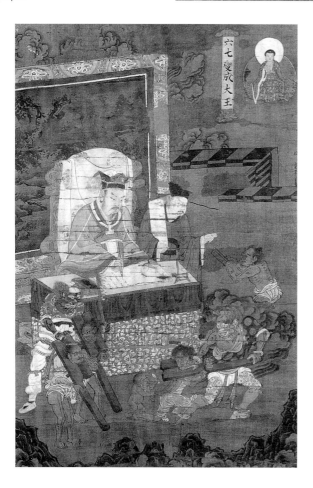

to the background cartouche in the Kanazawa Library scroll, a Buddha figure floats in undefinable space, assuring the pious onlooker that the king, as fierce as he may be, is merely the incarnation of a benevolent Buddha.

It is obvious that single figures and groups, as well as other motifs, were transferred onto the picture ground by the mechanical means of stencils. Most likely, the painters had a pounce—a sheet of paper on which the contour lines of a motif are indicated by small holes. When these sheets were laid on the painting surface, and they were pounced with black or colored powder, the contours became visible beneath. Such pricked papers, a few centuries older, were found in the Buddhist caves at Dunhuang in the deserts of western China. They were used to paint the rows of "Thousand Buddhas" on ceilings, for example.[26]

Once the dotted outlines were complete, a master painter reworked them in ink using a brush. In a third stage, other artisans assumed the detailed execution and filled in the colors. Such a division of labor has a long tradition in Buddhist painting. The celebrated master painter Wu Daozi (active about 710–760) is known to have painted the outlines of Buddhist figures in ink and left the coloring to others,[27] and even the modern painter Zhang Daiqian (1899–1983) continued this workshop tradition when he made copies of paintings in Dunhuang.[28]

Buddhist painters favored stencils in part because they facilitated the replication of images in great numbers. As with the printing of holy texts in many copies, producing many images engendered merit for both the living and the dead. From this point of view, quantity counted for more than quality. Moreover, stencils guaranteed iconographic correctness. As with printed texts and charms, this was important for the efficacy of an image. By coloring in different palettes inside the outlines generated by the same stencils, the painters also achieved considerable aesthetic variety.[29]

The artisans in Ningbo workshops, although perhaps not the first to do so, went a step further by dividing their compositions into segments, singling out figures and figure groups, pieces of furniture, and landscape elements like clouds and rocks. They treated these motifs as movable parts and assembled them on the picture surface into compositions marked by various degrees of elaboration. This method rationalized production, and it engendered an economic advantage: the workshops could offer an entire program of sets to choose from, allowing them to attract a wide circle of customers of varying degrees of affluence.

A comparative glance at similar techniques elsewhere in world art may be worthwhile here. Fifteenth-century Timurid painting, for example, made use of pounced stencils and a restricted set of stereotyped images, in order to produce "a codified visual aesthetic" and "an internal royal vision that both celebrated and confirmed Timurid rule."[30]

At about the same time, around 1400, the principle of compilation was applied to religious sculpture in central Europe. For instance, figures that were quite similar to each other might differ only in the gestures of the hands. The methods to achieve these effects included taking negative impressions and even reproducing body parts through casting. The prevalent

means, however, were sketchbooks, which permitted relative freedom in actual execution.[31] By comparison, Chinese modular production appears to be more mechanical, systematic, and encompassing.

The Scripture of the Ten Kings

The textual basis for the iconography of the kings of hell is the *Scripture of the Ten Kings* (*Shi wang jing*).[32] It is an apocryphal text written in the style of Indian sutras by a Chinese Buddhist. The anonymous author probably lived in the province of Sichuan in the eighth or ninth century A.D.[33] Thirty-two handwritten copies of the *Scripture of the Ten Kings*, many of which are illustrated, were found in the caves of Dunhuang. The oldest dated version was made in A.D. 908.[34]

After a few formulaic introductory statements, the text begins with the traditional claim that this is a sermon that was given by the Buddha before he entered into nirvâna. Using conspicuous legal terminology, the narrative goes on to describe the journey of the deceased through hell. On the specified days mentioned above, they pass before the ten kings, where they are tortured and judged.

Fig. 7.25 (left) *Hell Scenes,* 9th century A.D., Fragment of wall painting from Bezeklik, 175 × 100 cm. Museum für Indische Kunst, Berlin

Fig. 7.26 (right) *Ksitigarbha with the Ten Kings,* 10th century A.D., Dunhuang. Hanging scroll, ink and color on silk, 84 × 53.6 cm. Musée Guimet, Paris

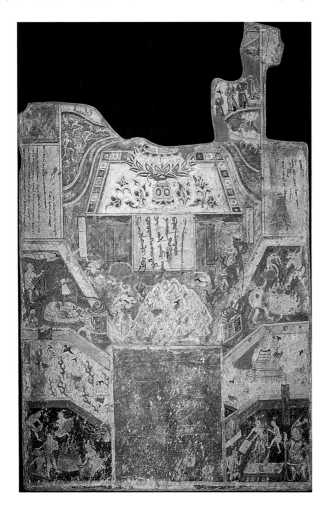

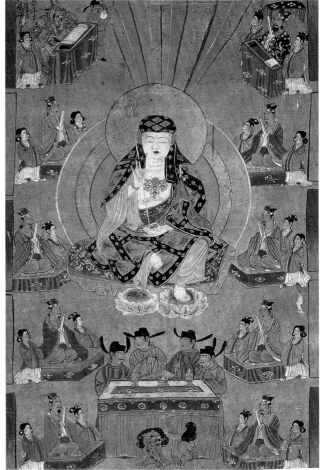

The Scripture of the Ten Kings also informs believers how, through preparatory practice during their own lifetime, they can accumulate merit that will help them through hell. If they fast and pray twice a month, and perform other meritorious deeds, such as commissioning the making of copies of the *Scripture of the Ten Kings* and votive statues, they may avoid punishment in hell, or even avoid hell entirely.[35]

The *Scripture* also instructs readers how they can alleviate the ordeals their relatives are suffering in the underworld. If the believers observe memorial rites on appropriate days, and if they have scriptures and statues made on behalf of their loved ones in hell, the departed may remain unharmed when they pass before the kings. Indeed, paintings depict sinners that have benefited in this way (e.g., Figs. 7.5, 7.23, 7.24).

Spirits constantly survey the performance of the faithful. In particular, the sutra mentions two spirit boys of good and evil,[36] who seem to be descendants of a species called "spirits born at the same time" (*jusheng shen*), which are mentioned in literature as early as A.D. 457.[37] The two spirit boys constantly accompany a human being throughout life. One boy records all good deeds, the other all evil deeds, and then they report to the underworld officials, who enter the deeds in the *Registry of the Dark Region* (*Ming'an*), a detailed record book containing a personal file on every individual. This dossier is presented to the kings before they pass their verdict.

Some Early Hell Paintings

The earliest pictures of hell did not include the ten kings.[38] Hells painted by the celebrated Wu Daozi in the eighth century left fishmongers and butchers so terrified that they stopped killing animals and changed their professions, yet no reference is known to his having painted the ten kings.[39] One of the earliest extant hell scenes, probably not later than the ninth century, provides an idea of Wu Daozi's work. The fragment of a wall painting from Bezeklik in central Asia includes dedicatory inscriptions in the Uighur language (Fig. 7.25).[40]

The representation of the main figure, the bodhisattva Ksitigarbha, has been destroyed. (A bodhisattva is an enlightened being, who hierarchically is one tier below the Buddha. The bodhisattva remains on earth to help sentient creatures attain salvation.) Behind the central bodhisattva, remnants of wavelike bands filled with tiny figures are visible on both sides. The figures represent the six paths, into one of which the deceased will be reborn. Various tortures are performed in the seven hells depicted in the lower half of the painting.

From literary records it is known that pictorial representations of the ten kings existed by the ninth century, and that in the tenth century they had become quite popular.[41] Yet only one coherent group of early images of the ten kings is extant. Like the scrolls from Ningbo, they were preserved by good fortune. They date from the tenth century and were among the scrolls that were rediscovered in 1906 in a cache at Dunhuang. No other contemporary images of the ten kings have been handed down.[42]

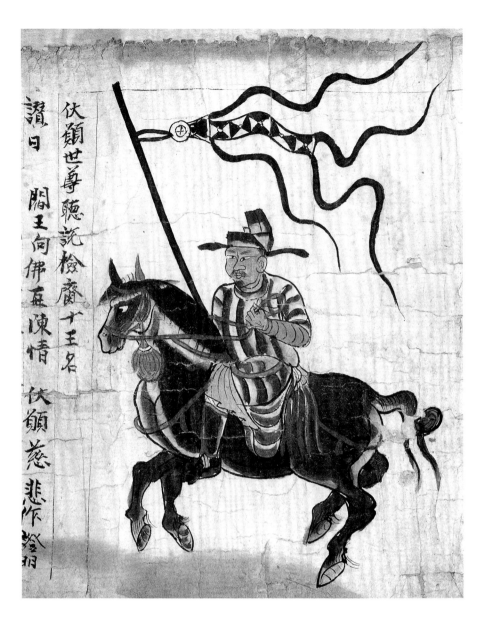

伏願世尊聽說檢齋十王名
讃曰
閻王向佛亙陳情
伏願慈悲作證羽

Fig. 7.27 *The Black Messenger* (detail of illustrated *Scripture of the Ten Kings*), mid- to late 10th century A.D., Dunhuang. Handscroll, ink and color on paper, 28 × ca. 495 cm. The British Library, London

On a hanging scroll in the Musée Guimet in Paris (Fig. 7.26), the figure of Ksitigarbha, with the rays of the (in this case) five paths above his halo, dominates the scene as it did in the example from Bezeklik. The ten kings are arranged in two rows on either side of the bodhisattva. Eight of them sit on small daises, and the two kings at the top of the rows have each acquired their own desks with writing implements. All but one are attended by the twin boys of good and evil, who are recognizable by the circular pigtails behind their ears. The king at Ksitigarbha's lower right, however, for reasons of space, has to be content with only one boy, as does the tenth king, in the upper left corner, but he is aided by an official who wears a hat with winged flaps. At the center bottom of the painting, four more court officials stand behind their own large desk.[43]

The legal and bureaucratic aspects of the underworld judgment are more elaborate still in the illustrated handscrolls of the *Scripture of the Ten Kings*. Here the kings follow one after the other, each one shown in his own separate scene. At the scroll's beginning, the kings are preceded by three

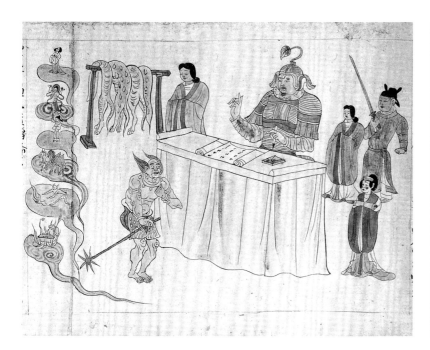
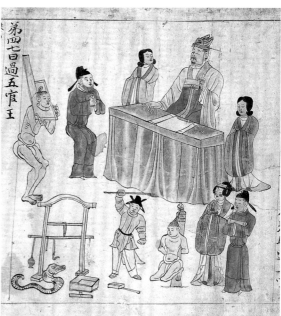

illustrations that begin with the Buddha preaching the sutra, followed by six bodhisattvas, then a black messenger riding a horse. He visits families in which somebody has recently died and checks what kind of meritorious deeds are being performed on behalf of the deceased (Fig. 7.27).[44]

The kings sit behind their desks in unarticulated space. The fourth king, flanked by the two boys and assisted by an official, watches the deceased culprits in front of him. One wears a heavy *cangue,* another is tied to a pole by his pigtail. A properly dressed couple carrying a votive figure and a sutra scripture in their arms is permitted to go free (Fig. 7.28). Behind the last king appears a depiction of the six paths, which reinforces the kings' decision-making power (Fig. 7.29). At the very end of some scrolls, a prison of hell enveloped in flames is depicted. The bodhisattva Ksitigarbha appears eventually to lead even the most wicked sinner out of the circuit of the underworld toward rebirth.

In the Dunhuang paintings, the kings assume ever more importance and autonomy. They come to be equipped with the paraphernalia of a Chinese magistrate, including brush, ink, documents, and desks, and they acquire a staff of boys, messengers, officials, standard bearers, and demons.[45]

In terms of typological development it is only a small step from the Dunhuang handscrolls, where each of the kings is represented in a single scene, to the sets of ten individual paintings in Ningbo, three or four centuries later. Nevertheless, there are significant differences between these two groups of paintings.

Modular Iconography

In all known sets from Ningbo, the first three scenes depicted on the Dunhuang handscrolls—the Buddha's sermon, the six bodhisattvas, and the black messenger—are missing, as is the prison of hell. These Dunhuang scenes placed the kings within a broader Buddhist context. By omitting this

Figs. 7.28–7.29
Two sections of illustrated *Scripture of the Ten Kings,* A.D. 912 or 971, Dunhuang. Handscroll, ink and color on paper, 34.2 × 680 cm (entire scroll). Kubosô kinen bijutsukan

Fig. 7.28 (right) *The Fourth King*
Fig. 7.29 (left) *The Tenth King*

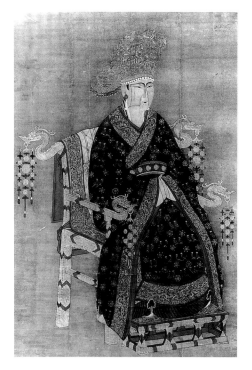

Fig. 7.30 *Zhangyi Empress Li, Consort of Emperor Zhenzong* (r. 998–1022), 1st half of 11th century. Hanging scroll, ink and color on silk, 177 × 120.8 cm. National Palace Museum, Taipei, Republic of China

Fig. 7.31 Anonymous, *Portrait of Ni Zan*, ca. 1340. Handscroll, ink and color on paper, 28.2 × 60.9 cm. National Palace Museum, Taipei, Republic of China

framework, the Ningbo workshops deprive the underworld of much of its fabulous and metaphysical quality.

A few sets, however, incorporate more than the scrolls of the ten kings. A Korean set from the Koryô period (918–1392), and a Japanese set, probably dating from the Muromachi period, include two additional scrolls that depict messengers, raising the possibility that messengers were also represented in some Ningbo sets.[46] A set of thirteen scrolls, again from Korea, boasts an additional painting of Ksitigarbha.[47] Some Ningbo sets also have a scroll showing Ksitigarbha flanked by the twin boys, which represents him as lord over the six paths.[48] Originally, other sets may have included such a scroll. But no set contains a depiction of the Buddha that is similar to the scene at the beginning of the Dunhuang handscrolls.

If a monastery had a hall of purgations, the Ksitigarbha painting may have been hung in the center, and the kings at the sides in two rows of five. This arrangement transposes the compositional scheme of the Dunhuang hanging scrolls onto the actual space of the hall, which explains why five kings always turn to the left and five to the right in the Ningbo sets.[49]

A further significant difference between the Dunhuang paintings and those from Ningbo concerns the setting surrounding the kings. In the Dunhuang scrolls the kings sit behind desks with cloth skirts. Except for a few rudimentary landscape elements, there is barely any indication of the immediate environment.

In the Ningbo scrolls, however, the settings are quite elaborate. In addition to the cloth-covered desk with the writing utensils, each king possesses a large armchair draped with a patterned cloth. This is painted in such a way that the curled ends of the crest rail above the king's head remain visible, as do the arms of the chair behind the king's elbows. Behind the chair rises a painted screen with a broad rim; some screens also have lateral wings. The scene is closed off by a richly decorated balustrade set on square tiles, both of which, in the more elaborate sets, include an angled corner.

These three elements—armchair, screen, and balustrade—are pictorial formulas that emphasize the authority of each judge. An identical iconographic repertoire was often employed in the representation of secular figures of high standing. Members of the imperial family—for example a consort of Emperor Zhenzong (r. 998–1022)—were typically depicted seated in sumptuous armchairs with dragon-shaped armrests and a precious cloth covering the back (Fig. 7.30).[50] Likewise, Chan patriarchs are presented in this way.[51] A painted screen behind the seat is another traditional attribute employed to convey the importance of secular figures, including emperors.[52] Officials and scholars, too, liked to be seen in front of screens decorated with landscape paintings. One unidentified fourteenth-century painter showed the scholar painter Ni Zan (1301–1374) relaxing in front of a landscape screen (Fig. 7.31).[53]

In life, as in art, both the armchair, and the placement of a screen behind a figure serve to frame a sitter and to augment his or her stature. But they also offer shelter from behind, requiring others to approach them from the front. This function is comparable to that of halos behind religious figures. The backs of chairs and screens in secular painting may, with some exaggeration, be thought of as profane halos.

Portraits of three consecutive Chan patriarchs on the so-called *Long Roll of Buddhist Images,* which probably was executed between 1172 and 1175, offer an opportunity to observe the metamorphosis of a halo into a landscape screen (Fig. 7.32).[54] The patriarch seated to the right has a traditional halo, a ring of light, behind his head. Behind his body, a woven mat positioned vertically is reminiscent of a flaming mandorla. The mat fitting into the back of the chair of the center figure is woven in the shape of a double halo that encompasses both the head and body of the sitter. A painted landscape appears at the back of the chair of the patriarch at the left. This kind of secularization of hieratic formulas is a hallmark of the Chan school.

The balustrade is a frequently seen element in Song paintings, in which it indicated an aristocratic mansion with a garden. In the Song-dynasty fan illustrated in Figure 7.33, the balustrade immediately suggests to the viewer that the children are from well-to-do families. They do not play on the streets because they have a personal heaven for their enjoyment.[55]

The painters in the Ningbo workshops did even more than equip their kings of hell with certain formulas commonly reserved for secular figures of high standing. Indeed, the entire ambience of the scenes is modeled on what was appropriate for government officials. Desk, screen, and balustrade are indispensable elements in a pictorial type that represents officials at leisure in the lush garden next to their mansion (Fig. 7.34).[56] The composition of such a scene is basically similar to that of the fifth king of hell and others from the Kôtôin set (see Fig. 7.2).

The same setting is depicted in secular court scenes. A woodblock illustration from *Plain Tales Fully Illustrated* (*Quanxiang pinghua*), printed between 1321 and 1323, shows an empress acting as a judge (Fig. 7.35).[57] The ambitious widow of the Han-dynasty emperor Gao, the later Empress Lü (r. 188–180 B.C.) decreed in 196 B.C. that Han Xin, a general loyal to her husband, should be beheaded. The designer again made use of the familiar repertoire of a desk covered by two cloths, one shorter than the other, the chair with curled armrests, the screen standing behind it, the clouds encroaching from the side, and the angled balustrade set on tiles. The oblong format allowed the illustrator to reveal more of the palace, where the judge resides. Her desk has been moved out in front of

Fig. 7.32 *Three Chan Patriarchs* (detail from *Long Roll of Buddhist Images*), ca. 1172–75. Handscroll, ink, color, and gold on paper, 30.4 × 1,881.4 cm. National Palace Museum, Taipei, Republic of China

Fig. 7.33 Anonymous, *One Hundred Children at Play,* 13th century. Fan, ink and slight color on silk, 28.8 × 31.3 cm. The Cleveland Museum of Art

Fig. 7.34 Anonymous, *Eighteen Scholars in a Garden,* 15th (?) century copy of Song-dynasty composition. Hanging scroll (from set of four), ink and color on silk, 173.7 × 103.5 cm. National Palace Museum, Taipei, Republic of China

the entrance, where it stands right on the borderline between the spheres of law and everyday life. In an abbreviated way the hell scenes also epitomize that liminal space where humans meet justice.[58]

Another page from the same book illustrates the story of Daji, the vicious consort of King Zhou. She implores her husband, who was the last ruler of the Shang dynasty, to have the palace ladies tortured. One is tied to a bronze pole and tortured by fire in front of the royal couple (Fig. 7.36).[59] This may have been a practice in real life, but the torture scenes in the Ningbo paintings employ magical and fantastic elements as well, including a

Fig. 7.35 *Empress Lü as Judge* (woodblock illustration from *Plain Tales Fully Illustrated*), 1321–23

Fig. 7.36 *Torture Scene before King Zhou* (woodblock illustration from *Plain Tales Fully Illustrated*), 1321–23

fire wheel that rotates by itself and pushes the sinners up into a knife moun-tain stacked with vertical blades.[60] To a certain extent, the torture scenes are thus exempt from the secularization of the kings and their entourage.

A woodblock illustration of another court scene in the *Great Dictio-nary of the Yongle Period* (*Yongle dadian*), completed in A.D. 1408, presents the reasonably famous story of a loyal chief minister of the Tang dynasty who ruled that the rebel An Lushan (died 757) be executed (Fig. 7.37).[61] Com-paring this with the eighth king in the Kôtôin set (see Fig. 7.4), it can be pointed out that the same five categories of figures are represented: judge, of-fice boy, officials, lictors, and culprits. In both instances the judge is the pri-mary figure. Immediately next to his chair stands a young staff member. The judge turns to one or two officials at his side, with whom he discusses the case. Another official may watch what happens in front of the desk, where the lictors attend to the culprits.

The figure types in Dunhuang a few centuries earlier were not yet as thoroughly secularized. In some paintings from Dunhuang, the fifth king, Yama, wears a hat that resembles a tasselled mortarboard with jade gems sus-pended from silk strings. In the Musée Guimet scroll, for example, the upper-most king in the right row is crowned by such a hat, which identifies him as Yama (see Fig. 7.26). This dignified headgear is comparable to a crown in the West as well as that worn by emperors in China. It reminds the viewer of Yama's noble Indian origin. The other kings in the Dunhuang scrolls wear hats of a simpler type.[62] In the Ningbo workshop scrolls, Yama has lost even this last small mark of distinction.[63] The once powerful and demonic sovereign of the underworld continent has been transmuted into a government official, symptomatic of the transformation that Buddhism underwent in China.

In the Dunhuang scrolls the kings are often flanked by the twin boys of good and evil, who regularly and invisibly observe the behavior of men, while the Ningbo painters relegate these spirits to the central scroll of the bodhisattva Ksitigarbha. Only one of them, probably the boy of good deeds, makes his appearance in the last scene, where tortures are no longer per-formed (see Fig. 7.5). In the other hells, those numinous beings have been replaced by office boys carrying the kings' seals.

Fig. 7.37 *The Trial of An Lushan* (woodblock illustration from *Great Dictionary of the Yongle Period*), 1408

Compared to the Dunhuang paintings, in the Ningbo renditions the number of court officials who assist the kings has multiplied, and a difference in the group of sinners is apparent. In Dunhuang almost every king judges some culprits who avoid punishment by carrying sutra scrolls and votive images (see Fig. 7.28). In Ningbo this type of fortunate sinner is encountered only rarely, mostly in the last scene. The chances to avoid torture and punishment have dwindled.

The Bureaucracy of Hell

Obviously, the staff in hell was believed to work in mimicry of the terrestrial administration. The officials surrounding the kings of hell had their counterparts in the system of governmental jurisdiction, which included judicial investigators (*pingshi*), legal auxiliaries (*fazhi*), and assistants (*cheng*) who assist the official in charge (*zhupan*) in determining the correct sentence.[64]

The immediate model was certainly the jurisdiction on the prefectural and district levels, which the viewers of these paintings were most likely to know from personal experience. Yet the comprehensive files of the underworld were probably thought to be more like those in the capital, such as in the Bureau of Executory Personnel (*liunei quan*), or in the Bureau of Administrative Personnel (*shenguan yuan*), agencies that maintained detailed registers on the performance of all officials in the empire. Those dossiers included regular reports made by superiors as well as other observations about the person in question. On the basis of these files, promotions were considered.[65]

It is interesting to note here that the number of government officials increased steadily through the Song period for more than two centuries. During the first decades of the dynasty, there were around ten thousand officials, or fewer. The peak was reached in 1196, when more than forty-three thousand were registered. Lu Xinzhong's workshop started production sometime thereafter.[66]

The parallels between the earthly and underworldly jurisdictions are also traceable through literary evidence. There are stories that the famous judge Bao, after leaving this world in A.D. 1062, became Director of the Court of Prompt Retribution of Mount Tai, a position that he had earned by his exemplary honesty. Other notable officials are said to have attained even the rank of Yama after their deaths.[67]

The compendium *Correct Lineage of the Buddhists* (*Shimen zhengtong*) of 1237 quotes a passage that confirms the essential parity between the terrestrial and underworld bureaucracies:

> *Yama Râja is called "Earth's Prefectures," just like the Son of Heaven among humans. The Magistrate of Mount Tai is like the Director of the Department of State Affairs. The Great Spirits, Recorders in the Five Paths, are like the Ministers of the Six Mianistries. The other offices in the paths of ghosts are like those in prefectures, districts, and so on.*[68]

At the beginning of this chapter the observation was presented that the artisans in the Ningbo workshops composed their paintings from movable parts. They had a certain repertoire of motifs and figures, which they assembled into various compositions. The principle of choosing from a repertoire of set parts and combining them was also applicable at the iconographical level. The painters chose motifs fraught with meaning. Armchair, desk, screen, and balustrade, in particular, force the viewer to recognize that the kings were highly placed persons who commanded respect and held power. The repertoire of figure types in the hell courts was the same as that in secular-court scenes. The Ningbo painters went further than those at Dunhuang four hundred years earlier. These later painters made the underworld resemble a bureaucratic agency, demonstrating the interchangeability between law and order in life and in death.

Yet, in spite of all the similarities between the terrestrial and the subterrestrial administration, there is still a major quality difference between them. Files in the underworld are kept on every individual, not just officials. Moreover, although there are tales of bureaucratic slipups and corruption, even in hell, the surveillance through invisible spirits must have been more effective as well as more frequent than surveillance on earth. In their hell scenes, the Ningbo painters presented the underworld as the model bureaucracy—or did they mean to show that perfect bureaucracy is hell?

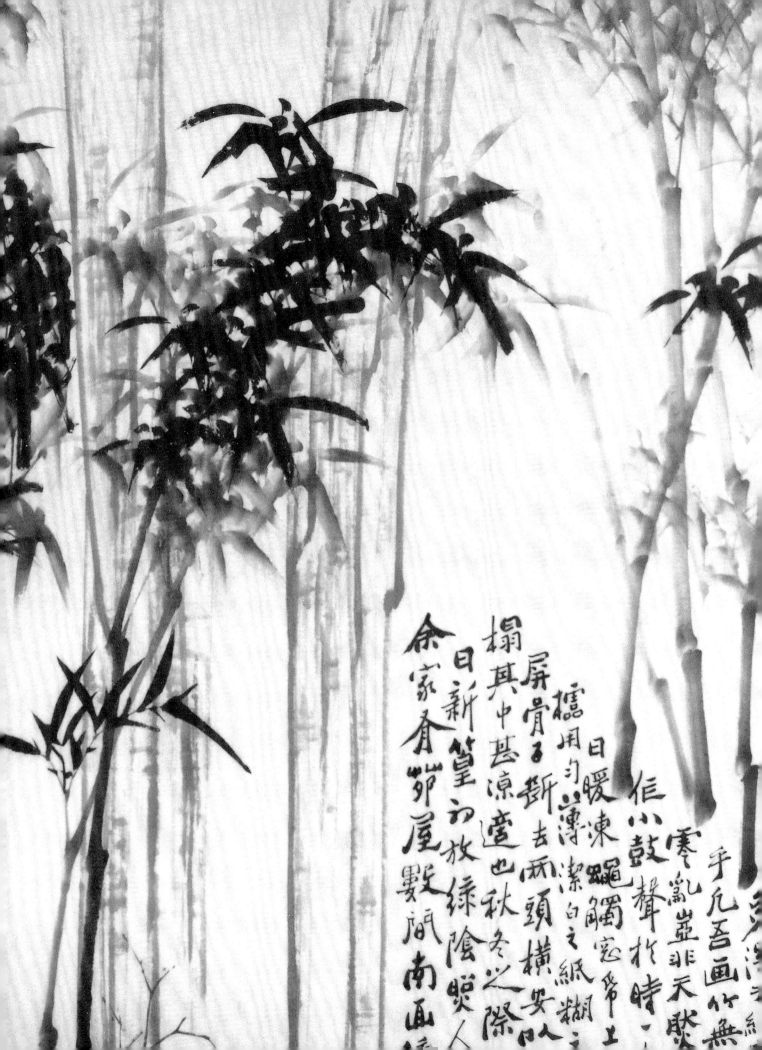

8 Freedom of the Brush?

T he previous chapters have identified, described, and ana-
lyzed modular systems in various areas of Chinese art.
This final chapter looks at artistic endeavors that go be-
yond the use of modules, namely calligraphy and painting, and it addresses
the question of what the Chinese have considered to be art.

Westerners and Chinese differ in their traditional definitions of art,
which have changed over time in both cultures. In ancient Rome, architec-
ture was considered the "mother of the arts," whereas in China architecture
belonged to the domain of the civil engineer. In the West, sculpture also held
a high rank, another legacy of classical antiquity, but sculpture was the busi-
ness of artisans in China. Calligraphy, however, enjoyed the highest artistic
position in China, while in the West it was a peripheral specialty.

The European concept of art has been constantly expanding since the
Renaissance. By the nineteenth century, westerners were admitting into their
pantheon of the fine arts many of the applied or minor arts, including metal
work, ceramics, and furniture, and this definition has also been applied by
the West to other quarters of the world.[1] For instance, today such Chinese
products as porcelains and lacquers are sold at European and American auc-
tions, where they fetch high prices and are acquired by museums and collec-
tors. These objects are included in books on Chinese art, and professors treat
them in art history courses in accordance with the modern Western concept
holding that aesthetic purposes are uppermost in defining art.

The Chinese concept of art has expanded in similar ways over the cen-
turies. For a long time it only comprised calligraphy and certain kinds of
painting, but today the Chinese have by and large adopted the modern West-
ern definition of art. Ancient tomb figures, Buddhist sculpture, bronzes,
ceramics, and lacquer dishes are collected and exhibited in the Shanghai
Museum just as they are in the National Museum in Tokyo or the Metropoli-
tan Museum of Art in New York.

Opposite:
Zheng Xie (1693–1765), *Bamboo* (detail of Fig. 8.1).
National Museum, Tokyo

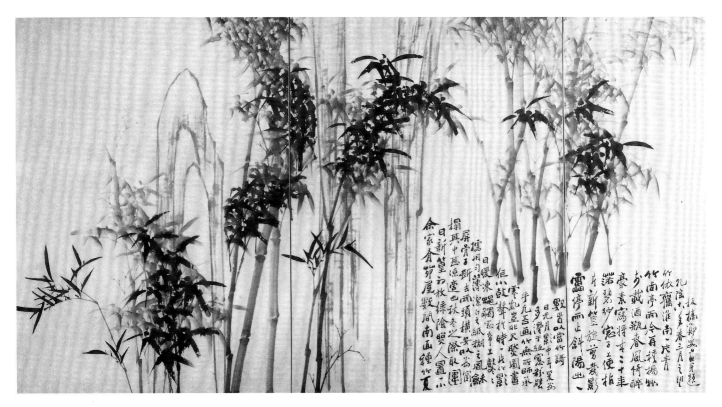

Fig. 8.1 Zheng Xie (1693–1765), *Bamboo,* 1753. Four-fold screen, ink on paper, 119.3 × 235.4 cm. National Museum, Tokyo

Several methods may be employed to establish what was considered art in imperial China. One is a terminological investigation, which might start from the observation that no general term for art existed in traditional China. The current word *meishu* is a late-nineteenth-century translation of the Japanese word *bijutsu*, which, in turn, is a translation of the French *beaux-arts*. Another line of inquiry might look at the social status of the makers. Those who produced the objects examined in the previous chapters were not considered artists in their time. Instead they were simply workers—or, at the most, skilled artisans—who manufactured luxury goods. But two additional methods will be used here to define art in China: an encyclopedia and art collections.

Classification of the Arts in the Encyclopedia

In the preface to his classic text *The Order of Things* (1966), Michel Foucault recalls his shattering laughter about a wondrous taxonomy of animals in a "certain Chinese Encyclopedia." The seemingly meaningless categories led Foucault to a central theme for his book, the question of whether the human mind is able to come up with valid classification at all. Yet Foucault played on the stereotype of China as Europe's "other," and he quoted a passage that is likely fictitious.[2] In actuality, the classification system of a Chinese encyclopedia, used properly, can reveal much about the minds of its

authors as well as about the things classified. (But then, if Foucault had been a better sinologist, he may not have written his book, which would have been a pity.)

The largest extant encyclopedia is the giant eighteenth-century *Synthesis of Books and Illustrations, Past and Present,* which, as discussed in chapter 6, entailed printing over one hundred million characters. As this comprehensive body of knowledge consists entirely of quotations, it is particularly worthwhile to inquire into what kind of information is quoted and how is it classified.

The ten thousand chapters of the *Encyclopedia* are divided into six major parts (*huibian*): Celestial Matters, Geography, Human Relationships, Science, Philosophy, and Polity.[3] These six parts comprise 32 sections (*dian*) with 6,109 headings (*bu*). No section or heading corresponds to art as it is understood today, and the topics of each of the previous seven chapters are found under various headings, with some topics treated more than once.

Script Almost everything the *Encyclopedia* records about the system of script and about calligraphy is found in its prestigious fifth part concerning philosophy (*lixue*), in the section about script (*zixue*). This section discusses the different script types, exemplary models of calligraphy, calligraphic treatises, writing materials, and it includes ample information on individual calligraphers.

Ritual bronzes Ritual bronzes are treated in three different places in the *Encyclopedia*, most extensively in the Production (*kaogong*) section, where these particular vessels are arranged by typology. The entries concerning bronzes appear after Boats and Oars and before Benches and Tables. The raw material bronze is listed between silver and lead in the section Food and Commerce (*shihuo*). The section that deals with branches of literature (*wenxue*) reviews inscriptions on bronzes as a particular literary genre, which is preceded by Admonitions and followed by Summons to Arms.

Tomb figures The *Encyclopedia* is, of course, completely void of information on the magic army of the First Emperor, which was discovered only in 1974, but no entries on other tomb figures are found either. The chapters on imperial tomb compounds in the section on Earth (*kunyu*) quote the famous passage from *Records of the Historian* that describes the interior of the First Emperor's tomb.[4] No further information about interred objects is found here or under the heading Sacrifices at Imperial Tombs and Ancestor Temples in the section concerning ritual (*liyi*). Sculpture, other than that made for tombs, is treated in the section about religion (*shenyi*), first under the heading Figures of God, and then, more specifically, under Buddhist Images, both sculptured and painted.

Factory art Lacquer, textiles, and porcelain are, like bronzes, dealt with extensively under Production. Food and Commerce contains an additional eleven chapters on textiles.

Architecture Production also informs at length about the system of architecture, in descending order from cities to palaces and halls on down to beams and pillars. Tombs are treated in the section Earth; and Religion

contains the headings Daoist Monasteries, Buddhist Monasteries, and Pagodas, which demonstrates that, in classifying architecture, function was more important than structure.

Printing Printing is not given a heading of its own, but scattered references are found in "Canonical and Other Literature" (*jingji*). Production has several chapters on seals.

Painting All kinds of stories about hell are recounted in Religion under the heading Dark Office. Buddhist Images records particular sculptures and paintings. The section Political Divisions has a detailed entry on the city of Ningbo. It even lists Cartbridge Ward, where Lu Xinzhong's workshop was located.[5] Yet the *Encyclopedia* does not mention Lu's workshop, which no longer functioned, its professional paintings having fallen into oblivion long before.

Painting by the so-called literati (*wenren*) is treated at length in the section Skills (*yishu*), which includes headings for, among others, Agriculture, Fishing, Archery, Charioteering, Medicine, Prognostication, Astronomy, Physiognomy, and Calculations. These categories derive from an elaboration of the six arts (*liuyi*) of antiquity—ritual, music, archery, charioteering, writing, and calculations—which are akin to the seven *artes liberales* of medieval Europe. Both denote certain occupations and professions that demand particular physical and mental skills and training.

Painting is the third-largest heading in the section, after Medicine and Calculations. Under Painting, one finds theoretical treatises, a wealth of biographical material on literati artists, and inscriptions recorded from particular scrolls. A separate heading, Painting and Calligraphy, is in the Script section, which, because of the high status accorded to writing, is more prestigious than Skills. Samples of handwriting by emperors, together with some of their paintings, are singled out in the section August Supreme (*huangji*).

In conclusion, the eighteenth-century *Encyclopedia* did not entertain the modern concept of art. What is called Chinese art today was at that time classified either as belonging to Production and Religion, that is, rather low in a hierarchy of values, or somewhat higher up, under Script and Skills. Calligraphy held the highest position because it was likened to literature; painting came next, because it was likened to calligraphy. These two media come closest to the modern definition of art. Manufactured objects qualified for a higher category only to the extent that they had "literary" value, which was best exemplified by inscribed bronzes.

Art Collections

The analysis of the classification system in the *Encyclopedia* can be corroborated by a look at the history and content of art collections in China. By definition, art collections include objects chosen primarily for their aesthetic quality rather than for their material, historical, political, or religious value. Hence art collections provide another possible definition of art: all objects in an art collection.

Long before they started to build art collections, Chinese rulers already had collections of precious things in their palaces, for example charts, registers, and holy objects such as the Nine Bronze Tripods, which were handed down from antiquity.[6] Ownership of these treasures guaranteed the legitimacy of the ruler and was taken as proof that he deserved the mandate of heaven and would lead a virtuous reign. Later imperial art collections inherited this legitimizing power of the early palace collections in secularized form. This is the reason why, when retreating from the mainland to Taiwan in the winter of 1948, Chiang Kai-shek took several hundred thousand objects from the former imperial collection with him. It was a unique venture in the history of art and the military.[7]

Rulers were not the only ones who collected precious ancient objects. In the tombs of many Han nobles one finds, apart from contemporaneous treasures, bronzes and jades that were hundreds, even thousands, of years old at the time of interment. Their beauty may have been one reason why owners wished to hold on to them for eternity, but it was not the primary reason. The ritual function of these objects, their significance as documents of antiquity, as tokens of a family tradition, or simply their sheer material value, were more important than their aesthetic quality.

Following is a brief overview of when the types of objects discussed in previous chapters entered art collections.

Script Specimens of script were the first items to be collected primarily for their aesthetic value. This began in the fourth century A.D. Prior to that, the major criterion for evaluating script had been its text or content. Now certain pieces, above all those by Wang Xizhi (303–361) and his son Wang Xianzhi (344–388), were collected for the quality and beauty of the handwriting itself. One prominent early example is Wang Xizhi's *Orchid Pavilion Preface* (see Fig. 1.5). Paintings followed suit, and many emperors and private individuals collected works of calligraphy and paintings during the Tang period (618–906).

Ritual bronzes These objects were made as tokens of political and religious power for elite families to use in rituals honoring their ancestors. Throughout all later epochs, ancient bronzes were highly esteemed, and, when they surfaced from under the earth, were sometimes presented to emperors as auspicious omens.

Systematic collecting of ancient bronzes began in the Northern Song dynasty (960–1127). The great patron of the arts, Emperor Huizong (r. 1101–25), owned several hundred objects, which he exhibited on special occasions in his palace halls. He commissioned a catalog of his bronzes that was comparable to those for his calligraphic pieces and paintings. This imperial catalog and other Song-period bronze catalogs compiled for private collectors contain woodblock illustrations and detailed information on the individual objects, including measurements, physical condition, and provenance. Yet the uppermost interest of collectors was captured by the inscriptions on these enigmatic vestiges from a remote past.[8]

During the Ming dynasty (1368–1644), scholar-officials, wealthy merchants, and other members of the cultured elite occasionally still put

ancient bronzes to use in their ancestral temples.[9] As a rule, however, bronzes were collected and treated as precious objects. In one listing, a late-fifteenth-century collector ranked his finest bronzes immediately below his works of calligraphy.[10] One or two owners took their beloved ancient bronzes with them to their graves. Such high regard was sometimes accorded to paintings and works of calligraphy as well.[11]

Bronzes from antiquity figured prominently in the collection of the Qianlong Emperor (r. 1736–95), the largest single art collection in Chinese history. Qianlong, like Huizong before him, ordered his bronzes to be recorded. In addition to his catalogs of calligraphy and painting, which total some 21,000 pages, four bronze catalogs appeared over a period of approximately forty-five years, describing a total of 3,688 items.[12] By this time, the aesthetic qualities of the objects received more attention. Some catalog albums boast exquisitely colored drawings, betraying a fascination with the beautiful form and surface of the metal.[13] Remarkably, Qianlong never had seals or inscriptions engraved on his bronzes, although he did so on jades and pieces of porcelain.[14] Size permitting, bronzes were included in the "boxes of many treasures" (*duobaoge*) that were constructed to contain a microcosm of the imperial collections, including tiny jades and minuscule bronzes of all ages, decorative objects in every medium, and miniature calligraphies and paintings.[15] Even if curiosity was dominant in the appeal of these cultural playthings (*wenwan*), a major criterion for selection was their aesthetic properties. Consequently the "many treasures" in these boxes come close to the modern definition of art.

Tomb figures Ceramic tomb figures entered Chinese art collections very late, possibly not before the twentieth century. Ancient specimens were little known before the period of archaeological excavations, as tomb robbers were mainly interested in objects made of jade and metal. The Chinese tend to shun things connected with death, and the idea of keeping in one's house objects made for a dead person did not appeal to them. Tomb figures finally began to enter art collections because westerners held the view that they, like Buddhist or Daoist statues, are sculpture.

Factory art Lacquer dishes, textiles, and porcelains were, above all, utilitarian items. If of exceptional quality, they could be considered luxury objects, but they still did not have a place in the Song imperial art collection. Song collectors may have been interested in certain contemporary manufactured products but hardly in ancient ones.

During the Ming dynasty, however, the cultured elite began to appreciate such goods, especially pieces of porcelain. Most were products of the time, but collectors also eagerly sought antique objects and valued them highly. Song-dynasty porcelains topped the list. The proud owners treasured them almost like pieces of calligraphy, paintings, and bronzes, often paying similar prices and including them in the catalogs of their collections. These catalogs and a body of literature on connoisseurship allow us to trace the gradual formation and the history of private collections through the peak period in the late Ming between about 1590 and 1630.[16] The art collections of these patrons were generally small, but the aesthetic quality of an object was

the foremost criterion for its inclusion. By expanding the definition of art, Ming-dynasty collectors added to a fascinating aspect of China's cultural fabric: its aesthetic dimension.

In the eighteenth century, the Qianlong Emperor adopted the late-Ming concept of art and gave it authority. His palace halls overflowed with exquisite pieces of porcelain, lacquerware, and furniture, both old and new. However, Qianlong never commissioned a catalog of these factory-art treasures. Apparently in the imperial collection firm distinctions were still made between calligraphy, paintings, ancient bronzes, and all other manufactured goods.

Architecture For obvious reasons, buildings cannot be considered in this discussion of the evolution of art collections. Architectural models, such as ceramic watchtowers of the Han dynasty, only entered museum collections with tomb figures.

Printing Printed products were collected separately in libraries. Illustrated books, even if designed by renowned painters, did not enter traditional art collections and were stored only with other books.

Painting A long time passed before professional religious paintings were included in art collections. Religious scrolls with lengthy inscriptions, compositions executed in ink, and scrolls by known artists—in short, paintings with literary quality—were given preference by collectors. Qianlong's collection was replete with such works and the first installment of his catalog of calligraphy and painting is devoted to them.[17] The palace even owned a painting of a Buddhist Luohan from the Ningbo workshops.[18] However, Qianlong does not seem to have accepted professional products done with movable stencils, like those by Lu Xinzhong. If given a chance, Chinese museums might acquire them today, but they would be following the lead of Japanese and Western museums.

Summing up these few observations (on a topic that deserves a book-length study), one can say that the scope of objects included in art collections in China continually broadened through the centuries. Collecting calligraphy began in the fourth century, followed by paintings shortly thereafter. Bronzes began to enter collections in the Song dynasty; manufactured luxury goods in the Ming dynasty. The eighteenth-century imperial collection validated the late-Ming concept of art. The introduction of a Western-art concept at the beginning of the twentieth century widened the spectrum even farther.

The examination of art collections thus supplements and modifies the observations made when surveying the *Encyclopedia*. Both the collections and the *Encyclopedia* emphasize the supremacy of calligraphy and painting as arts, and both grant ancient bronzes an elevated position because of their inscriptions. Yet by acquiring manufactured objects, the production of which involved module systems, Ming-dynasty art collectors had already transcended the traditional classification scheme that, later still, would be expounded in the *Encyclopedia*.

Neither the compilers of the *Encyclopedia* nor collectors believed that all beautiful pieces of calligraphy and all good paintings should be considered art. Officials with a literary education defined culture and claimed a monopoly

on art. Insisting on the distinction between their own calligraphy and that of scribes in offices, and between their paintings and works by professionals, the literati set their own practice apart in various ways. In calligraphy, they emphasized the cursive types of script amenable to individual expression, which were not the script types used by clerks for documents. For their own paintings, the literati preferred ink and light color rather than heavy pigments. Thereby they likened painting to calligraphy and avoided any resemblance to artisans' products in gaudy colors. They limited their repertoire of themes and motifs, at times narrowing it down to landscapes and plants, and they favored plants that required little technical competence to paint but were fraught with symbolic meaning. Indeed, attempts to distance themselves from professional practice go a long way to explain why the literati chose certain technical, stylistic, and aesthetic features for their own art.

The literati used their art collections as instruments by which to promote their definition of art. They primarily acquired pieces of calligraphy and painting that conformed to their own standards and were created by their own group. Handwritten Buddhist sutras, like those engraved into stone in the Cloud Dwelling Monastery (see Figs. 1.1, 1.6, 1.7, 1.10–1.12), did not qualify as art, nor did paintings such as those discussed in chapter 7, from Lu Xinzhong's workshop, because they were the work of professionals.

The Aesthetic Ambition of Calligraphy

In addition to his social status, the educated calligrapher distinguishes himself from the professional scribe through his aesthetic ambition. When exploring the aesthetic dimension of script, calligraphers start from the simple fact, observed in chapter 1, that no two versions of the same handwritten character are completely identical. The same phenomenon is found in other fields. No two blocks in a timber frame building are completely alike, nor are two absolutely identical cups found among the 150,000 porcelains in the shipwreck of the *Geldermalsen*. Yet, whereas craftsmen have been aiming for ever greater standardization, and have achieved ever more perfect conformity of modules and units, calligraphers have been doing the opposite. They consciously exploit variants that creep in unconsciously in the execution of characters, trying new shapes, finding new forms, studying previous masters' inventions, modifying their creations and interpreting them. Generation after generation, countless practitioners built the increasingly complex edifice that is the great calligraphic tradition in China.

In A.D. 777, the Buddhist monk Huaisu (about 735–about 799) wrote his autobiography (*Zixutie*). He was a master of the Mad Cursive Script (*kuangcao*), and his handscroll (Fig. 8.2) is one of the most extraordinary calligraphic creations of all epochs. A work in the literati mode, it represents an extreme aesthetic alternative to most other works illustrated in *Ten Thousand Things* so far.[19] Whereas those works involved division of labor among teams of mostly anonymous craftsmen, the *Autobiography* was created by an individual, and we know his name.

On the spectrum posited in chapter 2, extending from a holistic production on the one hand to total division of labor on the other, Huaisu's *Autobiography* exemplifies a purely holistic creation. The monk wrote it in a linear sequence from beginning to end, in a "rapid, uninterrupted flow of darting, looping brush movements."[20] He did not plan the shapes of his characters in advance but rather let them evolve under his brush spontaneously. When he began, he had yet to know the final form the work was to take. At each stage he could still experiment. Even shortly before the end, he came up with unforeseen shapes. These fantastic graphic inventions give his scroll a spectacular finale and add considerably to its quality.

The *Autobiography* also differs from modular works in that it is a unique opus. It is not part of a set of similar scrolls, and Huaisu possibly wrote it only once. Unlike bronze vessels, lacquer dishes, bracket arms, and books, the *Autobiography* cannot be duplicated or reproduced without losing its essential quality. There is only one original.

Nor is Huaisu's scroll built up of modules. One cannot identify distinct or interchangeable components that the monk may have written at different times and assembled later, or those which he used in this or other scrolls. Whereas working with modules depends upon standardization, division of labor, and predictability, calligraphers like Huaisu strove for original, personal, and spontaneous creations.

These aesthetic values are precisely those that lie at the core of Chinese art theory. The educated literati produced a voluminous and fascinating body of writing on aesthetic issues, with emphasis upon calligraphy and painting. One of the earliest known treatises, written in the fifth century A.D., already gives the highest praise to calligraphy imbued with spontaneity (*ziran*).[21]

One eighth-century text relates how Wang Xizhi wrote his *Orchid Pavilion Preface* in the spring of A.D. 353 (see Fig. 1.5). He invited his friends for an outdoor party at a certain Orchid Pavilion. At the end of the day the

Fig. 8.2 Huaisu, *Autobiography* (detail), A.D. 777. Handscroll, ink on paper, 28.2 × 755 cm. National Palace Museum, Taipei, Republic of China

host evoked in beautiful prose the serene atmosphere of the gathering and spontaneously wrote his text down with his own brush. Very satisfied with his calligraphy, Wang Xizhi wanted to copy it the next day; yet, as the chronicler tells it, the master tried several hundred times, but was unable to match his performance of the previous day. The *Preface* was the outflow of a unique and felicitous moment of creation, which was never to repeat itself.[22]

Many theoreticians emphasized that a work of art is the visible manifestation of a unique personality, and that true artistic creation has to be distinctive. Although they acknowledged that a calligrapher has to spend years copying other masters' works, they nevertheless demanded that he must eventually develop a style of his own. They called it "getting the substance" of an old master, "transcending formal resemblance," and "becoming a master in one's own right." This is a tall order, considering that China has been home to millions of dedicated practitioners of calligraphy. Yet the system of calligraphic shapes is so resourceful that throughout the ages, and even today, masters have continuously been able to forge new, individual styles. Experience shows that even a very few characters can betray the hand of a particular calligrapher.

Not all calligraphy that conforms to the aesthetic ideals of the literati has to look wild and erratic like Huaisu's *Autobiography*. There exists a broad stylistic range. For example, Deng Shiru (1743–1805), whom some critics regard as the greatest calligrapher of the Qing dynasty, was a master of the stately and tectonic Seal Script (Fig. 8.3). He wrote very slowly, in full control of the movements of his hand at every moment. The subtle nuances in the width of each stroke and the delicate balance in the sophisticated composition of each character are inimitable.[23] Deng Shiru's epigraphic script conveys a totally different impression than Huaisu's swift brush traces, but both works embody the same aesthetic values of nonmodular art, which is spontaneous and unique.

Yet freedom of the brush is not easily won. A calligrapher works within a framework of many rules. First is the essential fact that he writes a prescribed sequence of brush movements. In every character, the individual strokes must follow one another in a specified order to be obeyed by everyone. This is especially important when contracting several strokes into one sweeping movement in cursive script. If a calligrapher were then to change the sequence of the strokes, his characters would degenerate into unintelligibility. The characters must also follow one another in a definite order, again, lest the text become incomprehensible.

When watching a calligrapher write, the viewer knows what was observed a few seconds ago, and what the calligrapher did in those few seconds. The viewer who knows the text, such as that of a famous poem, will also have a fair idea of what the calligrapher will do in the following seconds. When the eminent calligrapher Fu Shen wrote the two characters that stand for "ten thousand things" (*wanwu*) to be the frontispiece for this book, the well-informed spectators present at the occasion could anticipate every stroke as it was about to be written, but they could not visualize its final appearance (Fig. 8.4). Likewise, when a pianist performs a well-known piece,

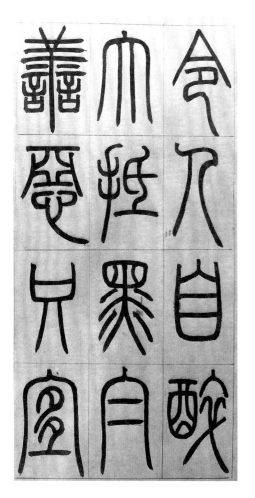

Fig. 8.3 Deng Shiru (1743–1805), Single leaf from album with Seal Script. Ink on paper, 31.3 × 16.2 cm. Formerly Collection of Zhou Peiyuan

Fig. 8.4 (left) Fu Shen (born 1937) writing the frontispiece for *Ten Thousand Things*, March 1997

Fig. 8.5 (below) Jackson Pollock (1912–1956) painting *Number 32*, 1950

educated listeners will not concentrate on *what* he plays (which they know already) but on *how* he plays. Both, a few characters written by a calligrapher and a few bars played by a pianist can embody the experience of a lifetime. The difference is, of course, that the performance of a calligrapher results in a permanent trace, which remains to be viewed.

A viewer watching Jackson Pollock paint, by contrast, may not remember what exactly he saw in the preceding ten seconds (Fig. 8.5). And he could hardly anticipate what the abstract artist would do next. Some critics who claim that modern action painters have felt akin to East Asian artists of the brush, and looked to them for inspiration and legitimacy, may have failed to see, or perhaps did not want to acknowledge, that Chinese calligraphy requires discipline from beginning to end.

Spontaneous freedom in calligraphy is further limited by the paradox that it has to be learned slowly, under painstaking training. When westerners develop a personal handwriting in their youth, certain ways of abbreviating and contracting letters creep in unintentionally, and these idiosyncrasies tend to remain for life. This is why banks have been persuaded to trust our signatures on checks. A Chinese calligrapher, by contrast, can hardly ever invent his own abbreviations. He learns spontaneous movements by slowly copying the spontaneous movements of earlier masters.

Frequently, a calligrapher's models are copies themselves. In so-called tracing copies (*shuanggou*), the copyist first traces the outlines of every single dot and stroke and then meticulously fills in the contours with small strokes

Fig. 8.6 (left) Detail of a tracing copy after *Xingrangtie*, letter in cursive script by Wang Xizhi (303–361), 7th century A.D. Handscroll, ink on *ying-huang* paper, 24.4 × 8.9 cm. Princeton University Art Museum, Princeton, New Jersey (anonymous loan)

Fig. 8.7 (right) Detail of the stone-cut (A.D. 1747) after *Xingrangtie*, letter in cursive script by Wang Xizhi (303–361). Sanxitang Collection, Beihai Park, Beijing

of black ink. A tracing copy of a letter by Wang Xizhi in the Princeton University Art Museum carefully preserves the spontaneous flow of the master's brush in this way (Fig. 8.6). [24]

A more common form of copy is the rubbing taken from a stone into which the shapes of characters have been accurately cut. Figure 8.7 shows a detail of the stone cut of the same letter by Wang Xizhi, done in 1747 for the Sanxitang Collection of calligraphic rubbings, compiled at the imperial palace at Beijing. The traces of his swift movements are preserved here for eternity, frozen as it were.

A third phenomenon that severely curtails the freedom of a calligrapher is the pervasiveness of technical, aesthetic, and stylistic standards. Materials—namely brush, inkstone, ink, and paper or silk—and technique underwent no essential changes after the fourth century A.D. The three main types of script, regular, running, and cursive, were also formulated in the fourth century and have been in use from that time to today.

Only within this framework did calligraphers create personal styles. When considered valuable, these styles could be canonized and become part of an available repertoire of models. Masterpieces embodying those standards were reproduced through rubbings and, beginning in the tenth century, conveniently brought together in albums. A calligrapher could choose which of these exemplars to learn. Although the styles were not modules in a physical sense, their codification reveals a modular pattern of thought.

The enormous stylistic coherence in Chinese calligraphy is unparalleled in world art. It mirrored, and at the same time fostered, a social coherence among the literati class. Chapter 1 explained that the Chinese clung to their cumbersome system of script because it allowed the educated elite to read texts written thousands of years before and by people whose spoken language they would not have understood. Script was thus a powerful instrument to ensure the stability and survival of Chinese social and cultural institutions.

The literati reinforced the cohesive force of script by developing and exploiting the aesthetic dimension of calligraphy.[25] Although the full-fledged aesthetic system of calligraphy does not have such a long history as the system of script itself, it was in place for the last millennium and a half. That was precisely the period when the Chinese literati officials held political power. They made proficiency in calligraphy one of the fundamental requirements for admission to their club, and they claimed a monopoly on writing calligraphy as an art. It was one way to bolster class identity.

Because each piece of calligraphy results from a specified sequence of brush movements, the insider who follows these movements with his eyes can sense the body language in the writer's calligraphy and thereby recreate for himself the moments of the actual creation. As long as the aesthetic standards do not change, every calligrapher can thus establish a personal rapport with the writer of any given piece, even if he lives hundreds of miles away, or hundreds of years later. In a quasi-graphological sense, the viewer evaluates the writer's personality and visualizes him as an individual human being.

The Aesthetic Ambition of Painting

The situation in painting is similar to that in calligraphy, although not identical. As they did for calligraphy, the literati clearly set forth their attitudes in theoretical literature, and they applied to painting the aesthetic standards they had first formulated for calligraphy. Mimesis was not the pressing issue it was in Europe, and not the foremost purpose of a painting. Its essential qualities, rather, were to be found "beyond representation." Spontaneous execution was always a core value, even if it was interpreted in varying ways.[26] Like a calligrapher, a so-called literati painter had to study old masters widely, but at some point he had to find a style that revealed his own unique personality. A professional painter was not expected to do this. If the arbiters of art labeled a fellow painter an artisan (*jiang*), or even called him vulgar (*su*), this was a very severe criticism that thereby questioned his social position.

Xu Wei (1521–1593) was a paragon of the literati painter who also excelled as a poet and writer of prose. His behavior bordered on madness; he mutilated himself and beat his third wife to death. Yet his paintings are admired as masterworks of an untrammeled genius, and they have influenced generations of artists right up to today (Fig. 8.8). In extolling expressive qualities similar to those of Huaisu, Xu Wei formed rocks and plants by splashing ink erratically onto the paper. His brushwork appears utterly spontaneous and he does not seem to have premeditated the exact shapes in detail.[27]

Like Huaisu's wild cursive script, Xu Wei's eccentric performance represents only one facet of the spectrum. So-called orthodox painters like Wang Yuanqi (1642–1715) who take time to build their compositions slowly and deliberately equally conform to the standards of literati aesthetics (Fig. 8.9).

The framework of rules is not as pervasive for a painter as it is for a calligrapher. There is no prescribed order of brushstrokes, and formulas for motifs are not codified as strictly as are abbreviations in cursive script. But

Fig. 8.8 Xu Wei (1521–1593), *Flowers and Other Plants* (detail). Handscroll, ink on paper, 30 × 1,053.5 cm (entire scroll). Nanjing Museum

Fig. 8.9 Wang Yuanqi (1642–1715), *Landscape in the Style of Huang Gongwang,* 1679. Hanging scroll, ink and color on silk, 80 × 36.8 cm. Linden-Museum, Stuttgart

even in his most idiosyncratic inventions, a painter still must render specific objects, such as rocks or trees, legible, as one might a handwritten text. There is no pure abstract painting, even if some painters push the boundary to the limit.

As in calligraphy, ubiquitous technical standards that have been in place for over a thousand years further curtail the freedom of a painter's brush. Apart from a few colors, he uses, in effect, the calligrapher's materials: brush, inkstone, ink, and paper or silk. And except for the addition of ink washes, the painter's technique is also similar to the calligrapher's.

There is a further parallel. Like a calligrapher who copies model pieces by old masters into an album of rubbings, thereby building his repertoire of styles, a painter may study paintings by old masters in the form of small versions assembled in an album. A famous example is the album *To See Large Within Small* (*Xiaozhong xianda*). It contains twenty-two copies after Song- and Yuan-dynasty masters that the great Dong Qichang (1555–1636) entrusted to his young protégé, Wang Shimin (1592–1680). Wang Shimin studied them so intensively that, "in his paintings, every composition, every design, texture, and ink wash had its origin in an ancient source."[28] After Dong Qichang, it became fashionable among certain painters to produce albums in which each leaf was painted in the style of a different old master. Randomly choosing from a repertoire of codified styles and then combining them into one work reveals, again, a modular pattern of thought.

If modular thought was indeed ingrained as deeply in the Chinese mind as the previous chapters have suggested, it should come as no surprise that it made itself felt in painting in still other respects. Indeed, in spite of their avowed disdain for modular production, literati painters worked along modular lines in building compositions and in combining motifs.

A famous landscape composition by the influential literati painter Mi Youren (1072–1151) begins at the right with a stretch of flat land and distant mountain ranges enveloped in clouds (Fig. 8.10). A lonely fishing boat floats in the void. Gradually the composition broadens, the mountains become larger, and a few roofs of buildings appear between leafy treetops. A stream emerges from the mountains, is spanned by a bridge leading to a riverbank covered with trees, and finally reaches the expanse of water in the foreground. Thereafter the focus of the scene quickly recedes again. The last mountains at the left disappear once more into background clouds.

Fig. 8.10 Mi Youren (1072–1151), *Cloudy Mountains,* 1130. Handscroll, ink, lead white, and slight color on silk, 43.4 × 194.3 cm. The Cleveland Museum of Art

The scroll in the next illustration (Fig. 8.11), done in a looser style and with more ink wash, is attributed to the Chan monk Muxi (about 1269). No other handscroll with such a bold composition is known. Immediately after the opening scene at the right, all motifs fade into empty space. Yet as unorthodox as the result might be, Muxi merely rearranged Mi Youren's well-known compositional type. He transposed the left-hand section of the composition to the right and slightly reduced its size. The bridge is missing; the river disgorging from the mountains flows directly into the foreground water, but details such as the fishing boat and some buildings reoccur at corresponding places. One is reminded of the Ningbo painters who pushed figures of demons and sinners around in paintings of the kings of hell.[29]

Even a master like Xu Wei, whose creations look so unrestrained, may have built his compositions from interchangeable parts. Repeatedly his handscrolls show similar fruits and plants arranged in various orders. The artist also inscribed the same poems several times. Often his paintings are undated and lack a dedication, which suggests that he may have offered them on the "free market." Perhaps he even employed a team of helpers.[30]

In addition to shuffling entire passages of compositions, painters often treated motifs like modules, as witnessed most blatantly in painting manuals, which were modeled on prototypes in botany and mineralogy. There was a long tradition, beginning in the early centuries A.D., of concern with classification of plants appropriate for eating, for medicine, and also for immortality. Stones were similarly classified according to their medical benefits and other uses. However, early examples of such illustrated treatises have not survived into our time.[31] Painting manuals, primarily printed using the woodblock technique, likewise show plants and stones, but these illustrations are meant as repertoires of motifs to be used by painters. One of the earliest manuals, which dates from about 1238, contains one hundred pages of various plums.[32] Figure 8.12 shows a sample page from another manual, this one composed about 1351, that also illustrates types of plums with their branches and blossoms. The accompanying text identifies each one and explains in poetic verse how it should look when painted.[33] Still another famous painting manual, dating a few decades earlier, codifies the depiction of bamboo.[34]

Fig. 8.11 Muxi (ca. 1269), *Evening Glow over a Fishing Village*. Hanging scroll, ink on paper, 33.1 × 115.3 cm. Nezu Institute of Fine Arts, Tokyo

Fig. 8.12 *Plum Blossoms* (page from *Pine Studio Plum Manual*), between 1351 and 1365. Woodblock print, 21 × 17.6 cm

Fig. 8.13 *Rocks* (double page from *Mustard Seed Garden Manual of Painting,* ed. of 1679). Woodblock print, ca. 25.5 × 30 cm

Most influential was the so-called *Mustard Seed Garden Manual of Painting* (*Jieziyuan huazhuan*), which was printed in four installments beginning in 1679, and often reprinted thereafter in China and in Japan. Its many monochrome and colored woodcuts contain all the separate motifs that a painter might need, and they teach how paintings to the taste of literati can be built up from these modules. One page presents rocks in the styles of the classical masters Ni Zan (1301–1374) and Wu Zhen (1280–1354), with comments on each of their particular approaches to brushwork (Fig. 8.13). Another page illustrates how to paint bamboo stalks with branches, segments, and nodes (Fig. 8.14). The righthand page shows branches growing on old stalks and tender stalks; the lefthand page displays branches growing on fine stalks and double stalks. Still another page in this manual (Fig. 8.15) classifies brushstrokes for bamboo leaves—those accomplished in one stroke in the shape of a horizontal boat or a crescent moon; in two

Fig. 8.14 (left) *Bamboo Stalks* (double page from *Mustard Seed Garden Manual of Painting,* ed. of 1679). Woodblock print, ca. 25.5 × 30 cm

Fig. 8.15 (right) *Bamboo Leaves* (double page from *Mustard Seed Garden Manual of Painting,* ed. of 1679). Woodblock print, ca. 25.5 × 30 cm

strokes like a fish tail; two types of three-stroke leaves that resemble either a wild goose in flight or a goldfish's tail; in four strokes, like crossing fish tails; five strokes, like crossing fish tails and a wild goose; or in six strokes, like a pair of geese.

After having studied the *Mustard Seed Garden Manual*, even a dilettante painter could assemble these motifs into whole compositions and thereby achieve passable paintings. The remarkable fact that it was possible at all to dissect literati paintings in this way and to codify their parts demonstrates once again how akin module systems were to the Chinese mode of thinking.

Modular Paintings

Nevertheless, most literati painters looked down on the *Mustard Seed Garden Manual*. They pointed out, correctly, that its compiler, Wang Gai (active 1677–1705), was somewhat ignorant because he had little access to good paintings in important collections. In addition it was felt that woodblock illustrations cannot convey the vibrant quality and nuances of original brushwork. Yet the works of literati painters betray that many of them treated motifs as modules, in ways similar to painting manuals, albeit not as mechanically.

An example is the oeuvre of the orthodox master Wang Yuanqi, another paragon of the literati tradition (see Fig. 8.9). He compiled a standard compendium of writings on calligraphy and painting, in which he espoused traditional literati values.[35] It was due to his influence that the Kangxi Emperor (r. 1662–1722) propagated the orthodox tradition at court and in the empire.

Many of Wang Yuanqi's compositions resemble one another closely, and his repertoire of motifs is rather limited. Almost invariably, he used a group of trees on a riverbank in the foreground, a bridge, groups of buildings between trees, or a flight of steps leading up to a monastery in the saddle of a high mountain. The size of his motifs hardly increased with the size of his scrolls. In large paintings he simply added more motifs. Yet the master never worked mechanically. Seamlessly joining the

Fig. 8.16 (left) Xu Beihong (1895–1953), *Standing Horse*, 1942. Hanging scroll, ink and light color on paper, 101.5 × 48.2 cm. Arthur M. Sackler Gallery, Smithsonian Institution, Washington, D.C.

Fig. 8.17 (below) Xu Beihong (1895–1953), *Galloping Horse*, 1941. Hanging scroll, ink and light color on paper, 130 × 76 cm

parts of his compositions together, he turns each one into an individual creation. The greatness of his art lies not in novel formal inventions but in the endlessly varied execution of familiar motifs.[36]

Xu Beihong (1895–1953) is another artist who used a modular approach to painting. His bravura ink paintings of horses have become world famous. Seeing a scroll with a single horse (Figs. 8.16, 8.17), the viewer is taken aback by the forceful spontaneity of the dashing animal.[37] In a group of horses, he finds similar legs, manes, tails, and equivalent sets of brushstrokes for heads, necks, and chests (Fig. 8.18). A comparative analysis of a large number of his paintings reveals how Xu Beihong created the bravado of his horses from set parts.

Literati painters were not shy about producing works on a large scale, which may be one reason why they resorted to modular compositions. Cheng Zhengkui (1604–1676), for example, painted some three hundred landscape handscrolls, all with the same title, *Dream Journey Among Streams and Mountains* (*Jiangshan woyutu*). As each scroll was, on average, almost three meters long, he produced nearly one kilometer of landscape painting![38] The great literati painter of the modern age, Zhang Daiqian (1899–1983), completed some thirty thousand paintings in his lifetime, the prices of which were determined by their size.[39]

Zhang Daiqian was not the first Chinese painter to set up a fixed price list.[40] Many others had done so before, including Zheng Xie (1693–1765), who once again typifies the educated painter in the literati tradition. He set the prices of his paintings according to size and added wryly that he preferred hard cash over presents or food that might not meet his personal taste.[41]

Fig. 8.18 Xu Beihong (1895–1953), *Galloping Horses,* 1942. Hanging scroll, ink and light color on paper, 95 × 181 cm

Zheng Xie was not a marginal figure. Counted among the so-called Eight Eccentrics of Yangzhou, he was the only one among this loosely knit group of independent painters who attempted the highest state examination (*jinshi*). He passed in 1736, the second best in the country, and subsequently he served twelve years as a magistrate. He was widely praised as a benevolent and upright official who cared for his subjects. During the catastrophic famine of 1746–47 he opened the government storehouses to save the starving people.

Zheng Xie was also a prolific writer. His sixteen *Family Letters* (*Jiashu*), which he sent over the course of several years to a cousin twenty-four years younger than he, are well known.[42] In accordance with the literati ideal, Zheng Xie also excelled in poetry, calligraphy, and seal carving. The artist has remained famous into modern times, copies of his calligraphy continue to be sold everywhere in China, and the scholarly literature concerning him is plentiful.

Zheng Xie wrote extensively about the arts and about his own practice, paying profuse tribute to the convictions and values of the literati painter. In his own judgment, his art was neither ancient nor modern, bamboo was in his mind, and as he drew it, it took shape spontaneously:

> *I have ten thousand bamboo stalks in my mind,*
> *Which burst forth at any moment as dripping wet ink.*
>
> *When I painted in youth, I followed the rules;*
> *But as an old man, I'm careless and do away with methods.*

The artist studies old masters, but Heaven, he claims, is his true master:
> *The way Heaven gives life, is the way I paint.*[43]

Yet Zheng Xie's avowed freedom of the brush did not prevent him from developing a module system. He concentrated on very few motifs—mostly bamboo, wild orchids, and rocks, once saying, somewhat exaggeratedly, that he had painted nothing but orchids and bamboo in fifty years.[44] Both plants are easy to execute in ink, and each is fraught with symbolism in literati lore. The resilient bamboo stands for firmness and integrity, scholarly aspirations, and the concern of an official for the common people, while the fragrant orchid recalls loyalty and purity, and the life away from the intrigues of officialdom. Rocks, which also appear frequently in Zheng Xie's paintings, signify solidity, perseverance, and longevity.[45]

At times, Zheng Xie laid out his entire repertoire in the format of a handscroll, on which his preferred motifs followed one after the other.[46] He also did this in an album of eight leaves, three of which are shown in Figures 8.19–8.21.[47] The bamboo consists of a few branches rendered in thin ink lines, and a cluster of leaves described by sweeping movements of a resilient, obliquely held brush. Although executed similarly, no two stalks or leaves are completely identical. For the orchid, the painter used an entirely different set of brushstrokes:

Fig. 8.19 (top) Zheng Xie (1693–1765), *Bamboo,* 1749. Album leaf, ink on paper

Fig. 8.20 (center) Zheng Xie (1693–1765), *Orchid,* 1749. Album leaf, ink on paper

Fig. 8.21 (bottom) Zheng Xie (1693–1765), *Rock,* 1749. Album leaf, ink on paper

long, undulating lines, and short, straighter ones for two kinds of leaves; staccato strokes for the segmented stems; and soft, sometimes grayish hues for the petals. The variously shaped dots for the pistils are all known from calligraphy. Zheng Xie renders rocks as oblong blocks with vertical divisions. Here the painter resorted to still other kinds of brushwork: broad, angular contour lines combined with short sweeps to the side that convey the stony surface. Round, inky dots suggest moss or other vegetation.

On these three compositions, Zheng Xie placed his signature at the top, the left side, or the right, respectively. For all of these he happened to

Fig. 8.22 (left) Zheng Xie (1693–1765), *Bamboo.* Hanging scroll, ink on paper

Fig. 8.23 (center) Zheng Xie (1693–1765), *Bamboo.* Hanging scroll, ink on paper

Fig. 8.24 (right) Zheng Xie (1693–1765), *Bamboo.* Hanging scroll, ink on paper

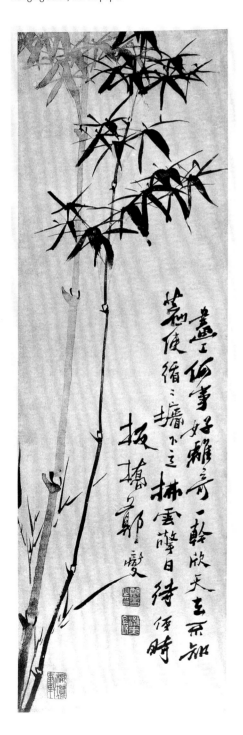
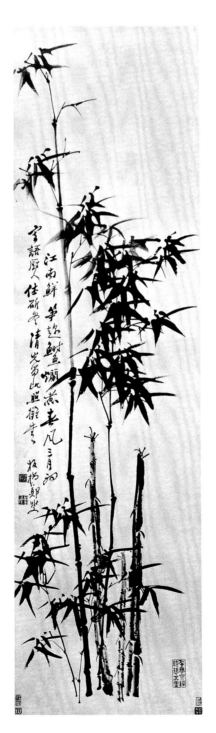
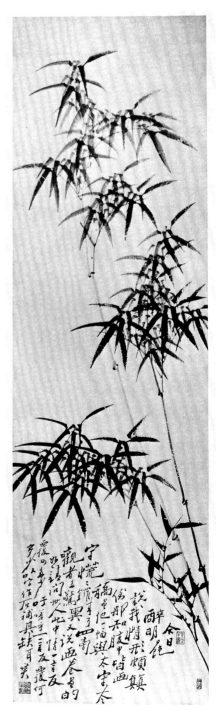

use the same seal, but other leaves in the same album show several others of his seals and different forms of his name. The artist made use of various signatures and seals to diversify his compositions.

With bamboo, orchid, and rock, Zheng Xie built compositions—probably thousands of them—along three principles: multiplication, combination, and individual execution of each motif. Hanging scrolls for which bamboo is the sole motif (Figs. 8.22–8.26) reveal similar clusters of leaves that were done with the same stroke types as those in the album. At times the clusters mesh in lush profusion, which can be seen especially well in the

Fig. 8.25 (left) Zheng Xie (1693–1765), *Bamboo.* Hanging scroll, ink on paper

Fig. 8.26 (right) Zheng Xie (1693–1765), *Bamboo.* 1757. Hanging scroll, ink on paper, 226.5 × 91.5 cm. National Museum, Tokyo

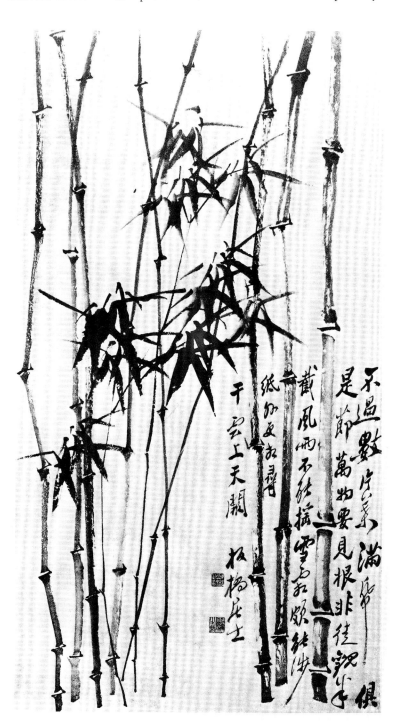

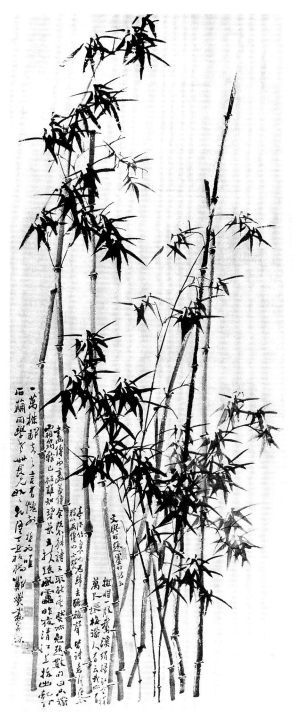

Fig. 8.27 (right) Zheng Xie (1693–1765), *Bamboo and Rock*. Hanging scroll, ink on paper

Fig 8.28 (below) Zheng Xie (1693–1765), *Misty Bamboo on a Distant Mountain*. 1753. Set of four hanging scrolls, ink on paper, 68.2 × 179.2 cm. The Metropolitan Museum of Art, New York

painting that opens this chapter (Fig. 8.1). The stalks are more elaborate in the long hanging scrolls, but codified stroke types are apparent for thin and for thick stalks, as are formulas for the nodes between the segments.

As the amount of surface space increased, the painter did not enlarge the clusters of bamboo leaves correspondingly. Rather, he added more clusters of a similar size. (Because the artist always uses seals of a similar size, one can estimate the actual size of the painting by referring to the seals in the reproductions for scale.) Painting larger bamboo would require different body movements that would have to originate from the painter's arm and shoulder, rather than from his wrist and fingers. This is the same principle found in bronze decor, in the bracketing of palace

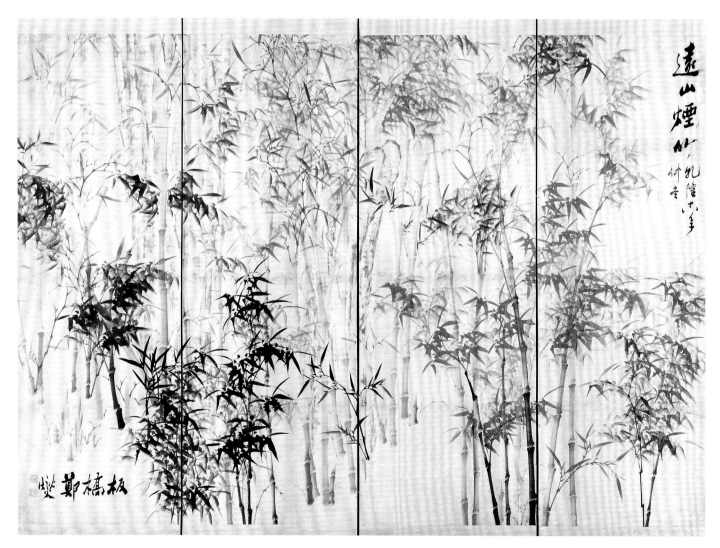

halls, and in porcelain decoration: in units that are large in absolute size, modules do not grow proportionately, but new modules are added instead.

In compositions that combine bamboo and rock (Figs. 8.27–8.33), the rocks are of the familiar oblong type. In the larger scrolls several rocks stand upright, one behind the other. They appear in front of the bamboo or behind it, below it or above. Zheng Xie manipulated his compositions quite consciously. He once wrote that he refused to abide by the rule that holds that rocks should be less prominent than bamboo.[48] In one hanging scroll the rock towering above the bamboo is meant as an admonishment for the young recipient of the painting to raise his head, as the master's dedicatory inscription informs (Fig. 8.32).[49]

Bamboo and rocks are the two motifs that Zheng Xie combined most frequently. But he also painted orchids alone, orchids with rocks, and a few other motifs, such as mushrooms or thorns. In a hanging scroll for which he combined rocks and bamboo with orchids and mushrooms (Fig. 8.34), the rocks and the bamboo clusters would have fit just as well in one of the other compositions already illustrated here.[50]

Inscriptions are used for further variation. The master freely placed his calligraphy in the composition, extending the game of combinations even to the level of meaning. He sometimes wrote different inscriptions on nearly identical compositions, thereby altering their iconographical message. A bamboo stalk may represent the fishing rod of a retired recluse or it may signify vigorous growth for a newborn son.[51]

The exchangeability between subject matter and inscription had economic implications, too. Rather than preparing a painting for a particular

Fig. 8.29 (left) Zheng Xie (1693–1765), *Bamboo and Rock*. Hanging scroll, ink on paper

Fig. 8.30 (center) Zheng Xie (1693–1765), *Bamboo and Rock*. 1758. Hanging scroll, ink on paper, 171 × 91 cm

Fig. 8.31 (right) Zheng Xie (1693–1765), *Bamboo and Rocks*. 1765. Hanging scroll, ink on paper

Fig. 8.32 (below, left) Zheng Xie (1693–1765), *Bamboo and Rocks,* ca. 1762. Hanging scroll, ink on paper, 170 × 79 cm. Museum für Ostasiatische Kunst, Berlin

Fig. 8.33 (below, right) Zheng Xie (1693–1765), *Bamboo and Rocks,* 1756. Hanging scroll, ink on paper

Opposite:

Fig. 8.34 (opposite) Zheng Xie (1693–1765), *Bamboo and Fungi.* Hanging scroll, ink on paper, 187.7 × 93.2 cm. Asian Art Museum of San Francisco, The Avery Brundage Collection. Gift of The Asian Art Foundation of San Francisco

recipient and dedicating it to him, as was customary among traditional literati painters, Zheng Xie could finish a work before he knew who would buy it. This allowed him to produce works for a large and anonymous clientele.

Motifs such as bamboo, orchid, and rock are not modules in a physical sense, like blocks and brackets, but Zheng Xie treated them as modules when he multiplied and combined them. However, the individual execution in Zheng Xie's compositions sets his motifs apart from modules in manufactured goods. For instance, each of the nodes on the thicker bamboo stalk at the left of Figure 8.22 result from three strokes: a large horizontal one topping off the lower segment, and two little, dark curves that connect to the segment above. The same three strokes appear in the dark, thin stalk at the right, where they are smaller correspondingly, but each node has them. The painter repeated them again and again, as if writing a character with

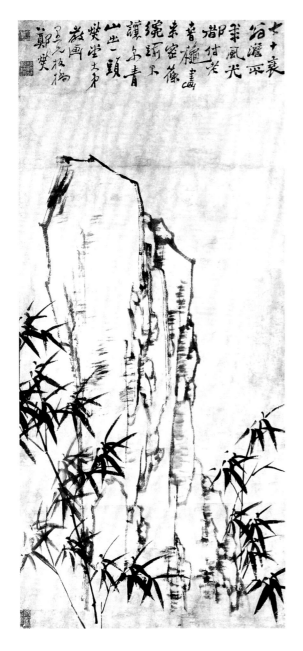

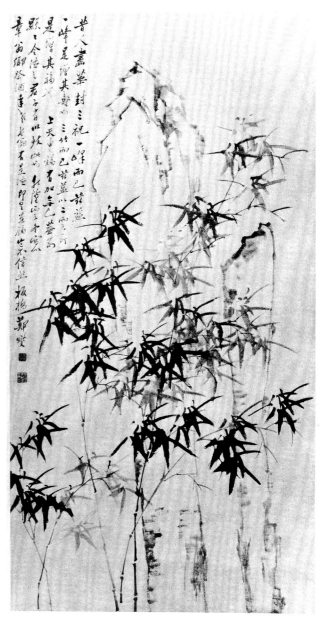

three strokes. His hand moved always in the same way. That is why Chinese literati painters like to say that they "write" (*xie*) a painting. But now consider the most amazing fact: all nodes are clearly different. Although the painter wielded his brush in the same way a thousand times, he still managed to do it differently each time. The same holds true for his clusters of bamboo leaves, of which two absolutely identical ones cannot be found in the entirety of Zheng Xie's oeuvre.

Considering that the artist's hand moved almost automatically, this achievement is all the more astonishing. Yet individual execution is the very quality by which literati painters set their work apart from that of artisans: the application of boundless inventive energy in the ever-changing execution of details. It is to this creativity that Zheng Xie referred when saying that he painted like heaven gives life. He saw no contradiction between his claim to spontaneity and the fact that he rendered bamboo stalks using the same stroke types over and over again.

Painters like Zheng Xie strive to emulate nature in two respects. They produce large, almost limitless quantities of works and are enabled to do so by module systems of compositions, motifs, and brushstrokes. But, they also imbue every single work with its own unique and inimitable shape, as nature does in its prodigious invention of forms. A lifetime devoted to training his aesthetic sensibilities enables the artist to approximate the power of nature. For the Chinese literati painter, modular systems and individuality are but two sides of the same coin. Its name is *creativity*.

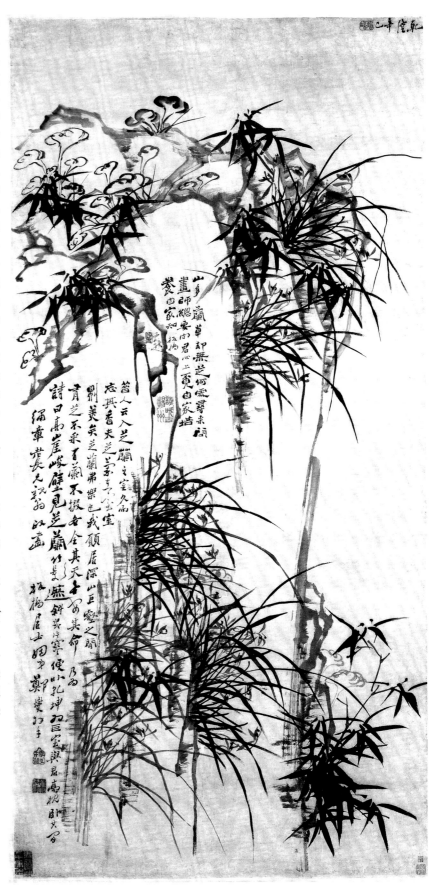

The two quotations that begin this book (page i), which together serve as its underlying motto, are from, respectively: Shao Yong, *Guanwu waipian* (Outer chapter on observation of things), in *Huangji jingshi,* 31166; and Zhou Dunyi, *Taiji tushuo* (Diagram of the supreme ultimate explained), in Zhou Dunyi and Zhang Zai, *Zhou Zhang quanshu,* vol. 1, 47.

Introduction

1. The comprehensive dictionary *Zhongwen da cidian* contains 49,905 characters.
2. Shaughnessy, "I ching," 216.
3. For Leibniz's (1646–1716) fascination with the *Yijing,* see Mungello, *Curious Land,* especially 318–28.
4. For this cave at Yunjusi (Cloud Dwelling Monastery), see Tsukamoto, "Hôzan Ungo-ji."
5. Julien and Champion, *Industries,* 453.
6. "Tous ces peuples étaient autrefois bien supérieurs à nos peuples occidentaux dans tous les arts de l'esprit et de la main. Mais que nous avons regagné le temps perdu! Les pays [occidentaux] . . . font devenues les premiers pays de la terre." Voltaire, *Essai,* vol. 18 (*Du Japon*), 283 f.
7. Ford, "Mass Production." I would like to thank Professor Robert Bagley for this reference.
8. For the principle of modularity in animals and humans, see Gould, *Eight Little Piggies,* 254–60. Fodor, *Modularity,* 37, 47, and 128, entertains the possibility of informational encapsulation in cognitive modular input systems, but supposes that central cognitive processes are nonmodular.
9. In his essay "The Work of Art in the Age of Mechanical Reproduction," first published in 1936.
10. E.g., Belting, *Likeness and Presence.* For a specific critique of Benjamin, see Bredekamp, "Der simulierte Benjamin."
11. Bryson, *Vision and Painting,* 1, takes the competition between Zeuxis and Parrhasius as his starting point in analyzing mimesis as a core issue in Western art.

Chapter 1 *The System of Script*

1. This topic was first presented in Ledderose, "Modul und Serie," and in Ledderose, "Zimu yu daliang Sheng chan." The term *ten thousand things* (*wanwu*) refers to categories of things rather than to single items. See the translations in Röllike, *"Selbst-Erweisung,"* passim.
2. *Stele for the Xuanmi Pagoda of Dharma Master Data* (*Data fashi Xuanmita bei*) of A.D. 841, now in the Forest of Stele in Xian (*Xian beilin*). See Liu Boqing, *Liu ti,* 5–6.
3. For a detailed discussion of the "Eight Laws in the Character *yong*" (*yongzi bafa*), see Fujiwara, *Shofu, soku shofu.* vol. 2, 3–48.
4. The thirteenth-century theorist Chen Si quotes the eighth-century writer Li Yangbing telling the story. Reference in Driscoll and Toda, *Chinese Calligraphy,* 36–38.
5. For the engraved sutra stones at the Yunjusi, see Ledderose, "Ein Programm."
6. For visual perception as an information-processing problem, see Marr, *Vision.*
7. For types and styles in calligraphy, see Ledderose, *Mi Fu,* 7–9.
8. Boltz, *Origin.* An intriguing find are eleven characters incised on a ceramic shard, believed by some to belong to the Longshan culture (ca. 2000 B.C.). Shandong daxue, "Shandong Zouping."
9. Sun Haibo, ed., *Jiaguwen bian* 1965, the standard dictionary of script on oracle bones, contains 4,672 characters, 2,949 of which are not deciphered or classified. See Keightley, Sources, 59n.8.
10. Based on the breakdown of a sample of 1,226 graphs into the six traditional categories of character composition (*liushu*) made by Li Xiaoding in 1968. Quoted by Keightley, *Sources,* 68n.49.
11. For a transcription of the text into modern graphs see Keightley, *Sources,* fig. 12.
12. Zhang Guangyuan has argued that the oracle bone script is a kind of simplified script type, and that the difference between it and the bronze script is one of function, not of chronology. See Zhang Guangyuan, "Shang Zhou jinwen."
13. Beginning phase of the Middle Western Zhou dynasty, ca. 875–825 B.C. For the date, see Rawson, *Western Zhou Ritual Bronzes,* 19. Translations of the inscription in Shaughnessy, *Sources,* 3–4, and Wu, *Monumentality,* 93–94. More references to the inscription, ibid., 300n.86.
14. For a German translation and discussion of the *Yishan bei* inscription, see Eckhard Schneider, "Schrift," in Ledderose and Schlombs, eds., *Jenseits der Großen Mauer,* 243–48.
15. Bodde, "The State and Empire of Ch'in," 56–58.
16. *Huangting jing, Waijing jing* (Book of the yellow court, book of the outer view), written in A.D. 356. See Ledderose, *Mi Fu,* 70 f.

17. The simplified character *lan* does not fall into one of the three categories of abbreviation mentioned before but rather derives from an early cursive form.

18. For a comparative analysis of the major writing systems in world history, see Sampson, *Writing Systems*.

Chapter 2 *Casting Bronze the Complicated Way*

1. Li Chi (Li Ji), the head of the excavation team at Anyang during the prewar campaigns, gives a moving account of the early hardships and achievements (Li, Chi, *Anyang*). Chang, *Shang Civilization,* 48–52 lists publications about the campaigns from 1928 to 1976. Most comprehensive is Zhongguo shehui kexueyuan kaogu yanjiusuo, ed., *Yinxu de faxian yu yanjiu.* For brief information concerning all campaigns up to 1985, see article by Yang Baocheng in *Yinxu de faxian yu yanjiu,* 8–24.

2. Discovered in tomb M 260 in 1939 when the Sino-Japanese War had brought systematic excavations to a standstill, it was first left in the ground out of fear that the Japanese army might seize it. Only in 1946 was the vessel retrieved. Akiyama, Andō, and Matsubara, *Arts of China,* vol. 1, figs. 9–10. For a map with the location of the find, see *Kaogu* (1977, no. 1), 21. For identification of the tomb, see *Kaogu Xuebao* (1987, no. 1), 105.

3. Ma, *Ancient Chinese Bronzes,* 94–96. The identity of Mother Wu and the date of the vessel are convincingly discussed by Bagley, *Shang Ritual Bronzes,* 534n.14; fig. 133.

4. Archaeological report: Zhongguo shehui kexueyuan kaogu yanjiusuo, ed., *Yinxu Fu Hao mu.* For a discussion of the tomb inventory and its position in a cross-cultural perspective, see Müller-Karpe, "Das Grab der Fu Hao," 31–68. Zheng Zhenxiang gives a summary discussion of the tomb in Goepper et al., *Das Alte China,* 106–14. English translation in Rawson, ed., *Mysteries,* 240–47. For objects from the tomb, see Goepper, et al., *Das Alte China,* 213–47.

5. Bagley, *Shang Ritual Bronzes,* 54n.100. Genealogy of the Anyang kings, ibid., 523. For Fu Hao's identity and date, see Huber, "Some Anyang Royal Bronzes."

6. Zhongguo shehui kexueyuan kaogu yanjiusuo, ed., *Yinxu Fu Hao mu,* 15, 31.

7. For regional styles of the early Bronze Age in China, see Bagley, "Appearance and Growth"; Bagley, "Early Bronze Tomb"; and Rawson, "Shang and Western Zhou Designs."

8. Bagley, *Shang Ritual Bronzes,* 17, 47n.27.

9. Riegel, "Li chi."

10. Li, Chi, *Anyang,* 251.

11. Wu, *Monumentality,* 1–75.

12. So argues Rawson, "Statesmen or Barbarians?," 89.

13. Rawson, *Chinese Bronzes,* 19–20.

14. Chang, *Art, Myth, and Ritual,* 37.

15. Hayashi, "Concerning the Inscription."

16. For these rules in the Eastern Zhou period, see Li, Xueqin, *Eastern Zhou and Qin,* 460–64.

17. For the symbolic equivalent of social and material values in early societies, see Renfrew, "Varna." Rawson, "Late Shang Bronze Design," 85 f., connects differences in the ornamentation and in the vessel sets to the social ranks of the respective owners.

18. This includes only pieces of styles IV and V in Max Loehr's epoch-making division of five Anyang styles. Loehr, "Bronze Styles."

19. Schlombs, ed., *Meisterwerke,* no. 7.

20. Bagley, *Shang Ritual Bronzes,* no. 78. When sold at auction in 1974, the vessel fetched Gns. 170,000 ($428,400)—at the time, the highest price ever paid for a Chinese bronze. Mayer Collection, lot 228.

21. When Vadime Elisseeff analyzed the bronze decor of the Anyang period, he defined between eight and sixteen different types of the various anatomical parts. Elisseeff, *Bronzes archaiques,* tables 26–38.

22. Karlgren, "Notes on the Grammar." For other classifications, see Erdberg, "Terminology"; Zhang Guangzhi et al., *Shang Zhou qingtongqi;* and Hayashi, *In Shū jidai seidōki monyō,* 17–90.

23. Many examples support the bicorporal, split-animal reading. For instance, the snakelike bodies of two confronted dragons on the front and back of a *fangyi* in the Freer Gallery in Washington, D.C., join their bodies into a single head on the narrow sides of the vessel. See Pope et al., *Freer Chinese Bronzes,* vol. 1, pl. 36. More references to this question in Chang, *Art, Myth, and Ritual,* 60 , 75 f., and in Wu, *Monumentality,* 47–48.

24. The problem is reviewed by Kesner, "Taotie Reconsidered." See also the essays in Whitfield, ed., *Problem of Meaning.*

25. Loehr, *Ritual Vessels,* 13 f.

26. Bagley, *Shang Ritual Bronzes,* 18 f., 50n.47. Bagley, "Meaning and Explanation."

27. For this vessel, see Shanghai bowuguan, ed., *Shanghai bowuguan cang qingtongqi,* no. 13; Fong, ed., *Great Bronze Age,* no. 27; and Rawson, *Western Zhou Ritual Bronzes,* 29 f., 412 f.

28. Umehara, *Nihon shūcho,* vol. 1, no. 17. Bagley, *Shang Ritual Bronzes,* fig. 132, and stylistic analysis, 28 f.

29. An idea proposed by Rawson, "Late Shang Bronze Design," 76.

30. For the southern origin of animal-shaped vessels and their fate in Anyang, see Bagley, *Shang Ritual Bronzes,* 30–36; and Rawson, "Shang and Western Zhou Designs," especially 86.

31. The *Ya Chou gong* in the Idemitsu Museum, Tokyo. Umehara, *Nihon shūcho,* vol. 3, no. 262. Rawson, *Western Zhou Ritual Bronzes,* Fig. 117.10.

32. See the list of *gong* vessels in Hayashi, *In Shū jidai seidōki no kenkyū,* vol. 1 (plates), pls. 371–76 (there called *yi*). Discussion of the typology in Rawson, *Western Zhou Ritual Bronzes,* 692–707.

33. Zhongguo shehui kexueyuan kaogu yanjiusuo, ed., *Yinxu Fu Hao mu,* pls. 26–27.

34. Bagley, *Shang Ritual Bronzes,* Introduction.

35. Guo Baojun, *Shang Zhou tongqiqun,* 39, fig. 9 (rubbing), pl. 31, nos. 2, 4, 5 (photo). Zhongguo shehui kexueyuan kaogu yanjiusuo, ed., *Yinxu fajue baogao,* pl. 33. Reproduced in Bagley, *Shang Ritual Bronzes,* fig. 207.

36. Freestone, Wood, and Rawson, "Shang Dynasty Casting Moulds."

37. Wilson, "Early Chinese Foundry Operations," has made a stylistic analysis of the Fu Hao inscriptions.

38. This is the process as described by Barnard, *Bronze Casting and Bronze Alloys,* 157–61. Matsumaru, "Shishuo Yin Zhou," and Zhang Guangyuan, "Shang Zhou jinwen," discuss a different technique of forming inscriptions in clay that involves the use of leather.

39. The long, identical inscriptions in the body and the lid of the tenth-century B.C. *Ling fangyi* in the Freer Gallery are well known. Illustration of vessel and inscriptions in Pope et al., *Freer Chinese Bronzes,* vol. 1, nos. 38, 213, 221; and Rawson, *Western Zhou Ritual Bronzes,* 63, fig. 80. The inscriptions *Fu Hao* in body and lid of a *fanglei* from Lady Hao's tomb look as if they could have been written by different hands. Zhongguo shehui kexueyuan kaogu yanjiusuo, ed., *Yinxu Fu Hao mu,* 54, nos. 7–8.

40. Pope et al., *Freer Chinese Bronzes,* vol. 1, no. 94, 479–83; and Karlgren, *Catalogue of Chinese Bronzes,* no. 51, pl. 71.

41. This point has been stressed by Thote, "De quelques décors," 22 f., n.17. A masterful overview of the period is Thote, "I Zhou Orientali."

42. First pointed out by Keyser in her pathbreaking technical analysis, "Decor Replication." I follow the lucid description of the casting process with pattern blocks by Bagley in his "Replication Techniques," and "What the Bronzes from Hunyuan Tell Us."

43. Bagley, "Replication Techniques," n.2.

44. Shanxi sheng Kaogu yanjiusuo, ed., *Houma zhutong yizhi,* and So, *Eastern Zhou Ritual Bronzes,* 36–45, 424–25. Most penetrating studies on the Houma finds are those by Bagley (cited in this chapter's notes 42 and 45).

45. Bagley, "Debris," fig. 17; Institute of Archaeology of Shanxi Province, *Art of the Houma Foundry,* passim.

46. Pointed out in Rawson (with Michaelson), *Chinese Jade,* 65.

47. Pope et al., *Freer Chinese Bronzes,* vol. 1, no. 103, 528–31. Reportedly the vessel belongs to the group of bronzes found at Liyu in Shanxi, which are believed to have been cast at Houma. The text mentions comparative pieces, including the *ding* in the Musée Guimet, Paris.

48. Umehara, *Ôbei shūcho,* vol. 3, no. 164.

49. Kindly pointed out to me by Professor Bagley. For another example of identical pattern blocks, see Bagley, "What the Bronzes from Hunyuan Tell Us," 54.

50. Rawson has done pioneering work on the issue of sets. See, for example, her "Ancient Chinese Ritual Bronzes."

51. Illustrations of ritual bronzes from this tomb in Zhongguo shehui kexueyuan kaogu yanjiusuo, ed., *Yinxu Fu Hao mu,* pls. 3–63; and *Yinxu qing tongqi,* pls. 99–146; and in Zheng and Chen, *Yinxu.*

52. Description and typology in Zhongguo shehui kexueyuan kaogu yanjiusuo, ed., *Yinxu Fu Hao mu,* 74–85, detailed measurements, 235–36; pls. 42–58. Drawing after Rawson, "Ancient Chinese Ritual Bronzes," 811.

53. Zhongguo shehui kexueyuan kaogu yanjiusuo, ed., *Yinxu Fu Hao mu,* 85–89, 237–38, and pls. 54–58.

54. See Li and Wan, *Yinxu chutu qingtong gu xingqi,* 22. Plates IV and V reveal variations in the decorative pattern of different sides of the same *gu* beaker.

55. See the technical study by Hua et al., "Fu Hao mu."

56. Because the archaeological report illustrates only selected items of Lady Hao's bronzes and gives only one view of each, it is hard to know the precise differences between the various subgroups, and to determine whether the *gu* within one subgroup bear the same decoration. Poor, "The Master," compares Fu Hao's *gu* and closely related beakers in an attempt to identify the style of an individual master.

57. Ma, *Ancient Chinese Bronzes,* 29–34, gives examples for the composition of sets.

58. Hoard of Wei bo Xing in Zhuangbai, Fufeng County, Shaanxi Province. Cf. Rawson, *Western Zhou Ritual Bronzes,* 19, 149, and passim. Drawing of vessels from this hoard in Rawson, "Ancient Chinese Ritual Bronzes," 817, and in Rawson, ed., *The British Museum Book,* 350. See also Wu, *Monumentality,* 92–99.

59. Rawson, *Western Zhou Ritual Bronzes,* 96–110, discusses changes in the repertoire of vessel sets of the Western Zhou. For the ritual revolution, see Rawson, "Statesmen or Barbarians?," 87–93. As early as 1936 Max Loehr emphasized the epochal stylistic changes happening in the ninth century B.C. Loehr, "Beiträge."

60. For bells, see the monumental study by von Falkenhausen, *Suspended Music.*

61. Ibid., 32–39, which also provides further references.

62. Tomb no. 1 in Leigudun, Suizhou, Hubei Province. Archaeological report: Hubeisheng bowuguan, ed., *Zeng hou Yi mu,* vol. 1, 476.

63. For these bells, see von Falkenhausen, *Suspended Music,* 5–12 and passim.

64. See note 2, above.

65. Franklin, "On Bronze and Other Metals."
66. In the following, cf. Franklin, "The Beginnings of Metallurgy."
67. Bagley, "Replication Techniques," 239.
68. Keightley, "Early Civilisation," 50 f., has identified massive mobilization of labor as one of the typical features of the early cultural tradition in China.

Chapter 3 *A Magic Army for the Emperor*

1. *Chūka jinmin kyôwakoku kodai seidôki ten,* cat. nos. 127–29, and discussion of the terra-cotta army by Maxwell K. Hearn in Fong, ed., *Great Bronze Age,* 334–73.
2. Hearn, ibid., 370, fig.127. See also Ledderose and Schlombs, eds., *Jenseits der Großen Mauer,* 282, fig. 229.
3. Thieme et al., *Zur Farbfassung der Terrakottaarmee.*
4. Sima, *Shiji,* 6:265. Translation in Yang and Yang, trans., *Selections,* 186.
5. Sima, *Shiji,* 6:232. Yang and Yang, trans., *Selections,* 163. Cf. Yuan, "Qindai de shi, ting taowen," 96 (reprint p. 77). Yuan, "Qin ling bingmayong de zuozhe," 60–61 (reprint pp. 201–202).
6. Sima, *Shiji,* 6:256. Yang and Yang, trans., *Selections,* 179. For the legal status of the workers, see Liu Yunhui, "Lishan tukao."
7. For archaeological evidence, see page TK of this book.
8. Sima, *Shiji,* 6:256; Yang and Yang, trans., *Selections,* 179.
9. Sima, *Shiji,* 6:268 f.; Yang and Yang, trans., *Selections,* 189. Cf. Yuan, "Qin Shihuangling kaogu jiyao," 143 (reprint pp. 19–20).
10. The literature on the necropolis of the First Emperor is considerable and redundant. Yuan and Zhong, *Qin yong yanjiu wenji,* 677–86, includes a bibliography of articles published between 1962 and 1985. Among the many comprehensive descriptions of the tomb compound, the most detailed is Yuan, *Qin Shihuangling bingmayong yanjiu.* Strong on all military aspects is Wang Xueli, *Qin yong zhuanti yanjiu.* In English, see Thorp, "Archaeological Reconstruction"; Li, Xueqin, *Eastern Zhou and Qin,* 251–62. Schlombs, "Grabanlage und Beigaben," has made full use of studies by Chinese archaeologists. I follow her and the concise account by Yuan, "Qin Shihuangling kaogu jiyao," 133–46.
11. Segalen, Voisins, and Lartigue, *Mission archéologique,* vol. 1, pl. 1.
12. Sima, *Shiji,* 6:265. Yang and Yang, trans., *Selections,* 186.
13. Sima, *Shiji,* 7:315. Yang and Yang, trans., *Selections,* 221.
14. Ban, *Hanshu,* 1:44. Translation by Dubs, *History of the Former Han,* vol. 1, 90.
15. While the custom is only documented for the Western Han dynasty, it is believed to have originated in the Qin. Croissant, "Funktion und Wanddekor," 95–97. Yuan, *Qin Shihuangling bingmayong yanjiu,* 56–59.
16. Wu, "From Temple to Tomb," 95 f.; Wu, *Monumentality,* 115–17.
17. Zhao, "Qin Shihuangling."
18. Qin Shihuangling kaogudui, "Qin Shihuangling xice."
19. *Qin ling erhao tong chema,* 65.
20. Qin yong kaogudui, "Qin Shihuang lingyuan peizang."
21. For the Supreme Forest, see Schafer, "Hunting Parks."
22. Qin yong kaogudui, "Qin Shihuangling dongce majiukeng."
23. Qin yong kaogudui, "Lintong Shangjiaocun."
24. Sima, *Shiji,* 87:2553. Translation in Bodde, *China's First Unifier,* 36.
25. Shihuangling, "Qin Shihuangling xice," 6, no. 5 (reprint p. 569). Yuan, *Qindai taowen,* 27–37, 105, no. 234. This mass burial of forced laborers is not unique; 522 such tombs of the second century A.D. have been found near Luoyang. Inscriptions on tiles identify the tombs' occupants as criminals and frequently record their penalty and the date of their death. See Zhongguo kexueyuan kaogu yanjiusuo, "Dong Han Luoyangcheng."
26. Petty officers of the fourth rank stood on chariots to the right of the driver. Wang Xueli, *Qin yong zhuanti yanjiu,* 201, 630 f. For the ranking system, see Loewe, "Orders of Aristocratic Rank," 99; and Li, Xueqin, *Eastern Zhou and Qin,* 464–66.
27. For the following, see the archaeological excavation report: *Qin Shihuangling bingmayong keng,* vol. 1, 4–45; and Schlombs in Ledderose and Schlombs, eds., *Jenseits der Großen Mauer,* 272–78.
28. Personal communication by professor Yuan Zhongyi, October 1995.
29. Yuan, *Qin Shihuangling bingmayong yanjiu,* 69.
30. Ibid.
31. Sima, *Shiji,* 6:256. Yang and Yang, trans., *Selections,* 179.
32. Yuan, *Qin Shihuangling bingmayong yanjiu,* 69 f.; and Yuan, *Qindai taowen,* 43–45.
33. According to the text *Wei Liao zi,* which may date from the third century B.C. See Weigand, *Staat und Militär,* 115. Quoted by Chun-mei Tschiersch in Ledderose and Schlombs, eds., *Jenseits der Großen Mauer,* 83.
34. Yuan, *Qin Shihuangling bingmayong yanjiu,* 351.
35. Qin yong kaogudui, "Qindai taoyao yizhi."
36. Yuan, *Qin Shihuangling bingmayong yanjiu,* 352.
37. According to Brandt, *Chinesiche Lackarbeiten,* 7, lacquer was a product of species other than *Rhus verniciflua,* which is often cited as the exclusive source of lacquer. Therefore it is more correct botanically to use the generic term *Toxicodendron verniciflua.*

38. Yang Hong, *Zhongguo gu bingqi luncong,* 4–18. Leather armor for men and horses from the tomb of Marquis Yi of Zeng (after 433 B.C.) has come to light. See Hubeisheng bowuguan, ed., *Zeng hou Yi mu,* vol. 1, 332–52, and vol. 2, pls. 112–20. For Tang-dynasty fragments of scale armor made of lacquered leather, now in the British Museum, see Whitfield, *Art of Central Asia,* vol. 3: *Textiles, Sculpture, and Other Arts,* pl. 49.

39. Very small scales represent special armor made of iron. A standing general with crossed hands wears such an iron apron. See Ledderose and Schlombs, eds., *Jenseits der Großen Mauer,* 240.

40. Sima, *Shiji,* 126:3203. Yang and Yang, trans., *Selections,* 408.

41. Wang Xueli, *Qin yong zhuanti yanjiu,* 508–21. Detailed report on the pigments by Thieme et al., *Zur Farbfassung der Terrakottaarmee,* and Lin, "Lack und Lackverwendung."

42. *Qin Shihuangling bingmayong keng,* vol. 1, 249.

43. Yuan, "Qin zhongyang duzao de bingqi." Wang Xueli, *Qin yong zhuanti yanjiu,* 374–419. Li, Xueqin, *Eastern Zhou and Qin,* 234 f.

44. Hulsewé, *Remnants,* 59.

45. The inscribed blade of the type *pi* is the first one on the upper left in Fig. 3.16, and the center one in Fig. 3.17. See *Qin Shihuangling bingmayong keng,* vol. 1, 265, 268.

46. Hounshell, *From the American System,* has shown that developing technologies for the manufacture of firearms in nineteenth-century America was essential for the emergence of modern mass production. I should like to thank Dr. Edward Eigen for this reference. See also Ledderose, "Qualitätskontrolle."

47. Bodde, "State and Empire of Ch'in," 20.

48. For iron utensils found in the vicinity of the necropolis of the First Emperor, see Wagner, *Iron and Steel,* 206–207; and Chun-mei Tschiersch in Ledderose and Schlombs, eds., *Jenseits der Großen Mauer,* 210–16.

49. Translation by Hulsewé, *Remnants.* See also Heuser, "Verwaltung und Recht."

50. The Greeks began to employ infantry formations after 700 B.C. As in China, the new type of warfare harbored considerable social and moral implications. See Murray, *Early Greece,* 124–36. It is my pleasure to thank Dr. Fernande Hölscher for this reference.

51. According to Kolb, *Infanterie,* 64, 142.

52. For a detailed account of this battle, see ibid., 240–52.

53. Lewis, *Sanctioned Violence,* 60 f.

54. Quoted by Lewis, ibid., 113.

55. Ibid., 97–135.

56. Loewe, "Orders of Aristocratic Rank," 104.

57. Lewis, *Sanctioned Violence,* 62.

58. Fang, *Jinshu,* 60:1651. Memorial submitted by Yu Shinan (A.D. 558–638) in Wang Pu, comp., *Tang huiyao,* 20:393. Quoted by Wechsler, *Offerings of Jade and Silk,* 266n.15.

59. Illustrated in Shandong sheng, "Qi gucheng," 17.

60. Preliminary reports by Han, "Fengxiang," and Han and Jiao, "Qindu Yongcheng," 120 f. Brief discussion in Yuan, *Qin Shihuangling bingmayong yanjiu,* 51.

61. Cai, "Suizang mingqi." References to *mingqi* in classical literature cites von Falkenhausen, "Ahnenkult und Grabkult," 48, nos. 35, 39.

62. Wang Renbo, "General Comments," 39. Rawson, ed., *British Museum Book,* 138 f.

63. Cf. Cox, *Exhibition of Chinese Antiquities.* For Chu culture, see Lawton, ed., *New Perspectives on Chu Culture.*

64. Thorp, "Qin and Han Imperial Tombs."

65. Archaeological report: Hubei sheng bowuguan, ed., *Zeng hou Yi mu.* Thote, "Double Coffin."

66. Kesner, "Likeness of No One," 126, emphasizes the "fictive reality through various figurative methods" in the necropolis.

67. Sima, *Shiji,* 5:194. Quoted by von Falkenhausen, "Ahnenkult und Grabkult," 41.

68. Lewis, *Sanctioned Violence,* 27.

69. Sima, *Shiji,* 6:265. Translation quoted from Yang and Yang, trans., *Selections,* 186.

70. For loess as a raw material in ceramic technology, see Freestone, Wood, and Rawson, "Shang Dynasty Casting Moulds," 257 f. See also Rawson, ed., *British Museum Book,* 214 f.

71. Physiognomical variety as a condition for magic efficacy has been suggested by von Erdberg, "Die Soldaten," 228. For magic portraits in later Chinese art, see Croissant, "Der unsterbliche Leib," 235–68.

72. Some 170 tiles with seals have been found. For lists of the names, see Yuan, "Qin ling pingmayong de zuozhe," 53, 56 (reprint pp. 186, 192); Yuan, *Qindai taowen,* 19; and Yuan, *Qin Shihuangling bingmayong yanjiu,* 354, 361.

73. Yuan Zhongyi first discussed the inscriptions in "Qin ling pingmayong de zuozhe." The archaeological report of the excavation, *Qin Shihuangling bingmayong keng,* vol. 1, 194–207, 433–43, comprehensively treats all inscriptions found in pit no. 1 up to 1984. Yuan's treatment in *Qindai taowen,* 13–26, is briefer but takes into account the inscriptions from pits nos. 2 and 3 as well. He basically repeats the same numbers in his *Qin Shihuangling bingmayong yanjiu,* 352–65. The following numbers are based on Yuan's *Qindai taowen.*

74. Yuan, "Qin ling pingmayong de zuozhe," 57–60.

75. Hulsewé, *Remnants,* 110 f.

76. For the legal position of the *gongshi,* see Hulsewé, *Remnants,* 62. For his responsibilities, see Yang Jianhong, "Cong Yunmeng," 89.

77. Qin yonggeng kaogudui, "Qin Shihuangling pingmayong keng chutu de taoyong." *Qin Shihuangling bingmayong keng,* vol. 1, 163–83.

78. Detailed lists with exact measurements in *Qin Shihuangling bingmayong keng,* vol. 1, 349–75.

79. Ibid., 110–14, 127–38, 142–56, 163–70.

80. Von Erdberg, "Die Soldaten," 228, defines four types of mustache. The excavators now count twenty-four types of beard. Personal communication by Professor Yuan Zhongyi, October 1995.

81. *Qin Shihuangling bingmayong keng,* vol. 1 (English text p. 498). The assertion that the faces of the soldiers are portraits has already been refuted by von Erdberg, "Die Soldaten." Kesner, "Likeness of No One," discusses theoretical aspects of the issue. For a systematic treatment of portraiture, see Seckel, "Rise of Portraiture," and his comprehensive study, *Porträt.*

82. The report *Qin Shihuangling bingmayong keng,* vol. 1, 181, identifies four types of hands: (1) a hand with stretched fingers made in two molds; (2) a hand with bent fingers made from molds; (3) a hand that is mostly covered by the sleeve; and (4) a hand with bent fingers in which the fingertips are modelled and attached to a palm made from molds.

83. *Qin Shihuangling bingmayong keng*, vol. 2, 161, fig. 5.

84. Corresponds to type 2 in note 82, above.

85. Corresponds to type 4 in note 82, above.

Chapter 4 *Factory Art*

1. Archaeological report: Hunan sheng bowuguan and Zhongguo kexueyuan kaogu yanjiusuo, eds., *Changsha Mawangdui yi hao Han mu.* For the food vessels, see Pirazzoli-t'Serstevens, "Art of Dining." Prüch, *Lacke,* gives a comprehensive analysis of lacquer of the Western Han dynasty.

2. Wang Liqi, *Yantielun jaozhu,* 353. Pirazzoli-t'Serstevens, "Art of Dining," 215 f., explains why the importance of this passage should not be overrated. For a discussion of the text, see Loewe, "Yen t'ieh lun."

3. So argues Yu, "Qin Han qiqi jiage kaobian."

4. Umehara, *Shina Kandai,* 40 f. and pl. 35. Wang, *Han Civilization,* 84 and fig. 113 (Chinese edition, 47, fig. 48).

5. References in Wang Zhongshu, *Han Civilization,* 243 f., nn. 6–7.

6. The lid and an annotated translation of the inscription were first published by Mänchen-Helfen, "Zur Geschichte der Lackkunst," 53–56, and fig. 19. Illustrated in Brandt, *Chinesische Lackarbeiten,* no. 15. My translation is based on the transcription in Umehara, *Shina Kandai,* 14 f., with some changes in the names.

7. An early and comprehensive study of inscribed Han lacquers is Umehara, *Shina Kandai.* Willetts, *Foundations of Chinese Art,* 127–35, gives a good treatment in a Western language.

8. Wang Zhongshu, *Han Civilization,* 84–91 (Chinese edition, 47–51).

9. In some cases, we may be dealing with different members of the same family.

10. For the yearly contribution, see Hulsewé, *Remnants,* 46 f., n.8; for standardization, 57; for quality control of lacquer production, 97 f., 111 f.

11. Illustrated in Xian shi, "Sanqiaozhen Gaoyaocun," 64, no. 2. Discussion in Wang Zhongshu, *Han Civilization*, 102 (Chinese edition, 57).

12. French translation of the inscription in Pirazzoli-t'Serstevens, "Ateliers, patronage et collections princières," 524 f.

13. Chen Zhi, "Guqi wenzi congkao," 81.

14. Huang, "Xian Sanqiao Gaoyaocun," 198, 201.

15. Example mentioned by Wang Zhongshu, *Han Civilization,* 106 f., and fig. 150. Color plate in Zhongguo meishu quanji bianji weiyuanhui, ed., *Zhongguo meishu quanji, Gongyi meishu bian,* vol 5. *Qingtongqi, xia,* pl. 236.

16. Umehara, *Shina Kandai,* 46 f., pl. 40.

17. Xianyang diqu wenguanhui and Maoling bowuguan, "Shaanxi Maoling," 13, fig. 41; pl. 4.1; text of inscription, 3; rubbing, 16, fig. 58. Color plates in Zhongguo meishu quanji bianji weiyuanhui, ed., *Zhongguo meishu quanji, Gongyi meishu bian,* vol. 5: *Qingtongqi, xia,* pls. 209–11. Discussion and French translation of the inscription in Pirazzoli-t'Serstevens, "Ateliers, patronage et collections princières," 521–23.

18. Kuhn, "Silk Weaving," 80, observes: "From the Zhou era until the early Tang era, therefore, Chinese silk as a rule is warp-patterned. This differentiates Chinese fabrics from those of other cultures."

19. Xia, *Jade and Silk,* 52.

20. For the production of silk, see the extensive treatment in Kuhn, *Textile Technology,* 285–433.

21. Needham, *Science and Civilisation,* vol. 4, part 2, 9.

22. Sylwan, "Silk from the Yin Dynasty." Vollmer, "Textile Pseudomorphs."

23. Zhongguo shehui kexueyuan kaogu yanjiusuo, ed., *Yinxu Fu Hao mu,* 17 f., pls. 187–88.

24. Kuhn, "Silk Workshops," 406, compares the working steps in the two technologies. Chang, *Shang Civilization,* 230–33, argues that different lineage groups specialized in the production of various industrial goods.

25. Needham, *Science and Civilisation,* vol. 4, part 2, 26.

26. Kuhn, "Silk Weaving," 103.

27. Willetts, *Foundations of Chinese Art*, 135–44. Xia, *Jade and Silk,* 55–64.

28. Hunan sheng bowuguan and Zhongguo kexueyuan kaogu yanjiusuo, eds., *Changsha Mawangdui yi hao Han mu,* vol. 1, 69, no. 329-5.

29. Hundt, "Über vorgeschichtliche Seidenfunde."

30. Lach, *Asia in the Making of Europe,* vol. 1, 21, 81. For a controversial discussion of the subject, see Kuhn, "Where Did the Roads Meet?" 174–90.

31. For a comprehensive discussion, see Höllmann, *Neolithische Gräber.*

32. Keightley, "Archaeology and Mentality," 95–102 and 108, analyzes the differentiation in the Neolithic ceramic tradition in China as reflecting social structure and mentality. He sees a connection between compartmentalization of vessel shapes and that of social and intellectual organization.

33. Tichane, *Ching-Te-Chen,* 4.

34. Yuan, Tsing, "Porcelain Industry," 47. See also Dillon, "Jingdezhen."

35. Yuan, Tsing, "Porcelain Industry," 51.

36. *Jiangxi sheng dazhi.* Preface 1597. Quoted by Medley, "Organisation and Production."

37. Yabe, "Kasei keitokuchin."

38. See also *Da Ming huidian,* 82:35. Lau, "Ceremonial Monochrome Wares."

39. Curtis, "Markets, Motifs."

40. Comprehensive study by Krahl (with Erbahar), *Chinese Ceramics.*

41. Schmidt, ed., *Porzellan aus China und Japan,* 216–18.

42. Volker, *Porcelain,* 23 f., 51.

43. Jörg, "Chinese Porcelain for the Dutch," 197.

44. List in Jörg, *Porcelain and the Dutch China Trade,* 105–107; exact numbers for all types of dishes imported between 1729 and 1793, app. 11, 225–306.

45. Ibid., 125, 197.

46. Howard and Ayers, *China for the West,* 379, arrive at a similar range by a different calculation. They estimate that, throughout the eighteenth century, on average two Chinese armorial services of some two hundred pieces each were made for export every week, which amounts to about two million pieces of armorial porcelain in that century. The authors believe this to have been about one percent of the total export ware.

47. Rose Kerr in Clunas, ed., *Chinese Export,* 44. For technological advances in European porcelain production at the end of the eighteenth century, see Sheaf and Kilburn, *Hatcher Porcelain Cargoes,* 99.

48. Howard and Ayers, *China for the West,* 84, no. 41.

49. Jörg, *Porcelain and the Dutch China Trade,* 102.

50. See the auction catalog *Nanking Cargo.*

51. Illustration of the cargo list in Jörg, *Geldermalsen,* 58, fig. 35–36. Cf. Sheaf and Kilburn, *Hatcher Porcelain Cargoes,* 97.

52. Jörg, *Geldermalsen,* 95. Sheaf and Kilburn, *Hatcher Porcelain Cargoes,* 149.

53. I follow the terminology of Jörg, *Geldermalsen,* 67, where he refers to all cups with an even brown glaze on the outside as coffee cups.

54. Documented, e.g., in the painting *Literary Gathering* by Emperor Huizong (r. 1101–26). See *Masterpieces of Chinese Painting,* pl. 8, detail.

55. Sheaf and Kilburn, *Hatcher Porcelain Cargoes,* 104 f., 122–28.

56. Jörg, *Geldermalsen,* 61.

57. Howard and Ayers, *China for the West,* 379.

58. See Schiffer, *China for America,* 188. Detweiler, *Chinaware.*

59. Girmond, "Chinesische Bilderalben," especially 20–22.

60. The album in Altenburg, Saxony, is fully reproduced and discussed by Girmond, "Porzellanherstellung."

61. Cf. a similar scene in an album painted between 1731 and 1746. Reproduced in Staehelin, *Book of Porcelain,* leaf 23.

62. Staehelin, *Book of Porcelain,* leaf 33. For further porcelain albums in Western collections, see ibid., 82n.11; and Girmond, "Porzellanherstellung," 117 f., n.3.

63. Halde, *Déscription,* vol. 2, 216–46. An English translation appeared in 1741 and a German one in 1748. For an early English translation of the two letters, see Burton, *Porcelain,* 84–122; for a good summary, Jenyns, *Later Chinese Porcelain,* 6–16. Tichane, *Ching-Te-Chen,* 51–128, gives a translation illustrated by instructive photographs from present-day Jingdezhen.

64. Tichane, *Ching-Te-Chen,* 71 f.

65. Ibid., 70, 73.

66. Ibid., 57.

67. Ibid., 78.

68. Ibid., 70.

69. Kingery and Vandiver, *Ceramic Masterpieces,* 151.

70. See Teng, "Chinese Influence."

71. For Wedgwood's various measures, see McKendrick, "Josiah Wedgwood." For work time and hourly wage in general, Dohrn-van Rossum, *History of the Hour,* 289–321.

72. Kingery and Vandiver, *Ceramic Masterpieces,* 151, 204.

Chapter 5 *Building Blocks, Brackets, and Beams*

1. Figures quoted from Glahn, "Chinese Building Standards," 162.

2. The hall was first studied in 1937 by the eminent architectural historian Liang Sicheng (1901–72), who established its date and published detailed drawings. Liang, "Ji Wutaishan." The study has been reprinted

twice (see Bibliography). Some of Liang's original drawings, with English explanations, are reproduced in Liang, *Pictorial History,* 48–49. Further treatment of the hall in Liu Dunzhen, *Zhongguo gudai jianzhu shi,* 128–39, and in Zhongguo kexueyuan ziran kexueshi yanjiusuo, comp., *Zhongguo gudai jianzhu jishu shi,* 69–73 (English ed., pp. 75–80). For a discussion in English, see Alexander Soper in Sickman and Soper, *Art and Architecture of China,* 243–54; more recently, Shatzman Steinhardt, "Mizong Hall." Fairbank, *Liang and Lin,* 94–97, relates the circumstances of the discovery of the hall.

3. For the following numbers and arguments, see Glahn, "Chinese Building Standards," 162.

4. Sickman and Soper, *Art and Architecture of China,* 243.

5. In the following, compare also Fu, "Survey."

6. Illustrations and explanations in Soper, *Evolution of Buddhist Architecture in Japan,* 94–102, pls. 45–54; and Paine and Soper, *Art and Architecture of Japan,* 187–88.

7. Liang, "Ji Wutaishan," reprint, *Liang Sicheng wenji,* 195.

8. Wheatley, *Pivot of the Four Quarters,* 430.

9. In his discussion of Chinese architecture, Joseph Needham also speaks of the bays as "modules." He emphasizes that they are keyed to the size and scale of human beings. Needham, *Science and Civilisation,* vol. 4, part 3, 67.

10. See Liu Dunzhen, "Ming Changling." Liang, *Pictorial History,* no. 49. Paludan, *Imperial Ming Tombs,* 57–70.

11. See the comparison between the two halls in Liang, "Tangzhaotisi." The Tōshōdaiji hall may be the older type. There is some evidence that the front wall of the Foguangsi main hall was originally set back one bay as well. (Personal communication by Professor Tanaka Tan, Kyoto)

12. Plan from Li Yuming, ed., *Shanxi gu jianzhu,* 20. Cf. also the reconstruction in Shatzman Steinhardt et al., *Chinese Traditional Architecture,* 155. Another example, among many, is the Zhihua monastery of A.D. 1444 in Beijing, which has a succession of courtyards and secondary buildings on both sides. See Liu Dunzhen, "Beiping Zhihuasi."

13. In the Western Hills, near Beijing. From zu Castell, *Chinaflug,* pl. 74. The Changling mentioned above (note 10) is a large tomb courtyard.

14. The literature on the city of Chang'an is extensive. Good surveys are Wang Chongren, *Gudu Xian;* Kuhn, ed., *Chinas Goldenes Zeitalter,* 34–44, with copious footnotes, 50. See also Shatzman Steinhardt, *Chinese Imperial City Planning,* 93–96.

15. All measurements from Su, "Sui Tang Chang'an."

16. Chung, "Symmetry and Balance."

17. Chinese archaeologists have reconstructed the imposing buildings in the palace in elaborate drawings. For the Linde Hall, see e.g., Liu and Fu, Lindedian fuyuan de chubu yanjiu." Yang Hongxun, "Tang Daminggong."

18. For public spaces in ancient Greek cities, see Hölscher, *Öffentliche Räume.*

19. Among the several authoritative surveys of the history of Chinese architecture are: the classic Liu Dunzhen, *Zhongguo gudai jianzhu shi,* which has appeared in many editions; Zhongguo kexueyuan ziran kexueshi yanjiusuo, comp., *Zhongguo gudai jianzhu jishu shi,* which boasts more material and technical details and an English edition. Zhongguo jianzhu kexue yanjiuyuan, comp., *Zhongguo gujianzhu* has good photographs with short explanations as well as an English edition. Each of these surveys treats a similar canon of monuments.

20. Zhejiang sheng, "Hemudu yizhi."

21. Reconstruction in Yang Hongxun, "Cong Panlongcheng." For the Panlongcheng site, see Bagley, "P'an-lung-ch'eng"; Thorp, "Origins," 35.

22. Yang Hongxun, "Xi Zhou Qiyi." Thorp, "Origins," 26–31.

23. The visual evidence is discussed by Yang Hongxun, "Dougong qiyuan." Chen, *Zhongguo gudai mujiegou.* For further references, see Shatzman Steinhardt, "Mizong Hall," 48n.25.

24. The scenes were first studied by von Erdberg, "A Hu." See also Jenny F. So, in Fong, ed., *Great Bronze Age,* no. 91, 316–17.

25. For good photographs, see Tokyo kokuritsu hakubutsukan, ed., *Chūzan ōkoku,* pl. 4; and Liu Laicheng et al., *Zhanguo xianyu,* pl. 55.

26. Yang Hongxun, "Dougong qiyuan," 14.

27. Xu et al., *Sichuan Handai shique,* 31–34, pls. 67–120.

28. Guo Daiheng, "Lun Zhongguo gudai mugou jianzhu," 41–43.

29. See, for instance, the different reconstructions of the Han-dynasty ceremonial Bright Hall (*Mingtang*) by Wang Shiren, "Han Chang'an cheng," and by Yang, "Cong yizhi kan."

30. A complete history of imperial city planning is given by Yang Kuan, *Zhongguo gudai ducheng.* For the period from Han to Tang in particular, see Shatzman Steinhardt, *Chinese Imperial City Planning,* 72–92.

31. Shatzman Steinhardt gives a comprehensive bibliography on Tang architecture, "Mizong Hall," 47–48n.16.

32. See the detailed study by Xiao, *Dunhuang jianzhu.* Tanaka, *Chūgoku kenchikushi,* 291–352, contains a systematic study of depictions of Tang architecture in tomb wall paintings.

33. For discussion of the dates, see the restoration report: Naraken bunkazai hozon jimusho, ed., *Kokuhō Hokkiji,* 1–4. See also Soper, *Evolution of Buddhist Architecture,* 304 f.; Parent, "Reconsideration" (Jan. 1977): 83.

34. A lid covered the cavity, which is 18.1 cm across the mouth and 15.2 cm deep. Nothing is known about the whereabouts of the relics. Parent, "Reconsideration" (May 1977): 78.

35. Measurements in Naraken bunkazai hozon jimusho, ed., *Kokuhō Hokkiji,* 6.

36. After a restoration of the building in 1678, in fact, two units existed between the corners of the third story; its front comprised three bays. Only in the early 1970s was the original two-bay arrangement restored. See Asano, *Nara jidai kenchiku,* 122–134, and Parent, "Reconsideration" (June 1977): 81–83. The photograph (Fig. 5.27) shows the building before its restoration, while the elevation (Fig. 5.29) shows it as it is seen at present.

37. Naraken bunkazai hozon jimusho, ed., *Kokuhō Hokkiji,* 56–57.

38. Parent, "Reconsideration" (Feb. 1977): 78, illustrates a section of part of the first story and provides Japanese and English terms for all wooden members.

39. Naraken bunkazai hozon jimusho, ed., *Kokuhō Hokkiji,* 12.

40. For this famous building, see the monograph by Chen, *Yingxian muta;* Zhongguo kexueyuan ziran kexueshi yanjiusuo, comp., *Zhongguo gudai jianzhu jishu shi* (English ed., 96–97); Shatzman Steinhardt, "Ying Xian Timber Pagoda"; idem, "Liao: An Architectural Tradition," 12–14; and idem, *Liao Architecture,* 103–21.

41. For an analysis of iconography and style, see Gridley, "Chinese Buddhist Sculpture," 90–106.

42. Without the 3.76-meter-high terrace and the mast atop the uppermost roof, the actual timber portion measures 51.14 meters. Figures in Chen, *Yingxian muta,* 37.

43. A discussion of the dates, ibid., 20–22. Also Shatzman Steinhardt, "Liao: An Architectural Tradition," 12, 36.

44. Chen, *Yingxian muta,* 11, 45.

45. Ibid., 6, 11, 45.

46. Number ibid., 45, without detailed identification.

47. Ibid., 8.

48. Professor Wang Guixiang of the Beijing Institute of Civil Engineering and Architecture kindly provided these numbers to me in a letter dated August 16, 1997.

49. Chen, *Yingxian muta,* 7.

50. Ibid., 6.

51. Ibid., 59–60. For other large-scale dimensions in the pagoda, see Fu, "Survey," 27.

52. The best study on the *Yingzao fashi* is an annotated translation into modern Chinese prepared by Liang Sicheng and edited by his students: Liang, *Yingzao fashi zhushi.* Glahn has written three important articles in English that deal with the text: "On the Transmission," "Chinese Building Standards," and "Research on the *Ying-tsao fa-shih.*" Chen Mingda presents systematic research in *Yingzao fashi damuzuo* and *Zhongguo gudai mujiegou.* Guo, Qinghua, "Structure," contains an annotated English translation of chapters 4 and 5.

53. For this text, see Needham, *Science and Civilisation,* vol. 4, part 3, 81–84; Glahn, "On the Transmission,"

241n.20; Xia, "*Mengxi bitan.*" Tanaka, "Zhongguo jianzhu duliang," 152–54.

54. Glahn, "On the Transmission," 236n.3.

55. Ibid., 255.

56. Li Jie, *Li Mingzhong Yingzao fashi.*

57. Li Jie, *Li Mingzhong Yingzao fashi, Chazi:* 1a.

58. Resumes of the content are given by Glahn, "On the Transmission," 232–65; Liang, *Yingzao fashi zhushi,* 5–6.

59. The *fen* and *cai* system has often been discussed. For concise treatments, see Guo and Xu, "Zhongguo gudai mugou jianzhu," 44–46; Glahn, "Building Standards," 169–72; Tanaka, "Zhongguo jianzhu duliang."

60. Liang, *Yingzao fashi zhushi,* 240–88, provides explanations and modern drawings with detailed measurements of all types of wooden members, plans, and sections. For a glossary with illustrations of the technical terms in *Yingzao fashi,* see Guo and Xu, "Song *Yingzao fashi shuyu huishi.*" Guo, Qinghua, "Structure," 149–82, gives an English translation of terms with glossary.

61. Transformation into the metric system according to Guo and Xu, "Zhongguo gudai mugou," 44.

62. Discussion of the eight grades and drawings of eight cross sections in Liang, *Yingzao fashi zhushi,* 240; Glahn, "Building Standards," 172; idem, "Research on the *Ying-tsao fa-shih,*" 48; Tanaka, "Zhongguo jianzhu duliang," 159. Drawing of buildings in eight grades in Chen, *Yingzao fashi damuzuo,* vol. 2, pl. 1.

63. Legge, trans., *Li Ki,* vol. 1, 400. Quoted in Li Jie, *Li Mingzhong Yingzao fashi,* 1:3b.

64. Chen, *Yingzao fashi damuzuo,* vol. 1, 27–30. Guo, Qinghua, "Structure," 68–87.

65. Chen, *Yingxian muta,* 54–56.

66. See Shatzman Steinhardt, "Mizong Hall," 35. Chen, *Zhongguo gudai mujiegou,* 64–68, gives a list of detailed measurements of twenty-four Tang- and Song-dynasty buildings. More lists with measurements, idem, *Yingzao fashi damuzuo,* vol. 1, 150–201.

67. Plan and explanation in Guo Daiheng, "Lun Zhongguo gudai mugou jianzhu," 37, fig. 7; quoted in Glahn, "Research on the *Ying-tsao fa-shih,*" 55.

68. Noted by Shatzman Steinhardt, "Mizong Hall," 34.

69. Tanaka, "Zhongguo jianzhu duliang," 154–55.

70. Chapter on the measurements of bones (*gudu*) in *Huangdi neijing, taisu* (The Yellow emperor's inner classic, grand plain), dating from the second or first century B.C., with commentary written by Yang Shangshan during the Sui dynasty (A.D. 589–617). Yang Shangshan, *Huangdi neijing, taisu,* 228–31.

71. Guo and Xu, "Zhongguo gudai mugou jianzhu," 46. The importance of the carpenter in traditional building practice has been stressed by Ruitenbeek in "Ansichten über Architektur," and *Carpentry and Building.*

72. Li Jie, *Li Mingzhong Yingzao fashi, Kanxiang*: 3a. Glahn, "Building Standards," 49.

73. Li Jie, *Li Mingzhong Yingzao fashi*: 17, 2a–b.

74. Ibid., 19: 1b–2a.

75. A government manual from 1734, *Gongbu gongcheng zuofa zeli* (The board of construction engineering regulations), distinguishes eleven grades and gives a prescription for twenty-seven standard buildings. It is more systematic and less intricate than *Yingzao fashi*. See the pioneering study by Liang, *Qingshi yingzao zeli* (first pub. 1934). For a comparison with *Yingzao fashi*, see Guo and Xu, "Zhongguo gudai mugou jianzhu," 55–57; Fu, "Survey," 32.

Chapter 6 *The Word in Print*

1. For the organization of the printing office, see Shaw, *Imperial Printing*, 9–14.

2. Zhang Xiumin, *Zhongguo yinshua shi*, 717, speaks of 160 million characters. Giles, *Alphabetical Index*, ix, more reasonably, estimates 100 million.

3. These numbers are given by Kim Kan in his memorials about preparing wooden type. See Tsien, *Paper and Printing*, 327–30.

4. The printed margin indicates the part (Polity), section (Production), and chapter (50), which equals the heading Palace Halls, and therein Historical Events, first part, page 12.

5. Figure first given in 1847 by Julien, "Documents," 517. Quoted by, among others, Giles, *Alphabetical Index*, xvii, and Zhang Xiumin, *Zhongguo yinshua shi*, 718.

6. Giles, *Alphabetical Index*, xvi–xvii.

7. For the history of printing with copper, see Fuchs, "Kupferdruck."

8. *Wuyingdian juzhenban congshu* (Collectanea printed by the hall of martial eminence in movable type). See Zhang Xiumin, *Zhongguo yinshua shi*, 702–705. These especially rare books were chosen from the gigantic collection *Siku quanshu* (Complete library of the four treasuries), which the palace began to assemble in 1772. For the political implication, see Guy, *The Emperor's Treasures*, 22–25.

9. Tsien, *Paper and Printing*, 327–30.

10. Kim Kan, [*Qinding*] *Wuyingdian juzhenban chengshi* ([Imperially approved] Manual of the hall of martial eminence for printing with movable type). Together with Kim Kan's memorials, his *Manual* is included among the very books that he printed for the palace. For the text without illustrations, see the well-known Huang and Deng, eds., *Meishu congshu*. First translated into German with commentary by Schierlitz, "Zur Technik." English translation and commentary by Rudolph, "Chinese Movable Type"; idem, *Chinese Printing Manual*.

11. The first page in the book *Baozhenzhai fashu can* (Eulogies on model calligraphy from the studio for treasuring originals) by Yue Ke (1183–1234).

12. Quoted from Rudolph, "Chinese Movable Type," 334.

13. For the advantages of woodblock printing, see Twitchett, *Printing and Publishing*, 85–86.

14. For a brief treatment of nineteenth-century missionary printing, see Helliwell, "Two Collections."

15. See Wu, "Development of Typography," 294–96.

16. Developed by Morisawa Nobuo and Ishii Mokichi.

17. *Nongshu* (Book of agriculture), by Wang Zhen (fl. 1290–1333). See Carter, *Invention of Printing in China*, 213–17; Tsien, *Paper and Printing*, 206–208.

18. Heijdra and Cao, "World's Earliest Extant Book," 70–89.

19. *Puljo chikchi simch'e yojol*. See Kim, *Han'guk ko inswae kisulsa*, 124–25.

20. Shen Gua, *Xin jiaozheng Mengxi bitan*, 18:184. Translated in Carter, *Invention of Printing in China*, 212–13. Tsien, *Paper and Printing*, 201–202.

21. *Jingang boruo boluomi jing*. Stein, *Serindia*, vol. 2, 893, 1088; vol. 4, pl. 100. Carter, *Invention of Printing in China*, 54–66. Tsien, *Paper and Printing*, 151. Wood, *Chinese Illustration*, 8–11.

22. *Wugou jingguang da tuoluoni jing*. Translated by the Tokharian master Mituoshan. *Taishō* no. 1024; *Hōbōgirin*, fascicule annexe, 59.

23. Empress Kōken Tennō reigned 749–759 and once again 765–769. Her posthumous name is Shōtoku Tennō.

24. Carter, *Invention of Printing in China*, 46–53; Tsien, *Paper and Printing*, 150–51, 336–37.

25. Nara rokudaiji taikan kankōkai, ed., *Nara rokudaiji taikan*, vol. 4: *Hōryūji* 4, 65–66, pls. 213–15.

26. Kim, *Han'guk ko inswae kisulsa*, 18–22; Sohn, "Early Korean Printing"; Tsien, *Paper and Printing*, 149–50, 322.

27. Twitchett, *Printing and Publishing*, 88–89. Tsien, *Paper and Printing*, 146–49.

28. Tsien, *Paper and Printing*, 158.

29. See Schopen, "Phrase."

30. Hubei sheng bowuguan, ed., *Zeng hou Yi mu*, vol. 1, 452–58; vol. 2, pls. 169–231.

31. Tsien, *Paper and Printing*, 237. For the later history of ink in China, see Franke, *Kulturgeschichtliches*.

32. For the history of paper in China, see Pan, *Zhongguo zaozhi jishu*; and Xu Mingji, *Zhongguo gudai zaozhishu*.

33. Seckel, "Wurzeln der chinesischen Graphik," systematically discusses the Chinese graphic techniques' roots in bronze casting technique, and the underlying patterns of thought in both.

34. Lawton, "Rubbings of Chinese Bronzes."

35. Chang, "Some Dualistic Phenomena," has raised the question whether a coherent dualism characterized Shang society.

36. Bagley, *Shang Ritual Bronzes*, 38–41.

37. Zhongguo lishi bowuguan, comp., *Chūgoku rekishi hakubutsukan*, no. 60, 195. The date of this vessel has been much debated. Li, Xueqin, *Eastern Zhou and Qin*, 226, states "663–660 B.C." Agreeing with him on stylistic grounds, So, *Eastern Zhou Ritual Bronzes*, 112, suggests "second quarter of the seventh century B.C."

38. Ling, "Yinwentao."

39. Especially in and near the Eastern Han–dynasty capital Luoyang, near Zhengzhou, and in the Nanyang area. The first collection and Western-language studies of these tiles were made by the bishop of Henan; White, *Tomb Tile Pictures*. Zhou and Lü, *Henan Handai*, contains many illustrations.

40. Henan sheng, "Zhengzhou Nanguan," 22, fig. 19. Zhou and Lü, *Henan Handai*, fig. 190. I would like to thank Ms. Yu-ling Huang of the University of Kansas, who pointed out this example in a seminar paper.

41. Some of the Chicago stamps seem to have been used on two tiles in the Freer Gallery, Washington, D.C. See Bulling, "Hollow Tomb Tiles," 37, pls. 12a, 13.

42. Ling, "Shupibu."

43. Textile no. 340-11. Hunan sheng bowuguan and Zhongguo kexueyuan kaogu yanjiusuo, eds., *Changsha Mawangdui yi hao Han mu*, vol. 1, 56–57; vol. 2, pl. 117. Shanghai shi fangzhi kexue yanjiuyuan, Shanghai shi sichou gongye gongsi wenwu yanjiuzu, ed., *Changsha Mawangdui yi hao Han mu chutu fangzhipin*, 108–11, figs. 93–94, pls. 35–36. Wang Xu, "Mawangdui Han mu," 476–77, pl. 12.2.

44. Textile no. N-5. Shanghai shi fangzhi kexue yanjiuyuan, Shanghai shi sichou gongye gongsi wenwu yanjiuzu, ed., *Changsha Mawangdui yi hao Han mu chutu fangzhipin*, 106–07, pls. 31–34; Wang Xu, "Mawangdui Han mu," 471, 474–78, pl. 12.3.

45. Lü, "Nan Yue wang mu," 138, 178–79. Guangzhoushi wenwu guanli weiyuan hui et al., eds., *Xi Han Nan Yue wang mu*, vol. 1, 481; vol. 2, pl. 31 (fragment of printed silk). Mai and Huang, *Lingnan Xi Han*, 123.

46. For the tomb, see Prüch, ed., *Schätze für König Zhao Mo*. For these seals, see Uta Lauer in Prüch ibid. 122–27, 256–57.

47. Xiong, "Changsha xin faxian," 49, 52, pl. 1.2. Li, Xueqin, *Eastern Zhou and Qin*, 362 f.

48. Good photo in Chavannes, *Documents Chinois*, pl. XV, no. 539. Description in Stein, *Serindia*, vol. 2, 700–701. Tsien, *Written on Bamboo and Silk*, 119–21, pls. VIII E, XIX B. Ling, "Yinwentao," 32, 55, mentions literary evidence for Han-dynasty military certificates made of silk called *xu*, which are believed to have carried the stamp of an official seal. Ling, "Shupibu," 209 f., 220 f., refers to a fourteen-inch-long wooden official seal of the Sui dynasty, which was impressed over the seams in government documents.

49. In an unpublished paper, "Ensigillation: A Buddho-Taoist Technique in Exorcism," the late Michel Strickman explored the textual evidence for the early use of religious seals.

50. Carter, *Invention of Printing in China*, 13 f.

51. *Taishō* no. 1238 (according to Strickman).

52. *Taishō* no. 1265, translated in the mid-seventh century (according to Strickman).

53. Collon, *First Impressions*.

54. Carter, *Invention of Printing in China*, 58, 64. For the impact of printing in general and of wrapped-back binding in particular, see Cherniack, "Book Culture," 37–40.

Chapter 7 *The Bureaucracy of Hell*

1. The first part of this chapter is an expanded version of Ledderose, "Kings of Hell."

2. In his thoughtful study *La naissance du purgatoire*, le Goff shows that neither the word nor the idea of purgatory existed in Christianity before the latter half of the twelfth century. He also analyzes the fundamental changes in mentality and in the concepts of time and space that led to the "birth of purgatory."

3. In the Kōtōin are kings nos. 1, 4, 5, 6, 8, and 10. Kings nos. 2, 3, and 9 are replacements. See Suzuki, ed., *Chūgoku* vol. 4:JT 12-001.

4. The mirrors in Ningbo always reveal one of two scenes, the other being a fellow killing geese.

5. For the workshops in Ningbo, see Fontein, "Lost and Found"; Fong, *Beyond Representation*, 332–48.

6. Kings of hell paintings in Western collections, such as those in Berlin, Boston, and New York, also arrived in these museums via Japan.

7. For a comparative study of the signatures, see Watanabe, "Kanki aru Sō Gen butsuga."

8. Lu Xinzhong is not found in Chinese historical sources, but is mentioned as a specialist on hell paintings in the Japanese treatise *Kundaikan sōchōki*, which was compiled in 1470 by the painter and connoisseur Nōami (1397–1471) and completed in 1511 by his grandson Sōami (1485?–1525). See *Kundaikan sōchōki*, 29.

9. Illustration in Suzuki, ed., *Chūgoku*, vol. 4:JT 108-001, 7/11.

10. For the location of the workshop in Ningbo, see Ebine, "Ninpō butsuga"; Ide, "Riku Shinchū kō," part 2, 147.

11. Inscriptions on ceramic pillows of the period also indicate that they were made by a certain family (*jia*). See Whitfield, "Tz'u-chou Pillows."

12. The question of the date is discussed by Tanaka, "Riku Shinchū"; Suzuki, *Mindai kaigashi*, 105–107.

13. First published by Tanaka, "Riku Shinchū." Suzuki, ed., *Chūgoku*, vol. 3:JM 4-001, 7/10, indicates that the series still belonged to the Japanese Agency of Cultural Affairs (Bunkachō) at the time of publication (1980s).

14. Former Ellen B. Elliott Collection. Sold at Christie's New York, Nov. 25, 1991. All ten paintings are published in color in the auction catalog.

15. Suzuki, ed., *Chūgoku,* vol. 4:JT 88-002 (the seventh king is not illustrated).

16. Kumagai, "Kyūshu shozai," 40, suggests that the Zendōji set was produced in Korea in the second half of the sixteenth century, following a Lu Xinzhong prototype. Kajitani, "Riku Shinchū," however, has shown that the set existed in Japan by 1373.

17. Suzuki, ed., *Chūgoku,* vol. 4:JT 10-002, 4/10.

18. Ibid., vol. 3:JM 9-001, 2/10.

19. Ibid., vol. 4:JT 12-001, 3/9. For a nineteenth-century copy of the entire set of ten scrolls, see Croissant and Wakabayashi, *Japanese Paintings,* vol. 1, 32, no. 45; vol. 2, 185–86.

20. A set in Jōshōji displays still another formula in the composition with the woman and baby; Suzuki, ed., *Chūgoku,* vol. 4:JT 39-001, 6/11. This set is in a group of its own. Kajitani, "Riku Shinchū," has attempted a grouping of all sets.

21. Suzuki, ed., *Chūgoku,* vol. 4:JT 108-001, 6/11.

22. Ibid., vol. 4:JT 20-001, 6/10.

23. Ibid., vol. 3:JM 23-011.

24. Ibid., vol. 3:JM 10-001, 3/5.

25. Ibid., vol. 4:JT 62-001, 6/10.

26. Whitfield, *Art of Central Asia,* vol. 2, pls. 78–80. Fraser, "Régimes."

27. Zhu Jingxuan, *Tang chao minghualu,* 14, makes a special point that Wu Daozi personally added the colors in a wall painting in the Tiangongsi in Luoyang. Translation by Soper, "T'ang Ch'ao Ming Hua Lu," 208.

28. Fu (with Stuart), *Challenging the Past,* 22, 140.

29. Matsumoto, " 'Kata' ni yoru zōzō."

30. Lentz and Lowry, *Timur,* 177, 376.

31. Beck and Bredekamp, "Kompilation der Form."

32. The full title in version P 2003 in the Bibliothèque Nationale, Paris, is *Fo shuo Yanluo wang shouji sizhong yuxiu shengqi wangsheng jingtu jing* (The Scripture spoken by the Buddha to the four orders on the prophecy given to King Yama Râja concerning the sevens of life to be cultivated in preparation for rebirth in the pure land). An early study of the *Scripture* is Sakai, "Jūō shinkō." Since then the scholarly literature has become considerable. It is fully absorbed in the comprehensive monograph by Teiser, *Scripture.*

33. On the Sichuan tradition of Buddhist figure painting, see Wai-kam Ho in *Eight Dynasties,* xxxi–xxxiv.

34. Teiser, *Scripture,* 239–41.

35. On the days of fast, see Forte and May, "Chōsai."

36. Soymié has taken a good look at these boys. See his "Les dix jours de jeûne de Ksitigarbha"; idem, "Les dix jours de jeûne du taoisme."

37. In *Yaoshi liuyi guang ruai benyuan gongde jing.* Cf. Soymié, "Notes d'iconographie," part 2, 50. Mochizuki, *Bukkyō daijiten,* 675.

38. In his *Lidai minghuaji* of A.D. 847, Zhang Yanyuan records wall paintings with hell scenes in the monasteries Baochasi and Jinggongsi in the capital Chang'an. See Acker, *Some T'ang and Pre-T'ang Texts,* vol. 1, 265, 271.

39. Zhu Jingxuan, *Tang chao minghualu,* 16. Soper's translation, "T'ang Ch'ao Ming Hua Lu," 210. Teiser, "Having Once Died," 440–43.

40. Von LeCoq, *Buddhistische Spätantike,* part 4, pl. 19, text 28. From temple compound no. 8 in Bezeklik, where all wall paintings show a Chinese style. LeCoq dates it from the ninth to tenth century.

41. Teiser, "Having Once Died," 433–64. Idem, *Scripture,* 37–40, 80.

42. The paintings are discussed by, among others, Matsumoto, *Tonkōga,* 402–16, pls. 106–18; Tokushi and Ogawa, "Jūō shōshichikyō"; Kawahara, "Tonkōga Jizōzu shiryō"; and Whitfield, *Art of Central Asia,* vol. 2, 318–19, 338–39. For pictures of kings of hell in central Asia, see von Gabain, "Ksitigarbha-Kult."

43. Giès et al., *Arts de l'Asie Centrale,* vol. 2, pl. 62-1. Cartouches on similar scrolls identify the four court officials as Wang, Song, Cui, and Zhao (ibid., pl. 63-1), and name the officials of the heavenly tribunal (*tiancao panguan*) and the officials of the terrestrial agency (*difu panguan*); ibid., pl. 61.

44. Teiser, *Scripture,* 285 f.

45. For a brief typological sequence of the kings of hell paintings from Dunhuang, see Ledderose, "A King of Hell," 37–40.

46. In Hōshōji and Saikyōji respectively. Suzuki, ed., *Chūgoku,* vol. 4:JT 158-001, 8/11; vol. 4:JT 129-001, 4/6.

47. In the Seikadō Library, Tokyo. Kawakami and Toda, *Torai kaiga,* nos. 29–31. Suzuki, ed., *Chūgoku,* vol. 4:JM 8-004.

48. For example, sets in the Seiganji, Kenchōji, and Eigenji. Suzuki ed., *Chūgoku,* vol. 4:JT 13-001, 1/11; 28-003, 1/11; 108-001, 11/11 .

49. In China, a hall of purgation that housed the paintings of the ten kings was called a hall of the ten kings (*shiwang dian*) or a hall of the dark agency (*mingfu dian*); in Japan, Yama hall, or *Emmadō.* Mochizuki, *Bukkyō daijiten,* 2217c. An example in Japan is discussed by Ōgushi, "Hōjōji jussaidō no jigokue." For the lore of hell in general, see Sawada, *Jigoku hen.*

50. *Masterpieces of Chinese Portrait Painting,* pl. 20.

51. For example, the portrait of Zhongfeng Mingben (1264–1325) in Fontein and Hickman, *Zen Painting and Calligraphy,* no. 15.

52. For example, the fifteenth-century portrait of the

Hongzhi emperor in Fong et al., *Possessing the Past,* pl. 162.

53. Ibid., 312–14, pl. 155. For the significance of screens in general, see the thoughtful study by Wu, *Double Screen.*

54. Chapin, *Long Roll,* pl. 20, nos. 46–48. From right to left, the section shows great masters Sengcan, Daoxin, and Hongren.

55. *Eight Dynasties,* no. 39. Balustrade and screen are combined in a twelfth-century fan by Su Hanchen, in Boston; Tomita, *Portfolio,* pl. 74. In another scene from the *Long Roll of Buddhist Images,* chair, screen, and balustrade are the attributes of a government official who, with the help of two attendants, dispenses goods to the poor. Chapin, *Long Roll,* pl. 30, no. 73.

56. Li Lina, *Huazhong jiaju tezhan,* 54. The set of four paintings follows Song-dynasty prototypes. The shape of the ceramics and the furniture depicted on the scrolls indicate a Ming-dynasty date.

57. *Quanxiang,* vol. 4: *Quanxiang Qian Hanshu pinghua,* 297–98.

58. The celebrated judge Bao Zheng (999–1062) was the first one to allow litigants to come directly to the courtroom through the main gate without first having to report their case to the outer clerks. See Hayden, "Legend of Judge Pao," 344.

59. *Quanxiang,* vol. 1: *Qinxian Wu wang fa Zhou pinghua,* 25–26.

60. From the Seiganji set. Suzuki ed., *Chūgoku,* vol. 4:JT 13-001, 6/11.

61. An Lushan was sentenced to death, but later pardoned. For the incident, see Pulleyblank, *Background of the Rebellion of An Lushen,* 22 f., 116–20. *Cambridge History of China,* vol. 3, 407. I thank Professor Wai-kam Ho for directing my attention to the *Yongle dadian* illustration.

62. A woodblock illustration from a commentary to the *Record of Ritual (Liji)* of about A.D. 1220 shows these two types of headgear, the *mian* and the *guan.* See Zheng Zhenduo, *Zhongguo gudai mukehua,* vol. 1. For rules about different types of official headgear in the Song dynasty, see Tuo Tuo, comp., *Songshi,* 151:3522.

63. An exception is the Seiganji set, where both Yama and the king of Mount Tai wear hats of the *mian* type.

64. See Kracke, *Civil Service,* 42.

65. Ibid., 43 f., 86 f.

66. Li Hongqi, "Songdai guanyuanshu," tables on 84, 99. I thank Professor Joseph McDermott for alerting me to this material.

67. Hayden, "Legend of Judge Pao," 345 f. Soymié, "Notes d'iconographie," part 2, 166.

68. *Shimen zhengtong* 4, *Dainihon zokuzōkyō,* 130:401 a–b. Quoted by Tokushi and Ogawa, "Jūō shōshichikyō," 272; translation from Teiser, *Scripture,* 65.

Chapter 8 *Freedom of the Brush?*

1. Kristeller, "Modern System of the Arts."

2. Foucault, *Order of Things,* xv. For a critical comment on Foucault's sources, see Hay, ed., in his Introduction to *Boundaries of China,* 6–9. Further references in Nelson, "Map of Art History," 29n.10.

3. The translation of many classificatory terms is adopted from Giles, *Alphabetical Index.*

4. *Gujin tushu jicheng* 5:129, 3a–b. Translation above, chapter 3, page TK, of *Ten Thousand Things.*

5. *Gujin tushu jicheng* 6:976, 19a.

6. For the paradigmatic meaning of this legend, see Wu, *Monumentality,* 4–11.

7. For the history of the imperial art collection, see Chang, "National Palace Museum." For the political role of imperial art collections, see Ledderose, "Der politische und religiöse Charakter," and idem, "Some Observations."

8. On Song bronze catalogs, see Rudolph, "Preliminary Notes"; Poor, "Notes"; Kerr, *Later Chinese Bronzes,* 14–18; James C. Y. Watt in Fong et al., *Possessing the Past,* 219–22; and Harrist, "Artist as Antiquarian."

9. Clunas, *Superfluous Things,* 100.

10. Ibid., 105.

11. Ibid., 101. A prominent historical case is that of the Tang emperor Taizong who, when leaving this world in A.D. 649, took the *Orchid Pavilion Preface* with him.

12. Lawton, "Imperial Legacy." Idem, "Rong Geng," fig. 4, illustrates the title pages of the four catalogs.

13. See the illustration of a Tang-dynasty gilt-bronze rhyton in Fong et al., *Possessing the Past,* pl. 351d.

14. Pointed out by Lawton, "Jin Futing."

15. Fong et al., *Possessing the Past,* 553.

16. Clunas, in his perspicacious monograph *Superfluous Things.*

17. The *Bidian zhulin* (Pearl forest in secret halls) of 1744 was a pilot project for the far larger *Shiju baoji* (Treasure bags from stone moat), which appeared in three installments in 1745, 1793, and 1816.

18. Wang Jie et al., *Bidian zhulin,* vol. 1, 100b. Color illustration in Li Lina, *Huazhong jiaju tezhan,* 42–43.

19. For a detailed study of the *Autobiography,* see Schlombs, *Huaisu.*

20. Wen Fong in Fong et al., *Possessing the Past,* 118.

21. Yang Xin (370–442) quoted in Yu He, *Lunshubiao,* 14a. Cf. Ledderose, "Some Taoist Elements," 267.

22. He Yanzhi, *Lantingji,* 55a. Quoted in Ledderose, *Mi Fu,* 19.

23. For Deng Shiru's aesthetic achievements, see Ledderose, "Calligraphy at the Close of China's Empire," 199–206.

24. Fu, *Traces of the Brush,* 5–8. For tracing copies, see Ledderose, *Mi Fu,* 34–35, 75–76.

25. For the following, see Ledderose, "Chinese Calligraphy," 35–39.

26. For the ideal of spontaneity, see Nelson, "Three Ch'ing Critics."

27. Wai-kam Ho and Dawn Ho Delbanco give a succinct evaluation of the scroll's artistic merit in Brown and Shapiro, eds., *Rings,* no. 264.

28. For the album, see Zhang Zining, "Xiaozhong xianda." Wen Fong in Fong et al., *Possessing the Past,* 474–76. Quotation from Zhang Geng, *Guochao huazhenglu, juan shang,* 2., translated by Fong.

29. This compositional relationship and similar other cases are described by Ogawa in "Relationship." According to Ogawa, 133, Muxi's rearrangement is only one of fifty-six possible formulas that can be derived from Mi Youren's compositional prototype. For further treatment of Song and Yuan landscape compositions, see Ogawa, "Sô Gen sansuiga."

30. See Ryor "Self-Expression."

31. Chen Dexing, "*Meihua xishenpu* yanjiu," pl. 18, illustrates a sample page in a pharmacopeia from the Zhenghe era (1111–17), with plants and accompanying explanations. A similar combination of image and text is found in painting manuals.

32. *Meihua xishenpu* (Manual for enjoying the spirit of plum blossoms) by Song Boren. The earliest complete edition (1261) is kept in the Shanghai Museum. See the in-depth study by Wiedehage, *Das Meihua xishen pu des Song Boren;* and Bickford, *Ink Plum,* 45–46.

33. *Songzhai meipu* (Pine studio plum manual) by Wu Taisu. See Shimada, ed., *Shôsai baifu,* pl. 78; Bickford, *Ink Plum,* 185–96.

34. *Zhupu xianglu* (Bamboo manual with detailed descriptions) by Li Kan (1245–1320). German translation by Lippe-Biesterfeld, "Li K'an." See also Yi, "Analysis."

35. *Peiwenzhai shuhuapu* (Encyclopedic compilation of writings on calligraphy and painting from the Peiwen studio). 1708.

36. Von Spee gives an analysis of the modular structure of Wang Yuanqi's paintings in the Wu Zhen and the Ni Zan modes in "Modulsystem und gestalterische Freiheit."

37. A *Standing Horse* (1944) is almost identical to the Sackler steed in Fig. 8.16. See *Xu Beihong Centenary Album,* no. 34.

38. Cahill, *Fantastics and Eccentrics,* 57–59, no. 19. *Eight Dynasties,* 311–13, no. 231.

39. Fu (with Stuart), *Challenging the Past,* 15, 78.

40. Cahill, *Painter's Practice,* 54–59.

41. Text in Zheng Xie, *Zheng Banqiao ji,* 194 f. Translations and commentary in Scott, "Yangchow and Its Eight Eccentrics" 11; Rogers and Lee, *Masterworks of Ming and Qing Paintings,* 197; Pohl, *Cheng Pan-ch'iao,* 59; Hsü, "Zheng Xie's Price List," 261. Some modern scholars have regarded Zheng Xie's famous list as irony, but Ginger Cheng-chi Hsü and James Cahill have argued persuasively that the artist meant it seriously and literally. See Hsü, "Merchant Patronage," 215–21; idem, "Zheng Xie's Price List"; idem, *Bushel of Pearls;* Cahill, *Three Alternative Histories,* 102–109; idem, *Painter's Practice,* 22 f.

42. Translation by Diény, "Lettres Familiales."

43. For Zheng Xie's views on painting, see Pohl, *Cheng Pan-ch'iao,* 136–60; translated on 141, 145, 146.

44. Ibid., 139.

45. Ibid., 160.

46. See Zhang and Hu, eds., *Yangzhou baguai,* vol. 5, no. 134, for a handscroll with orchids, rocks, bamboo, and orchids with thorns, the latter a metaphor for the lofty scholar being harassed by petty officials.

47. Ibid., vol. 6, no. 145.

48. Pohl, *Cheng Pan-ch'iao,* 141.

49. For a discussion of the painting and a translation of the inscription, see Ledderose, *Orchideen und Felsen,* 233–37.

50. Formerly in the collection of Victoria Contag (Nü-wa-chai). Discussion and translation of inscription in Speiser, Goepper, and Fribourg, *Chinesische Kunst,* 165.

51. Cahill, *Painter's Practice,* 22 f. (quoting dissertation by Ginger Cheng-chi Hsü). For a comparable phenomenon in the plum paintings of Jin Nong (1687–1764), another Yangzhou painter, see Hsü, "Incarnations," 23–45.

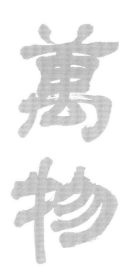

NOTE TO READERS: European-derived names that include particles such as "de," "von," or "zu" will be found alphabetized as though such particles were absent. For example, "von Spee" will be found under "Spee." While East Asian writers' family names generally are not set apart by punctuation, a comma follows the family names of authors who wrote their works in English. All East Asian family names are alphabetized as though no commas were present, however. Thus "Li, Chu-tsing" is followed by "Li Hongqi," which precedes "Li, Xueqin."

Acker, William B. *Some T'ang and Pre-T'ang Texts on Chinese Paintings.* 2 vols. Sinica Leidensia 8 and 12. Leiden: Brill, 1954–74.

Akiyama, Terukazu, Kōsei Andō, Saburo Matsubara. *Arts of China.* (Translation of *Chūgoku bijutsu*). 3 vols. Tokyo and Palo Alto, Calif.: Kodansha International, 1968–70.

Asano, Kiyoshi. *Nara jidai kenchiku no kenkyū* (Research on architecture of the Nara period). Tokyo: Chūō kōron bijutsu Press, 1969.

Bagley, Robert W. "P'an-lung-ch'eng: A Shang City in Hubei." *Artibus Asiae* 39 (1977): 165–219.

———. *Shang Ritual Bronzes in the Arthur M. Sackler Collections,* Ancient Chinese Bronzes in the Arthur M. Sackler Collections 1. Washington, D.C.: Arthur M. Sackler Foundation; Cambridge, Mass.: Arthur M. Sackler Museum, 1987.

———. "Shang Ritual Bronzes: Casting Technique and Vessel Design." *Archives of Asian Art* 43 (1990): 6–20.

———. "An Early Bronze Tomb in Jiangxi Province." *Orientations* 24, no. 7 (July 1993): 20–36.

———. "Meaning and Explanation." In *The Problem of Meaning in Early Chinese Ritual Bronzes,* edited by Roderick Whitfield (*q.v.*), 34–55.

———. "Replication Techniques in Eastern Zhou Bronze Casting." In *History from Things: Essays on Material Culture,* edited by Steven Lubar and W. David Kingery. Washington, D.C.: Smithsonian Institution Press, 1993, 234–41.

———. "What the Bronzes from Hunyuan Tell Us about the Foundry at Houma." *Orientations* 26, no. 1 (Jan. 1995): 46–54.

———. "The Appearance and Growth of Regional Bronze Using Cultures." In *The Great Bronze Age of China,* edited by Wen C. Fong (*q.v.*), 109–33.

———. "Debris from the Houma Foundry." *Orientations* 27, no. 9 (Oct. 1996): 50–58.

Ban Gu. *Hanshu.* 100 juan. Beijing: Zhonghua shuju, 1962.

Barnard, Noel. *Bronze Casting and Bronze Alloys in Ancient China,* Monumenta Serica Monograph 14. Tokyo: Australian National University and Monumenta Serica, 1961.

Barnhart, Richard M. "Wei Fu-jen's *Pi Chen T'u* and the Early Texts on Calligraphy." *Archives of the Chinese Art Society of America* 18 (1964): 13–25.

Beck, Herbert, and Horst Bredekamp. "Kompilation der Form in der Skulptur um 1400: Beobachtungen an Werken des Meisters von Grosslobming." *Städel-Jahrbuch,* new series 6 (1977): 129–57.

Belting, Hans. *Likeness and Presence: A History of the Image before the Era of Art.* Translated by Edmund Jephcott. Chicago: University of Chicago Press, 1994.

Benjamin, Walter. "The Work of Art in the Age of Mechanical Reproduction." Translated by Harry Zohn. In Walter Benjamin, *Illuminations,* 211–44. London: Fontana Press, 1992.

Bickford, Maggie. *Ink Plum: The Making of a Chinese Scholar-Painting Genre.* Cambridge: Cambridge University Press, 1996.

Bodde, Derk. *China's First Unifier: A Study of the Ch'in Dynasty as Seen in the Life of Li Ssu (280?–208 B.C.).* 2nd ed. Hong Kong: Hong Kong University Press, 1967.

———. "The State and Empire of Ch'in." In *The Cambridge History of China* (q.v.), vol. 1: *The Ch'in and Han Empires, 221 B.C.–A.D. 220,* edited by Denis Twitchett and Michael Loewe, 20–102.

Boltz, William G. *The Origin and Early Development of the Chinese Writing System,* American Oriental Series 78. New Haven: American Oriental Society, 1994.

Brandt, Klaus Joachim. *Chinesische Lackarbeiten.* Exh. cat. Stuttgart: Linden-Museum, 1988.

Bredekamp, Horst. "Der simulierte Benjamin: Mittelalterliche Bemerkungen zu seiner Aktualität." In *Frankfurter Schule und Kunstgeschichte,* edited by Andreas Berndt et al., 117–40. Berlin: Dietrich Reimer, 1992.

Brown, J. Carter, and Michael Shapiro, eds. *Rings: Five Passions in World Art.* Exh. cat. Atlanta: High Museum of Art; New York: Abrams, 1996.

Bryson, Norman. *Vision and Painting: The Logic of the Gaze.* New Haven: Yale University Press, 1983.

Bulling, Anneliese. "Hollow Tomb Tiles: Recent Excavations and Their Dating." *Oriental Art* 11, no. 1 (spring 1965): 27–42.

Burton, William. *Porcelain: A Sketch of Its Nature, Art, and Manufacture.* London: Cassell, 1906.

Cahill, James. *Fantastics and Eccentrics in Chinese Painting.* Exh. cat. New York: Asia House Gallery, 1967.

———. *Hills beyond a River: Painting of the Yüan Dynasty, 1279–1368.* New York: Weatherhill, 1976.

———. *Three Alternative Histories of Chinese Painting,* The Franklin D. Murphy Lectures 9. Lawrence: University of Kansas, Spencer Museum of Art, 1988.

———. *The Painter's Practice: How Artists Lived and Worked in Traditional China,* Bampton Lectures in America. New York: Columbia University Press, 1994.

Cai Yonghua. "Suizang mingqi guankui" (A modest view on funerary spirit utensils). *Kaogu yu wenwu* (1986, no. 2): 74–78.

The Cambridge History of China, edited by Denis Twitchett and John K. Fairbank. Cambridge: Cambridge University Press, 1978 ff.

Carter, Thomas Francis. *The Invention of Printing in China and Its Spread Westward.* 1925. Rev. ed. by L. Carrington Goodrich. New York: Ronald Press, 1955.

zu Castell, Wulf Diether Graf. *Chinaflug.* Berlin: Atlantis, 1938.

Chang, Kwang-chih. "Some Dualistic Phenomena in Shang Society." *Journal of Asian Studies* 24 (Nov. 1964): 45–61.

———. *Shang Civilization.* New Haven: Yale University Press, 1980.

———. *Art, Myth, and Ritual: The Path to Political Authority in Ancient China.* Cambridge: Harvard University Press, 1983.

Chang, Lin-sheng. "The National Palace Museum: A History of the Collection." In Fong et al., *Possessing the Past: Treasures from the National Palace Museum, Taipei* (q.v.), 3–25.

Chapin, Helen B. *A Long Roll of Buddhist Images.* Ascona: Artibus Asiae, 1972.

Chase, W. Thomas, et al. *Ancient Chinese Bronze Art: Casting the Precious Sacral Vessel.* New York: China House Gallery, China Institute of America, 1991.

Chavannes, Édouard. *Les documents Chinois découverts par Aurel Stein dans les sables du Turkestan Oriental.* Oxford: Oxford University Press, 1913.

Chen Chaohuan, ed. *Jieziyuan huapu daquan* (Great compendium of the *Mustard Seed Garden Manual of Painting*). Taipei: Wenguang tushu Company, 1991.

Chen Dexing. "*Meihua xishenpu* yanjiu" (Study of the *Meihua xishenpu*). Master's thesis. Institute of Art History, National Taiwan University, Taipei, 1996.

Chen Menglei et al., comps. *Gujin tushu jicheng.* See *Gujin tushu jicheng.*

Chen Mingda. *Yingxian muta* (The timber pagoda in Ying County). Beijing: Wenwu Press, 1980.

————. *Yingzao fashi damuzuo yanjiu* (Research on structural timber work according to *Building Standards*). 2 vols. Beijing: Wenwu Press, 1981.

————. *Zhongguo gudai mujiegou jianzhu jishu: Zhanguo–Bei Song* (Technique of traditional timber frame architecture in China: From Warring States to Northern Song). Beijing: Wenwu Press, 1990.

Chen Zhi. *Liang Han jingji shiliao luncong* (Discussion and collection of materials concerning the economy of the two Han dynasties). Xian: Shaanxi renmin Press, 1958.

————. "Guqi wenzi congkao" (Miscellaneous notes on inscriptions on ancient vessels). *Kaogu* (1963, no. 2): 80–86.

Cherniack, Susan. "Book Culture and Textual Transmission in Sung China." *Harvard Journal of Asiatic Studies* 54 (1994): 5–125.

Chūka jinmin kyōwakoku kodai seidōki ten (Exhibition of ancient bronzes of the People's Republic of China). Exh. cat. Tokyo: Nihon Keizai shinbunsha, 1976.

Chung, Saehyang P. "Symmetry and Balance in the Layout of the Sui-Tang Palace City of Chang'an." *Artibus Asiae* 56 (1996): 5–17.

Clunas, Craig. *Superfluous Things: Material Culture and Social Status in Early Modern China.* Cambridge, Eng.: Polity Press, 1991.

————, ed. *Chinese Export: Art and Design.* London: Victoria and Albert Museum, 1987.

Collon, Dominique. *First Impressions: Cylinder Seals in the Ancient Near East.* Chicago: University of Chicago Press, 1987.

Cox, John Hadley. *An Exhibition of Chinese Antiquities from Ch'ang-sha.* Exh. cat. New Haven: Yale University, Gallery of the Fine Arts, 1939.

Croissant, Doris. "Funktion und Wanddekor der Opferschreine von Wu Liang Tz'u: Typologische und ikonographische Untersuchungen." *Monumenta Serica* 23 (1964): 88–162.

————. "Der unsterbliche Leib: Ahneneffigies und Reliquienporträt in der Porträtplastik Chinas und Japans." In *Das Bildnis in der Kunst des Orients,* edited by Martin Kraatz et al. (*q.v.*), 235–68.

Croissant, Doris, and Misako Wakabayashi. *Japanese Paintings in the Linden-Museum Stuttgart: A Selection from the Baelz Collection.* 2 vols. Stuttgart: Linden-Museum Stuttgart; Tokyo: Kodansha, 1991.

Curtis, Julia B. "Markets, Motifs and Seventeenth-Century Porcelain from Jingdezhen." In *The Porcelains of Jingdezhen,* edited by Rosemary E. Scott (*q.v.*), 123–50.

Da Ming huidian. See Shen and Zhao. *Da Ming huidian.*

Danto, Arthur C. *Beyond the Brillo Box: The Visual Arts in Posthistorical Perspective.* New York: Farrar, Straus and Giroux, 1992.

Deng Yizhi. *Deng Shiru fashu xuanji* (A selection of calligraphies by Deng Shiru). Beijing: Wenwu Press, 1964.

Detweiler, Susan Gray. *George Washington's Chinaware.* New York: Abrams, 1982.

Diény, J. P. "Les 'Lettres Familiales' de Tscheng Pan-K'iao." In *Mélanges* 2, 15–67. Bibliothèque de l'Institut des Hautes Etudes Chinoises 14. Paris: Presses Universitaires de France, 1960.

Dillon, Michael. "Jingdezhen as a Ming Industrial Center." *Ming Studies* 6 (spring 1978): 37–44.

Dohrn-van Rossum, Gerhard. *History of the Hour: Clocks and Modern Temporal Orders.* Translated by Thomas Dunlap. Chicago: University of Chicago Press, 1996.

Driscoll, Lucy, and Kenji Toda. *Chinese Calligraphy.* Chicago: University of Chicago Press, 1935.

Dubs, Homer H. *The History of the Former Han Dynasty.* 3 vols. Baltimore: Waverly Press, 1938–55.

Ebine Toshio. "Ninpō butsuga no kokyō" (The hometown of the Buddhist paintings from Ningbo). *Kokka* 1097 (Oct. 1986): 60–65.

Eight Dynasties of Chinese Painting: The Collections of the Nelson Gallery–Atkins Museum, Kansas City, and the Cleveland Museum of Art. Exh. cat. Cleveland: Cleveland Museum of Art, 1980.

Elisseeff, Vadime. *Bronzes archaiques Chinois au Musée Cernuschi,* vol. 1. Paris: L'asiathèque, 1977.

Emmerling, Erwin. "Die Tonfiguren-Armee des Kaisers Qin Shihuangdi." In *Entwicklung und Erprobung von Konservierungstechnologien für Kunst- und Kulturgüter der Provinz Shaanxi/VR China. Jahresbericht 1989 und 1990,* 28–31. Munich: Bayrisches Landesamt für Denkmalpflege, 1990.

von Erdberg Consten, Eleanor. "A *Hu* with Pictorial Decoration: Werner Jannings Collection, Palace Museum, Peking." *Archives of the Chinese Art Society of America* 6 (1952): 18–32.

———. "A Terminology of Chinese Bronze Decorations." *Monumenta Serica* 16 (1957): 287–314; 17 (1958): 208–54; 18 (1959): 245–93. Rev. ed. in Eleanor von Erdberg. *Ancient Chinese Bronzes: Terminology and Iconology,* 7–144. Bad Wildungen: Siebenberg Verlag, 1993.

———. "Die Soldaten Shih Huang Ti's—Porträts?" In *Das Bildnis in der Kunst des Orients,* edited by Martin Kraatz et al. (*q.v.*), 221–34.

Fairbank, Wilma. *Liang and Lin: Partners in Exploring China's Architectural Past.* Philadelphia: University of Pennsylvania Press, 1994.

von Falkenhausen, Lothar. "Ahnenkult und Grabkult im Staat Qin." In *Jenseits der Großen Mauer,* edited by Lothar Ledderose and Adele Schlombs (*q.v.*), 35–48.

———. *Suspended Music: Chime-Bells in the Culture of Bronze Age China.* Berkeley: University of California Press, 1993.

Fang Xuanling, comp. *Jinshu.* 130 juan. A.D. 644. Reprint. Beijing: Zhonghua shuju, 1974.

Fodor, Jerry A. *The Modularity of Mind.* Cambridge: MIT Press, 1983.

Fong, Wen C. *Beyond Representation: Chinese Painting and Calligraphy, 8th–14th Centuries.* New York: Metropolitan Museum of Art; New Haven: Yale University Press, 1992.

———, ed. *The Great Bronze Age of China: An Exhibition from the People's Republic of China.* Exh. cat. New York: Metropolitan Museum of Art, 1980.

Fong, Wen C., et al. *Possessing the Past: Treasures from the National Palace Museum, Taipei.* Exh. cat. New York: Metropolitan Museum of Art; Taipei: National Palace Museum, 1996.

Fontein, Jan. "Lost and Found: A Painting of a Lohan by Chao Ch'iung." In *Sung Studies—Études Song— In Memoriam Étienne Balazs,* edited by Françoise Aubin. Series 2: *Civilisation* 2, 189–200. Paris: École des Hautes Études en Sciences Sociales, 1980.

Fontein, Jan, and Money L. Hickman. *Zen Painting and Calligraphy.* Exh. cat. Boston: Museum of Fine Arts, 1970.

Ford, Henry. "Mass Production." In *Encyclopaedia Britannica* (1947).

Forte, Antonino, and Jacques May. "Chôsai." *Hôbôgirin* 5 (1979): 392–406.

Foucault, Michel. *The Order of Things: An Archaeology of the Human Sciences.* New York: Vintage Books, 1970.

Franke, Herbert. *Kulturgeschichtliches über die chinesische Tusche,* Bayrische Akademie der Wissenschaften, Philosophisch-Historische Klasse, Abhandlungen, new series 14. Munich: Beck Verlag, 1962.

Franklin, Ursula Martius. "The Beginnings of Metallurgy in China: A Comparative Approach." In *The Great Bronze Age of China: A Symposium,* edited by George Kuwayama (*q.v.*), 94–99.

———. "On Bronze and Other Metals in Early China." In *The Origins of Chinese Civilization,* edited by David N. Keightley, 279–96. Berkeley: University of California Press, 1983.

Fraser, Sarah E. "Régimes of Production: The Use of Pounces in Temple Construction." *Orientations* 27, no. 10 (Nov. 1996): 60–69.

Freestone, I. C., Nigel Wood, and Jessica Rawson. "Shang Dynasty Casting Moulds from North China." In *Cross-Craft and Cross-Cultural Interactions in Ceramics,* edited by Patrick E. McGovern, Ceramics and Civilization 4, 253–73. Westerville, Ohio: American Ceramic Society, 1989.

Fu, Shen C. Y. *Traces of the Brush: Studies in Chinese Calligraphy.* New Haven: Yale University Art Gallery, 1977.

———, with major contribs. and trans. by Jan Stuart. *Challenging the Past: The Paintings of Chang Dai-chien.* Washington, D.C.: Arthur M. Sackler Gallery, 1991.

Fu Xinian, "Survey: Chinese Traditional Architecture." In Nancy Shatzman Steinhardt et. al., *Chinese Traditional Architecture* (q.v.), 9–45.

Fuchs, Walter. "Der Kupferdruck in China vom 10. bis. 19. Jahrhundert." *Gutenberg-Jahrbuch* (1950): 67–85.

Fujiwara Sosui. *Shofu, soku shofu no kenkyû* (A study of the *Shupu* and the *Xu shupu*). 2 vols. Tokyo: Seishin shobô, 1973.

von Gabain, Annemarie. "Ksitigarbha-Kult in Zentralasien: Buchillustrationen aus den Turfan-Funden." In *Indologentagung* (1971), edited by Herbert Härtel and Volker Moeller, 47–71. Wiedbaden: Franz Steiner Verlag, 1973.

Giès, Jacques, et al. *Les arts de l'Asie Centrale: La collection Paul Pelliot du Musée National des Arts Asiatiques—Guimet.* 2 vols. Paris: Kodansha and Réunion des musées nationaux, 1995.

Giles, Lionel. *An Alphabetical Index to the Chinese Encyclopaedia.* London: British Museum, 1911.

Girmond, Sybille. "Die Porzellanherstellung in China, Japan, und Europa: Historische und technische Details." In *Porzellan aus China und Japan: Die Porzellangalerie der Landgrafen von Hessen-Kassel,* edited by Ulrich Schmidt (q.v.), 107–42.

———. "Chinesische Bilderalben zur Papierherstellung: Historische und stilistische Entwicklung der Illustrationen von Produktionsprozessen in China von den Anfängen bis ins 19. Jahrhundert." In Wolfgang Schlieder et al., *Chinesische Bambuspapierherstellung: Ein Bilderalbum aus dem 18. Jahrhundert,* 18–38. Berlin: Akademie Verlag, 1993.

Glahn, Else. "On the Transmission of the *Ying-tsao fa-shih.*" *T'oung Pao* 61 (1975): 232–65.

———. "Chinese Building Standards in the 12th Century." *Scientific American* 244, no. 5 (May 1981): 162–73.

———. "Research on the *Ying-tsao fa-shih.*" In Nancy Shatzman Steinhardt et. al., *Chinese Traditional Architecture* (q.v.), 47–57.

Goepper, Roger, et al. *Das Alte China: Menschen und Götter im Reich der Mitte 5000 v.Chr.–220 n.Chr.* Edited by Kulturstiftung Ruhr, Essen. Exh. cat. Munich: Hirmer, 1995.

le Goff, Jacques. *La naissance du purgatoire.* Paris: Gallimard, 1981. *The Birth of Purgatory,* translated by Arthur Goldhammer. Chicago: University of Chicago Press, 1984.

Gould, Stephen Jay. *Eight Little Piggies: Reflections in Natural History.* New York: W. W. Norton, 1993.

Gridley, Marion Leidig. "Chinese Buddhist Sculpture under the Liao: Free-Standing Works in situ and Selected Examples from Public Collections." Ph.D. diss. 1985. University of Kansas. Ann Arbor, Mich.: University Microfilms, 1985.

Guangzhoushi wensu guanli weiyuanhi et al., eds., *Xi Han Nan Yue wang mu* (The Western Han tomb of the king of Nan Yue). 2 vols. Beijing: Wenwu Press, 1991.

Gujin tushu jicheng (Synthesis of books and illustrations, past and present). Compiled by Chen Menglei (1651–after 1723). Reprint. N.p.: Zhonghua shuju, 1934–39.

Guo Baojun. *Shang Zhou tongqiqun zonghe yanjiu* (A comprehensive study of the Shang and Zhou bronze vessel group). Beijing: Wenwu Press, 1981.

Guo Daiheng. "Lun Zhongguo gudai mugou jianzhu de moshu zhi" (Modular systems in traditional Chinese timber architecture). In *Jianzhushi lunwenji* 5, edited by Qinghua daxue jianzhuxi, 31–47. Beijing: Qinghua daxue Press, 1981.

Guo Daiheng and Xu Baian. "Zhongguo gudai mugou jianzhu" (Traditional Chinese timber architecture). In *Jianzhushi lunwenji* 3, edited by Qinghua daxue jianzhuxi, 16–72. Beijing: Qinghua daxue Press, 1979.

———. "Song *Yingzao fashi* shuyu huishi" (Assorted explanations of technical terms in the Song-dynasty *Yingzao fashi*). In *Jianzhushi lunwenji* 6, edited by Qinghua daxue jianzhuxi, 1–79. Beijing: Qinghua daxue Press, 1984.

Guo, Qinghua. "The Structure of Chinese Timber Architecture: Twelfth-Century Design Standards and Construction Principles." Ph.D. diss. Chalmers University of Technology, Gothenburg, Sweden, 1995.

Guy, R. Kent. *The Emperor's Four Treasures: Scholars and the State in the Late Ch'ien-lung Era.* Cambridge: Harvard University Press, 1987.

du Halde, Jean Baptiste. *Déscription géographique, historique, chronologique, politique, et physique de l'empire de la Chine et de la Tartarie Chinoise.* 4 vols. Paris, 1735–39. Translated by Richard Brookes. London: B. Dod, 1741.

Han Wei. "Fengxiang Qingong lingyuan zuantan yu shijue jianbao" (Brief report on probings and trial excavations at the necropolis of the Qin royalty at Fengxiang). *Wenwu* 7 (1983): 30–37.

Han Wei and Jiao Nanfeng. "Qindu Yongcheng kaogu fajue yanjiu zongshu" (General account of research on the excavations of the Qin capital Yong). *Kaogu yu wenwu* (1988, vols. 5–6): 111–26.

Harrist, Robert E., Jr. "The Artist as Antiquarian: Li Gonglin and His Study of Early Chinese Art." *Artibus Asiae* 55 (1995): 237–80.

Hay, John, ed. *Boundaries of China.* London: Reaction Books, 1994.

Hayashi Minao. *In Shû jidai seidôki no kenkyû* (Research on bronze vessels of the Yin and Zhou periods), *In Shû seidôki sôran* (Conspectus of Yin and Zhou bronzes), vol. 1 of 2. Tokyo: Yoshikawa Kôbunkan, 1984.

———. *In Shû jidai seidôki monyô no kenkyû* (Research on decor patterns on bronze vessels of the Yin and Zhou periods), *In Shû seidôki sôran* (Conspectus of Yin and Zhou bronzes), vol. 2 of 2. Tokyo: Yoshikawa Kôbunkan, 1986.

———. "Concerning the Inscription 'May Sons and Grandsons Eternally Use This [Vessel]'." *Artibus Asiae* 53 (1993): 51–58.

Hayden, George A. "The Legend of Judge Pao: From the Beginnings through the Yüan Drama." In *Studia Asiatica: Essays in Asian Studies in Felicitation of the Seventy-Fifth Anniversary of Professor Ch'en Shou-yi,* Chinese Materials and Research Aids Center, Occasional Series 29, 339–55. San Francisco: Chinese Materials Center, 1975.

He Yanzhi (8th century). *Lantingji* (*Record on the* Orchid Pavilion Preface). Reprint. In Zhang Yanyuan, comp. *Fashu Yaolu* (q.v.) 3.

Heijdra, Martin, and Cao Shuwen. "The World's Earliest Extant Book Printed from Wooden Movable Type?" *Gest Library Journal* 5, no. 1 (spring 1992): 70–89.

Helliwell, David. "Two Collections of Nineteenth-Century Protestant Missionary Publications in Chinese in the Bodleian Library." *Chinese Culture* 31, no. 4 (Dec. 1990): 21–38.

Henan sheng wenwuju wenwu gongzuo dui. "Zhengzhou Nanguan 159 hao Hanmu de fajue" (Excavation of Han tomb no. 159 at Zhengzhou, Nanguan). *Wenwu* (1960, vols. 8–9): 19–24.

Heuser, Robert. "Verwaltung und Recht im Reich des Ersten Kaisers." In *Jenseits der Großen Mauer,* edited by Ledderose and Schlombs (q.v.), 66–75.

Höllmann, Thomas O. *Neolithische Gräber der Dawenkou-Kultur in Ostchina,* Materialien zur Allgemeinen und Vergleichenden Archäologie 2. Munich: C. H. Beck, 1983.

Hölscher, Tonio. *Öffentliche Räume in frühen griechischen Städten,* Schriften der Philosophisch-Historischen Klasse der Heidelberger Akademie der Wissenschaften 7. Heidelberg: Universitätsverlag C. Winter, 1998.

Hou Renzhi, ed. *Beijing lishi dituji* (Collection of maps on the history of Beijing). Beijing: Beijing Press, 1988.

Hounshell, David A. *From the American System to Mass Production, 1800–1932: The Development of Manufacturing Technology in the United States.* Baltimore: Johns Hopkins University Press, 1984.

Howard, David, and John Ayers. *China for the West: Chinese Porcelain and Other Decorative Arts for Export Illustrated from the Mottahedeh Collection.* 2 vols. London, New York: Sotheby Parke Bernet, 1978.

Hsü, Ginger Cheng-chi. "Merchant Patronage of Eighteenth-Century Yangzhou Painting." In *Artists and Patrons: Some Social and Economic Aspects of Chinese Painting,* edited by Chu-tsing Li, 215–21. Lawrence: University of Kansas, 1989.

———. "Zheng Xie's Price List: Painting as a Source of Income in Yangzhou." In *Chinese Painting under the Qianlong Emperor,* edited by Ju-hsi Chou and Claudia Brown. *Phoebus: A Journal of Art History* 6, no. 2 (1991): 261–71.

———. "Incarnations of the Blossoming Plum." *Ars Orientalis* 26 (1996): 23–45.

———. *A Bushel of Pearls: Painting for Sale in Eighteenth-Century Yangchou.* Stanford, Calif.: Stanford University Press, [forthcoming].

Hua Jueming et al. "Fu Hao mu qingtongqi qun zhuzao jishu de yanjiu" (Research on the casting technique of the group of bronze vessels from Fu Hao's tomb). *Kaoguxue jikan* 1 (1981): 244–72.

Huang Binhong and Deng Shi, eds. *Meishu congshu* (Collectanea on art). 30 vols. Taipei: Yiwen Press, 1975.

Huang Zhanyue. "Xian Sanqiao Gaoyaocun Xi Han tongqi qun mingwen bushi" (Supplementary explanations of the inscriptions on the group of Western Han bronzes from Xian City, Sanqiao, Gaoyaocun). *Kaogu* (1963, vol. 4): 198–201.

Hubei sheng bowuguan, ed. *Zeng hou Yi mu* (The tomb of Marquis Yi of Zeng). 2 vols. Beijing: Wenwu Press, 1989.

Huber, Louisa G. Fitzgerald. "Some Anyang Royal Bronzes: Remarks on Shang Bronze Decor." In *The Great Bronze Age of China: A Symposium,* edited by George Kuwayama (*q.v.*), 16–43.

Hulsewé, A. F. P. *Remnants of Ch'in Law: An Annotated Translation of the Ch'in Legal and Administrative Rules of the 3rd Century B.C. Discovered in Yün-meng Prefecture, Hu-pei Province in 1975.* Leiden: Brill, 1985.

Hunan sheng bowuguan and Zhongguo kexueyuan kaogu yanjiusuo, eds. *Changsha Mawangdui yi hao Han mu* (Han-dynasty tomb no. 1 at Mawangdui, Changsha). 2 vols. Beijing: Wenwu Press, 1973.

Hundt, Hans-Jürgen. "Über vorgeschichtliche Seidenfunde." *Jahrbuch des Römisch-Germanischen Zentralmuseums Mainz* 16 (1969): 59–71.

Hunter, Sam. *Jackson Pollock.* Museum of Modern Art, New York, *Bulletin* 24, no. 2 (1956–57).

Ide Seinosuke. "Riku Shinchû kô: Nehan hyôgen no henyô" (On Lu Xinzhong: Historical changes in nirvana painting). *Bijutsu Kenkyû* part 1: 354 (Sept. 1992): 77–92; part 2: 355 (Jan. 1993): 156–58.

Institute of Archaeology of Shanxi Province. *Art of the Houma Foundry.* (English preface by Robert Bagley). Princeton: Princeton University Press, 1996.

Jenyns, Soame. *Later Chinese Porcelain: The Ch'ing Dynasty (1644–1912).* London: Faber and Faber, 1971.

Jörg, Christian J. A. *Porcelain and the Dutch China Trade.* The Hague: Martinus Nijhoff, 1982.

———. *The Geldermalsen: History and Porcelain.* Groningen: Kemper, 1986.

———. "Chinese Porcelain for the Dutch in the Seventeenth Century: Trading Networks and Private Enterprises." In *The Porcelains of Jingdezhen,* edited by Rosemary E. Scott (*q.v.*), 183–205.

Julien, Stanislas. "Documents sur l'art d'imprimer á l'aide de planches en bois, de planches en pierre, et de types mobiles, inventé en Chine bien longtemps avant que l'Europe en fit usage; extraits des livres Chinois." *Journal Asiatique* series 4, vol. 9 (1847): 505–34.

Julien, Stanislas, and Paul Champion. *Industries anciennes et modernes de l'empire chinois.* Paris: Jean Maisonneuve, 1869.

Kaishien gaden (Mustard Seed Garden manual of painting), *Shoshû: Sansui juseki* (part 1: Landscapes, trees, and rocks). Translated by Aoki Masaru; commentary by Iriya Yoshitaka. 2 vols. Kyoto: Chikuma shobô, 1975.

Kajitani Ryōji. "Riku Shinchū hitsu jūōzu" (The ten kings painted by Lu Xinzhong). *Kokka* 1020 (Feb. 1979): 22–38.

Kan, Itsu Ei hi (The stele of Yi Ying from the Han dynasty). *Shoseki meihin sōkan* 2, no. 49. Tokyo: Nigensha, 1965.

Karlbeck, Orvar. "Anyang Moulds." *Bulletin of the Museum of Far Eastern Antiquities* 7 (1935): 39–60.

Karlgren, Bernhard. "Notes on the Grammar of Early Bronze Décor." *Bulletin of the Museum of Far Eastern Antiquities* 23 (1951), 1–80.

———. *A Catalogue of the Chinese Bronzes in the Alfred F. Pillsbury Collection.* Minneapolis: University of Minnesota Press, 1952.

Kasuga gongen genki-e (Illustrated record of the miracles of the Kasuga deity), Nihon emakomono zenshu 15. Tokyo: Kadokawa shoten, 1963.

Kawahara Yoshio. "Tonkôga Jizôzu shiryô." (Material of Jizô paintings in Dunhuang). *Bukkyô geijutsu* 97 (July 1974): 99–123.

Kawakami Kei and Toda Teisuke. *Torai kaiga* (Painting from overseas), Nihon kaigakan 12. Tokyo: Kôdansha, 1971.

Keightley, David N. *Sources of Shang History: The Oracle Bone Inscriptions of Bronze Age China.* Berkeley: University of California Press, 1978.

———. "Archaeology and Mentality: The Making of China." *Representations* 18 (spring 1987): 91–128.

———. "Early Civilization in China: Reflections on How it Became Chinese." In *Heritage of China: Contemporary Perspectives on Chinese Civilization,* edited by Paul S. Ropp, 15–54. Berkeley: University of California Press, 1990.

Kerr, Rose. *Later Chinese Bronzes,* Victoria and Albert Museum Far Eastern Series. London: Bamboo Publishing, 1990.

Kesner, Ladislav. "The Taotie Reconsidered: Meanings and Functions of Shang Theriomorphic Imagery." *Artibus Asiae* 51 (1993): 29–53.

———. "Likeness of No One: (Re)presenting the First Emperor's Army." *Art Bulletin* 77, no. 1 (March 1995): 115–32.

Keyser, Barbara. "Decor Replication in Two Late Chou Bronze Chien." *Ars Orientalis* 11 (1979): 127–62.

Kim Kan [Jin Jian]. [Qinding] *Wuyingdian juzhenban chengshi* ([Imperially approved] manual of the imperial printing office of the Hall of Martial Eminence for printing with movable type). 1777. In Huang Binhong and Deng Shi, eds. *Meishu congshu* (q.v.), part 3, section 8, 149–78.

Kim, Tujong. *Han'guk ko inswae kisulsa* (History of ancient printing technology in Korea). Seoul: Tamgudang, 1981.

Kingery, W. David, and Pamela B. Vandiver. *Ceramic Masterpieces: Art, Structure, Technology.* New York: Free Press, 1986.

Kolb, Raimund Theodor. *Die Infanterie im Alten China: Ein Beitrag zur Militärgeschichte der Vor-Zhan-Guo-Zeit,* Materialien zur allgemeinen und vergleichenden Archäologie 43. Mainz: Philipp von Zabern, 1991.

Kraatz, Martin, et al., eds. *Das Bildnis in der Kunst des Orients.* Abhandlungen für die Kunde des Morgenlandes 50, no. 1. Stuttgart: Franz Steiner Verlag, 1990.

Kracke, E. A., Jr. *Civil Service in Early Sung China, 960–1067,* Harvard-Yenching Institute Monograph Series 13. Cambridge: Harvard University Press, 1953.

Krahl, Regina, with Nurdan Erbahar. *Chinese Ceramics in the Topkapi Saray Museum, Istanbul: A Complete Catalogue.* 3 vols. London: Sotheby's, 1986.

Kristeller, Paul Oskar. "The Modern System of the Arts." In Paul Oskar Kristeller, *Renaissance Thought and the Arts.* Princeton: Princeton University Press, 1990.

Kuhn, Dieter. "The Silk Workshops of the Shang Dynasty." In *Explorations in the History of Science and Technology in China: Compiled in Honour of the Eightieth Birthday of Dr. Joseph Needham, FRS, FBA,* edited by Li Guohao et al., 369–408. Shanghai: Shanghai Chinese Classics Publishing House, 1982.

———. *Textile Technology: Spinning and Reeling*. In Joseph Needham, *Science and Civilisation in China,* vol. 5, part 9. Cambridge: Cambridge University Press, 1988.

———. "Silk Weaving in Ancient China: From Geometric Figures to Patterns of Pictorial Likeness." (Festschrift Nathan Sivin, 1995). *Chinese Science* 12: 77–114.

———. "Where Did the Roads Meet?" *T'oung Pao* 83 (1997): 174–90.

———, ed. *Chinas Goldenes Zeitalter: Die Tang-Dynastie (618–906 n.Chr.) und das kulturelle Erbe der Seidenstraße*. Exh. cat. Heidelberg: Edition Braus, 1993.

Kumagai Norio. "Kyûshu shozai tairiku denrai no butsuga" (Buddhist paintings from the mainland preserved in Kyûshu). *Bukkyô geijutsu* 76 (July 1970): 33–48.

Kundaikan sōchōki (Complete inventory of the Shōgun collection). In Wada Toshihiko, ed. *Gadôshû. (Dai nippon bunko: Geidôhen)*, 17–31. Tokyo: Shunyôdô shoten, 1938.

Kuno Takeshi and Suzuki Kakichi, eds. *Hôryûji, Genshoku nihon no bijutsu* (The arts of Japan in color) 2. Tokyo: Shôgakkan, 1966.

Kuwayama, George, ed. *The Great Bronze Age of China: A Symposium*. Los Angeles: Los Angeles County Museum of Art, 1983.

Lach, Donald F. *Asia in the Making of Europe*. 3 vols. Chicago: University of Chicago Press, 1965–93.

Lau, Christine. "Ceremonial Monochrome Wares of the Ming Dynasty." In *The Porcelains of Jingdezhen*, edited by Rosemary E. Scott (*q.v.*), 83–100.

Lawton, Thomas. *Chinese Figure Painting*. Exh. cat. Washington, D.C.: Smithsonian Institution, 1973.

———. "An Imperial Legacy Revisited: Bronze Vessels from the Qing Palace Collection." *Asian Art* 1, no. 1 (1987–88): 50–59.

———. "Jin Futing: A 19th-Century Chinese Collector-Connoisseur." *Transactions of the Oriental Ceramic Society* 54 (1989–90): 35–61.

———. "Rubbings of Chinese Bronzes." *Bulletin of the Museum of Far Eastern Antiquities* 67 (1996): 7–48.

———. "Rong Geng and the Qing Imperial Bronze Collection: Scholarship in Early Twentieth-Century China." *Apollo* (March 1997): 10–16.

———, ed. *New Perspectives on Chu Culture during the Eastern Zhou Period*. Washington, D.C.: Arthur M. Sackler Gallery, Smithsonian Institution, 1991.

von LeCoq, Albert. *Die Buddhistische Spätantike in Mittelasien,* part 4: *Atlas zu den Wandmalereien und beschreibender Text zum Atlas*. Berlin: D. Reimer, 1924.

Ledderose, Lothar. "Der politische und religiöse Charakter der Palastsammlungen im chinesischen Altertum." In *Zur Kunstgeschichte Asiens: 50 Jahre Lehre und Forschung an der Universität Köln,* edited by Roger Goepper et al, 153–59. Wiesbaden: Franz Steiner Verlag, 1977.

———. "Some Observations on the Imperial Art Collection in China." *Transactions of the Oriental Ceramic Society* 43 (1978–79): 33–46.

———. *Mi Fu and the Classical Tradition of Chinese Calligraphy*. Princeton: Princeton University Press, 1979.

———. "A King of Hell." In *Suzuki Kei sensei kanreki kinen Chûgoku kaigashi ronshû* (Festschrift for Professor Suzuki Kei: Collected Articles on the History of Chinese Painting), 31–42. Tokyo: Yoshikawa kôbunkan, 1981.

———. "Kings of Hell." In *Zhongyang yanjiuyuan guoji hanxue huiyi lunwenji: Yishushi zu* (Proceedings of the international conference on Sinology: Section on art history), 191–219. Taipei: Academia Sinica, 1981.

———. "Some Taoist Elements in the Calligraphy of the Six Dynasties." *T'oung Pao* 70 (1984): 246–78.

———. "Chinese Calligraphy: Its Aesthetic Dimension and Social Function." *Orientations* 17, no. 10 (Oct. 1986): 35–50.

———. "Modul und Serie in der chinesischen Kunst." *Jahrbuch der Heidelberger Akademie der Wissenschaften für 1989* (1990): 72–74.

————. "Ein Programm für den Weltuntergang: Die steinerne Bibliothek eines Klosters bei Peking." *Heidelberger Jahrbücher* 36 (1992): 15–33.

————. "Zimu yu daliang shengchan" (Module and mass production). In *International Colloquium on Chinese Art History 1991.*In *Proceedings: part 2: Painting and Calligraphy,* edited by National Palace Museum, 821–47. Taipei: National Palace Museum, 1992.

————. "Qualitätskontrolle im Alten China." In *Markt und Macht in der Geschichte,* edited by Helga Breuninger and Rolf Peter Sieverle, 239–64. Stuttgart: Deutsche Verlagsanstalt, 1995.

————. "Calligraphy at the Close of China's Empire." In *Art at the Close of China's Empire,* edited by Ju-hsi Chou, 189–207. Phœbus, Occasional Papers in Art History 8. N.p.: Arizona State University, 1998.

————. *Orchideen und Felsen: Chinesische Bilder im Museum für Ostasiatische Kunst, Berlin.* Berlin: G-und-H-Verlag, 1998.

Ledderose, Lothar, and Adele Schlombs, eds. *Jenseits der Großen Mauer: Der Erste Kaiser von China und seine Terrakotta-Armee.* Exh. cat. Gütersloh and Munich: Bertelsmann Lexikon Verlag, 1990.

Legge, James, trans. *The Li Ki,* Sacred Books of the East 27–28. 2 vols. Oxford, Eng.: Clarendon Press, 1885.

Lentz, Thomas W., and Glenn D. Lowry. *Timur and the Princely Vision: Persian Culture in the Fifteenth Century.* Exh. cat. Los Angeles: Los Angeles County Museum of Art; Washington, D.C.: Arthur M. Sackler Gallery, 1989.

Lewis, Mark Edward. *Sanctioned Violence in Early China.* Albany: State University of New York Press, 1990.

Li, Chi. *Anyang.* Folkstone: Dawson, 1977.

Li Chi, ed. *Hou Chia Chuang (Houjiazhuang)* (The Yin-Shang cemetery site at Anyang, Honan), vol. 5: *Xibeigang mu 1004* (Tomb no. 1004 at Xibeigang). Taipei: Academia Sinica, Institute of History and Philology, 1970.

Li, Chu-tsing. *Trends in Modern Chinese Painting: The C. A. Drenowatz Collection,* Artibus Asiae Supplementum 36. Ascona: Artibus Asiae, 1979.

Li Hongqi. "Songdai guanyuanshu de tongji" (Calculations on the numbers of Song-dynasty officials). Songshi yanjiuji 18, edited by Song Xi, 79–104. Taipei: Guoli bianyiguan, 1988.

Li Ji and Wan Jiabao. *Yinxu chutu qingtong gu xingqi zhi yanjiu* (Studies of the bronze *ku*-beaker excavated from Hsiao T'un and Hou Chia Chuang), Zhongguo kaogu baogaoji xinbian, Gu qiwu yanjiu zhuankan, Archaeologica Sinica new series 1. Edited by Li Ji et al. Taipei: Zhongyang yanjiuyuan lishi yuyan yanjiusuo, 1964.

Li Jie (d. 1110). *Li Mingzhong* Yingzao fashi (*Building Standards* by Li Mingzhong). 1103. Reprint. N.p.: Zhuanjing shushe, 1925.

Li Lina. *Huazhong jiaju tezhan* (Special exhibition of furniture in paintings). Exh. cat. Taipei: Guoli gugong bowuyuan, 1996.

Li, Xueqin. *Eastern Zhou and Qin Civilizations.* Translated by K. C. Chang. New Haven: Yale University Press, 1985.

Li Yuming, ed. *Shanxi gu jianzhu tonglan* (A panorama of ancient Chinese architecture in Shanxi). Taiyuan: Shanxi renmin Press, 1986.

Liang Sicheng. "Ji Wutaishan Foguangsi jianzhu" (Recording the architecture of the Foguang monastery on Mount Wutai), *Zhongguo yingzao xueshi huikan* 7, no. 1 (1937): 13–61. Reprints: *Wenwu cankao ziliao* 5–6 (1953), 80–123; and *Liang Sicheng wenji* (Collected articles of Liang Sicheng), vol. 2, 177–218. Beijing: Zhongguo jianzhu gongye Press, 1984.

————. "Tangzhaotisi jingtang yu Zhongguo Tangdai jianzhu" (The Golden Hall of Tôshôdai-ji and Chinese Tang-dynasty architecture). In *Liang Sicheng wenji* (Collected articles of Liang Sicheng), vol. 4, 290–314. Beijing: Zhongguo jianzhu gongye Press, 1980.

————. *Qingshi yingzao zeli* (Qing-dynasty standard building regulations). Beijing: Zhongguo jianzhu gongye Press, 1981.

———. Yingzao fashi *zhushi* (Translation and commentary on *Building Standards*). Beijing: Zhongguo jianzhu gongye Press, 1983.

——— [Liang, Ssu-ch'eng]. *A Pictorial History of Chinese Architecture: A Study of the Development of Its Structural System and the Evolution of Its Types.* Edited by Wilma Fairbank. Cambridge: MIT Press, 1984.

Lin, Chunmei. "Lack und Lackverwendung im frühen China." In *Entwicklung und Erprobung von Konservierungstechnologien für Kunst- und Kulturgüter der Provinz Shaanxi/VR China, Jahresbericht 1993,* 41–45. Munich: Bayrisches Landesamt für Denkmalpflege, 1993.

Ling Chunsheng. "Shupibu yinhua yu yinshuashu faming" (Decorative prints on barkcloth and the invention of printing). *Bulletin of the Institute of Ethnology, Academia Sinica* 14 (autumn 1962): 193–214 (Chinese); 215–28 (English). Reprinted as chapter 5 in: Ling Chunsheng. *Shupibu yinwentao yu zaozhi yinshuashu faming* (Barkcloth, impressed pottery, and the inventions of paper and printing), Institute of Ethnology, Academia Sinica Monographs 3, 87–122. Nangang-Taipei: Institute of Ethnology, Academia Sinica, 1963.

———. "Yinwentao de huawen ji wenzi yu yinshuashu faming" (Designs and inscriptions on impressed pottery and the invention of printing). *Bulletin of the Institute of Ethnology, Academia Sinica* 15 (spring 1963): 1–47 (Chinese); 48–63 (English). Reprinted as chapter 6 in Ling Chunsheng, *Shupibu yinwentao yu zaozhi yinshuashu faming* (Barkcloth, impressed pottery, and the inventions of paper and printing), Institute of Ethnology, Academia Sinica Monographs 3, 123–85. Nangang-Taipei: Institute of Ethnology, Academia Sinica, 1963.

Lippe-Biesterfeld, Ernst Aschwin Prinz zur. "Li K'an und seine 'Ausführliche Beschreibung des Bambus': Beiträge zur Bambusmalerei der Yüan-Zeit." *Ostasiatische Zeitschrift,* new series 18 (1942–43): 1–35, 83–114, 166–83.

Liu Boqing. *Liu ti Xuanmita biaozhun xizi tie* (Sheet for practicing characters according to the standard of Liu Gongquan's style in his Xuanmi pagoda inscription). Beijing: Beijing Press, 1962.

Liu Chunhua and Song Guangsen, eds. *Xu Beihong huaji* (Paintings by Xu Beihong). See *Xu Beihong huaji.*

Liu Dunzhen. "Beiping Zhihuasi rulaidian diaochaji" (Record on the investigation of the Tathagata hall in Zhihua monastery in Beiping). *Zhongguo yingzao xueshi huikan* 3, no. 3 (1932): 1–70. Reprinted in *Liu Dunzhen wenji* (Collected articles of Liu Dunzhen) 1, 61–128. Beijing: Zhongguo jianzhu gongye Press, 1982.

———. "Ming Changling" (The Changling mausoleum of the Ming dynasty). *Zhongguo yingzao xueshi huikan* 4, no. 2 (1933): 42–59. Reprinted in *Liu Dunzhen wenji* (Collected articles of Liu Dunzhen) 1, 261–86. Beijing: Zhongguo jianzhu gongye Press, 1982.

———. *Zhongguo gudai jianzhu shi* (History of ancient Chinese architecture). 2nd ed. Beijing: Zhongguo jianzhu gongye Press, 1984.

Liu Laicheng et al. *Zhanguo xianyu lingmu gizhen: Heibei Pingshan Zhongshan guowang mu* (Rarities from the necropolis of the state Xianyu in the Warring States period: The tomb of the king of Zhongshan in Pingshan, Heibei Province). In *Zhongguo kaogu wenwu zhi mei* (*q.v.*), vol. 6.

Liu Yunhui. "Lishan tukao" (Investigation about the corvée laborers at Mount Li). *Wenbo* 1985, no. 1, 52–54. Reprinted in Yuan Zhongyi, ed. *Qin Shihuangling bingmayong bowuguan lunwen xuan* (*q.v.*), 401–407.

Liu Zhiping and Fu Xinian. "Lindedian fuyuan de chubu yanjiu" (Preliminary research on the reconstruction of the Linde hall). *Kaogu* (1963, no. 7): 385–402.

Loehr, Max. "Beiträge zur Chronologie der älteren chinesischen Bronzen." *Ostasiatische Zeitschrift,* new series 12 (1936): 3–41.

———. "The Bronze Styles of the Anyang Period." *Archives of the Chinese Art Society of America* 7 (1953): 42–53.

———. *Ritual Vessels of Bronze Age China.* New York: Asia Society, 1968.

Loewe, Michael. "The Orders of Aristocratic Rank of Han China." *T'oung Pao* 48 (1960): 97–174.

———. "Yen t'ieh lun." In *Early Chinese Texts,* edited by Michael Loewe (*q.v.*), 477–82.

————, ed. *Early Chinese Texts: A Bibliographical Guide.* Early China Special Monograph Series 2. Berkeley: Society for the Study of Ancient China, 1993.

Lū Liedan. "Nan Yue wang mu chutu de qingtong yinhua tuban" (Relief bronze pattern stamps excavated from the tomb of the king of Nan Yue). *Kaogu* (1989, no. 2): 138, 178–79.

Ma, Chengyuan. *Ancient Chinese Bronzes.* Hong Kong: Oxford University Press, 1986.

Mai Yinghao and Huang Zhanyue. *Lingnan Xi Han wenwu baoku: Guangzhou Nan Yue wang mu* (A treasure trove of cultural relics from the Western Han dynasty in Lingnan: the tomb of the king of Nan Yue at Guangzhou). In *Zhongguo kaogu wenwu zhi mei* (*q.v.*), vol. 9.

Mainichi shinbun kokuhô iinkai, ed. *Kokuhô* (National treasures of Japan). 6 vols. Tokyo: Mainichi shinbunsha, 1963–67.

Mänchen-Helfen, Otto. "Zur Geschichte der Lackkunst in China." *Wiener Beiträge zur Kunst- und Kulturgeschichte Asiens* 11 (1937): 32–64.

Marr, David. *Vision: A Computational Investigation on the Human Representation and Processing of Visual Information.* New York: W. H. Freeman, 1982.

Masterpieces of Chinese Painting in the National Palace Museum. Taipei: National Palace Museum, 1970.

Masterpieces of Chinese Portrait Painting in the National Palace Museum. Taipei: National Palace Museum, 1971

Matsumaru Michio (Songwan Daoxiong). "Shishuo Yin Zhou jinwen de zhizuo fangfa" (Tentative remarks on the method of making bronze inscriptions in the Yin and Zhou periods). *Gugong wenwu yuekan* 101 (1991, no. 8): 110–19.

Matsumoto Eiichi. *Tonkôga no kenkyû* (Research on paintings from Dunhuang). Tokyo: Tôhô bunka gakuin, 1937.

————. " 'Kata' ni yoru zôzô" (The modeling of Buddhist images by the use of moulds). *Bijutsu kenkyû* 156 (1950): 1–15.

[Mayer Collection]. *The Frederick M. Mayer Collection of Chinese Art.* Auction catalog. London: Christie's, June 24–25, 1974.

McKendrick, Neil. "Josiah Wedgwood and Factory Discipline." *The Historical Journal* 4 (1961): 30–55.

Medley, Margaret. "Organisation and Production at Jingdezhen in the Sixteenth Century." In *The Porcelains of Jingdezhen,* edited by Rosemary E. Scott (*q.v.*), 69–82.

Mochizuki Shinkô. *Bukkyô daijiten* (Great dictionary of Buddhism). 10 vols. 3rd ed. Tokyo: Sekai seiten kankô kyôkai, 1958–63.

Müller-Karpe, Hermann. "Das Grab der Fu Hao von Anyang." In *Beiträge zur allgemeinen und vergleichenden Archäologie* 1, edited by Hermann Müller-Karpe, 31–68. Munich: C. H. Beck, 1979.

Mungello, David E. *Curious Land: Jesuit Accommodation and the Origins of Sinology,* Studia Leibnitiana Supplementa 25. Wiesbaden: Franz Steiner Verlag, 1985.

Murray, Oswyn. *Early Greece,* Cambridge: Harvard University Press, 1993.

The Nanking Cargo: Chinese Export Porcelain and Gold, European Glass, and Stoneware. Auction catalog. Amsterdam: Christie's, 1986.

Nara no jiin to tempyô chôkoku (Temples in Nara and the sculpture of the Tempyô period), Genshoku nihon no bijutsu 3. Edited by Asano Kiyoshi and Mori Hisashi. Tokyo: Shôgakkan, 1966.

Nara rokudaiji taikan kankôkai, ed. *Nara rokudaiji taikan* (Conspectus of the six great temples of Nara). 14 vols. Tokyo: Iwanami shoten, 1967–73.

Naraken bunkazai hozon jimusho, ed. *Kokuhô Hokkiji sanjûtô shûri kôji hôkokusho* (Report on the restoration work of the national treasure three-storied Hokkiji pagoda). Nara: Naraken kyôiku iinkai, 1976.

Needham, Joseph. *Science and Civilisation in China,* vol. 4: *Physics and Physical Technology;* part 2: *Mechanical Engineering.* Cambridge: Cambridge University Press, 1965.

———. *Science and Civilisation in China,* vol. 4: *Physics and Physical Technology,* part 3: *Civil Engineering and Nautics.* Cambridge: Cambridge University Press, 1971.

Nelson, Robert S. "The Map of Art History." *Art Bulletin* 79, no. 1 (March 1997): 28–40.

Nelson, Susan E. "Three Ch'ing Critics on Yuan Painting and the Ideal of Spontaneity." *Journal of the American Oriental Society* 106, no. 2 (1986): 297–306.

Nezu Kaichiro, ed. *Seizansô seishô* (Illustrated catalog of the Nezu collection). 10 vols. Tokyo: Benrido, 1940–43.

Ogawa, Hiromitsu. "The Relationship between Landscape Representations and Self-Inscriptions in the Works of Mi Yu-jen." In *Words and Images: Chinese Poetry, Calligraphy, and Painting,* edited by Alfreda Murck and Wen C. Fong, 123–40. New York: Metropolitan Museum of Art; Princeton: Princeton University Press, 1991.

———. "Sô Gen sansuiga ni okeru kôsei no denshô" (Traditions in Song and Yuan landscape painting composition). *Tôkyô daigaku daigakuin jinbun shakaikei kenkyûgaku: Bungakubu bijutsushi kenkyûshitsu. Bijutsushi ronsô* 13 (1997): 1–40.

Ôgushi Sumio. "Hôjôji jussaidô no jigokue" (Hell paintings in the Hall of the Ten Fasts in Hôshôji). *Bijutsu kenkyû* 176 (July 1954): 96–102.

Ôta Hirotarô, ed. *Nihon kenchikushi kiso shiryô shûsei* (Compendium of basic materials on the history of architecture in Japan) 4; *Butsudô* (Buddhist halls) 1. Tokyo: Chûôkôron bijutsu Press, 1981.

Paine, Robert Treat, and Alexander Soper. *The Art and Architecture of Japan,* Pelican History of Art. Harmondsworth: Penguin Books, 1955.

Paludan, Ann. *The Imperial Ming Tombs.* New Haven: Yale University Press, 1981.

Pan Jixing. *Zhongguo zaozhi jishu shigao* (Draft history of the techniques of papermaking). Beijing: Wenwu Press, 1979.

Parent, Mary Neighbour. "A Reconsideration of the Role of Hôrinji in the History of Japanese Architecture." *The Japan Architect* (Jan. 1977): 77–84; (Feb. 1977): 73–80; (April 1977): 77–84; (May 1977): 77–84; (June 1977): 77–84; (July 1977): 77–84.

Pirazzoli-t'Serstevens, Michèle. "Ateliers, patronage et collections princières en Chine à l'Époque Han," Académie des Inscriptions et Belles-Lettres, Comptes rendus des séances de l'année 1990 (April–June), 521–36. Paris: Diffusion de Boccard, 1990.

———. "The Art of Dining in the Han Period: Food Vessels from Tomb No. 1 at Mawangdui." *Food and Foodways* 4, nos. 3–4 (1991): 209–19.

Pohl, Karl-Heinz. *Cheng Pan-ch'iav. Poet, Painter, and Calligrapher,* Monumenta Serica Monograph Series 21. Nettetal: Steyler Verlag, 1990.

Poor, Robert J. "Notes on the Sung Dynasty Archaeological Catalogs." *Archives of the Chinese Art Society of America* 19 (1965): 33–43.

———. "The Master of the 'Metropolis'-Emblem Ku." *Archives of Asian Art* 41 (1988): 70–89; 43 (1990): 61–62.

Pope, Alexander, et al. *The Freer Chinese Bronzes,* Freer Gallery of Art Oriental Studies 7. 2 vols. Washington, D.C.: Smithsonian Institution, 1967–69.

Prüch, Margarete. *Die Lacke der Westlichen Han-Zeit (206 v.–6 n.Chr.): Bestand und Analyse,* Europäische Hochschulschriften, series 28: Kunstgeschichte, vol. 299. Frankfurt am Main: Peter Lang, 1997.

———, ed., with collaboration of Stephan von der Schulenburg. *Schätze für König Zhao Mo: Das Grab von Nan Yue.* Exh. cat. Frankfurt: Schirn Kunsthalle, 1998.

Pulleyblank, Edwin G. *The Background of the Rebellion of An Lu-shan.* London: Oxford University Press, 1955.

Qin ling erhao tong chema (Bronze chariot with horses no. 2 in the necropolis of Qin), edited by Shaanxi sheng Qin yong kaogudui and Qin Shihuang bingmayong bowuguan, Kaogu yu wenwu congkan 1. Xian: Kaogu yu wenwu, 1983.

Qin Shihuangling bingmayong keng: Yi hao keng fajue baogao, 1974–1984 (The pits with the terra-cotta army in the necropolis of the First Emperor of Qin: Excavation report of pit no. 1, 1974–1984), edited byShaanxi sheng kaogu yanjiusuo and Shihunagling Qinyongkengkaogu fajuedui. 2 vols. Beijing: Wenwu Press, 1988.

Qin Shihuangling kaogudui. "Qin Shihuangling xice Lishan siguan jianzhu yizhi qingli jianbao" (Brief report on clearing the architectural remains of the food office at Mount Li at the western side of the necropolis of the First Emperor of Qin). *Wenbo* (1987, no. 6): 3–32.

Qin yong kaogudui. "Lintong Shangjiaocun Qinmu jingli jianbao" (Brief report on inspecting the Qin tombs at Shangjiaocun, Lintong County). *Kaogu yu wenwu* (1980, no. 2): 42–50. Reprinted in Yuan and Zhang, eds., *Qin yong yanjiu wenji* (q.v.), 542–58.

———. "Qin Shihuangling dongce majiukeng zuantan qingli jianbao" (Brief report on probing and clearing the horse-stable pits on the eastern side of the necropolis of the First Emperor of Qin). *Kaogu yu wenwu* (1980, no. 4): 31–41. Reprinted in Yuan and Zhang, eds., *Qin yong yanjiu wenji* (q.v.), 589–613.

———. "Qin Shihuangling yuan peizang zuantan qingli jianbao" (Brief report on probing and clearing the accompanying burials in the funerary park of the First Emperor of Qin). *Kaogu yu wenwu* (1982, no. 1): 25–29. Reprinted in Yuan and Zhang, eds., *Qin yong yanjiu wenji* (q.v.), 636–42.

———. "Qindai taoyao yizhi diaocha qingli jianbao" (Brief report on investigating and clearing Qin-period kiln remains). *Kaogu yu wenwu* (1985, no. 5): 35–39.

Qin yongkeng kaogudui. "Qin Shihuangling pingmayong keng chutu de taoyong taoma zhizuo gongyi" (The technology for manufacturing the terra-cotta figures and horses unearthed from the pits of the terra-cotta army in the necropolis of the First Emperor of Qin). *Kaogu yu wenwu* (1980, no. 3): 108–19. Reprinted in Yuan and Zhang, eds., *Qin yong yanjiu wenji* (q.v.), 78–94.

Quanxiang pinghua wuzhong (Five kinds of plain tales fully illustrated). Beijing: Xinhua Press, 1956. (Reprint of edition in Naikaku Bunko, Tokyo, printed 1321–23).

Rawson, Jessica. *Chinese Bronzes: Art and Ritual.* London: British Museum, 1987.

———. "Statesmen or Barbarians? The Western Zhou as Seen through Their Bronzes." *Proceedings of the British Academy* 75 (1989): 71–95.

———. *Western Zhou Ritual Bronzes from the Arthur M. Sackler Collections,* Ancient Chinese Bronzes from the Arthur M. Sackler Collections 2. Washington, D.C.: Arthur M. Sackler Foundation; Cambridge, Mass.: Arthur M. Sackler Museum, 1990.

———. "Shang and Western Zhou Designs in Jade and Bronze." In *International Colloquium on Chinese Art History 1991: Proceedings,* part 1: *Antiquities,* edited by National Palace Museum, 73–105. Taipei: National Palace Museum, 1992.

———. "Ancient Chinese Ritual Bronzes: The Evidence from Tombs and Hoards of the Shang (c. 1500–1050 B.C.) and the Western Zhou (c. 1050–771 B.C.) Periods." *Antiquity* 67, no. 257 (Dec. 1993): 805–23.

———. "Late Shang Bronze Design: Meaning and Purpose." In *The Problem of Meaning in Early Chinese Ritual Bronzes,* edited by Roderick Whitfield (q.v.), 67–95.

———, with assistance of Carol Michaelson. *Chinese Jade: From the Neolithic to the Qing.* London: British Museum, 1995.

———, ed. *The British Museum Book of Chinese Art.* London: British Museum, 1992.

Rawson, Jessica, et al. *Mysteries of Ancient China: New Discoveries from the Early Dynasties.* Exh. cat. London: British Museum, 1996.

Renfrew, Colin. "Varna and the Emergence of Wealth in Prehistoric Europe." In *The Social Life of Things: Commodities in Cultural Perspective,* edited by Arjun Appadurai, 141–68. Cambridge: Cambridge University Press, 1986.

Riegel, Jeffrey K., "Li chi." In *Early Chinese Texts,* edited by Michael Loewe (*q.v.*), 293–97.

Rogers, Howard, and Sherman E. Lee. *Masterworks of Ming and Qing Paintings from the Forbidden City.* Lansdale, Penn.: International Arts Council, 1989.

Röllike, Hermann-Josef. *"Selbst-Erweisung": Der Ursprung des ziran-Gedankens in der chinesischen Philosophie des 4. und 3. Jhs. v.Chr,* Europäische Hochschulschriften, series 27, vol. 51. Frankfurt am Main: Peter Lang, 1996.

Rudolph, R. C. "Chinese Movable Type Printing in the Eighteenth Century." In *Silver Jubilee Volume of the Zimbun Kagaku Kenkyusyo, Kyoto University,* 317–35. Kyoto: Research Institute of Humanistic Studies, 1954.

———. *A Chinese Printing Manual.* Los Angeles: Ward Ritchie Press, 1954.

———. "Preliminary Notes on Sung Archaeology." *Journal of Asian Studies* 22 (1962–63): 169–77.

Ruitenbeek, Klaas. "Ansichten über Architektur und die Praxis des Bauens." In *Lebenswelt und Weltanschauung im Frühneuzeitlichen China,* Münchner Ostasiatische Studien 49, edited by Helwig Schmidt-Glintzer, 157–76. Stuttgart: Franz Steiner, 1990.

———. *Carpentry and Building in Late Imperial China: A Study of the Fifteenth-Century Carpenter's Manual Lu Ban jing,* Sinica Leidensia 23. Leiden: Brill, 1993.

Ryor, Kathleen. "Self-Expression and Commodification in the Painting of Xu Wei (1521–1593)." Ph.D. diss., New York University, 1998.

Sakai Tadao. "Jūō shinkō ni kan suru shomondai oyobi Enraō jukikyō" (Questions concerning the belief in the ten kings and the scripture on the prophecy bestowed on King Yama). In *Saitō sensei koki shukuga kinen ronbunshū* (Festschrift for Professor Sakai on his Seventieth Birthday), edited by Saitō sensei koki shukugakai, 611–56. Tokyo: Katanae shoin, 1937.

Sampson, Geoffrey. *Writing Systems: A Linguistic Introduction.* Stanford: Stanford University Press, 1985.

Sawada Mizuho. *Jigoku hen: Chūgoku no meikai setsu* (Scenes from hell: tales from the Chinese underworld). Kyoto: Hōzōkan, 1968.

Schafer, Edward H. "Hunting Parks and Animal Enclosures in Ancient China." *Journal of the Economic and Social History of the Orient* 11 (1968): 318–43.

Schierlitz, Ernst. "Zur Technik der Holztypendrucke aus dem Wu-ying-tien in Peking." *Monumenta Serica* 1 (1935–36): 17–38.

Schiffer, Herbert, Peter Schiffer, and Nancy Schiffer. *China for America: Export Porcelain of the 18th and 19th Centuries.* Exton, Penn.: Schiffer Publishing, 1980.

Schlombs, Adele. "Grabanlage und Beigaben des Ersten Kaisers." In *Jenseits der Großen Mauer,* edited by Lothar Ledderose and Adele Schlombs (*q.v.*), 250–57.

———. *Huaisu and the Beginnings of Wild Cursive Script in Chinese Calligraphy,* Münchner Ostasiatische Studien 75. Stuttgart: Franz Steiner, 1998.

———, ed. *Meisterwerke aus China, Korea und Japan: Museum für Ostasiatische Kunst, Köln.* Munich: Prestel, 1995.

Schmidt, Ulrich, ed. *Porzellan aus China und Japan: Die Porzellangalerie der Landgrafen von Hessen-Kassel.* Exh. cat. Berlin: Dietrich Reimer, 1990.

Schopen, Gregory. "The Phrase *sa prthîvipradesas caityabhûto bhavet* in the Vajracchedika: Notes on the Cult of the Book in Mahayana." *Indo-Iranian Journal* 17, nos. 3–4 (Nov.–Dec. 1975): 147–81.

Scott, Rosemary E., ed. *The Porcelains of Jingdezhen,* Colloquies on Art & Archaeology in Asia 16. London: Percival David Foundation of Chinese Art, 1993.

Scott, William Henry. "Yangchow and Its Eight Eccentrics." *Asiatische Studien* 17 (1964): 1–19.

Seckel, Dietrich. "Die Wurzeln der chinesischen Graphik." *Asiatische Studien* 20 (1966): 1–40.

———. "The Rise of Portraiture in Chinese Art." *Artibus Asiae* 53 (1993): 7–26.

———. *Das Porträt in Ostasien,* vol. 1: introduction, part 1: *Porträt-Typen;* vol. 3, part 3: *Porträt-Funktionen.* Heidelberg: Universitätsverlag C. Winter, 1997–99.

Segalen, Victor, Gilbert de Voisins, and Jean Lartigue. *Mission archéologique en Chine.* 3 vols. Paris: Paul Geuthner, 1923–35.

Shaanxi sheng kaogu yanjiusuo and Shihuangling Qinyongkeng kaogu fajuedui, eds. *Qin Shihuangling bingmayong keng.* See *Qin Shihuangling bingmayong keng.*

Shaanxi sheng Qin yong kaogudui and Qin Shihuang bingmayong bowuguan, eds. *Qin ling erhao tong chema.* See *Qin ling erhao tong chema.*

Shandong daxue lishixi kaogu zhuanye. "Shandong Zouping Dinggong yizhi di si, wu ci fajue jianbao" (Brief report on the fourth and fifth excavations at the site of Dinggong Village, Zouping Prefecture, Shandong Province). *Kaogu* (1993, no. 4): 295–99.

Shandong sheng wenwu kaogu yanjiusuo. "Qi gucheng wu hao Dong Zhou mu ji daxing xunmakeng de fajue" (Excavation of Eastern Zhou tomb no. 5 at the ancient capital of Qi and of the large-scale pit with sacrificial horses). *Wenwu* (1984, no. 9): 14–19.

Shanghai bowuguan, ed. *Shanghai bowuguan cang qingtongqi* (Bronze vessels in the collection of the Shanghai Museum). 2 vols. Shanghai: Shanghai renmin meishu Press, 1964.

Shanghai shi fangzhi kexue yanjiuyuan, Shanghai shi sichou gongye gongsi wenwu yanjiuzu, ed. *Changsha Mawangdui yi hao Han mu chutu fangzhipin de yanjiu* (A study of the textile specimens unearthed from Han-dynasty tomb no. 1 at Mawangdui, Changsha). Beijing: Wenwu Press, 1980.

Shanxi sheng kaogu yanjiusuo, ed. *Houma zhutong yizhi* (Bronze foundry sites at Houma). 2 vols. Beijing: Wenwu Press, 1993.

Shao Yong (1011–77). *Huangji jingshi* (Supreme principles governing the world). In *Zhengtong daozang* no. 1040, vols. 38–39: 30508–31188. Taipei: Yiwen Press, 1977.

Shatzman Steinhardt, Nancy. "Ying Xian Timber Pagoda." In Shatzman Steinhardt et al., *Chinese Traditional Architecture* (q.v.), 109–19.

———. *Chinese Imperial City Planning.* Honolulu: University of Hawai'i Press, 1990.

———. "The Mizong Hall of Qinglong Si: Space, Ritual, and Classicism in Tang Architecture." *Archives of Asian Art* 44 (1991): 27–50.

———. "Liao: An Architectural Tradition in the Making." *Artibus Asiae* 54 (1994): 5–39.

———. *Liao Architecture.* Honolulu: University of Hawai'i Press, 1997.

Shatzman Steinhardt, Nancy, et al. *Chinese Traditional Architecture.* Exh. cat. New York: China Institute of America, China House Gallery, 1984.

Shaughnessy, Edward L. *Sources of Western Zhou History: Inscribed Bronze Vessels.* Berkeley: University of California Press, 1991.

———. "I ching (Chou I)." In *Early Chinese Texts,* edited by Michael Loewe (q.v.), 216–28.

Shaw, Shiow-jyu Lu. *The Imperial Printing of Early Ch'ing China, 1644–1805,* Asian Library Series 20. Taipei: Chinese Materials Center, 1983.

Sheaf, Colin, and Richard Kilburn. *The Hatcher Porcelain Cargoes: The Complete Record.* Oxford: Phaidon, 1988.

Shen Gua. *Xin jiaozheng Mengxi bitan* (Newly revised edition of *Mengxi bitan*). Revised by Hu Daojing. Hong Kong: Zhonghua shuju, 1975.

Shen Shixing (1535–1614) and Zhao Yongxian (1535–96). *Da Ming huidian* (Collected statues of the Ming dynasty). Beijing: Neifu, 1587.

Shihuangling Qin yongkeng kaogu fajuedui. "Qin Shihuang lingxice Zhaobeihucun Qin xingtu mu" (Tombs of Qin-dynasty criminal laborers near the village Zhaobeihucun at the western side of the necropolis of the First Emperor of Qin). *Wenwu* (1982, no. 3): 1–11. Reprinted in Yuan and Zhang, eds., *Qin yong yanjiu wenji* (q.v.), 559–74.

Shimada Shûjiro, ed. *Shôsai baifu* (Pine Studio Plum manual). Hiroshima: Hiroshima shiritsu chûô toshokan, 1988.

Shimen zhengtong (The correct lineage of the Buddhists). In *Dainihon zokuzôkyô.* 150 vols. 1905–12. Vol. 130, 712–925. Reprint Taipei: Xin wenfeng, 1977.

Shodō zenshū (Compendium of calligraphy). 26 vols. 3rd ed. Tokyo: Heibonsha, 1966–69.

Sickman, Laurence, and Alexander Soper. *The Art and Architecture of China,* Pelican History of Art. Harmondsworth: Penguin Books, 1956.

Sima Qian. *Shiji.* 130 juan. Beijing: Zhonghua shuju, 1962.

Sirén, Osvald. *Chinese Painting.* 7 vols. London: Lund and Humphries, 1956–58.

So, Jenny. *Eastern Zhou Ritual Bronzes from the Arthur M. Sackler Collections,* Ancient Chinese Bronzes from the Arthur M. Sackler Collections 3. New York: Arthur M. Sackler Foundation; Washington, D.C.: Arthur M. Sackler Gallery, Smithsonian Institution, 1995.

Sohn, Pow-Key. "Early Korean Printing." In *Der gegenwärtige Stand der Gutenberg-Forschung,* edited by Hans Widmann, 216–31. Stuttgart: Anton Hiersemann, 1972.

Soper, Alexander Coburn. *The Evolution of Buddhist Architecture in Japan.* Princeton: Princeton University Press, 1942.

———. *Kuo Jo-Hsü's Experiences in Painting,* T'u-hua chien-wen chih (Studies in Chinese and related civilizations) 6. Washington, D.C.: American Council of Learned Societies, 1951.

———. "T'ang Ch'ao Ming Hua Lu." *Artibus Asiae* 21 (1958): 204–30.

Soymié, Michel. "Notes d'iconographie chinoise: les acolytes de Ti-tsang." *Arts Asiatiques* 14 (1966): 45–78; 16 (1967): 141–70.

———. "Les dix jours de jeûne de Ksitigarbha." In *Contributions aux études sur Touen-houang,* Hautes Études Orientales 10, 135–59. Geneva and Paris: Librairie Droz, 1979.

———. "Les dix jours de jeûne du taoisme." In *Yoshioka hakase kanreki kinen Dôkyô kenkyū ronshū* (Festschrift for Dr. Yoshioka: Collected articles on research in Daoism), 1–21. Tokyo: Kokusho kankôkai, 1980.

von Spee, Clarissa. "Modulsystem und gestalterische Freiheit: Die Landschaftsbilder des Literatenmalers Wang Yuanqi (1642–1715)." Master's thesis, University of Heidelberg, 1994.

Speiser, Werner, Roger Goepper, and Jean Fribourg. *Chinesische Kunst: Malerei, Kalligraphie, Steinabreibungen, Holzschnitte.* Fribourg: Office du Livre, 1965.

Staehelin, Walter A. *The Book of Porcelain: The Manufacture, Transport, and Sale of Export Porcelain in China during the Eighteenth Century.* London: Lund and Humphries, 1966.

Stein, Mark Aurel. *Serindia: Detailed Report of Explorations in Central Asia and Westernmost China.* 5 vols. Oxford: Clarendon Press, 1921.

Su Bai. "Sui Tang Chang'an cheng he Luoyang cheng" (The cities of Chang'an and Luoyang in the Sui and Tang dynasties). *Kaogu* (1978, no. 6): 401, 409–25.

Sun Haibo, ed. *Jiaguwen bian* (Dictionary of script on oracle bones), Kaoguxue zhuankan yizhong di shisi hao. Beijing: Zhongguo kexueyuan kaogu yanjiusuo, 1965.

Suzuki Kei. *Mindai kaigashi kenkyū: Seppa* (Research on the history of Ming-dynasty painting: The Zhe School). Tôykô: Mokujisha, 1968.

———, ed. *Chûgoku kaiga sôgôzuroku* (Comprehensive illustrated catalog of Chinese paintings). 5 vols. Tokyo: Tôkyô daigaku shuppansha, 1982–83.

Sylwan, Vivi. "Silk from the Yin Dynasty." *Bulletin of the Museum of Far Eastern Antiquities* 9 (1937): 119–26.

Tanaka Ichimatsu. "Riku Shinchū hitsu jūôzu" (Paintings of the ten kings by Lu Xinzhong). *Kokka* 878 (May 1965): 27–31.

Tanaka Tan. *Chûgoku kenchikushi no kenkyū* (Research on the history of Chinese architecture). Tokyo: Kôbundô, 1989.

——— [Tianzhong Dan]. "Zhongguo jianzhu duliang shang de jiben danwei—fen" (The basic unit of measurement in Chinese architecture—the *fen*). In *Yazhou keji yu wenming* (Asian science and civilization), edited by Zhao Lingyang and Feng Jinrong, 151–63. Hong Kong: Mingbao Press, 1995.

Teiser, Stephen F. "Having Once Died and Returned to Life: Representations of Hell in Medieval China." *Harvard Journal of Asiatic Studies* 48, no. 2 (Dec. 1988): 433–64.

———. *The Scripture of the Ten Kings and the Making of Purgatory in Medieval Chinese Buddhism,* Studies in East Asian Buddhism 9. Honolulu: University of Hawai'i Press, 1994.

Teng, Ssu-yü. "Chinese Influence on the Western Examination System." *Harvard Journal of Asiatic Studies* 7 (1942–43): 267–312.

Thieme, Christine, et al. *Zur Farbfassung der Terrakottaarmee des I. Kaisers Qin Shihuangdi: Untersuchung und Konservierungskonzept,* Bayrisches Amt für Denkmalpflege, Forschungsbericht 12/1993. Munich: Bayrisches Amt für Denkmalpflege, 1993.

Thorp, Robert L. "An Archaeological Reconstruction of the Lishan Necropolis." In *The Great Bronze Age of China: A Symposium,* edited by George Kuwayama (*q.v.*), 72–83.

———. "Origins of Chinese Architectural Style: The Earliest Plans and Building Types." *Archives of Asian Art* 36 (1983): 22–28.

———. "The Qin and Han Imperial Tombs and the Development of Mortuary Architecture." In *The Quest for Eternity: Chinese Ceramic Sculptures from the People's Republic of China,* edited by Susan L. Caroselli, 17–37. Exh. cat. Los Angeles: Los Angeles County Museum of Art; London: Thames and Hudson, 1987.

Thote, Alain. "The Double Coffin of Leigudun Tomb No. 1: Iconographic Sources and Related Problems." In *New Perspectives on Chu Culture during the Eastern Zhou Period,* edited by Thomas Lawton (*q.v.*), 23–46. Washington, D.C.: Arthur M. Sackler Gallery, 1991.

———. "De quelques décors au serpent sur les bronzes rituels du royaume de Chu." In *Hommage à Kwong Hing Foon: Études d'histoire culturelle de la Chine,* edited by Jean-Pierre Diény, Bibliothèque de l'Institut des Hautes Études Chinoises 30, 15–42. Paris: Collège de France, Institut des Hautes Études Chinoises, 1995.

———. "I Zhou Orientali." In *La Cina,* edited by Michèle Pirazzoli-t'Serstevens, Storia Universale del' Arte, vol. 1 of 2, 95–165. Turin: Utet, 1996.

Tichane, Robert. *Ching-Te-Chen: Views of a Porcelain City.* Painted Post: New York State Institute for Glaze Research, 1983.

Tokushi Yūshō and Kanichi Ogawa. "Jūō shōshichikyō sanzukan no kōzō" (Painted manuscripts of the *Shih-Wang-Sheng-Ts'i Ching*). *Chūō Ajia bukkyō bijutsu,* Saiiki bunka kenkyū, Monumenta Serindica 5, 355–96. Kyoto: Hōzōkan, 1962.

Tokyo kokuritsu hakubutsukan (Tokyo National Museum), ed. *Chūzan ōkoku bunbutsu ten: Chūgoku sengoku jidai no yū* (Exhibition of relics from the Zhongshan kingdom: Highlights from the Warring States period in China). Exh. cat. Tokyo: Nihon keizai shinbunsha, 1981.

———, ed. *Sōkō Itsu bō* (Tomb of Marquis Yi of Zeng). Exh. cat. Tokyo: Nihon keizai shinbunsha, 1992.

Tomita, Kojiro. *Portfolio of Chinese Paintings in the Museum [of Fine Arts, Boston]: Han to Sung Periods.* Cambridge: Harvard University Press, 1933.

Tsien, Tsuen-Hsuin. *Written on Bamboo and Silk: The Beginnings of Chinese Books and Inscriptions.* Chicago: University of Chicago Press, 1962.

———. *Paper and Printing.* In Joseph Needham, *Science and Civilisation in China,* vol. 5: *Chemistry and Chemical Technology,* part 1. Cambridge: Cambridge University Press, 1985.

Tsukamoto Zenryū. "Hōzan Ungo-ji no sekkoku daizōkyō" (The Buddhist canon carved into stone at the Cloud Dwelling Monastery in Fangshan County). In Tsukamoto Zenryū, *Tsukamoto Zenryū chosakushū* (The collected writings of Tsukamoto Zenryū), vol. 5, 291–611. Tokyo: Daitō shuppansha, 1975.

Tuo Tuo, comp. *Songshi.* 40 juan. Beijing: Zhonghua shuju, 1977.

Twitchett, Denis. *Printing and Publishing in Medieval China.* New York: Frederic C. Beil, 1983.

Umehara Sueji. *Ōbei shūcho Shina kodō seika* (Selected relics of ancient Chinese bronzes from collections in Europe and America). 7 vols. Osaka: Yamanaka, 1933–35.

———. *Shina Kandai kinenmei shikki zusetsu* (Illustrated catalog of lacquerware with dated inscriptions from the Han dynasty in China). Kyoto: Kuwana Bunseidō, 1943.

———. *Nihon shūcho Shina kodō seika* (Selected relics of ancient Chinese bronzes from collections in Japan). 6 vols. Osaka: Yamanaka, 1959–64.

Volker, T. *Porcelain and the Dutch East India Company, 1602–1682,* Mededelingen van het Rijksmuseum voor Volkenkunde, Leiden 11. Leiden: Brill, 1971.

Vollmer, John. "Textile Pseudomorphs on Chinese Bronzes." In *Archaeological Textiles,* edited by Patricia L. Fiske, Irene Emery Roundtable on Museum Textiles, 1974: Proceedings, 170–74. Washington, D.C.: Textile Museum, 1974.

Voltaire. *Essai sur les moeurs et l'esprit des nations et sur les principaux faits de l'histoire depuis Charlemagne jusque'a Louis XIII,* Oeuvres completes de Voltaire, vols. 16–19. Basle: Jean-Jacques Tourneisen, 1785.

Wagner, Donald B. *Iron and Steel in Ancient China,* Handbuch der Orientalistik, 4th section: *China,* 9. Leiden, New York: Brill, 1993.

Wang Chongren. *Gudu Xian* (The old capital Xian). Xian: Shaanxi renmin meishu Press, 1981.

Wang Jie et al. *Bidian zhulin, Shiqu baoji xubian* (Sequel to Pearl forest in secret halls and treasure bags from stone moat). 8 Vols. Preface 1793. Reprint: Taipei: Guoli Gugong bowuyuan, 1971.

Wang Liqi. *Yantielun jiaozhu* (Annotated edition of *Discussion on Salt and Iron*). 2 vols. Tianjin: Guji Press, 1983.

Wang Pu, comp. *Tang huiyao* (Manual of Tang institutions), Lidai huiyao series 1, vols. 5–7. Preface A.D. 961. Taipei: Shijie shuju, 1968.

Wang Renbo. "General Comments on Chinese Funerary Sculpture." In *The Quest for Eternity: Chinese Ceramic Sculptures from the People's Republic of China,* edited by Susan L. Caroselli, 39–61. Exh. cat. Los Angeles: Los Angeles County Museum of Art; London: Thames and Hudson, 1987.

———, ed. *Sui Tang wenhua* (The culture of the Sui and Tang dynasties). Hong Kong: Zhonghua shuju, 1990.

Wang Shiren. "Han Chang'an cheng nanjiao lizhi jianzhu (Datumencun yizhi) yuanzhuang de tuice" (Hypothetical reconstruction of the ceremonial buildings in the southern suburb of the Han-dynasty city of Chang'an (the Datumen Village site). *Kaogu* (1963, no. 9): 501–15.

Wang Xu. "Mawangdui Han mu de sizhiwu yinhua" (Printed patterns on silk pieces from the Han-dynasty tomb at Mawangdui). *Kaogu* (1979, no. 5): 471, 474–478.

Wang Xueli. *Qin yong zhuanti yanjiu* (Special topic research on the Qin dynasty figures). Xian: San Qin Press, 1994.

Wang Zhongshu. *Han Civilization.* Translated by K. C. Chang et al. New Haven: Yale University Press, 1982. (Chinese edition: *Handai kaoguxue gaishuo* [Outline of Han-dynasty archaeology]), Kaoguxue zhuankan, series 1, no. 16. Beijing: Zhonghua shuju, 1984.)

Watanabe Hajime. "Kanki aru Sō Gen butsuga" (Song- and Yuan-period Buddhist paintings carrying signatures). *Bijutsu kenkyū* 45 (Sept. 1935): 422–28.

Wechsler, Howard J. *Offerings of Jade and Silk: Ritual and Symbol in the Legitimation of the T'ang Dynasty.* New Haven: Yale University Press, 1985.

Weigand, Jörg. *Staat und Militär im alten China: Mit Übersetzung des Traktates von Wei Liao über Staat und Militär.* Bonn: Wehling Verlag, 1979.

Wheatley, Paul. *The Pivot of the Four Quarters: A Preliminary Enquiry into the Origins and Character of the Ancient Chinese City.* Chicago: Aldine, 1971.

White, William Charles. *Tomb Tile Pictures of Ancient China.* Toronto: University of Toronto Press, 1939.

Whitfield, Roderick. "Tz'u-chou Pillows with Painted Decoration." In *Chinese Painting and the Decorative Style,* edited by Margaret Medley, Colloquies on Art & Archaeology in Asia 5, 74–94. London: Percival David Foundation of Chinese Art, 1975.

————. *The Art of Central Asia: The Stein Collection in the British Museum.* 3 vols. Tokyo: Kodansha International, 1982–85.

————, ed. *The Problem of Meaning in Early Chinese Ritual Bronzes,* Colloquies on Art & Archaeology in Asia 15. London: Percival David Foundation of Chinese Art, 1993.

Wiedehage, Peter. *Das* Meihua xishen pu *des Song Boren aus dem 13. Jahrhundert: Ein Handbuch zur Aprikosenblüte in Bildern und Gedichten.* Sankt Augustin: Institut Monumenta Serica, 1995.

Willetts, William. *Foundations of Chinese Art: From Neolithic Pottery to Modern Architecture.* London: Thames and Hudson, 1965.

Wilson, J. Keith. "Early Chinese Foundry Operations: Evidence from Shang Bronze Inscriptions." Unpublished manuscript.

Wong, Gertrude C., ed. *Xu Beihong Centenary Album.* See *Xu Beihong Centenary Album.*

Wood, Frances. *Chinese Illustration.* London: British Library, 1985.

Wu, Hung, "From Temple to Tomb: Ancient Chinese Art and Religion in Transition." *Early China* 13 (1988): 78–115.

————. *Monumentality in Early Chinese Art and Architecture.* Stanford: Stanford University Press, 1995.

————. *The Double Screen: Medium and Representation in Chinese Painting.* Chicago: University of Chicago Press, 1996.

Wu, Kwang Tsing. "The Development of Typography in China during the Nineteenth Century." *Library Quarterly* 22 (1952): 288–301.

Xia Nai. "*Mengxi bitan zhong de Yu Hao* Mujing" (The *Classic of Wood Work,* by Yu Hao, in *Brush Jottings from Dream Creek*). *Kaogu* (1982, no. 1): 73–78.

————. *Jade and Silk of Han China,* Franklin D. Murphy Lectures 3. Translated and edited by Chu-tsing Li. Lawrence, Kansas: Helen Foresman Spencer Museum of Art, 1983.

Xian shi wenwu guanli weiyuanhui. "Sanqiaozhen Gaoyaocun chutu de Xi Han tongqi qun" (A group of Western Han bronzes unearthed at Sanqiaozhen, Gaoyaocun). *Kaogu* (1963, no. 2): 62–70.

Xianyang diqu wenguanhui and Maoling bowuguan. "Shaanxi Maoling yihao wuming zhong yi hao congzangkeng de fajue" (Excavation of accompanying pit no. 1 of the unidentified mound no. 1 at the Maoling in Shaanxi). *Wenwu* (1982, no. 9): 1–17.

Xiao Mo. *Dunhuang jianzhu yanjiu* (Research on architecture in Dunhuang). Beijing: Wenwu Press, 1989.

Xie Jin (1369–1415) et. al., comps. *Yongle dadian.* See *Yongle dadian.*

Xiong Chuanxin. "Changsha xin faxian de Zhanguo sizhiwu" (Newly discovered silk pieces from the Warring States period in Changsha). *Wenwu* (1975, no. 2): 49–56.

Xu Beihong Centenary Album, Collection of the Cheng Family, edited by Gertrude C. Wong. Hong Kong: Ying Man, 1995.

Xu Beihong huaji (Paintings by Xu Beihong), edited by Liu Chunhua and Song Guangsen. 6 vols. Beijing: Beijing Press, 1981–88.

Xu Mingji. *Zhongguo gudai zaozhishu qiyuanshi yanjiu* (Research on the history and the origin of the technique of papermaking in China). Shanghai: Jiaotong daxue Press, 1991.

Xu Wenbin et al., comps. *Sichuan Handai shique* (Han-dynasty stone *Que*-gates in Sichuan). Beijing: Wenwu Press, 1992.

Yabe Yoshiaki. "Kasei keitokuchin yô no konran to sôzô" (Disorder and creativity in the kilns at Jingdezhen during the Jiajing period). *Tôyô tôji* 12–13 (1982–85): 63–99.

Yang Hong. *Zhongguo gu bingqi luncong* (Discussions of old Chinese weapons). Beijing: Wenwu Press, 1985.

Yang Hongxun. "Cong Panlongcheng Shangdai gongdian yizhi tan Zhongguo gongting jianzhu fazhan de jige wenti" (Some questions concerning the development of Chinese palace architecture in light

of the Shang-period palace remains at the site of Panlongcheng). *Wenwu* (1976, no. 2): 16–25. Reprinted in Yang Hongxun, *Jianzhu kaoguxue lunwenji* (q.v.), 81–93.

———. "Dougong qiyuan kaocha" (An investigation of the origin of the bracketing system). In *Jianzhu lishi yu lilun*, edited by Wang Shijun, vol. 2, 5–16. [N.p.]: Jiangsu renmin Press, 1981. Reprinted in Yang Hongxun, *Jianzhu kaoguxue lunwenji* (q.v.), 253–67.

———. "Xi Zhou Qiyi jianzhu yizhi chubu kaocha" (A reconnaissance of the remains of Western Zhou buildings at Qiyi). *Wenwu* (1981, no. 3): 23–33. Reprinted in Yang Hongxun, *Jianzhu kaoguxue lunwenji* (q.v.), 94–109.

———. "Tang Daminggong Lindedian fuyuan yanjiu jieduan baogao" (Initial research report on the reconstruction of the Lindedian hall in the Daminggong palace of the Tang dynasty). In *Zhongguo kaoguxue yanjiu: Xia Nai xiansheng kaogu wushi nian jinian lunwenji* (Archaeological researches in China: A collection of papers in commemoration of the fiftieth year of Professor Xia Nai's work in archaeology), edited by Zhongguo kaoguxue yanjiu bianweihui, vol. 2 of 2, 237–63. Beijing: Kexue Press, 1986. Reprinted in Yang Hongxun, *Jianzhu kaoguxue lunwenji* (q.v.), 234–52.

———. "Cong yizhi kan Xi Han Chang'an mingtang (biyong) xingzhi" (Shape and system of *mingtang* and *biyong* at the Western Han capital Chang'an in light of their remains). In Yang Hongxun, *Jianzhu kaoguxue lunwenji* (q.v.), 169–200.

———. *Jianzhu kaoguxue lunwenji* (Collected essays on the archaeology of architecture). Beijing: Wenwu Press, 1987.

Yang, Hsien-yi, and Gladys Yang, trans. *Selections from Records of the Historian by Szuma Chien.* Beijing: Foreign Languages Press, 1979.

Yang Jialuo, ed. *Yishu congbian* (Compendium of texts on the arts). Taipei: Shijie shuju, 1962.

Yang Jianhong. "Cong Yunmeng Qin jian kan Qindai shougongye he shangye de rugan wenti" (Some questions concerning light industry and commerce in the Qin dynasty, as seen in the Qin-dynasty legal code from Yunmeng). *Jiang Han kaogu* (1989, no. 2): 87–92.

Yang Kuan. *Zhongguo gudai ducheng zhidushi yanjiu* (Research on the history of old imperial-city plans in China). Shanghai: Shanghai guji Press, 1993.

Yang Shangshan (Sui dynasty). *Huangdi neijing, taisu* (The Yellow emperor's inner classic, grand plain). Tainan: Wang jia Press, 1985.

Yang Xin (370–442). *Cai gulai nengshu renming* (A selection of the names of capable calligraphers beginning from ancient times to the present). In Zhang Yanyuan, comp. *Fashu Yaolu* (q.v.), part 1.

Yi, Sung-mi. "An Analysis of Li K'an's *Chu-p'u hsiang-lu*." *Misul Charyo* 35 (Dec. 1984): 1–21.

Yongle dadian (Great dictionary of the Yongle period). 1408. Compiled by Xie Jin (1369–1415) et. al.

Yu He. *Lunshubiao* (Memorial on calligraphy). Preface A.D. 470. In Zhang Yanyuan, comp. *Fashu Yaolu* (q.v.), part 2.

Yu Huaqing. "Qin Han qiqi jiage kaobian" (Investigation of price differences of lacquered utensils of the Qin and Han periods). *Zhongguo shi yanjiu* (1984, no. 4): 97–104.

Yuan, Tsing. "The Porcelain Industry at Ching-te-chen, 1500–1700." *Ming Studies* 6 (spring 1978): 45–53.

Yuan Zhongyi. "Qindai de shi, ting taowen" (Inscriptions on ceramics of Qin-dynasty city offices). *Kaogu yu wenwu* (1980, no. 1): 93–98. Reprinted in Yuan Zhongyi et al., eds. *Qin Shihuangling bingmayong bowuguan lunwen xuan* (q.v.), 71–83.

———. "Qin zhongyang duzao de bingqi keci zongshu" (General account of engraved inscriptions on Qin weapons made under central supervision). *Kaogu yu wenwu* (1984, no. 5): 100–12. Reprinted in Yuan Zhongyi et al., eds. *Qin Shihuangling bingmayong bowuguan lunwen xuan* (q.v.), 333–58.

———. "Qin ling bingmayong de zuozhe" (The makers of the terra-cotta army in the Qin necropolis). *Wenbo* (1986, no. 4): 52–62. Reprinted in Yuan and Zhang, eds. *Qin yong yanjiu wenji* (q.v.), 183–207.

———. *Qindai taowen* (Inscriptions on ceramics of the Qin dynasty). Xi'an: San Qin Press, 1987.

———. "Qin Shihuangling kaogu jiyao" (Summary of the archaeology at the necropolis of the First Emperor of Qin). *Wenwu yu kaogu* (1988, nos. 5–6): 133–146. Reprinted in Yuan Zhongyi et al., eds. *Qin Shihuangling bingmayong bowuguan lunwen xuan* (*q.v.*), 1–27.

———. *Qin Shihuangling bingmayong yanjiu* (Research on the terra-cotta army in the necropolis of the First Emperor of Qin). Beijing: Wenwu Press, 1990.

Yuan Zhongyi et al., eds. *Qin Shihuangling bingmayong bowuguan lunwen xuan* (Selected articles from the Museum of the Terra-cotta Army at the necropolis of the First Emperor of Qin). Xian: Xibei daxue Press, 1989.

Yuan Zhongyi and Zhang Zhanmin, eds. *Qin yong yanjiu wenji* (Research articles on the Qin-dynasty figures). Xian: Shaanxi renmin meishu Press, 1990.

Yun-Kremer, Myong-ok. "Waffen." In Ledderose and Schlombs, eds. *Jenseits der Großen Mauer* (*q.v.*): 306–309.

Zhang Geng. *Guochao huazhenglu* (Records on investigation of painters of the [Qing] dynasty). 1739. In *Huashi congshu* (Compendium of painting histories), edited by Yuan Anlan. Shanghai: Renmin meishu Press, 1963.

Zhang Guangyuan. "Shang Zhou jinwen zhizuo fangfa de shangque" (Discussing the method of making bronze inscriptions in the Shang and Zhou periods). *Gugong wenwu yuekan* 104 (1991, no. 11): 56–71.

———. "Shangdai jinwen wei zhengtizi, jiaguwen wei jiantizi shuo" (Proposing that Shang-period bronze script was official writing, and oracle bone script was abbreviated writing). *Gugong wenwu yuekan* 141 (1994, no. 2): 24–31.

Zhang Guangzhi et al. *Shang Zhou qingtongqi yu mingwen de zonghe yanjiu* (Inscribed bronzes of the Shang and Chou: A comprehensive study), Zhongyang yanjiuyuan lishi yuyan yanjiusuo, zhuankan (Institute of History and Philology, Academia Sinica, Special Publications) 62. Taipei: Zhongyang yanjiu yuan, 1973.

Zhang Qiyun. ed. *Zhongwen da cidian*. See *Zhongwen da cidian*.

Zhang Wanli and Hu Renmou, eds. *Yangzhou baguai shuhuaji* (Selected painting and calligraphy of the Eight Eccentrics of Yangchow). 8 vols. Hong Kong: Cafa, 1970.

Zhang Xiumin. *Zhongguo yinshua shi* (History of printing in China). Shanghai: Renmin Press, 1989.

Zhang Yanyuan (9th century), comp. *Fashu Yaolu* (Important records about methods of calligraphy). In Yang Jialuo, ed. *Yishu congbian* (*q.v.*), vol. 1, section 1.

Zhang Zining. "Xiaozhong xianda xiyi" (Dispelling doubts about the album *To See Large within Small*). In *Qingchu si Wang huapai yanjiu lunwenji* (Collected research articles on the painting school of the Four Wangs at the beginning of the Qing dynasty), edited by Duoyun, 505–82. Shanghai: Shanghai shuhua Press, 1993.

Zhao Kangmin. "Qin Shihuang lingbei er, san, si hao jianzhu yizhi" (Architectural remains nos. 2, 3, and 4 north of the necropolis of the First Emperor of Qin). *Wenwu* (1979, no. 12): 13–16. Reprinted in Yuan and Zhang, eds., *Qin yong yanjiu wenji* (*q.v.*), 614–19.

Zhejiang sheng wenwu guanli weiyuanhui and Zhejiang sheng bowuguan. "Hemudu yizhi diyiqi fajue baogao" (Excavation report of the remains at Hemudu, first season). *Kaogu xuebao* (1978, no. 1): 39–94.

Zheng Xie. *Zheng Banqiao ji* (Collected works of Zheng Xie). Preface by Fu Baoshi. Hong Kong: Zhonghua shuju, 1979.

Zheng Zhenduo. *Zhongguo gudai mukehua xuanji* (Selections from traditional Chinese woodblock illustrations). 10 vols. Beijing: Renmin meishu Press, 1985.

Zheng Zhenxiang and Chen Zhida. *Yinxu dixia guibao: Henan Anyang Fu Hao mu* (Underground valuables at Yinxu: The tomb of Lady Hao at Anyang, Henan Province). In *Zhongguo kaogu wenwu zhi mei* (*q.v.*), vol. 2.

Zhongguo jianzhu kexue yanjiuyuan, comp. *Zhongguo gujianzhu* (Chinese traditional architecture). Beijing: Zhongguo jianzhu gongye Press, 1983. (English edition: Chinese Academy of Architecture, comp. *Classical Chinese Architecture*. 2nd ed. Beijing: China Building Industry Press; Hong Kong: Joint Publishing Co., 1986.)

Zhongguo kaogu wenwu zhi mei (The beauty of archaeological relics in China), edited by Wenwu Press, Guangfu shuju qiye gufen. 10 vols. Beijing: Wenwu Press, 1994–95.

Zhongguo kexueyuan kaogu yanjiusuo Luoyang gongzuodui. "Dong Han Luoyangcheng nanjiao de xingtu mudi" (An Eastern Han–dynasty cemetery for criminal laborers in the southern suburb of Luoyang). *Kaogu* (1972, no. 4): 2–19.

Zhongguo kexueyuan ziran kexueshi yanjiusuo, comp. *Zhongguo gudai jianzhu jishu shi* (History of the technique of ancient Chinese architecture). Beijing: Kexue Press, 1985. (English edition: Institute of the History of Natural Sciences, Chinese Academy of Social Sciences, comp. *History and Development of Ancient Chinese Architecture*. Beijing: Science Press, 1986.)

Zhongguo lishi bowuguan, comp. *Chûgoku rekishi hakubutsukan* (The museum of Chinese history), Chûgoku no hakubutsukan 5. Tokyo: Kôdansha; Beijing: Wenwu Press, 1982.

Zhongguo meishu quanji bianji weiyuanhui, ed. *Zhongguo meishu quanji, Gongyi meishu bian* (The great treasury of Chinese fine arts, arts and crafts). 12 vols. Beijing: Wenwu Press; Shanghai: Shanghai renmin meishu Press, 1985–88.

Zhongguo shehui kexueyuan kaogu yanjiusuo, ed. *Yinxu Fu Hao mu* (Tomb of Lady Hao at Yinxu). Wenwu Press, 1980.

————, ed. *Yinxu qing tongqi* (Ritual bronzes from Yinxu). Beijing: Wenwu Press, 1985.

————, ed. *Yinxu fajue baogao, 1958–1961* (Report on excavations at Yinxu, 1958–61). Beijing: Wenwu Press, 1987.

————, ed. *Yinxu de faxian yu yanjiu* (Discoveries and research at Yinxu). Beijing: Science Press, 1994.

Zhongwen da cidian (The encyclopedic dictionary of the Chinese language), edited by Zhang Qiyun. 40 vols. Taipei: Zhongguo wenhua xueyuan chubanbu, 1966.

Zhou Dao and Lü Pin. *Henan Handai huaxiang zhuan* (Han-dynasty pictorial tiles from Henan Province). Shanghai: Renmin meishu Press, 1985.

Zhou Dunyi (1017–73) and Zhang Zai (1020–77). *Zhou Zhang quanshu* (The complete works of Zhou Dunyi and Zhang Zai), edited by Okada Takehiko (Gangtian Wuyan). 3 vols. Taipei: Zhongwen chubanshe, 1972.

Zhu Jingxuan (ca. 842). *Tang chao minghualu* (Record of famous painters of the Tang dynasty). In Huang and Deng, eds. *Meishu congshu* (q.v.), vol. 2, section 6.

Glossary of Chinese Names and Terms

an 案
An Lushan 安祿山 (died 757)
ang 昂
Anyang 安陽
Apanggong 阿房宮

Bao 褒 (family name)
Bao Jin zhai fatie 寶晉齋法帖
Bao Zheng 包拯 (judge; 999–1062)
Baobeizhuang 包背裝
Baochasi 寶刹寺
Baozhenzhai fashu zan 寶眞齋法書贊
Bazhu di san 八柱第三
Beihai 北海
Beijing 北京
bi 匕
Bi Sheng 畢昇 (11th cent.)
bian 變
biandian 邊殿
Bidian zhulin 秘殿珠林
bijutsu 美術
bingbian 丙編
bu 部
bugeng 不更

cai 材
Canton. *See* Guangzhou
cao ⺿ (grass 艸)
cao rufu 草乳栿
caoshu 草書
Cen 岑
Chan 禪
Chang'an 長安
Changlegong 長樂宮
Changling 長陵
Changsha 長沙
Chen Mingda 陳明達
Chen Si 陳思
chenfang tou 襯枋頭
cheng 丞
Cheng Zhengkui 程正揆 (1604–1676)
Chiang Kai-shek 蔣介石 (1887–1975)
Chongshansi 崇善寺
Chu 楚

ci 此
cong 從
Cuo 䤮

Da Ming huidian 大明會典
Dada fashi Xuanmita bei 大達法師玄秘塔碑
Dai 軑 (princess; died after 168 B.C.)
Daitokuji 大德寺
Daji 妲己
Daminggong 大明宮
dan 石
dancai 單材
Daoxin 道信
Daozong 道宗 (r. 1055–1101)
Dawenkou 大汶口
deng 等
Deng Shiru 鄧石如 (1743–1805)
dian 典
diantang 殿堂
Diao 鴞
diaogong 泂工
difu 地栿
difu panguan 地府判官
ding 鼎
Dong Qichang 董其昌 (1555–1636)
Dongjian 東間
Dongwu 東武
dou 枓
dougong 枓栱
du 讀
duchuan 都船
dui 敦 (type of bronze vessel)
dun 敦 (dun of Zhou Dunyi)
Dunhuang 敦煌
duobaoge 多寶閣

Eigenji 永源寺
Emmadō 閻羅堂
Erlitou 二里頭

Fan 氾
fang 坊
fangding 方鼎
fanglei 方罍
Fangshan 房山
fangyi 方彝

fangzun 方尊
fazhi 法直
feizi 飛子
fen 分
Feng 豐 (family name of wood-worker)
Feng 馮 (family name of painter)
Feng 鳳 (family name of deputy administrator)
Fengxiang 鳳翔
fo 佛
Fo shuo Yanluo wang shouji sizhong yuxiu shengqi wangsheng jingtu jing 佛說閻羅王受記四眾預修生七往生淨土經
Fogongsi 佛宮寺
Foguang zhenrong chansi 佛光眞容禪寺
Foguangsi 佛光寺
fu 福
Fu Hao 婦好 (inscription)
Fufeng 扶風
Fu Shen 傅申 (born 1937)

Ganjin. *See* Jianzhen
Gao 高 (r. 206–195 B.C.)
Gao Yi 高頤 (died A.D. 209)
Gaoyaocun 高窯村
Ge Hong 葛洪 (4th cent.)
gengzhitu 耕織圖
gong 栱 (bracket arm)
gong 宮 (palace)
gong 觥 (type of bronze vessel)
gong 工 (workday)
gong Jiang 宮疆
gongshi 工師
gongshui 宮水
gu 觚 (bronze beaker)
Gu 古 (family name of gilder)
guan 冠
guang 廣
Guanghan 廣漢
Guangzhou 廣州
Guanwu waipian 觀物外篇
guazi gong 瓜子栱
gudu 骨度
gui 簋
Gujin tushu jicheng 古今圖書集成

Hakata 博多
Han Xin 韓信 (died 196 B.C.)
Hangzhou 杭州
He Huijian 何惠鑑
He Yanzhi 何延之 (8th cent.)
Hemudu 河姆渡
Hokkiji 法起寺
Hônenji 法然寺
Hongren 宏忍
Hongzhi 弘治
Hôrinji 法輪寺
Hôryûji 法隆寺
Hôshôji 寶性寺
Houma 侯馬
hu 壺
hua 化
huagong 華栱 (projecting bracket)
huagong 畫工 (painter)
Huai 淮
Huaisu 懷素 (ca. 735–ca. 799)
Huangcheng 皇城
Huangdi neijing, taisu 黃帝內經,
　　太素
huangji 皇極
Huangting jing, Waijing jing 黃庭
　　經, 外景經
huangtugong 黃涂工
huanqiu 圜丘
Huashou jing 華手經
Huayanjing 華嚴經
hugong zushi 護工卒史
huibian 彙編
Huizong 徽宗 (r. 1101–25)

Ishii Mokichi 石井茂吉

ji 極 (ultimate)
ji 機 (loom)
jia 家 (workshop)
Jia 嘉 (family name of government
　　inspector)
jiaguwen 甲骨文
jian 間 (bay)
jian 鑑 (type of bronze basin)
Jiang 疆 (family name of foreman)
jiang 匠 (artisan)
Jiangshan woyou tu 江山臥遊圖
Jianping 建平
jiantizi 簡體字
jianzao chu 監造處
Jianzhen 鑑眞 (Japanese: Ganjin)
jiaodui shuji chu 校對書籍處
jiaohu dou 交互枓
Jiashu 家書
jie 街

Jieziyuan huazhuan 芥子園畫傳
jimiao 極廟
jin 今 (now)
jin 金 (metal)
jin 斤 (pound)
Jin 晉 (state)
Jin Jian 金簡 (d. 1794)
Jin Nong 金農 (1687–1764)
Jing 景 (duke; 577–537 B.C.)
Jingdezhen 景德鎮
Jinggongsi 景公寺
jingji 經籍
jinshi 進士
jinwen 金文
jiqi 祭器
Jôdoji 淨土寺
Jôdoshû 淨土宗
Jôshôji 定勝寺
jue 爵
Jun 駿
jusheng shen 俱生神
juzi 居眥

kaishu 楷書
Kanagawa Prefectural Museum 神
　　奈川縣立博物館
Kanazawa Library 金澤文庫
Kangxi 康熙 (r. 1662–1722)
Kangxi zidian 康熙字典
kaogong 考工
Kasuga gongen genki-e 春日權現
　　驗記繪
Kenchôji 建長寺
Kim Kan. See Jin Jian
Kondô 金堂
Kôtôin 高桐院
kou 口
ku 苦
Kuan 寬
kuangcao 狂草
Kubosô kinen bijutsu kan 久保惣
　　紀念美術館
Kundaikan sôchôki 君台觀左帳記
kunyu 坤輿
Kyongjû 慶州
Kyôto 京都

lai 來
lan 蘭
lan'e 闌額
Lanting ji 蘭亭記
Lanting xu 蘭亭序
Lanzhou 蘭州
le 樂
lei 罍

Leigudun 擂鼓敦
Li 李 (family name)
Li 麗 (mountain)
li 力 (force)
Li Ji (Li Chi) 李濟
Li Jie 李誠 (died 1110)
Li Kan 李衎 (1245–1320)
Li Si 李斯 (ca. 280–208 B.C.)
Li Xiaoding 李孝定
Li Yangbing 李陽冰
Liang 良 (family name of chief
　　administrator)
liang 兩 (ounce)
Liang Sicheng 梁思成 (1901–
　　1972)
liaoyan fang 撩檐枋
Liji 禮記
Lindedian 麟德殿
Ling fangyi 令方彝
linggong 令栱
lingshi 令史
Lingyinsi 靈隱寺
Lintong 臨潼
lishu 隸書
Liu Gongquan 柳公權 (778–865)
liuchuanfu 六椽栿
liunei quan 流內銓
liushu 六書
liuyi 六藝
lixue 理學
liyi 禮儀 (ritual)
Liyi 麗邑 (District of Li)
Liyu 李峪
Lolang 樂浪
Long 隆
Longquan 龍泉
Longshan 龍山
Lu 陸
Lu Xinzhong 陸信忠 (13th cent.)
Lu Xinzhong bi 陸信忠筆
Lü 呂 (r. 188–180 B.C.)
Lü Buwei 呂不韋 (died 235 B.C.)
ludou 櫨枓
Lunshu biao 論書表
Luohan 羅漢
luohan fang 羅漢枋
Luoyang 洛陽

mangong 慢栱
Mao Zedong 毛澤東 (1893–1976)
Maoling 茂陵
Masaki Museum 正木美術館
Mawangdui 馬王堆
Meihua xishen pu 梅花喜神譜
meishu 美術

Mengxi bitan 夢溪筆談
Mi Youren 米友仁 (1074–1151)
mian 冕
miao 廟
Ming'an 冥案
mingfu dian 冥府殿
mingqi 明器
mingtang 明堂
minyao 民窯
Mituoshan 彌陀山
Morisawa Nobuo 森澤信夫
mu 木
Mu 穆 (duke; 659–621 B.C.)
Mujing 木經
muque 母闕
Muxi 牧谿 (ca. 1269)

Nagasaki 長崎
Nan Yue 南越
Nanchansi 南禪寺
Nangyang 南陽
Nara 奈良
neiguan 內官
Nezu Institute of Fine Arts 根津
　　美術館
Ni Zan 倪瓚 (1301–1374)
nidao gong 泥道栱
Ningbo 寧波
Nôami 能阿彌 (1397–1471)
Nongshu 農書
nü 女

odaruki 尾棰

Paegun 白雲 (1299–1375)
Panlongcheng 盤龍城
Peiwenzhai shuhuapu 佩文齋書畫譜
pi 鈹
pingshi 評事
Pulguksa 佛國寺
puzuo 鋪作
Pyongyang 平壤

Qi 齊
Qiang 墻
qi ang jiaohu dou 騎昂交互枓
Qianlong 乾隆 (r. 1736–95)
qifu gong 騎栿栱
Qin 秦
Qin gong gui 秦公簋
Qin Shihuangdi 秦始皇帝 (r.
　　221–210 B.C.)
qindian 寢殿
Qing gongbu gongcheng zuofa zeli 清
　　工部工程做法則例

qinggong 清工
Qingyuanfu 慶元府
Qingzhen 清鎮
Qishan 岐山
qixin dou 齊心枓
qu 曲
Quanxiang pinghua 全相平話
que 闕
Qufu 曲阜

ren 亻 (*ren* 人)
Rencheng 任城
Renmin ribao 人民日報
Rong 戎

Sai 賽
Saikyôji 西教寺
sandou 散枓
sanjû no tô 三重塔
Sanxi tang 三希堂
Seiganji 誓願寺
Sen-oku Hakuko Kan 泉屋博古
　　館
Sengcan 僧璨
shanggong 上工
Shanghai 上海
Shangjiaocun 上焦村
Shanglin 上林
shao 邵
Shao Yong 邵雍 (1011–1077)
shaofu 少府
Shen Gua 沈括 (1031–1095)
sheng 升
shenguan yuan 審官院
shenyi 神異
Shi Qiang pan 史墻盤
Shiwang dian 十王殿
Shi wang jing 十王經
shihuo 食貨
Shiji 史記
shijie 世界
Shimen zhengtong 釋門正統
Shiqu baoji 石渠寶笈
shinbashira 心柱
shou 壽 (long life)
shou 扌 (hand 手)
shôwa 昭和
shu 術 (art)
Shu 蜀 (Sichuan)
shuanggou 雙鉤
shuatou 耍頭
shui 水
shuo 說
Shuowen jiezi 說文解字
Si Mu Wu fangding 司母戊方鼎

sigong 寺工
siguan 飤官
siheyuan 四合院
Sima Qian 司馬遷 (born 145 B.C.)
Sôami 相阿彌 (1485?–1525)
song 誦
Song Boren 宋伯仁
Songzhai meipu 松齋梅譜
su 俗
Su Hanchen 蘇漢臣
sufang 素枋
sugong 素工
Sui 睢
Suizhou 隨州
Sumitomo 住友
Suzhou 蘇州

Tai 泰 (mountain)
tai 太 (supreme)
Taiji tushuo 太極圖說
Taijigong 太極宮
Taiyuan 太原
Takamatsu 高松
Tan 潭
Tanaka Tan 田中淡
Tao Qian 陶潛 (365–427)
taotie 饕餮
tiancao panguan 天曹判官
Tiangongsi 天宮寺
tianran 天然
tiantan 天壇
timu 替木
tingtang 廳堂
tingxie 亭榭
Tôshôdaiji 唐招提寺

Wai-Kam Ho (See He Huijian)
wang 王
Wang Anshi 王安石 (1021–1086)
Wang Gai 王概 (active 1680–
　　1700)
Wang Guixiang 王貴祥
Wang Mang 王莽 (r. 9–22 A.D.)
Wang Shimin 王時敏 (1592–
　　1680)
Wang Xianzhi 王獻之 (344–388)
Wang Xizhi 王羲之 (303–361)
Wang Yuanqi 王原祁 (1642–
　　1715)
Wang Zhen 王禎 (fl. 1290–1333)
Wang Zhongshu 王仲殊 (1925–)
wan 萬
wanwu 萬物
Wei bo Xing 微伯癭
Wei Liao zi 尉繚子

Weiyanggong 未央宮
wen 文
wenren 文人
wenwan 文翫
wenxue 文學
Wu 武 (emperor; r. 140–87 B.C.)
Wu 戊 (family name)
Wu 吳 (state)
wu 無 (without)
Wu Daozi 吳道子 (active ca. 710–
 760)
Wu Ding 武丁
Wu Taisu 吳太素
Wu Zetian 武則天 (624–705)
Wu Zhen 吳鎮 (1280–1354)
Wugou jingguang da tuoluoni jing
 無垢淨光大陀羅尼經
Wutaishan 五臺山
Wuwei 武威
Wuying dian 武英殿

xian 縣 (district)
Xian 西安 (city)
Xian beilin 西安碑林
xiang 巷
Xiang Yu 項羽 (232–202 B.C.)
Xianyang 咸陽
Xianyang Ke 咸陽笴
Xiaomintun 孝民屯
Xiaozhong xianda 小中現大
xiaozhuan 小篆
xie 寫
xingshu 行書
Xingrang tie 行穰帖
Xintian 新田
xiu 修
xiugong 髹工
Xixia 西夏
xu 繻
Xu Beihong 徐悲鴻 (1895–1953)
Xu Shen 許慎 (ca. 55–ca. 149)
Xu Wei 徐渭 (1521–1593)

ya 亞
Ya Chou gong 亞醜觥
yacao fang 壓槽枋
Yamato 大和
Yan 燕 (state)
yan 焉 (particle)
yan 言 (word)
yanchuan 檐椽
yang 陽
Yang Xin 羊欣 (370–442)
yangshuo 陽朔
Yangzhou 揚州

Yangzi 揚子
Yanshi 偃師
Yantielun 鹽鐵論
yanzhu 檐柱
Yaoshi liuli guang rulai benyuan gong-
 de jing 藥師琉璃光如來本
 願功德經
yejing 業鏡
Yi 宜 (family name of lacquerer)
yi 頤 (yi of Zhou Dunyi)
yi 藝 (art)
yi 匜 (type of bronze vessel)
Yi Ying bei 乙瑛碑
Yijing 易經
yin 陰
yinghuang 硬黃
Yingxian 應縣
Yingxian muta 應縣木塔
Yingzao fashi 營造法式
Yishan bei 嶧山碑
yishu 藝術
yong 永 (eternal)
Yong 雍 (city)
Yongle 永樂 (r. 1403–24)
Yongle dadian 永樂大典
Yongzi bafa 永字八法
you 卣 (type of bronze vessel)
You 有 (family name of lacquerer)
Yu 馭
Yu Hao 喻皓 (active 965–995)
Yu He 虞龢 (ca. 470 A.D.)
Yu Shinan 虞世南 (558–638)
yuan 掾
Yuan Zhongyi 袁仲一
Yue 越
Yue Ke 岳珂 (1183–1234)
Yunjusi 雲居寺
yuwu 宇屋

zaogong 造工
Zendôji 善導寺
Zeng hou Yi 曾侯乙 (died ca.
 433)
Zhang 張 (family name of work-
 shop painter)
Zhang 章 (family name of govern-
 ment inspector)
zhang 長 (chief administrator)
Zhangyi 章懿
Zhang Daiqian 張大千 (1899–
 1983)
Zhang Guangyuan 張光遠
Zhang Yanyuan 張彥遠
Zhaobeihucun 趙背戶村
Zheng Xie 鄭燮 (1693–1765)

Zhengzhou 鄭州
Zhenzong 眞宗 (r. 998–1022)
Zhihua 智化寺 (monastery)
zhong 鐘
Zhongfeng Mingben 中峰明本
Zhongshan 中山 (state)
zhongwei 中尉
Zhou 紂 (king)
zhou 周 (zhou of Zhou Dunyi)
Zhou Ba 周霸 (ca. 19 B.C.)
Zhou Bo 周搏 (ca. 18 B.C.)
Zhou Dunyi 周敦頤 (1017–1073)
Zhou Peiyuan 周培源
zhu 諸
Zhuangbai 莊白
zhuchu 柱礎
zhupan 主判
Zhupu xianglu 竹譜詳錄
Zhuque dajie 朱雀大街
zhuri lunzhuan banfa 逐日輪轉
 辦法
zi 子
zique 子闕
ziran 自然
Zixutie 自敘帖
zixue 字學
Ziying 子嬰
Zong 宗
zucai 足材
zun 樽

Index

Numbers in *italics* indicate pages on
which pictures are found.

abbreviated characters (*jiantizi*),
 21–22, *21*
abstraction, in Chinese art, 202
action painting, 198
aesthetics
 art objects valued in terms of, 190
 of bronze vessel decorations, 41
 of calligraphy, 3, 194–99
 Chinese theory of, 195–96,
 200–202
 of painting, 200–213
 Western theory of, 7
afterlife, Buddhist beliefs about,
 164–65, 176–77
albums
 of old master paintings, for copy-
 ing, 202
 porcelain production depicted in,
 98–100, *98–99*
 production processes depicted in,
 98–100
Alexander the Great, 63
alphabet, 22–23
An Lushan, 183
anatomy, units of body measurement
 in, 6, 136
ancestors, offerings to, 29, 191–92
animals, fabulous (*taotie*), 32–35
antiquarians, Song period, 35
Anyang (Henan Province), 28
 Shang tombs at, 26–28, *26,* 45–46
Apang palace of First Emperor, 119
archaelogical excavations
 vs. looters and tomb robbers,
 26–28, 45
 scientific control and recording of,
 26–28
 of tombs, 25–28, 45, 51, 53
architecture (Chinese)
 five levels of, 107–17
 history and historians of, 117–20,
 133
 measurement units in, 132, 134
 models of, 193
 standardization of, prescribed in
 Yingzao fashi, 3, 119, 132–37
 status of, vs. Western, 187
 timber frame, 3, 5

treated in the *Synthesis,* 189–90
 See also pagodas; post and beam
 construction
armchair motif, 180–81
armies, Qin, 63–64
 terra-cotta. *See* Qin Shihuangdi:
 magic army of terra-cotta
 soldiers
art(s)
 applied and minor, 3, 187
 Buddhist. *See* Buddhist art
 Chinese
 collecting of, 3, 190–94
 developments in, 2, 202
 factory production of. *See*
 factory art
 people's definition of, 187–94
 term for (*meishu*), 188
 See also individual arts, e.g. callig-
 raphy; painting; porcelain; *etc.*
 originality and, 7
 realism in, 7
 Western
 collectibility of Chinese art in-
 fluenced by, 193
 definition of, 187
artists and artisans (Chinese)
 jiang (artisan) and *su* (vulgar)
 applied to, 200
 literati distinguished from, 194
 names of, inscribed on objects, 2,
 61, 69–70, *69,* 76, 78–80, 159
 status of, 188
Augustus the Strong, elector of
 Saxony, 89

Bagley, Robert, 35, 42
balustrade motif, 180–81
bamboo motif, 97, 204–205, 207–13
Bao, judge, apotheosis of, 184
Bauhaus, module concept of, 134
bays (architecture), 111–13
 building grades and, 135
 increase in number of, 111–13
 in typical floor plans, *104*
Beijing
 imperial palace at. *See* Imperial
 Palace (Beijing)
 layout of, 117
 significance of location of, 111
bells, military, 59

Benjamin, Walter, 7
Bezeklik, wall painting from, *176, 177*
Bi Sheng, 150
bodies
 stamps on, 160
 units of measurement of, 6, 136
Boettcher, Georg Friedrich, 89
bone, inscriptions on (*jiaguwen*),
 18–20
book(s)
 Chinese
 bound format for, 142, 161
 collected in libraries, 193
 handscroll format for, 151, 161
 mass production of, 3
 traditional design of, 142–46
 as random-access devices, 161
Book of Changes (*Yijing*), 2
boxes of many treasures (*duobaoge*),
 192
bracketing (post-and-beam construc-
 tion), 107–11, *107–109,* 118
 described in *Yingzao fashi,*
 133–34, *134, 135*
bronze
 casting of, 25–49
 factory system of production for,
 2, 5, 38–44, 48–49
 molds for, assembly of, 38, *38*
 printing process anticipated by,
 153–56
 Shang module systems in, 2
 inscriptions in (*jinwen*), 19,
 40–41, *40, 41,* 155, 156, *156*
 collectors' interest in, 191
 monopolization of, 29
 nonritual vessels, 80–81
 ritual vessels (Chinese), 25–49
 clay copies of, 66
 collecting of, 191–92
 decoration of, 30–38, 41, 44,
 118, 153
 excavation of, 25–28
 function of, 28–29
 handed down through genera-
 tions, 29–30
 hoards of, 28
 mechanical duplication of,
 41–44
 registers and compartments of,
 36–38, 156–57

"ritual revolution" in types of
(Shang to Zhou), 46–47
sets of, 45–48
social hierarchy expressed by,
29–30
treated in the *Synthesis,* 189
types of, 28–29, 36–38
uniqueness of, 25
Brush Jottings from Dream Creek
(*Mengxi bitan;* Shen Gua), 150
brush writing. *See* calligraphy
brushstroke(s), 10–11
from calligraphy of Liu Gong-
quan, *10,* 11
characters built from, 9–11
in painting of traditional motifs,
204–205
from *yong* ("eternal"), *10,* 11
Buddha, relics of, 152–53
Buddhism, 164–66, 176–77, 180
Chan school of, 180–81
in China, 176
in Japan, 167
missionary activities and, 152–53
Pure Land School of, 167
sutras in. *See* sutras
use of seals in, 160
Buddhist art, 163–85
division of labor in production of,
175
iconography of, 179–85
modular production of, 2, 3
Building Standards (*Yingzao fashi*), 3,
119, 132–37
buildings
grades of (*deng*), 119, 135–36, *136*
sets of, in courtyards, 113–14
south-facing orientation of, 111
bureaucracy, Chinese government
growth in numbers of, 184
as model for bureaucracy of hell,
163
origin of, in factory production, 5
Byzantium, 85

calligraphy, 11
aesthetics of, 3, 194–99
as art, 187–90
collectors and collecting of, 3,
193–94
individuality seen in, 196–99
by literati vs. professionals, 194
materials for, 199
rules of, need to learn, 196–99
status of, East vs. West, 187
supremacy of, 193–94

variations in characters in, 13, 18,
194–99
See also characters; script
carpenters, East Asian, 127–32, *127*
tools used by, *126,* 127, *127*
See also post and beam construc-
tion
ceramics
factory production of, 3
technology of, 39
See also porcelain
chalice, celadon (Kassel), 88, *88*
Chan Buddhism, 180–81
Chang'an (modern Xian), 114–17,
119–20
monasteries in, 226*n*38
plan of, 114, *116*
tombs near, 81
Changling (Changping County, Hebei
Province), Mausoleum of Em-
peror Yongle, *111,* 112, *112*
Changsha (Hunan Province), tomb
in, 160
characters, 11–23
abbreviated, 21–22, *21*
composed of strokes, 9–11
by Empress Wu Zetian, 152
modular composition of, 10,
14–18
shapes and sizes of, 17
standardization of
during Qin 3, 20
lack of, during Shang, 18–20
styles of, 18–22, 199
variations and individuality in
shapes of, 13, 18, 40–41,
194–99
See also calligraphy; script:
Chinese; *specific characters*
chariots, 63
in Shang burial, 26, 63, *63*
Chen Mingda, 132
Cheng Zhengkui, 206
Chiang Kai-shek, 191
China
bureaucracy and record keeping
in, 184
cultural unity of, 4, 22–23
trade with Japan by, 167
unification of, 61–62, 114
china. *See* porcelain
Chinese (language)
modularity of, 2
unified by Chinese script,
22–23
See also characters

Chongshansi (Taiyuan, Shanxi
Province), 114, *114*
Christie's (auction house), 97
Chu state, 43, 59, 62
cities, modular-grid layout of, 3,
114–17, 119
civil service system, European, 101
Classic of Wood Work (*Mujing*), 133,
136
classification
Foucault on, 188–89
of plants and stones, in illustrated
manuals, 203
clay
in bronze casting, 154–56
funerary objects of, 65, 66
printing on, 156–57
properties of, 67–68
seal stamps on, 160
Clerical Script (*lishu*), 20
Colbert, Jean-Baptiste, 101
*Collectanea Printed by the Hall of Mar-
tial Eminence in Movable Type*
(*Wuyingdian juzhengban cong-
shu;* Kim Kan), *138,* 141, 142,
143, 145, 146
*Collected Statutes of the Great Ming
Dynasty* (*Da Ming huidian*), 87,
87, 96
collection(s), Chinese
artists' study of works in, 202,
205
of calligraphy, 3, 193–94
collector's seal inscribed on works
in, 192
imperial, catalogues of, 191, 192
indicating what was considered
art, 190–94
composition
of landscapes, standard, 203
of painting motifs, 170, 202–13
on porcelain, 94–97
Confucius, 67, 111
Correct Lineage of the Buddhists
(*Shimen zhengtong*), 184
courtyard(s), 113–14
hierarchy of buildings in, 136, *136*
single and double, 113, *113*
in *Yingzao fashi,* 136
creation process
Chinese theories of, 7, 9
effect of modular methods on,
6–7, 48–49, 213
holistic vs. modular, 48–49, 195
nature and, 6, 7, 207, 213
crossbows, 60, 62

Cuo, King of Zhongshan, tomb of, 118
cylinder scrolls (ancient Near East), 161

Da Ming huidian (*Collected Statutes of the Great Ming Dynasty*), 87, *87*, 96
Dai, Princess, tomb of (Mawangdui, Hunan Province)
 lacquered dishes in, 77, *77*
 textiles in, 84, *84*, 157, *158*
Daji, consort of King Zhou, 182
Daoism, 148, 160
Daozong, Emperor, 127
Dawenkou culture, 85
Delft ceramics, 90
Deng Shiru, calligraphy by, 196, *196*
Denmark, traders from, 89
Description de la Chine (du Halde), 100
dhâranî, 151–52
 miniature pagodas bearing, 151, *151*
 printed roll with (Pulguksa monastery, Korea), 151–52, *151*
Diamond Sutra scroll (from Dunhuang caves), *150*, 151, 152
dictionaries, Chinese, 14, 20, 215n1(1)
Diderot, Dénis, 141
ding (vessel)
 in Musée Guimet, 44, *44*
 from Panlongcheng, *39*, 40
Discourses on Salt and Iron (*Yantielun*), 77
Dong Qichang, 202, *202*
Draft Script (*caoshu*, cursive), 21, 194
dragons, 32, 35
drainage pipes, 69
 Qin, *68*, 69
drums, military, 59
dui vessel (Freer), 44, *44*
Dunhuang caves
 hell scrolls from, 179–84
 Ksitigarbha with the Ten Kings scroll from, *176*, 178, 183
 painted scrolls from, 179, *179*, 183, 184
 Scripture of the Ten Kings (*Shi wang jing*) from, *178*, 179, *179*, 184
 scriptures found in, *150*, 151, 176, 177
 wall paintings in, 2, 120, *120*, 175

effigies, 66
Eight Eccentrics of Yangzhou, 207

Eighteen Scholars in a Garden (anon.; Taipei), 181, *182*
Encyclopedia. See Synthesis of Books and Illustrations, Past and Present (*Gujin tushu jicheng*)
encyclopedias (Chinese)
 classification system of, 188–90
 as models for European versions, 141
England. *See* Great Britain
Entrecolles, Père François Xavier d', 100–101
Essential Paragraphs of Buddhist Patriarchs Pointing Straight Toward the Very Heart, 150
Europe
 Chinese trade with, 88–91
 porcelain produced in, 89–90, 101
 sculpture from, 175
 silk production in, 3, 84–85
 See also West, the
Explaining Graphs and Analyzing Characters (*Shuowen jiezi*), 20
export ware (porcelain), 88–90

factories (Chinese), 2–5, 38–44, 48–49, 75
 state-run vs. private, 69–70, 75–80, 84, 87–88
factory art, 4–5, 48, 75–101
 collecting of, 192–93
 lacquerware, 77–80
 porcelain, 85–101
 treated in the *Synthesis,* 189
fangding (vessel), 27
 Beijing, 27, *27*, 48
fanglei (vessel), 36, 37
 Kyoto, 37, *37*
 Shanghai, 36, *37*, 153
fangyi (vessel), 30, 36
 Cologne, *24*, 30–34, *31*, *32*, 153–54
 Freer, 217n39
 New York (Metropolitan Mus.), *33*, 34, 36, 154
 Sackler (Washington, D.C.), 36, *36*
fen (unit of measure), 134
Fengguosi (Yixian, Liaoning), Daxiongbao Hall, *111*
First Emperor. *See* Qin Shihuangdi
Fogongsi (Buddha Palace Monastery), 127
Foguangsi monastery (Wutaishan, Shanxi Province), main hall, 103–11, *104–106*, 120, 135
food preparation (Chinese)
 modularity of recipes for, 4

in ritual meals, 29
Ford, Henry, 4–5
Foucault, Michel, 188–89
fourfold yard (*siheyuan*), 113
France, industrialization in, 101
fu Hao. *See* Hao, Lady
Fu Shen, 196
 calligraphy by, *ii*, 196, *197*
funerary objects, 65, 66, 192

Gamble, William, 149
Gaodi, Emperor, 181
Gaoyaocun (near Xian), hoard of bronze vessels from, 80
Garland Flower Sutra (*Huayanjing*), 149–50
Ge Hong, 160
Geldermalsen shipwreck, porcelain retrieved from, 90–97, *90*, *91*, *93*, *95–97*
gong (vessel), 38
 Ya Chou gong (Tokyo), 38, *38*, 40, *41*
grading of buildings, 119, 135–36, *136*
graphic design, bronze decor as, 153–54
Great Britain
 industrialization in, 101
 trade with China, 88, 89
Great Dhâranî Sutra of Stainless Pure Light, 151
Great Dictionary of the Yongle Period (*Yongle dadian*), 141, 183
 The Trial of An Lushan, 183, *183*
Great Silla dynasty (Korea), 151
Great Wall of China, 63
Greece, 7, 63
gu (vessel), 40, *40*, 45–46, *45*, *46*, 155
gui (vessel): Qin gong gui (Beijing), 156, *156*
Gujin tushu jicheng. See Synthesis of Books and Illustrations, Past and Present
Gutenberg, Johannes, 150

Halde, Jean Baptiste du, 100
halls, ground plans of, *111*
Han
 dynasty, 65
 palaces from, 119
 period
 cities of, 119
 elite of, 77–78
 excavations of sites from, 160
 textiles, 84, 157
 tombs, treasures in, 191

Han Xin, 181
handscrolls, 151, 161
Hao, Lady (fu Hao), tomb of, 27,
 45–46
 floor plan of, 27, *27*, 45
 vessels from, 40, *40*, 45, *45*, *46*,
 155, 217*n*56
heart pillar (*shinbashira*), 121
hell (Buddhist), 163–85
 kings of. *See* king(s) of hell
 painting(s)
 paintings of, 3, 177–85
 treated in the *Synthesis*, 190
Hemudu (Zhejiang Province),
 Neolithic site at, 117, *117*
Hokkiji pagoda (Nara Prefecture,
 Japan), *102*, 121–27, *121–27*
Hôrinji pagoda (Japan), 124, *126*, *127*
Hôryûji monastery (near Nara,
 Japan), 120
Houma (Shanxi Province), foundry
 at, 5, 42–43
Huaisu, 194–95
 autobiography of (*Zixutie*),
 194–95, *195*
Huizong, Emperor, 133
 collection of, 191

iconography
 of bronzes, 35
 of Buddhist art, 179–85
 of paintings, 207
 of porcelain, 97
 relevance of, 156
 of secular portraiture, 180–81
images, replication of, 175
imperial cities, 114–17
imperial collections, 191, 192
Imperial Palace (Beijing), 114, *115*,
 140, 199
 Hall of Supreme Harmony at, *111*,
 112, 115
Imperial Printing Office (Qing),
 140–48
India, 61
individuality, 5
 in calligraphy, 196–99
 in painting, 213
 in woodblock printing, 148
Industrial Revolution, 101
infantry, obedience required of, 63–64
ink, 153, 159, 161
inscriptions
 on bronze vessels. *See* bronze: in-
 scriptions in (*jinwen*)
 on paintings, 211–12
 on weapons (Qin), 60–61, *60*, *61*

iron, casting of, 62

jade, 29
Japan
 city layout in, 117
 early printing in, 152
 script in, 21
jian (vessel), 41
 Freer, 41, *42*, 155
 Minneapolis, 41, *42*, 155
jiantizi, 21–22, *21*
Jianzhen (Ganjin), 112
Jieziyuan huazhuan (*Mustard Seed
 Garden Manual of Painting*),
 204–205, *204*
Jin Jian. *See* Kim Kan
Jin Nong, 228*n*51
Jin state, 41–43, 63
Jinci (Taiyuan, Shanxi Province),
 Holy Mother Hall, *111*
Jingdezhen (Jiangxi Province)
 modern porcelain from, 86, *86*
 traditional porcelain production
 at, 3, 4, 5, 86–88, 89, 91,
 100–101
jue (vessel), 45–46
Julien, Stanislas, 3
Justinian, Emperor, 85

Kaishansi (Xincheng, Hebei
 Province), main hall, *111*
Kamakura period, 167
Kangxi, Emperor, 141, 205
Kangxi Era Dictionary (*Kangxi zidian*),
 20
Karlgren, Bernhard, 35
Kim Kan (Jin Jian)
 Manual of, 142–49, *143*, *147*
 printing by, *138*, 141–48, *143*, *145*
king(s) of hell painting(s), 167–68,
 190
 Third King, 171, *172*
 Fifth King, *164*, 165, 181
 Sixth King, *164*, 165, 172, *173*,
 174, 177
 Seventh King, 159, *162*, 168–72,
 168–73
 Eighth King, 165, *165*
 Tenth King, 166, *166*, 177, 183

Korea
 Buddhist scrolls in, 180
 city layout in, 117
 printing in, 150, 152
Kôtôin monastery (Kyoto, Japan),
 165

Ksitigarbha, 176–78, 180, 183

labor, 5
 division of, 49, 75, 101, 175
 measurement of, 137
 specialized, in factories, 75
lacquer, 59–60, 76–77
lacquerware
 as art form, 3
 collecting of, 192
 as indicator of social status, 77–78
 inscriptions on, 78, *78*, 79–80
 production of, 76–80
 treated in the *Synthesis*, 189
lai ("come"), 18–19, *19*
lan ("orchid"), 22, *22*
landscape motif, 97
Lanting xu (*Orchid Pavilion Preface*),
 11, *11*, 21, 191, 195–96
Latin (language), 22
law and law codes, 62
 in the afterlife, 165
Leibniz, Gottfried Wilhelm, 2
*Lettres édifiantes et curieuses de la
 Chine*, 100
li ("force"), 16, 17, *18*
Li Chi (Li Ji), 216*n*1
Li Jie, 133
Li Si, 20, 53
Liang Sicheng, 133, 222*n*2
Liao dynasty, 127
libraries, collections of, 193
Liji (*Record of Ritual*), 28, 135
Lingyinsi monastery (Hangzhou),
 152
literacy (Chinese), 1
 changes in script affecting, 18
 number of characters known by
 average person, 14
literati (*wenren*)
 art defined by 193–94
 class identity of, calligraphy and,
 199
 collections of, 167, 193–94
 painting by, 202–13
 values of, and iconography, 97
 writing central to life of, 1
Liu Gongquan, calligraphy of, 11
 stroke types derived from, *10*, 11
Loehr, Max, 35
loess, 67–68
Lolang (Korea), 78
*Long Roll of Buddhist Images: Three
 Chan Patriarchs* (Taipei), 181,
 181
Longshan culture, 85, 215*n*8(2)
looms, 83

Lotus Hand Sutra, stone inscription of, *8,* 11–13, *12,* 13, 14, 16, *16,* 20, 122
Lü Buwei, 53
Lü, Empress, 181
Lu Xinzhong
 workshop of, 167–68, 190
 The Fifth King, 164, 165, 181
 The Sixth King, 164, 165, 172, *173, 174,* 177
 The Seventh King, 159, *162,* 168–72, *168–73;* after, 170, *171*
 The Eighth King, 165, *165*
 The Tenth King, 166, *166,* 177, 183
 signature of, 167, *167*
luxury goods, 77, 83
 "art" considered to be, 188, 192

machine(s)
 vs. hand craft, in Chinese factories, 76
 invention of, 3–4, 83
Mad Cursive Script (*kuangcao*), 194–95
manuals
 on painting, 203–205
 on printing, 142–49
 usefulness of, in module system, 132–33, 148
manufacturing. *See* factories (Chinese)
Mao Zedong, 65
Maoling (mausoleum of Emperor Wu), 81
mass production, in China, 2–5
 bronze casting, 43–44
 porcelain, 3, 98–101
 weapons, 60
measurement(s)
 absolute and proportional, 119, 136
 anatomical, 6, 136
 architectural, 132, 134
 of work, 137
Meissen porcelain, 90
Mengxi Bitan (*Brush Jottings from Dream Creek;* Shen Gua), 150
metals, Qin-period technology of, 62
Mi Youren, 202, *202*
Ming
 dynasty, fall of, 88
 period, collecting in, 191–93
missionaries
 Buddhist, 152–53
 Christian, 149

modular production, 1–6
 vs. holistic (single artist), 48–49, 195
 individuality sacrificed in, 5
 mechanical, with hand finishing, 127
modules, 1–2, 134
 standardization of, 132–33, 148
molds, clay
 assembly of, 38, *38*
 for casting coins, 39, *39*
 for casting *fangyi,* 39, *39,* 154, 155
 for casting *jian,* 42, *43,* 155, 156
 patterns in, 154
monasteries, 167
 layout of, 113–14
 treated in the *Synthesis,* 190
 See also specific monasteries
motifs
 composition of, on porcelain, 91–97
 exotic, 43
 in paintings, modular use of, 163, 175, 185, 202–13
 See also specific motifs
movable type
 ceramic, 150
 disadvantages of, 148–49
 divisible, 149
 fonts for, 141, 144
 history of, 3, 141–44, 148–50, 156
 metal, 141–42, 149
 wood, 141, 142–44, 149
Mu, duke of Qin, tomb of, 67
Mujing (*Classic of Wood Work*), 133, 136
Muromachi period, 167
Mustard Seed Garden Manual of Painting (*Jieziyuan huazhuan*), 204–205, *204*
Muxi, 203, *203*

Nan Yue kingdom, tomb of 2nd king of, 157
 printed textiles in, 157, *158*
 seal of, 159, *159*
Nanchansi, main hall, 120
nature, artists' work and, 6, 7, 207, 213
Near East (ancient), 161
necropolises, 55, 61, 65–68.
 See also Qin Shihuangdi: necropolis of
Neolithic period
 buildings of, 117

lacquered utensils of, 76
pottery of, 85, 156
textiles of, 157
Netherlands, traders from, 88–89
New York Times, 22, *23*
newspapers (Chinese), 22, *23,* 149
Ni Zan, 180, 204
Ningbo (Zhejiang Province)
 hell scrolls from, 179–85
 painting workshops in, 163, 167–68, 193, 203
Noin Ula (Mongolia), 78
north (direction), 111
Northern Zhou dynasty, 114
nü ("woman"), 17, *17, 19*

officials (Chinese), depiction of, 181
 See also bureaucracy, Chinese government
One Hundred Children at Play (anon; Cleveland), 181, *181*
oracle bone inscriptions (*jiaguwen*), 18–20
orchid motif, 207–12
Orchid Pavilion Preface (*Lanting xu*), 11, *11,* 21, 191, 195–96
Order of Things (Foucault), 188–89
Ottoman Empire, 88

Paegun (Korean monk), 150
pagodas, 121–32
 in China, oldest extant, 127
 representing Buddha's tomb, 152
 treated in the *Synthesis,* 190
 upper stories of, 123
 See also architecture; *specific buildings*
painting(s)
 Buddhist
 collecting of, 193
 composition of, 170
 merit gained through, 175
 See also Buddhist art
 Chinese
 aesthetics of, 200–213
 as art, 187–90, 193–94
 individuality in, 213
 manuals on, 203–205, *203, 204*
 materials for, 194, 202
 mimesis in, 200
 modularity in, 202–13
 by professionals, vs. literati, 194
 secular portraiture, iconography of, 180–81
 spontaneity in, 200
 stencils used in, 175

training in and rules of, 202
treated in the *Synthesis,* 190
values prized in, 200, 213
by literati
collectors and collecting of,
193–94, 202–13
pricing of, 173, 206–207, 211–12
Palace of Great Brightness (Daming-
gong; Chang'an), 115, 120
Panlongcheng (Hubei Province),
Shang palace at, 117, *118*
paper
factory production of, 3
invention of, 139, 153
stamped seals on, 159–60
writing on, 20
paradise, Buddhist, 66, 120
pattern(s)
blocks, 42–44, *43, 49,* 154–57
repetition of
avoidance of, 46
in bronze vessels, 41–44
in Buddhist art, 3, 175
of textile motifs, 82
People's Daily (Renmin ribao), 22, *23*
People's Republic of China, script in,
21–23
Persia, 63
photocomposition, 149
*Pine Studio Plum Manual (Songzhai
meipu),* 203, *203*
Plain Tales Fully Illustrated, scenes
from, 181, *182, 183*
plants, illustrated in manuals, 203
Pollock, Jackson, *197, 198*
porcelain, 3, 4, *74,* 85–101
album depicting production of,
98–100, *98, 99*
collecting of, 192–93
European manufacture of, 89–90,
101
European specifications for Chi-
nese production of, 90, *90*
for export, 88–90
eyewitness accounts of production
of, 100–101
history of, 86–101
manuals on, 98–100
mass production of, 3, 98–101
motifs on, 91–97
treated in the *Synthesis,* 189
Portrait of Ni Zan (Taipei), 180, *180*
Portugal, traders from, 88
post and beam construction, 103–37
advantages of, 5–6, 103, 106–107
five levels of, 107–17

history of, 117–37
restoration of buildings con-
structed with, 123–24
sturdiness of, 5–6, 106–107
See also architecture
pottery, Neolithic, 85, 156
Presbyterian Mission Press, 149
printing, 139–61
aesthetics of, 139–40
blocks for, 153, *154*
delay in realization of, 153
and diffusion of social values, 5
European co-invention of, 3, 140,
150
on flat surface, 157, 160
history of, 149–53
mass production, mechanization,
and reproduction in, 139–40
modern methods of, 149
as modular system, 140, 146–48
with movable type. *See* movable
type
prehistory of, 153–60
treated in the *Synthesis,* 190
with woodblocks, 3, 148–50
prints (Chinese)
collecting of, 193
oldest (Dunhuang caves), 151
quantities of, 139–40
production, labor-intensive
in China vs. the West, 3
vs. expenditure for material, 111
See also labor
proofreading, 140–41
Pulguksa (South Korea), roll from,
151–52
Pure Land School (Jōdoshū), 167

Qi state, 62, 65
Qianlong Emperor, 192, 193
Qin
empire, destruction of, 54
period, 60, 69, 119
state, 51, 52–54, 62
military power of, 63–64
palace of, 69, 119
tombs from, 65, *65,* 67
and unification of China, 62–63
Qin Shihuangdi (First Emperor),
51–54
magic army of terra-cotta soldiers
of, 3, *50–53,* 51–73
burial pits for, 58, *58*
production method of, 68–73
sectional composition of, *68,*
69–73, *70–73*

workforce that created, 69–70
necropolis of, 53, 54, *54, 55,* 56
bronze chariots buried at, 56, *56*
construction of, 52–54, 57, 189
design of, 54–57
destruction of, 59
purpose of, 61–68
power of, in his time, 61–62
stone steles of, 19–20, *20,* 53
Qing dynasty
printing office of, 140–48
social hierarchies in, 5
tombs dating from, 114
Qingliansi (Jincheng County, Shanxi
Province), main hall, *111*
Qishan (Shaanxi Province), Western
Zhou palace at, 118, *118*

Réaumur, René-Antoine Ferchault de,
101
Record of Ritual (Liji), 28, 135
Records of the Historian (Shiji), 52–54
Regular Script (*kaishu*), 20–21, 148
Rencheng, kingdom of, stamped silk
from, 160, *160*
Renmin ribao. See People's Daily
reproduction (objects)
early trend toward, 2, 40–44, 85
in nature, 6–7
originality in art and, 7
of textiles, 82
ritual meals
Christian and Jewish, 29
Shang and Zhou, 28–29, 45
ritual vessels
bronze. *See* bronze: ritual vessels
(Chinese)
porcelain (*jiqi*), 87
rock motif, 97, 207–12
Rome (ancient)
imperial, plan of, *116,* 117
power of, 61, 63
signet rings from, 161
trade with China by, 84
roof(s), 106, 110, 113, 121
ruler(s)
Confucian ideal for, 111
legitimacy of, holy objects and,
191
tombs of, 65–68
Running Script (*xingshu*), 21

sacrifice(s)
in burials, 27, 56–57, 65
of humans and horses, 27, 57,
57, 65, 67

sacrifice(s): in burials (continued)
 inscriptions with, 57, *57*
 clay or wood substitutes for, 65
 of food and drink, 56
Sanskrit, sacred scripts in, 151
Sanxitang Collection (Beijing), 199
screen motif, 180–81
script
 Chinese, 4
 advantages of, vs. alphabet, 4,
 14–16, 22–23
 collecting of, 191
 grid arrangement of, 19
 history of, 7, 18–23
 modularity of, 1–2
 reproduced on flat surface (late
 Zhou), 3
 treated in the *Synthesis,* 189
 See also calligraphy; characters
 Western, 22–23
*Scripture of the Ten Kings (Shi wang
 jing),* 176–79
 The Black Messenger from (Dun-
 huang), *178, 179*
 scroll of scenes from (Dunhuang),
 178, 179, *179,* 184
scriptures, Buddhist
 collecting of, 193
 copying of, as meritorious, 177
 as relics, copying of, 152–53
sculpture
 European, 175
 status of, East vs. West, 187
 treated in the *Synthesis,* 189
seals (personal), 159–60, 192
Seal Script, 196, *196*
sets
 of bronze ritual vessels, 45–48
 of buildings in courtyards, 113–14
 of kings of hell paintings, 163–77
 of tableware, 96–97
Shaanxi Province, archaeological dis-
 coveries in, 51
Shang
 dynasty
 last ruler of, 182
 tombs dating from (Anyang),
 26–28, 63, 65
 period, 2, 5
 architecture of, 117–18
 bronze vessels from, 45–46
 factory production in, 4–5, 48
 mechanical reproduction
 avoided during, 44
 pottery of, 86
 rituals of, 25

script during, 18–20
 silk from, 83
Shanhuasi (Datong, Shanxi Province),
 Hall of the Deities, *111*
Shao Yong, 9
Shen Gua, 150
*Shi wang jing (Scripture of the Ten
 Kings),* 176–79
Shiji (Records of the Historian), 52–54
shijie ("world"), *12, 13,* 18, 122
*Shimen zhengtong (Correct Lineage of
 the Buddhists),* 184
*Shuowen jiezi (Explaining Graphs and
 Analyzing Characters),* 20
Sichuan Province, lacquerware
 factories in, 78
 que (towers) in, 118–19, *119*
signatures, Western, authenticity of,
 159, 198
silk
 establishment of European
 industry for, 3, 84–85
 manufacturing technique, 83–85
 seal stamps on, 160
Sima Qian, 52–54, 57, 189
Small Seal Script (*xiaozhuan*), 20, 53
Song
 dynasty
 bureaucracy of, 184
 imperial collection of, 192
 period
 antiquarians of, 35
 architecture of, 133
 collecting during, 191, 192
 paintings from, 181
south (direction), 111
Spain, traders from, 88
specialists, vs. generalists, 49, 75
Spring and Autumn Annals (Chunqiu)
 period, 62
Square Ding Dedicated to Mother Wu
 (Beijing), 27, *27,* 48
stamps, for printing on clay, etc.,
 156–60
standardization, 1–3
 artisans' need for, 194
 discrepancies and imperfections
 despite, 6, 72–73
 manuals achieving, 132–33
 of weights and measures, 62
Stein, Sir Aurel, 160
Stele of Yi Ying (Yi Ying bei), 20, *20*
Stele on Mount Yi, 20, *20,* 53
stencils, 175
stones, illustrated in manuals, 203
strokes. *See* brushstroke(s)

Sui dynasty, 114, 119
sutras
 Chinese imitation of, 176
 copying of, to gain merit and
 avoid punishment, 166, 184
Suzhou, silk production in, 84
Sweden, traders from, 89
*Synthesis of Books and Illustrations, Past
 and Present (Gujin tushu jicheng;
 Encyclopedia),* 139, 141–42,
 141, 189–90
 classification method used in,
 189–90

tableware
 sets of, 96–97
 social status indicated by, 77–78
Taizong, Emperor, 227*n*11
Tanaka Tan, 136
Tang
 dynasty, 114, 183
 palaces of, 120
 period
 architecture of, 117, 119–20
 collecting during, 191
 trade with the West during, 88
Tangut script, 150
Tao Qian, 97
taotie (motif), 32–37, *33, 35,* 41
 individuality of, 41
telegraph service (Chinese), 15
terra-cotta army. *See* Qin Shihuangdi:
 magic army of
textiles
 collecting of, 192
 factory production of, 3
 history of, 84, 157
 printing on, 157–58
 technical description of, 81–82
 treated in the *Synthesis,* 189
tile(s)
 for roofs, 106, 110
 in tombs, 156, 157, *157, 158*
timber, 59, 68, 103, 110–11
 standardization of, 119, 122
timber frame architecture. *See*
 architecture
Timurid painting, 175
*To See Large Within Small (Xiaozhong
 xianda;* Dong), 202
tomb(s)
 architecture of, 66
 compounds (Qing), 114, *114*
 excavation of, 25–28, 45, 53
 figures, 65–68
 collecting of, 192

wooden (Chu), 66, *66*
funerary objects in, 65, 192
imperial, 65
layout of, 26–27, 113
looting of, 26–28, 45, 54, 57
sacrifices in, 27, 56–57, 65
stamped tiles in, 156, 157, *157, 158*
tile-constructed (Henan Province), 156
treated in the *Synthesis*, 189–90
tools, carpentry, *126, 127, 127*
torture, 165, 182–83
Tōshōdaiji (Nara Prefecture, Japan), Golden Hall, 112–13, *112, 113*
towers (*que*), in Sichuan Province, 118–19, *119*
tracing copies (*shanggou*), 198–99, *198*
Trial of An Lushan (woodcut), 183, *183*
type. *See* movable type

Uighur (language), 177

variation(s), 13
by assembling standardized parts, 72–73
from mechanical reproduction, 86
Verenigde Oost Indische Compagnie (VOC), 88–89
vessels. *See* bronze: ritual vessels (Chinese)
Voltaire, 4

Wang Anshi, 137
Wang Gai, 205
Wang Shimin, 202
Wang Xianzhi, calligraphy of, 191
Wang Xizhi, calligraphy of, 11, *11, 21, 21,* 191, 195–96, *198,* 199
Wang Yuanqi, 200, *201,* 205–206
Wang Zhen, 224*n*17
Wang Zhongshu, 79
Warring States period (*Zhanguo*), 62, 65, 67
Water Basin of the Archivist Qiang, 19, *19,* 28
weapons, 60, *60,* 62
inscriptions on, 60, *60, 61*
in necropolises, 68
standardized and mass-produced (Qin), 60, 64
weaving, 81–83
Wedgwood, Josiah, 101
wen ("culture"), 83
West, the, 3–4, 7

learning from Chinese art production, 1, 3
manufactures and government of, 101, 141
See also Europe
Western Paradise (Dunhuang caves), 120, *120*
Western Zhou dynasty. *See* Zhou
wood. *See* timber
woodblock(s)
with Daoist charm, 148, *148,* 154
printing from, 3, 148–50
work. *See* labor
workers
bureaucratic control of, 57, 101
and managers, 137
wrapped-back binding (*baobei-zhuang*), 142
writing
as central to life of literati, 1
new materials for, effect on literacy of, 18, 20
See also calligraphy; characters; script (Chinese)
Wu Daozi, 175, 177
Wu Ding, King, 27
Wu, Emperor (Han), tomb of, 81
Wu state, 62
Wu Taisu, 228*n*34
Wu Zetian, Empress, 152
Wu Zhen, 204
Wutaishan, 103

Xian. *See* Chang'an
Xiang Yu, 54, 59
Xianyang (Qin capital)
destruction of, 54, 59
palace of First Emperor at, 69, 119
Xiaozhong xianda (*To See Large Within Small*; Dong), 202
Xing, earl of Wei, 28, 46–48, *46, 49,* 66
Xintian (Jin state), 42
Xixia dynasty, 150
Xu Beihong, *205,* 206, *206*
Xu Shen, 20
Xu Wei, 200, *200,* 203

Yama (fifth king of hell), 183, 184
yan ("word"), 10, 16, 17, *17,* 20, 21
Yan state, 62
Yanshi Erlitou (near Luoyang), 28
Yantielun (*Discourses on Salt and Iron*), 77
Yellow Emperor's Inner Classic, 136

Yi, marquis of Zeng, tomb of, 219*n*38
ritual vessels from, 47–48, *47,* 66
Yijing (*Book of Changes*), 2
Yingxian pagoda (Shanxi Province), 127–32, *128–31*
Yingzao fashi (*Building Standards*), 3, 119, 132–34, *135,* 135–37
yong ("eternal"), *10,* 11
Yong (ancient capital of Qin), 65
Yongle dadian. See Great Dictionary of the Yongle Period
Yongzheng, Emperor, 141
you (vessel), 36, *36*
Yu Hao, 133
Yu Shinan, 219*n*58
Yuan Zhongyi, 70
Yue state, 62
Yunjusi monastery (near Beijing), 13

Zendōji monastery (Hakata, Kyūshu, Japan), 170
Zhang Daiqian, 175, 206
Zhangyi Empress Li, Consort of Emperor Zhenzong (Taipei), 180, *180*
Zheng Xie, *186, 188,* 206–13, *207–13*
Zhenguosi (Pingyao, Shanxi Province), Ten Thousand Buddhas Hall, *111*
Zhengzhou (Henan Province), tiled tombs at, 156–57
Zhenzong, Emperor, 180
Zhihua monastery (Beijing), 222*n*12
Zhongshan kingdom, tomb of King Cuo, 118
Zhou Dunyi, 9, *9,* 16, *16*
Zhou, King (Shang), 182
Zhou
dynasty, 62
tombs of, 65
period
architecture of, 118
rituals in, 25, 28
ziran ("spontaneity"), 7, 195

Picture Sources

Sources are listed by chapter, alphabetically by source; numbers in parentheses refer to figure numbers in *Ten Thousand Things*.

Chapter 1

Fujiwara Sosui. *Shofu, soku shofu no kenkyū,* vol. 2, p. 4 (1.4)

Kan, Itsu Ei hi (1.17)

Ingeborg M. Klinger (1.1, 1.7, 1.9–1.13, 1.15, 1.16)

Lothar Ledderose, 1.21

Ledderose, *Mi Fu,* pl. 8 (1.18)

Liu Boqing. *Liu Ti Xuanmita biaozhun xizi tie,* pp. 5–6 (1.3)

New York Times, Jan. 20, 1999 (1.23)

People's Daily, Jan. 20, 1999 (1.22)

Shōwa Rantei, pl. 50 (1.5)

Sun Haibo, ed., *Jiaguwen bian,* p. 616 (1.14)

Chapter 2

Akiyama, Andô, and Matsubara, *Arts of China.* vol. 1, no. 37 (2.3)

Barnard, *Bronze Casting and Bronze Alloys in Ancient China,* p. 5 (2.27)

Chase, *Ancient Chinese Bronze Art,* p. 24 (2.21)

Fong, *The Great Bronze Age of China,* no. 27 (2.17); no. 4 (2.24)

Guo Baojun. *Shang Zhou tongqiqun zhonghe yanjiu* (2.23)

Idemitsu Museum, Tokyo (2.20, 2.28)

Institute of Archaeology of Shanxi Province, *Art of the Houma Foundry,* no. 27 (2.31)

Karlgren, "Notes on the Grammar," nos. 338–47 (2.14)

Keyser, "Decor Replication," p. 32 (2.32); p. 40 (2.33)

Ingeborg Klinger (2.1, 2.5–2.10)

Lothar Ledderose (2.25)

Li Chi, ed., *Hou Chia Chuang,* pl. III (2.2)

Minneapolis Institute of Arts (2.30)

Michael Nedzweski, (2.12, 2.13)

Rawson, "Ancient Chinese Ritual Bronzes," p. 811 (2.36); p. 82.21, 139 (2.11)

Rawson, ed., *British Museum Book of Chinese Art,* p. 350 (2.38); pp. 351–52 (2.39)

Sen-oku Hakuko Kan, Kyoto (2.19)

Shanghai bowungan, ed. *Shanghai bowungan cang quingtongqi,* vol. 2, no. 13 (2.18)

Smithsonian Institution, Freer Gallery of Art, Washington, D.C. (2.16, 2.29, 2.34)

Smithsonian Institution, Arthur M. Sackler Gallery, Washington, D.C. (2.15)

Tokyo kokuritsu hakubutsukan, ed., *Sōkō Itsu bō* 57 (2.40)

Umehara, *Ōbei shūcho Shina Kodō seika,* no. 3.164 (2.35)

Zhongguo shehui kexueyuan kaogu yanjiusuo, ed., *Yinxu Fu Hao mu,* p. 14 (2.4); p. 79 (2.26); LI, LII (2.37)

Chapter 3

China Pictorial 1986, no. 2 (3.19)

Lothar Ledderose (3.8, 3.32)

Ledderose, Lothar and Adele Schlombs, eds., *Jenseits der Großen Mauer,* p. 303 (3.3); p. 295 (3.4); p. 285 (3.5); frontispiece (3.6); p. 33 (3.9); p. 263 (3.10); p. 273 (3.13); p. 275 (3.14); p. 315 (3.15); p. 314 (3.16); p. 320 (3.17); p. 209 (3.21); p. 93 (3.23); p. 94 (3.24)

Museum of the Terra-Cotta Army for the First Emperor of Qin, Daniel Schwartz, photog. (3.1)

Selagen, Voisins, and Lartigue, *Mission archéologique en Chine,* vol. 1, pl. 1 (3.7)

Qin Shihuangling bingmayong keng, vol. 1: p. 173 (3.25); p. 177 (3.26); p. 179 (3.29); p. 180 (3.30); p. 181 (3.31)—vol. 2, pl. 9 (3.2); p. 160.2 (3.22); p. 161.4 (3.27); p. 161.2 (3.28)

From lantern slide no. 11.1: Smithsonian Institution, John Hadley Cox Archaeological Study Collection, Freer Gallery of Art and Arthur M. Sackler Gallery Archives (3.20)

Yuan, *Qin Shihuangling bingmayong yanjiu,* p. 42 (3.11)

Yuan, *Qindai taowen,* p. 280 (3.12)

Kaogu, 1972, no. 4, p. 25 (3.18)

Chapter 4

Howard and Ayers, *China for the West,* vol. 1, p. 84, no. 41 (4.10)

Hunan sheng bowungouan and Zhongguo kexueyuan kaogu yanjiuso, eds., *Changsha Mawangdui yi hao Han mu,* vol. 2, pl. 160 (4.2); pl. 78 (4.6)

Jörg, *Geldermalsen,* fig. 56 (4.11); fig. 21 (4.12)

Lothar Ledderose (4.1, 4.7)

Linden-Museum, Stuttgart (4.3)

The Nanking Cargo, p. 111, no. 2661 (4.14); p. 107, no. 2606 (4.15); p. 99, no. 2501 (4.16); p. 162, no. 3598 (4.17); p. 245, no. 5261 (4.18); p. 261, no. 5639 (4.19); p. 241, no. 5204 (4.20); p. 188, no. 4182 (4.21); p. 253, no. 5551 (4.22); p. 249, no. 5551 (4.23); p. 261, no. 5670 (4.24); p. 257, no. 5600 (4.25); p. 110, no. 2636 (4.26); p. 171, no. 3702 (4.27); p. 175, no. 3716 (4.28); p. 89, no. 2149 (4.29)

Gest Oriental Library and East Asian Collections, Princeton University (4.9)

Schloß und Spielkartenmuseum Altenburg, Saxony (4.30–4.34)

Shanghai shi fangzhi kexue yanjiuyuan, ed., *Changsha Mawangdui yi hao Han mu chutu fangzhipin de yanjiu,* pl. 9, no. N6-3 (4.5)

Sheaf and Kilburn, *The Hatcher Porcelain Cargoes,* p. 10, fig. 4 (4.13)

Staatliche Museen, Kassel (4.10)

Zhongguo meishu quanji weiyuanhui, ed., *Zhongguo meishu quanji, Gongyi meishu bian,* vol. 5, pl. 209 (4.4)

Chapter 5

zu Castell, *Chinaflug* (5.17)

Chen Mingda, *Yinxian muta*, figs. 4–5 (5.47); fig. 16 (5.48); pl. 87 (5.50); figs. 21, 30 (5.51)

Encyclopaedia Britannica, 1910–11 ed. (5.20)

Glahn, "Chinese Building Standards," p. 172 (5.52)

Guo Daiheng, "Lun Zhongguo gudai muguo jianzhu de moshu zhi," p. 37 (5.54)

Guo Daiheng and Xu Baian, *Jianzhushi lunwenji*, vol. 3, p. 40 (5.15)

Guo, Qinghua, "Structure of Chinese Timber Architecture," p. 45 (5.9); p. 450 (5.10)

Hou,ed., *Beijing lishi dituji*, cover (5.18)

Kasuga gongen genki-e, pl. 3a (5.45)

Lothar Ledderose, Lothar (5.1, 5.32, 5.33, 5.36–5.44)

Li Jie, *Li Mingzhong*, 30:7a (5.53)

Li Yuming, ed., *Shanxi gujianzhu tonglan*, pl. 20 (5.16)

Liang Sicheng [Liang, Ssu-ch'eng], *Pictorial History of Chinese Architecture*, p. 48, pl. 24j (5.5)

Linden-Museum Stuttgart (5.24)

Liu Dunzhen, *Zhongguo gudai jianzhu shi*, p. 130 (5.3); p. 9 (5.11)

Mainichi shinbun kokuhō iinkai, ed., *Kokuhō*, vol 1, pl. 18 (5.27)

Nara no jiin to tempyō chōkoku, pl. 53 (5.14)

Naraken bunkazai hozon jimusho, ed., *Kokuhō Hokkiji*, p. 5 (5.28); p. 1 (5.29); p. 7 (5.30); p. 3 (5.31); p. 11 (5.34); p. 15 (5.35)

Ota Hirotarō, ed., *Nihon kenchikushi kiso shiryō*, vol. 4, p. 230 (5.13)

Paine and Soper, *Art and Architecture of Japan*, p. 188, figs. 8D,C,B,A and E (5.8)

Segalen, Voisins, and Lartigue, *Mission archéologique en Chine* (5.25)

Shatzman Steinhardt et al., *Chinese Traditional Architecture*, p. 37 (5.6); p. 30 (5.19)

Whitfield, *Art of Dunhuang*, p. 72, pl. 172 (5.26)

Wenwu (1976, no. 2), p. 24 (5.22); (1981, no. 3) p. 25 (5.23)

Zhongguo gujianshu, p. 68 (5.2); p. 70 (5.7); 152 (5.12); p. 19 (5.21); p. 94 (5.46, 5.49)

Zhongguo kexueyuan ziran kexueshi yanjiusuo, comp., *Zhongguo gudai jianzhu jishgu shi*, p. 77, fig. 5-4-5 (5.4)

Chapter 6

Art Institute of Chicago (6.12, 6.13)

British Library (6.2)

Chavannes, *Les documents Chinois découverts par Aurel Stein*, pl. XV, no. 539 (6.18)

Kim, *Han'uk ko inswae kisulsa* (6.10)

Ingeborg Klinger (6.1)

Kuno and Suzuki, eds., *Hōryūji*, pl. 67 (6.9)

Mai and Huang, *Lingnan Xi Han wenwu baoku*, p. 123 (6.16); p. 147 (6.17)

Museum of Chinese History, Beijing (6.11)

Gest Oriental Library and East Asian Collections, Princeton University (6.3–6.7)

Shanghai shi fangzhi kexue yanjiuyuan, ed., *Changsha Mawangdui yi hao Han mu chutu fangzhipin de yanjiu*, pl. 36 (6.15)

Stein, *Serindia*, vol. 4, pl. 100 (6.8)

Zhou and Lü, *Henan Handai huaxiang zhuan*, p. 190 (6.14)

Chapter 7

British Library (7.27)

Cleveland Museum of Art (7.33)

Institute of Oriental Culture, Tokyo University (7.19)

Kanagawa Prefectural Museum, Yokohama, Japan (7.18, 7.23)

Ingeborg Klinger (7.9, 7.11, 7.13 , 7.14)

Kubosō kinen bijutsukan (7.28, 7.29)

von LeCoq, *Die Buddhistische Spätantike in Mittelasien* (7.25)

Masaki Museum, Osaka Prefecture, Japan (7.22)

Musée Guimet, Paris (7.26)

Museum für Ostasiatische Kunst, Berlin (7.1, 7.7)

National Museum, Nara, Japan (7.8)

National Palace Museum, Taipei, Republic of China (7.30–7.32, 7.34)

Quanxiang pinghua wuzhong (7.35, 7.36)

Princeton University Art Museum (7.15)

Sakata Munehiko (7.10, 7.12)

Yongle dadian (7.37)

Chapter 8

Asian Art Museum of San Francisco, The Avery Brundage Collection. Gift of the Asian Art Foundation of San Francisco (8.34)

Cleveland Museum of Art (8.10)

Deng, *Deng Shiru fashu xuanji*, p. 75 (8.3)

Linden-Museum, Stuttgart. Ursala Didoni, photog. (8.9)

Jieziyuan haupu daquan, pp. 626–27 (8.14); pp. 628–29 (8.15)

Jieziyuan haupudaquan, pp. 152-53; *Kaishien gaden*, vol. 2, pl. 88–89 (8.13)

Metropolitan Museum of Art, New York. P.Y. and Kinmay W. Tang Family Collection, (8.28)

Museum für Ostasiastische Kunst, Berlin (8.32)

Hunter, *Jackson Pollock*. Hans Namuth, photog., frontispiece (8.5)

Nanjing bowuyuan canghuaji, vol. 1, pl. 69 (8.8)

National Palace Museum, Taipei, Republic of China (8.2)

Nezu Kaichiro, ed., *Seizansō seishō*, vol. 1, pl. 11 (8.11)

Sanxitang Collection, Beihai Park, Beijing (8.7)

Shimada Shūjiro, ed., *Shōsai baifu*, p. 78 (8.12)

Smithsonian Institution, Arthur M. Sackler Gallery, Washington, D.C. (8.16)

Suiboku bijutsu taikei, vol. 11, pl. 96 (8.29)

Tokyo National Museum (8.1, 8.26)

Princeton University Art Museum, Bruce M. White, photog. (8.6)

Xu Beihong huaji, vol 2, pl. 43 (8.17); pl. 44 (8.18)

Yingyuan duoying 8 (8.25); p. 10 (8.30)

Zhang and Hu, eds., *Yangzhou baguai shuhuaji*, vol. 1, pl. 38 (8.31); pl. 34 (8.33)—vol. 2, pl. 80 (8.22); pl. 79 (8.24); pl. 76 (8.27)—vol. 6, pl. 145 (4) (8.19); pl. 145(2) (8.20); 145 (6) (8.21)—vol. 7, pl. 156 (8.23)

The A. W. Mellon Lectures in the Fine Arts

Delivered at the National Gallery of Art, Washington, D.C.

1952 Jacques Maritain
Creative Intuition in Art and Poetry

1952 Sir Kenneth Clark
The Nude: A Study of Ideal Form

1954 Sir Herbert Read
The Art of Sculpture

1955 Etienne Gilson
Art and Reality

1956 E. H. Gombrich
The Visible World and the Language of Art

1957 Sigfried Giedion
Constancy and Change in Art and Architecture

1958 Sir Anthony Blunt
Nicolas Poussin and French Classicism

1959 Naum Gabo
A Sculptor's View of the Fine Arts

1960 Wilmarth Sheldon Lewis
Horace Walpole

1961 André Grabar
Christian Iconography and the Christian Religion in Antiquity

1962 Kathleen Raine
William Blake and Traditional Mythology

1963 Sir John Pope-Hennessy
Artist and Individual: Some Aspects of the Renaissance Portrait

1964 Jakob Rosenberg
On Quality in Art: Criteria of Excellence, Past and Present

1965 Sir Isaiah Berlin
The Roots of Romanticism

1966 Lord David Cecil
Dreamer or Visionary: A Study of English Romantic Painting

1967 Mario Praz
On the Parallel of Literature and the Visual Arts

1968 Stephen Spender
Imaginative Literature and Painting

1969 Jacob Bronowski
Art as a Mode of Knowledge

1970 Sir Nikolaus Pevsner
Some Aspects of Nineteenth-Century Architecture

1971 T. S. R. Boase
Vasari: The Man and the Book

1972 Ludwig H. Heydenreich
Leonardo da Vinci

1973 Jacques Barzun
The Use and Abuse of Art

1974 H. W. Janson
Nineteenth-Century Sculpture Reconsidered

1975 H. C. Robbins Landon
Music in Europe in the Year 1776

1976 Peter von Blanckenhagen
Aspects of Classical Art

1977 André Chastel
The Sack of Rome: 1527

1978 Joseph W. Alsop
The History of Art Collecting

1979 John Rewald
Cézanne and America

1980 Peter Kidson
Principles of Design in Ancient and Medieval Architecture

1981 John Harris
Palladian Architecture in England, 1615–1760

1982 Leo Steinberg
The Burden of Michelangelo's Painting

1983 Vincent Scully
The Shape of France

1984 Richard Wollheim
Painting as an Art

1985 James S. Ackerman
The Villa in History

1986 Lukas Foss
Confessions of a Twentieth-Century Composer

1987 Jaroslav Pelikan
Imago Dei: The Byzantine Apologia for Icons

1988 John Shearman
Art and the Spectator in the Italian Renaissance

1989 Oleg Grabar
Intermediary Demons: Toward a Theory of Ornament

1990 Jennifer Montagu
Gold, Silver, and Bronze: Metal Sculpture of the Roman Baroque

1991 Willibald Sauerländer
Changing Faces: Art and Physiognomy through the Ages

1992 Anthony Hecht
On the Laws of the Poetic Art

1993 Sir John Boardman
The Diffusion of Classical Art in Antiquity

1994 Jonathan Brown
Kings and Connoisseurs: Collecting Art in Seventeenth-Century Europe

1995 Arthur C. Danto
After the End of Art: Contemporary Art and the Pale of History

1996 Pierre Rosenberg
From Drawing to Painting: Poussin, Watteau, Fragonard, David, and Ingres

1997 John Golding
Paths to the Absolute

1998 Lothar Ledderose
Ten Thousand Things: Module and Mass Production in Chinese Art